CRITICAL VOICES

Critical Voices

Women and Art Criticism in Britain 1880–1905

Meaghan Clarke

ASHGATE

Published by
Ashgate Publishing Limited
Gower House
Croft Road
Aldershot
Hants GU11 3HR
England

Ashgate Publishing Company
Suite 420
101 Cherry Street
Burlington, VT 05401-4405 USA

Ashgate website: http://www.ashgate.com

British Library Cataloguing in Publication Data
Clarke, Meaghan
Critical voices : women and art criticism in Britain 1880-1905
1. Women art critics - Great Britain - History - 19th
century 2. Women journalists - Great Britain - History - 19th
century 3. Art criticism - Great Britain - History 19th
century 4. Feminist art criticism - Great Britain -History,
19th century
I. Title
701.1'8'082'0941

Library of Congress Cataloging-in-Publication Data
Clarke, Meaghan.
 Critical voices : women and art criticism in Britain 1880–1905 / Meaghan Clarke.
 p. cm
 Includes bibliographical references and index
 ISBN 0-7546-0815-8 (alk. paper)
 1. Women art critics--Great Briatin--History--19th century. 2. Women journalists--
 Great Britain--History--19th century. 3. Art criticism--Great Britain--History--19th
 century. 4. Art, Modern--19th century. I. Title

N7482.5.C53 2005
701'.18'0820941--dc22

N 7482.5
.C53
2005

2004057433

ISBN 0 7546 0815 8

056347819

Typeset by IML Typographers, Birkenhead, Merseyside and Printed in Great Britain by
Biddles Ltd, King's Lynn.

Contents

List of figures VII

Acknowledgements IX

Abbreviations XI

1 Introduction 1

2 Art Criticism: Professional Patterns and Opportunities 11

3 'Art Critic' I never called myself: Re-visiting the 'Angel in the
 House' 45

4 'There is no sex in art': Art and Feminism 81

5 New Woman, New Criticism 115

6 Epilogue 155

Notes 163

Bibliography 193

Index 209

List of figures

1 Introduction

1.1 'Press Day at the Royal Academy', *Art Journal*, 1892, by permission of the British Library

2 Art Criticism: Professional Patterns and Opportunities

2.1 'Women's Rights', *Graphic*, 25 May 1872, courtesy of the British Library

2.2 *Florence Fenwick Miller, c.* 1880, photograph, Helen Blackburn Collection, Girton College, Cambridge

2.3 John Singer Sargent, *Alice Meynell*, 1894, pencil, 36.2 × 21.0 cm, by courtesy of the National Portrait Gallery, London

2.4 William Rothenstein, *Alice Meynell*, 1897, lithographed drawing, from *English Portraits* (1898)

2.5 Elizabeth Robins Pennell, 'From Berlin to Budapest on a Bicycle', *Illustrated London News*, 1892, courtesy of the British Library

2.6 Giovanni Boldini, *Lady Colin Campbell*, 1897, oil on canvas, 182.2 × 117.5 cm, by courtesy of the National Portrait Gallery, London

2.7 Lady Pauline Trevelyan and L. G. Loft, *Lady Emilia Frances Dilke c.* 1864, oil on millboard, 25.4 × 18.1 cm, by courtesy of the National Portrait Gallery, London

2.8 Hubert Herkomer, *Emilia Dilke*, 1887, oil on canvas, 139.7 × 109.2 cm, by courtesy of the National Portrait Gallery, London

2.9 Mary Thornycroft, *Mrs. Russell Barrington*, 1881, bronze, h 22 in, by courtesy of Leighton House Museum, London

3 'Art Critic' I never called myself: Re-visiting the 'Angel in the House'

3.1 Alice Meynell, 'Mrs. Adrian Stokes', *Magazine of Art*, 1901

3.2 Elizabeth Butler, *Rorke's Drift*, 1880, oil on canvas, 119.3 × 213.3 cm, The Royal Collection
© 2003, Her Majesty Queen Elizabeth II

3.3 Laura Alma-Tadema, *The Sisters*, engraving, *Art Journal*, 1883, courtesy of the British Library

3.4 Leighton, *Bath of Psyche*, 1890, oil on canvas, 189.2 × 62.2 cm
© Tate, London 2003

3.5 Holman Hunt, *Strayed Sheep*, 1852, oil on canvas, 78.5 × 94.0 cm
© Tate, London 2003

3.6 Alice Meynell, 'Newlyn', *Art Journal*, 1889, courtesy of the British Library

3.7 Stanhope Forbes, *Fish Sale on a Cornish Beach*, 1885, oil on canvas, 121.0 × 155.0 cm, Plymouth Art Gallery, courtesy of the Bridgeman Art Library

3.8 Elizabeth Armstrong Forbes, *School is Out*, 1889, oil on canvas, 105.5 × 118.7 cm, courtesy of the Bridgeman Art Library

4 'There is no sex in art': Art and Feminism

4.1 Florence Fenwick Miller, 'Ladies' Column', *Illustrated London News*, 12 May 1888, by courtesy of the British Library

4.2 Rosa Bonheur, *The Horse Fair*, 1853, oil on canvas, 244.5 × 506.7 cm, National Gallery, London

4.3 Henrietta Rae, *Ophelia*, 1890, oil on canvas, 158.8 × 226.5 cm, National Museums Liverpool, Walker Art Gallery

4.4 Henrietta Rae, *Psyche before the throne of Venus*, Royal Academy, 1894, oil on canvas, 193.0 × 304.8 cm, present location unknown, reproduced in Royal Academy Pictures

4.5 Louise Jopling, *Home Bright, Hearth Light*, 1896, 123.5 × 84.0 cm, National Museums Liverpool (Lady Lever Gallery)

4.6 'Character Sketch: Adelaide Johnson', *Woman's Signal*, 9 April 1896, courtesy of British Library

4.7 Lucy Kemp-Welch, *Colt Hunting in the Forest*, 1897, oil on canvas, 15.3 × 306.0 cm, Tate, London, by courtesy of Felix Rosenstiel's Widow & Son Ltd, London

4.8 Mary Cassatt, *Modern Woman*, 1893, courtesy of the Chicago Historical Society

5 New Woman, New Criticism

5.1 'Donna Quixote', *Punch*, 28 April 1894, courtesy of the British Library

5.2 Elizabeth Robins Pennell, *Over the Alps on a Bicycle*, 1897, courtesy of the British Library

5.3 Edward Burne-Jones, *The Mill*, 1870–82, oil on canvas, 90.8 × 197.5 cm courtesy of the Victoria and Albert Museum, London

5.4 Walter Richard Sickert, *Minnie Cunningham at the Old Bedford*, 1892, oil on canvas, 61.0 × 61.0 cm, Tate, © Estate of Walter R. Sickert 2004, All rights reserved, DACS

5.5 James Guthrie, *Midsummer*, 1892, oil on canvas, 90.0 × 124.5 cm, courtesy of the Royal Scottish Academy (Diploma Collection), Edinburgh

5.6 Edgar Degas, *L'Absinthe*, 1876, oil on canvas, 92.0 × 68.0 cm, courtesy of the Musée d'Orsay, Paris

5.7 James McNeill Whistler, *Nocturne: Blue and Gold – Old Battersea Bridge*, 1872–77, oil on canvas, 68.3 × 51.2 cm, © Tate, London 2003

5.8 James McNeill Whistler, *Arrangement in Black: Lady Meux*, 1881–82, oil on canvas, 194.1 × 130.2 cm, courtesy of the Honolulu Academy of Arts

5.9 John Singer Sargent, *Ellen Terry as Lady Macbeth*, 1889, oil on canvas, 375.2 × 198.1 cm, © Tate, London 2003

6 Epilogue

6.1 'A Jubilee Private View', *Punch*, 18 June 1887, courtesy of the British Library

6.2 *Blast*, 1914, courtesy of the British Library

Acknowledgements

I wish to acknowledge the numerous institutions and people who assisted me while I was conducting my research and writing for this book. Especially, I would like to thank my doctoral supervisor, Deborah Cherry, for her expertise, inspiration, support and encouragement. Several people have read and commented on this material at different stages and in particular I would like to thank Tim Barringer, Liz James, Lynda Nead, and Patricia Thane for their insight and inspiration. Thank you also to the innumerable individuals who have helped me to formulate ideas in discussion and at conferences on both sides of the Atlantic, including Laurel Brake, Julie Codell, Colin Cruise, Heather Haskins, Janice Helland, Linda K. Hughes, Ruth Livesey, Diana Maltz, Lara Perry, Talia Schaffer, and Ana Parejo Vadillo. For their encouragement I thank Chandler Kirwin, and Angela Carr, and offer this as a tribute to Natalie Luckyj (1945–2002). Friends, colleagues and students at several institutions, including those at the University of Manchester and subsequently the University of Sussex, offered discussions and enthusiasm along the way – special thanks to Bente Bjornholt, Sarah Cheang, Craig Clunas, Carolyn Dixon, Jennifer Gibson, Jos Hackforth-Jones, Tara Hamling, Maurice Howard, Nigel Llewellyn, Dan Rycroft, Michelle O'Malley, David Alan Mellor, Partha Mitter, Vibhuti Sachdev, Evelyn Welch and Steve Wharton.

I am indebted to librarians, archivists, curators and researchers in numerous institutions for their assistance in tracking manuscripts, periodicals, books and artworks. Thank you to John B. Attebury, Senior Reference Librarian, and to the staff at the Burns Library, Boston College, Boston for facilitating my research of the Meynell and Francis Thompson Collections, and Kate Perry, Archivist at Girton College, Cambridge and Miss J. Bennett, Assistant Curator, Walker Art Gallery, Liverpool for assistance with my research on Henrietta Rae. I am very grateful to Elizabeth Hawkins for inviting me to visit her family

archive and library. Additional thanks to the librarians and archivists at the Bodleian Library, Oxford; British Library, London; Harry Ransom Center, University of Texas, Austin; Special Collections, Library of Congress, Washington DC; Contemporary Medical Archives Centre, Wellcome Institute for the History of Medicine, London; Central Reference Library, Manchester; Women's Library, London; Heinz Archive, National Portrait Gallery, London; John Rylands Library, Manchester; the National Art Library, London, and the University of Glasgow Special Collections. The Interlibrary Loans staff at the University of Sussex Library have been extremely helpful with my interminable requests. Acknowledgement is also due to librarians and archivists at the following Canadian university libraries: Stauffer Library, Queen's University; D.B. Weldon Library, University of Western Ontario; and St Michael's College Library and Robarts Library, University of Toronto.

The Committee of Vice-Chancellors and Principals, the Royal Historical Society, and the Social Sciences and Humanities Research Council of Canada enabled me to undertake doctoral research. A Leverhulme Special Research Fellowship and an Oneal Research Fellowship at the Harry Ransom Center, University of Texas at Austin facilitated further research and a British Academy grant aided the production of this book. The School of the Humanities at the University of Sussex and the Royal Historical Society also subsidized overseas research and conferences.

Finally, friends and family have provided invaluable moral support and respite along the way – I am eternally grateful to Kristin Doern, Rachel Hammersley, Wendy Robins, Patoni Kawkab, the Rooke family, Cailin Clarke, Leslie Rockwell, Lance Rockwell and Benjamin Roberts. I dedicate this book to my mother, Sheila Rockwell Clarke, with thanks for her strength, literary acumen and never-ending enthusiasm for yet another draft, and in memory of my father, Ian Orford Clarke (1937–98).

Abbreviations

AJ	*Art Journal*
AM	*Atlantic Monthly*
BL	British Library
CMAC	Contemporary Medical Archives Centre
DC	*Daily Chronicle*
FR	*Fortnightly Review*
ILN	*Illustrated London News*
LC	Library of Congress
MA	*Magazine of Art*
ME	*Merry England*
NC	*Nineteenth Century*
NEAC	New English Art Club
PJ	*Palace Journal*
PMG	*Pall Mall Gazette*
RA	Royal Academy
WR	*Weekly Register*
WS	*Women's Signal*
WSJ	*Women's Suffrage Journal*

Introduction

Mr. Humphrey Ward, even though he bears, Atlas-like, upon his shoulders the weight of the Times, does not grudge himself a few minutes' relaxation in conversation with his brother and sister critics. Of the latter, indeed, as I have already hinted, there are legion; but among them are few who are an honour to their craft.[1]

Whatever M. H. Spielmann, editor of the *Magazine of Art*, may have thought in 1892, this book will show that the 'legion ... of sister critics' were indeed an 'honour to their craft', and moreover that women art critics made significant interventions in debates around contemporary art at the *fin de siècle*. Another article of the period, 'Art Critics of Today', was accompanied by the image *Press Day at the Royal Academy*. Here we see the annual Royal Academy exhibition of 1892 jam-packed with members of the press and amongst the crowds are the infamous 'legion' of women. One of them is depicted in fashionable dress strolling through the exhibitions rooms and, in the middle right of the image, another woman clutches a pen and paper, evidently hard at work. In fact, of the 29 critics clearly visible, six are female. Although women art critics provided considerable copy, in the form of reviews and articles, to the press of the time, they have been largely ignored in scholarly accounts of the late Victorian period. It is this oversight which *Critical Voices* will address.

Art journalism offers a particularly interesting focus for study because it afforded middle-class women access to a profession, one that was developing rapidly during the period 1880–1905. The sheer volume of journalistic output in the late nineteenth century provided tremendous opportunities for women to publish art journalism, and art writing was a genre that was already considered appropriate for women writers.

Women art writers widen our understanding of feminist history, specifically feminist interventions in politics and visual culture. The lives of women art writers represent the history of the nineteenth-century women's movement, for newspapers and periodicals were cultural sites in which

middle-class women made diverse contributions to the changing discourses about women's rights.

However, articles and reviews published by women not only inform women's history but also challenge existing narratives of 'Victorian' and 'modern' art history. They open up our comprehension of the role of art criticism in the construction of art history at precisely the point of its formation as a discipline. The dramatic expansion of the press produced a diversity and multiplicity of sites for art criticism, marking a popularization and democratization of the discipline. We will therefore see played out in the work of women art critics the importance of the press in the articulation of art history and the tensions inherent in the relationship of popular art criticism with elite visual culture.

In the late Victorian period the press was fundamental to the transmission and construction of contemporary culture. It was expanding rapidly, facilitated by improvements in technology and an ever-increasing readership.[2] The circulations and readership of periodicals varied widely, as did their editorial agendas. Specialist art periodicals had modest circulations and middle- and upper-class readers. Newspapers such as *The Times* had a readership in the 1880s of 100 000 and the more radical *Pall Mall Gazette* 12 250; in the 1870s the *Fortnightly Review* had 2500 readers, the *Athenaeum* 15 000 and the *Illustrated London News* had 70 000 readers, although key events resulted in levels of 200 000 for the latter.[3] However, sample circulation figures do not reflect this level of readership; it is clear that circulation continued in families and libraries long after newspapers and magazines had been sold to the customer.

Fine art reporting was vital to contemporary journalism; virtually all newspapers and magazines carried reviews of current exhibitions as well as articles accompanied by sumptuously reproduced prints. This meant that, both visually and textually, art was crucial to the marketing of journals, but simultaneously journals were crucial to the art market. This circularity illustrates the importance of art journalism which expanded considerably during these decades as periodical production far surpassed the 1860s. As active and integral agents of contemporary culture, these texts offer an invaluable archival source. Numerous journalists, male and female, were writing art criticism during the nineteenth century and the opportunities increased with the inception of such periodicals as the *Magazine of Art*, *Studio* and *Connoisseur*, as well as new mass-circulation newspapers, such as the *Star*.[4] The expansion of connoisseurship, and the institutionalization of the museum and art scholarship, altered the artistic climate in Britain and contributed to the professionalization of the critic.

In her study of contemporary art criticism in the mid-Victorian period, Elizabeth Prettejohn adopts a new focus that shifts attention away from the

'great-man paradigm' to a broader analysis of texts accepted as art criticism in their historical context.[5] In the late nineteenth century this approach likewise opens up new possibilities for analyses of texts and critics. Much work has been done on the New Critics in the 1890s, as well as on Roger Fry who became a strong influence in English art criticism as editor for the *Burlington Magazine* in 1903.[6] However, studies of new developments in art writing during this period have not included women critics.

During the early Victorian period women had already gained renown as writers on art and travel. Furthermore, the art world was already peopled by women as producers of art, as well as viewers and consumers. Editors became increasingly aware of the benefits of catering to these two overlapping categories: women as consumers of art and women as readers of journals. These factors conjoined with the dramatic expansion of art journalism meant that art writing was an area particularly open to professional women journalists. Indeed by the 1880s over 30 different women writers were contributing signed art articles to specialized publications such as the *Art Journal*, as well as more popular journals such as the *Illustrated London News*, although this vast body of art criticism has been neglected by critical analyses.[7] In England, the decades between 1880 and 1900 were a period in which, for the first time, women authors regularly contributed to national art publications, writing on contemporary and historical fine art as well as exhibition reviews.

The career trajectories of women journalists necessitate the examination of art writing across media, encompassing the specialist art press and mass-circulation newspapers, because individuals often wrote for several different journals simultaneously. Rosemary Betterton has observed that, in the struggle to change the place of women in culture and language, the traditional divisions between high art and mass culture have been challenged, as well as the compartmentalization of knowledge between the disciplines.[8] This book will similarly transgress these divisions by considering a diversity of journal formats, including art periodicals and weekly newspapers, as primary vehicles of late nineteenth-century mass culture and art criticism. This will entail analysing the various meanings they constructed as well as the cross-disciplinary intersections in their contents and production.

No scholarship has undertaken a broad analysis of the art writing by women produced during this period. The results of the initial survey of British periodicals during the period on which this book is based indicated hundreds of articles by women publishing as professional journalists; these articles were previously overlooked because they do not appear in existing directories of Victorian periodicals. This substantive amount of material, which has never been the subject of sustained research, functions as the core archive for this book. The texts occurred in a variety of forms, including book reviews, travel

articles, essays and reviews on historical and contemporary art. I made the decision to focus on the latter category of contemporary art because it quickly became apparent that, as critics, women played a key role in discourse on contemporary art by promoting certain individuals, styles and exhibitions while dismissing others in their regular columns and articles. This new wealth of archival material thus directs the contents of the book which draws on nineteenth-century criticism and history for contextualization.

Although late Victorian and Edwardian female art critics were distinctly middle-class, they were also working women. There were disparities within the category of middle class, and the positions of women relative to these sub-categories fluctuated during their lifetimes. Many women journalists existed on the sporadic and unpredictable income gained from freelance work. Those women who did gain more permanent positions still combined them with piecework. Throughout their lives, many Victorian women art critics seem to have worked constantly, either out of necessity or commitment to their profession. Books on art offered them another important career diversification and opportunity for supplementing journalistic earnings. Additionally, only a few women journalists confined themselves to writing about art: most produced a great deal of diverse material that intersected with political, religious, educational and medical discourses. Nor did women writers on art necessarily consider themselves as 'art critics'. The stereotype of the independently wealthy critic, epitomized by John Ruskin, did not apply to late nineteenth-century women. I track the importance of journalistic careers to women's livelihoods, and consequently their needs and abilities to market their writing to editorial and management levels in the magazine and newspaper industries.

While we know middle-class women's careers expanded in the later nineteenth century, this option of art journalism is still unexplored.[9] The only full-length study of women art historians, prepared by Claire Richter Sherman with Adele Holcomb, entitled *Women as Interpreters of the Visual Arts*, deals more generally with the development of English and American women's entry into museums, archaeology, and scholarship in the nineteenth and twentieth centuries.[10] In recent scholarship, Pamela Gerrish Nunn's essay, 'Critically Speaking,' is the only direct analysis of Victorian women art critics. Her research illustrates that,

While there are several kinds of writing for publication Victorian women practised successfully, and for which, indeed, they became and/or have remained well known, art criticism was emphatically not one. Thus the Victorian art critic's voice as a public noise can be generalised as a male voice, and those individual critics whose voices have been distinguished from the chorus by later generations – including John Ruskin, Philip Gilbert Hamerton, Frederic George Stephens, William Thackeray – were all men.[11]

She concludes therefore that, although 'several women did begin to function as art critics as men defined that term', the obstacles encountered in the pursuit of a professional career in art criticism prohibited most women from succeeding in what she perceives as a masculine sphere.[12] In fact, there were a considerable number of women art writers working in a number of different areas, although even in the nineteenth century many of those writing about women art writers could only cite a handful, and Spielmann, who noted they were 'legion', quickly dismissed all but 'a few'. Nonetheless, their presence suggests that art criticism was not an exclusively masculine sphere, nor was it 'patriarchally defined' as Nunn attests. The work of these scholars indicates the need for an expanded examination and analysis of women writing art criticism in Britain in the period 1880–1905, in order to more fully understand their navigation of professional journalism and production of knowledges about the visual arts.

Women art critics maintained diverse and shifting relationships with the women's movement. They reveal the complicated negotiations and modes of articulating a feminist politics during this period. On the one hand, the writing of some critics was directly informed by their involvement with the late nineteenth-century women's movement. Thus, the position of women artists within institutions and their career successes were part of a larger project that encompassed professional, legal and political rights for women. However, a closer analysis of this intentional conjoining of fine art and feminism reveals the tensions inherent in such a project in the 1880s and 1890s. On the other hand, several women art writers maintained a clear distinction between their interests in women's issues and their art writing. Neither expertise on the eighteenth-century feminist Mary Wollstonecraft nor associations with radical New Womanhood necessarily implied a feminist politics. Women journalists reveal the tensions around the New Woman category and, for some, the incommensurability of feminist politics and avant-garde art criticism. We will examine the specificity and diversity of these linkages in Chapter 5.

Recent research has highlighted the plurality of subject positions women occupied as artists in the Victorian period.

A recognition that subjectivity was contingent, fixed only fleetingly and subject to change will assist a move away from the notion of a centred, essential self which can be transferred seamlessly from 'life' into 'art'. It will also help to explain the non-coincidences between a woman's politics and her art.[13]

The notion of a fragmentary, decentred subjectivity helps to explain why a woman could simultaneously occupy diverse positions, and will assist in elucidating the dissonances between a woman's politics and her writing about art.[14] Paradoxically, although the notion of decentred subjectivities suggests the importance of discourses rather than individual subjects, it is the individual as a

singularity that bears witness to these conflicting discourses around gender. It is through the locus of the individual that these discourses meet and contest. Through individual lives one can take account of the conflictual nature of discursive formations. Individual subjects communicate this complexity, as well as the conflict and contrast between subjects. Thus it is through the microscope of specific lives that generalizations about contemporary discourses can be traced.

New professional women had emerged who moved across genres, working as journalists and art critics, novelists, activists and philanthropists. Although these separate genres – art criticism, literature, history, travel – have been categorized historically as distinct, case studies reveal their interdisciplinarity. Case studies of individual critics facilitate a mapping of the realities of late Victorian publishing; writers contributed on a diversity of subjects across a diversity of media. An exploration of publishing careers, as opposed to specific articles, enables a new way of looking at art writing across art movements, rather than in relation to individual groups or artists. In addition, what case studies intriguingly reveal about women art critics is their relationship to the women's movement; rather than existing in a separate sphere, these professional women navigated public space and intervened in debates around gender. Their interrogations reveal the instability and contestation endemic to the suffrage movement. All of these women at various intervals made statements which seem to contradict their professional lifestyle and interest in woman's rights.[15]

Another way of thinking about women's professional careers is in terms of tactics. Rey Chow writes of 'borders' as *'para-sites* that never take over a field in its entirety but erode it slowly and *tactically'*.[16] Here Chow draws on Michel de Certeau's formulation of a 'tactical' intervention as a 'calculated action determined by the absence of a proper locus'. Conceptually, a 'tactical' erosion of a field offers a way of understanding and analysing women's interventions into existing discourses, as well as their inventiveness.

Patterns of authorship in late nineteenth-century journalism presented an array of possible named and unnamed contributions on contemporary fine art. One tactic for intervening in art discourse was the latter – anonymous reviews were published regularly in the specialist art press and in more generalist newspapers and periodicals. Anonymity allowed women's writing to be taken seriously as art criticism. However, publishing art writing minus the signature in effect severed the author from the text. Hence women acquired a locus or space in art publishing, but only one in which the individual author was effaced. During the late nineteenth century this became a particular problem for women art journalists because the era of anonymous reviewing was giving way to an upsurge in the importance of named authorship. Signed reviews and articles were increasingly linked with the

notoriety of the author and even her or his celebrity status. In the context of this new focus on naming journalists, pseudonymous authorship provided a new 'tactic'. Texts could be associated with a particular *nom de plume*, in order to establish a named authority in the press. Initials as 'names' were a variation of this format, occasionally acting as acronyms, to reveal the identity of the author to readers with contextual knowledge of its translation. Alternatively, women attached their own signature to art reviews and articles thereby guaranteeing visibility and recognition for their work. Patterns for deploying signature versus other forms of authorship were therefore by no means clear-cut: they varied within the portfolios of individual authors and across the press as a whole. The specificity of women's choices about authorship within this period needs to be examined in conjunction with the texts themselves in order to map the complexity of these 'tactics' for intervening in the field of art criticism.

We will also see through, for example, the various institutional disputes within the Royal Academy, the tension between, on the one hand, the tactical need for women art critics to find a space for themselves and their work and, on the other hand, the desire for recognition of both individual women and women's role in art in general. The tactical interventions of women in art criticism therefore illustrate the wider historical tension between women's pragmatic pursuit of professional space and the political need for public or institutional recognition which culminates in the suffrage movement.

One further question which has been the focus of recent debate has been the relationship of middle-class women to the public space of the developing metropolis.[17] Art writers held a unique position in that not only did they travel from their homes to galleries, studios and exhibitions in the West End and beyond, but they recorded their visual engagement with the city in the rapidly expanding print media. Art criticism offered a formalized structure for the gaze, and one that was being increasingly professionalized. Public spaces were not limited to city streets; the art gallery afforded women journalists another kind of – interior – public space where they were observers and observed. Exhibitions such as the Royal Academy offered a space, albeit institutionally regulated, that implicitly included women as viewers and reviewers (if not as members). Art journalism afforded a professional aegis for women's exploration of the city, and (re)views by women are fundamental to our understanding of metropolitan visual culture.

The late nineteenth century witnessed dramatic shifts in art and exhibitionary practices that were routinely documented and debated in the press. Art journalism was central to this complex negotiation of the visual; critics were highly influential in determining the popularity of art and artists. Articles and reviews played a vital part in the cultural and economic exchanges of the contemporary art world. As Julie Codell recently observed,

'art historians often consider the press an unmediated voice, an "objective" response'.[18] It is my intent to redress this imbalance by considering the overlapping allegiances amongst critics, editors and artists, in conjunction with the specificity of critical responses. Women art journalists are not only interesting as professional women, but as art critics in their own right.

Women art writers intervened in a wide variety of debates concerning contemporary art. Critics recognized individual artists through biographical articles, and reviews encompassed a diversity of spaces and movements. Articles celebrated the lives and work of Royal Academicians, yet the exclusionary policies of the Royal Academy were also questioned in the context of women artists, both with regard to membership and access to life study in the academy schools. The Royal Academy was also heavily criticized for its lack of support for the new painting influenced by French Impressionism. The concerns of these latter artists, associated with the New English Art Club, were introduced to the Victorian public. As journalists some women argued for a shift away from the methods of studio-based academic painting to an appreciation of *plein air* painting. The constantly shifting nature of art writing is indicative of a more complex dynamic in the late Victorian art world, both in terms of the relationships of artists with critics, and in their links with the Royal Academy and the avant-garde.

I will locate art writing by women largely within contemporary issues around feminist politics and art world debates, particularly the contested rise of the 'modern' and the decline of the Royal Academy (RA). The book begins with a chapter introducing broader issues pertaining to the material and its contexts. Here I consider the gendered specificities of journalistic careers as they relate to women, and strategies of writing adopted by women. These aspects of women's access to art journalism are examined in order to comprehend the heterogeneity of their writings and their negotiation of the professional sphere. The study of career patterns reveals diverse social, political and religious discourses informing the approaches of women critics to art. The last three chapters contain three case studies: Alice Meynell, Florence Fenwick Miller and Elizabeth Robins Pennell.[19] I have selected these three women because they are among the most widely published women writers and exemplify the diversity of art-critical approaches and subjectivities in criticism by women. Their writings were accessible to male and female visitors to exhibition rooms, as well as to artists, viewers, dealers and buyers. Concomitantly, their texts contributed fundamentally to the construction of the discipline of art history. This book addresses the common themes shared by all three women: an interest in the debates around the RA and modernity and attitudes to women artists, to gender, to marriage and femininity.

Although a variety of similarities can be traced in Meynell's, Fenwick Miller's and Pennell's respective careers in art journalism, there were marked

differences in their educational backgrounds, religious and political affiliations, and feminist beliefs. The case studies allow, through the pursuit of a biographical line of enquiry, a detailed exploration of how women negotiated a career and marriage, home and working lives, while dealing with largely male-dominated social networks and clubs. Interestingly, in Spielmann's article on 'Press Day and the Critics' (quoted above), Fenwick Miller, Meynell and Pennell did not make his shortlist of women critics. Although Meynell and Pennell had published in his journal they presumably did not 'honour their craft'; instead their husbands were listed in their place as columnists for *Merry England* and the *Star* respectively. Nonetheless, both were named in 'Art Critics of Today'; in *Press Day at the Royal Academy*, Meynell is in the top centre with her back to the viewer, wearing a hat and veil, and Pennell is in the top right corner, also with her back to the viewer (Figure 1.1).[20] We see only the backs of these two women critics, both are accompanied by their husbands, and they are mentioned in the article in the context of their husbands' work. Indeed four of the women in the image have their backs to us. By illustrating four women from the back, the artist renders them faceless, that is almost unrecognizable or invisible. Although marginalized, Meynell and Pennell are nevertheless amongst six women critics visible in the image. And they remain identifiable, for the aesthetic gallery-goer Meynell's hat and elegant profile are unmistakable, even from the back. They both document the presence of women art critics at press views, and reveal the gaps between the visual representations of women critics and the writer's disinclination to mention them.

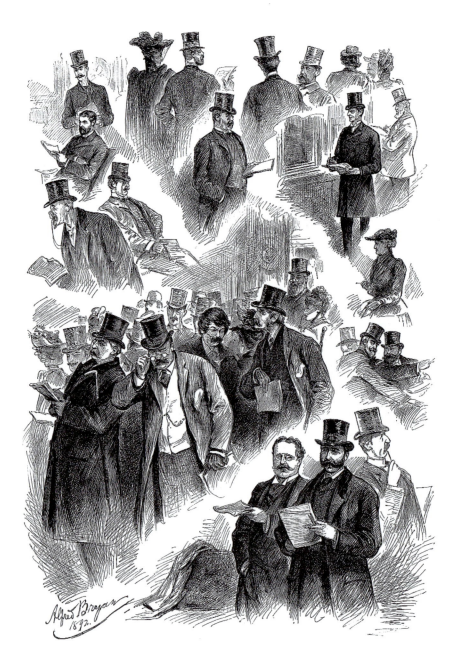

1.1 'Press Day at the Royal Academy', *Art Journal*, 1892

Art Criticism: Professional Patterns and Opportunities

Analysis of late nineteenth-century journalism reveals complex and shifting gender opportunity and career patterns. The following chapter will examine these patterns across a diverse range of individual journalists' experiences, in conjunction with a thematic exploration of related issues: education, marital status, professional and economic patterns. Extant accounts of women's experiences in the profession reveal a heterogeneity of histories; in spite of socio-economic constraints, women negotiated independent successes and remuneration. In addition, contemporary job guides for journalism and the rise of professional organizations indicate the expansion of the field of art journalism. Sexual difference will be considered in relation to the professionalization of journalism; modes of periodical production, editors, signatures and institutions were all implicated in art criticism. Finally, the chapter will map the positioning of women art writers within the new professional networks of journalists and artists.

Gender and journalism: career patterns and conditions

Despite advances in girls' education, the education of middle-class women was often limited to the home during the period 1860–80. Although money was spent on educating sons it was not made available for the education of daughters, a distinction which came to be resented by young women. Although some exclusive girls schools existed, their academic standards were not necessarily an improvement on governesses more concerned with deportment than learning.[1] Some women art critics, such as Emilia Dilke, received instruction in painting and drawing, pursuits considered appropriate to Victorian femininity, and obtained additional training in the expanding art schools, but the majority were taught at home by parents or

governesses. Alice Meynell and her sister Elizabeth were educated by their parents at various homes in England and Italy. Their stern scholarly father expected much of them at regular morning lessons which included history, maths, French, Italian and literature. Christiana Thompson, their mother, was a musical prodigy in her youth and her devotion to music and painting – 'blessed arts' – obviously influenced both daughters.[2] Slightly younger women such as Florence Fenwick Miller benefited from a more formal education. An only daughter, she studied medicine at Edinburgh University in the 1870s, but medical degrees were refused to women so she returned to London to the Ladies' Medical College.[3]

For women art critics, marriage did not necessarily mean an end to their career. For example, Dilke, Meynell and Fenwick Miller all negotiated successful professional careers while married. However, their relationships were markedly different. Emilia Dilke's relationship with her first husband, Mark Pattison, was described by her second, Charles Dilke,

there was no personal resistance to the influence over her of her husband. His mind and learning deserved the surrender of the educational direction of a young girl, however talented, to his mental and philosophical control; and he obtained it fully.[4]

Illness provided her with the opportunity to escape his increasingly unbearable controls on her behaviour and to work in France, a climate more favourable to her health. Meynell and Fenwick Miller, like many women, had to maintain their careers in order to support their family. Meynell's relationship with her husband was more professionally equal, but in order for their large family to survive, both parents had to work constantly. The editorship of the journals was a joint responsibility carried out by the remaining partner when one was away. In the case of Fenwick Miller, it became clear to her early in her marriage that a large share of the responsibility for their income would be hers, as her husband was not a very successful businessman.[5] Similarly, Julia Cartwright was responsible for providing for her own daughter's education at Oxford.[6] However, some women achieved success after leaving marriage and pursuing independent careers in journalism. After her divorce Gertrude Campbell wrote for several periodicals and was art editor of the *World* from 1889 to 1903.[7] Katherine de Mattos separated from her promiscuous husband and supported her two children by writing for literary and art periodicals.[8]

Several women critics remained single, including Helen Zimmern, Sophia Beale, Vernon Lee and Marion Hepworth Dixon. All of these women supported themselves by publishing continuously in a variety of periodicals and books.[9] Unmarried women were able to work and live independently with female friends; the most renowned of these individuals is Vernon Lee who travelled with her companion Clementine 'Kit' Anstruther-Thompson.

Lee lived in Florence, but she frequently stayed in London where her writings on art and aesthetics secured her prominence amongst its intellectual elite.[10] The 1880s was a period in which a generation of middle-class women, born in the 1850s and 1860s, lived with social and economic independence. They were united by a sense of rebellion against the constraints of bourgeois family life and a gravitation to London, where a professional and intellectually stimulating life was possible. As Deborah Epstein Nord has observed, what distinguished women in the 1880s was their dependence on one another in an urban female community and the *possibility* of being single without being odd.[11] In 1895, journalist Margaret Bateson attested to this possibility and repudiated economic and social assumptions concerning professional women; she observed that in fact she was no worse off with an income of £200 than a matron and children living on a husband's £400, while she benefited from a social network of female friends.[12]

However, unfavourable attitudes towards career women remained prevalent in the periodical press, further substantiated by the scientific currency of craniometry, anthropometry and eugenics, and their use in conservative reinscriptions of sexual roles; hence marriage was continually put forth as the ultimate goal for daughters. George Romanes's 1887 article elaborated on a new psychology of sexual difference: women lacked originality, were overpowered by their emotions, and their intellectual inferiority was linked with their brain weight.[13] Six years later Fenwick Miller employed her medical knowledge to debunk authoritatively the scientific validity of studies that found women to be of relatively lesser intelligence. Rather than arguing for a distinctly feminine nature, she aligned herself with the belief that civilization had determined current differences in development.[14] Yet, in an 1897 *Lady's Realm* article, 'What to do with our daughters', Mrs Henry Chetwynd wrote, 'without going into the vexed question of the comparative weights and size of the brains of men and women, it must be confessed that where power and an original creative faculty are concerned, women's work often fails.'[15] Hence, she discouraged art as a profession for girls, and instead advocated 'Domestic Economy' as work to which they were admirably fitted. Eugenics added another layer to the debate but with different motives: the ultimate duty of 'fit' women was as progenitors of the superior race.[16] According to the eugenicists' interpretation of evolutionary theory, it was necessary for women to pursue careers in motherhood for the benefit of future society. In contrast, economist Clara Collet asserted that women ought to pursue work which allowed them to be self-supporting and added that 'to expect one hundred women to devote their energies to attracting fifty men seems slightly ridiculous.'[17] Collet later contended that encouraging women with intellectual power to make themselves pecuniarily independent in an occupation was not injurious to the

race, because women or men of 'marked individuality' did not make the best husbands and wives.[18]

Mothers rather than fathers were often the figures who restricted independence and professional careers for women. This was not a result of scientific arguments. Mothers did not want their 'revolting daughters' to step outside the boundaries of acceptable female behaviour. Emilia Dilke's mother felt her daughter's continued education was too far from proper femininity and did not want her to attend South Kensington Art School. Fenwick Miller's irascible mother objected to her doing anything outside the home, but was persuaded by her father to allow her to attend medical school. Likewise, she was vehemently opposed to Fenwick Miller's candidacy for the London School Board and espousal of unsectarian education.[19] Julia Cartwright had many battles with her mother who found writing to be unnatural. According to Cartwright her mother cared less and less for Julia and her sister as they continued to pursue careers in writing and hospital work respectively.[20] Despite these familial constraints, by this time career guides were identifying journalism as a viable career option for women.

In his 1880 book, *Journals and Journalism with a Guide for Beginners*, Alice Meynell's husband (writing under the pen-name John Oldcastle) commented that there were 'not a few' women who had made a name for themselves in periodical literature.[21] In 1893 and 1894, the *Lady's Pictorial* published a series on 'Lady Journalists', with the assertion that journalism was a suitable profession for ladies that had 'happily long passed from the vague and uncertain region of theory into that of successfully accomplished fact'; no longer restricted to the vagaries of fashion or movements in frivolous circles, women journalists had won success writing on art and literature, on philanthropic effort, political and social achievements, foreign travel and exploration of great cities.[22] In a similar vein, in her 1895 book on professional women, the journalist Margaret Bateson encouraged women to enter the field of journalism because women there had a more assured position than in almost any of the other arts and professions. She argued that Harriet Martineau's important articles and Frances Power Cobbe's daily leaders had demonstrated that feminine ability was not handicapped in journalism despite the contrary remarks of 'croaking observers'. Furthermore, between men and women there was no question of rights and very little rivalry, for 'if proof was needed of the good fellowship that exists, it is found in the absolute equality of treatment meted out to both sexes by the Institute of Journalists'.[23] In 1892 W. T. Stead also stated that in the profession as a whole there was little sex prejudice one way or the other.[24] Yet over a decade later, Frances Low was less positive about gender parity; she claimed only two women reporters were doing the same work as men on the staffs of important newspapers.[25] Indeed research indicates that the gender ratio patterns and opportunities in

journalism were complex and changing, particularly in analyses of art criticism. While Stead and Bateson's optimism during the 1890s reflected the large numbers of women in art journalism, Low's observations echoed trends in art journalism after 1905 when the aggregate of women critics dwindled.

During the 1890s a plethora of books and articles was published advising women on professional careers, particularly that of journalism. The increase in women pursuing careers in journalism was linked to the marked number of new periodicals on the market combined with the discovery of the profitable woman-reader market. Although women readers were perceived as unwelcome censors of serious discourse by writers such as George Moore, periodicals attempted to expand female readership.[26] For example the *Review of Reviews* offered women readers scholarships to study Contemporary History at Oxford through a contest based on knowledge gained from reading the journal. Similarly, E. T. Cook of the new *Westminster Gazette* encouraged the railway newspaper reader to take the paper home to show his wife and family.[27] The woman's page became a standard feature of daily newspapers and general periodicals. When Alfred Harmsworth began the *Daily Mail* in 1896, he followed the pattern of the *Illustrated London News* through his inclusion of a woman's column. Margaret Beetham notes that he identified movements in women's worlds, 'that is, changes in dress, toilet matters, cookery and home matters generally as essential to a new kind of paper.'[28] The woman reader was vital to the commercial success of this new market; Harmsworth also put women's magazines specifically at the forefront of his publishing business and his major rivals followed. These changes were addressed by contemporary writers on journalism, and women were encouraged to take advantage of them. In the 1890s market, the market circumstances were in favour of women journalists, because editors wished to increase periodical circulations with content that addressed women. Stead observed that even the most hidebound of old editors were beginning to realize that their staff was incomplete without women.[29] Bateson argued that women writers enhanced articles by importing conversational ideas into their work, although these were labelled 'detestably colloquial' by the 'Old Guard'.[30] Many women art writers, including Meynell and Fenwick Miller, capitalized on this trend towards writing for female readerships.

One self-appointed career adviser to women journalists, E. A. Bennett, editor of *Woman*, was less inspiring in his 1898 *Journalism for Women*. Bennett asserted that a vast number of women in journalism secretly believed it to be a delightful game, completely missing its 'tremendous seriousness'.[31] He introduced his second chapter with the statement:

Unlike doctors who are women, of the dwellers in Fleet Street there are not two sexes, but two species – journalists and women-journalists – and the one is as far removed organically from the other as dog from cat.[32]

He proceeded to enumerate the 'Imperfections of the Existing Woman Journalist', accusing the large majority of women journalists of irresponsibility, unreliability and an inability to spell, punctuate or write grammatical English. The only woman journalist who survived his scathing summations was Alice Meynell, who he felt had a style unsurpassed in singularity, finesse and strength. Despite his references to differing species, Bennett did not attribute the failures of women journalists to genetic differences; rather their training was the root of the evil. Women were unreliable because they did not yet understand the codes of conduct that prevailed in their new profession. Not all editors adhered to the same opinion of women journalists. Mr Gibbons, editor of the *Lady's Pictorial*, stated that women did better newspaper work than men: 'They do their work more conscientiously and punctually and are vastly more reliable.'[33] Nevertheless, Bennett's book was frequently referred to by men and women alike. In an article of 1912 in the *Woman Journalist*, James J. Nolan, editor of *Hearth and Home*, asserted that Bennett's book ought to be reprinted and a copy given to every aspiring journalist.[34] Women also criticized the efforts of professional women journalists. According to Low, the standard of feminine journalism had declined since the days of Harriet Martineau and Frances Power Cobbe: 'Today every semi-educated girl attracted by an easy mode of earning a small income, takes to journalism.'[35]

In addition, despite Stead's claims about employing women, rigorous requirements for their success made journalism a challenging career option for women. They were forced to walk a fine line between Victorian standards of morality and femininity and expectations for equal work. On the one hand, Stead asserted that a woman could not presume upon sex and must succeed as a journalist, not as a woman. Women would be admonished as freely as male comrades because 'women need it more than anything else'; to 'spare the rod spoils the child' and 'women can bear spoiling quite as little as any child'.[36] Furthermore, in order to cover crime they would have to attend police courts and be out on the streets after midnight. He argued that if this was unacceptable then women need not apply for journalism on equal terms with men.[37] However, Martha Vicinus has demonstrated that, even in the 1880s, a lady was not supposed to wander the streets in the evening or eat alone.[38] In fact, Stead contradicted his own publication, for he had published a letter in 1886 from Olive Schreiner in which she described being accosted by a policeman when a male friend escorted her home one night, and in 1887 articles about Elizabeth Cass who was falsely arrested for streetwalking. Her charge was dismissed, but the magistrate noted that no respectable woman should be found walking on Regent Street at 9.00 p.m.[39] Furthermore, London was a dangerous city, home of Jack the Ripper in 1888, and women felt exposed and threatened in it.[40] Nord has also suggested that the constitution

of femaleness as a curiosity subverted women's ability to act as an investigator of public life.[41] Indeed, although Stead demanded equal work from women he did not want 'girls to be unladylike ... the unwomanly woman is a hideous thing in any profession'.[42] He also undermined his earlier claim of an unprejudiced world of journalism by warning women that their colleagues of the other sex would watch them 'with an attention that was always critical and sometimes not sympathetic'.[43] This disjuncture was further emphasized by an article written two years later in which Mary Frances Billington asserted that reporting was a limited field already crowded with men, therefore women would only be employed at a very low pay.[44] Stead's ideas about the egalitarian roles available for women in reporting did not appear to be experienced by women journalists in the field, thus revealing a reason for them to seek other spaces and modes for publication.

In practical terms, the spaces of arts journalism did not present the same difficulties for women writers as reporting. To begin with, galleries were available during the daytime and women were traversing the metropolis in growing numbers. Lynne Walker has mapped out the rapid increase in women's presence in the public spaces of the West End in the late nineteenth century; women in the workforce, particularly journalists, utilized public transport and the streets and entered public buildings. Women were present at exhibition openings and press days in the West End, as is made evident by their reviews in the press. Walker observes that the presence and autonomy of women in the West End 'engendered a dissonance between ideology and lived experience that made spaces for real change through the development of a public ideology for women'.[45] Articles and books written for women journalists offer a fractured and contradictory version of occupational standards; yet these dissonances evinced and effected changing opportunities for women journalists.

By 1892, even the art press acknowledged the presence of some women journalists among its ranks. Two articles written in the *Art Journal* and *Magazine of Art*, coinciding with the Press Day at the RA, mentioned female critics amongst the group, thereby validating their position within the profession.[46] 'Aliquis', writing for the *Art Journal*, added that 'some of these ladies contribute their "columns" exclusively to the ladies' journals, but Miss Dyer has for some years past been the Art critic of the *Daily News*, her connection with the Journal being, it may be noted, hereditary'.[47] Thus, although women are mentioned, they are categorized separately with women's journals, unless under exceptional circumstances such as familial associations. M. H. Spielmann, as has been noted, articulated a similarly dismissive attitude with his assertion that few of the women art critics present on Press Day honoured 'their craft'.[48] Although Spielmann employed numerous women to write for his magazine the women art writers were

reduced to a paragraph in his description whereas male art critics merited portraits and elaborate praise.

In spite of more opportunities, many women journalists during this period struggled to survive financially, as well as professionally. Stead's sage advice was reprinted six years later in the *Young Woman* article, 'What it Means to be a Lady Journalist', in which its author, Janet E. Hogarth, also contributed the more realistic perspective of a woman journalist to the article.[49] She substantiated Stead's claim that women who could not do night work would be denied the prizes of Fleet Street, but claimed it was possible to make a living in journalism, as distinct from literature, with chatty articles, women's papers or scrappy periodicals. Hogarth wished that girls eagerly looking to journalism knew more of the desperate struggle to make both ends meet and the necessity of accepting distasteful tasks. Margaret Bateson also admitted that the profession of journalism was not without its drawbacks; the newcomer must beware of the 'swindling fellow' and his quick-witted exploitation of human labour.[50] Marie Belloc Lowndes revealed how shady businessmen with little or no capital started publications and, after a certain time period, in which the woman contributor would continue to send contributions without payment, the periodical would abruptly cease to exist.[51]

Evelyn March Phillipps observed in 1892 that although many professions were now open to women, women's work was paid at such a low rate that some years elapsed before she could earn more than a pittance.[52] Low asserted that women's columns were remunerated at 'sweating' wages, yet the regularity of pay, however poor, at least guaranteed a rent contribution. The payment for freelance work ranged from fifteen shillings per column for the *Athenaeum* and *Connoisseur* to seven to ten shillings per column in *Hearth and Home*.[53] The literary earnings of Belloc Lowndes in the 1890s fluctuated wildly: some weeks she made £5 to £10 and other weeks no cheque arrived.[54] In an 1894 volume entitled *Women's Work*, Agnes Amy Bulley and Margaret Whitely stated that women starting at the bottom of the ladder would be content after some years' work to be earning £200 a year.[55] Despite these conditions, Low advised women to dress well because editors disliked employing women that looked poverty-stricken. Except in exceptional circumstances women were not to let it be known that they were struggling breadwinners. Men, she asserted, hated the idea of women taking part in the scramble for money and preferred employing women who were scribbling for any other reason but dire necessity.[56] Similarly, in 1880 Oldcastle (Wilfrid Meynell) had advised against sending pathetic tales of misfortune to editors, a habit which was 'essentially feminine', as this damaged chances of success.[57]

Thus women journalists in the late nineteenth century were caught in a web of conflicting ideologies about their professional position; they were

establishing the field and marginalized within it. For women art critics it was a challenge to achieve professional independence as they battled with the reality of exploitation by editors and publishers while constantly struggling with the unpredictability of freelance work. In 1873 Emilia Dilke (then E. F. S. Pattison) was offered the position of art critic for the *Academy* by Charles Appleton with the promise of an increase in pay from her current *Westminster Gazette* earnings.[58] However, Dilke had no financial independence until 1884 with the death of her notoriously miserly husband. Her letters during their marriage evidence her constant arguments with Mark Pattison about finances. Finally she resorted to the strategy of having her friend, Eleanor Smith, act as private banker for her own earnings.[59] In the 1880s and 1890s her earnings at last grew, with her work for the *Athenaeum* and book publications.

Julia Cartwright kept meticulous accounts of her earnings. Until 1890 she combined writing novels for the Society for Promoting Christian Knowledge, which provided a regular income, with her art writing for periodicals. In 1899 she was paid £150 for *Beatrice d'Este* and £20 each for *Quarterly Review* articles. During the 1890s she was able to devote herself to writing articles and books on art; she insisted on good terms from her publishers and her earnings grew to £300 per year.[60] Alice Meynell also recorded the earnings from each paragraph, article and book in her account book. In 1913, for example, she earned £465 3s 2d, chiefly from royalties, and noted that it was one of her best years. However, earlier in her career, the pay scales were not gender-neutral. Wilfred Meynell was paid at twice Alice Meynell's rate for *Daily Chronicle* paragraphs.[61]

Exploitation was the common lot of late Victorian middle-class working women. However, low pay and poor working conditions were often preferable to lifelong dependence on male relatives for unmarried women, while journalism could provide an escape for married women. Demoor comments that the liberating and empowering effect of enjoying financial independence, even though it meant 'grinding articles', was a reward in itself for female *Athenaeum* reviewers.[62] Women art writers negotiated independent positions and financial success, despite constraints on their access to education and employment, by formulating alternative methodologies for articulating artistic discourse. The majority of women art critics did not restrict their writing to art, but juggled other topics for periodicals as well as novels, prose and poetry, as exemplified by Meynell and Cartwright. Many women also negotiated gender restrictions by writing specifically for women as did Fenwick Miller and Ella Hepworth Dixon. In doing so they were able to bypass certain limitations while utilizing others to their own benefit. At the same time the professionalization of journalism opened up new opportunities for women.

Professionalization and sexual difference

During the 1880s and 1890s, the press underwent a period of transformation that encompassed a variety of developments: the New Journalism, recognition of individual journalists and growth of professional organizations. The so-called New Journalism was characterized by 'human interest' stories, interviews and shorter news articles with headlines. Some developments, such as investigative reporting, were derived from foundations laid in the 1850s and 1860s; however, the scale and nationwide distribution of the new Fleet Street was the true innovation.[63] The New Journalism depicted the substantial growth in the periodical press as part of the spread of democracy. Stead claimed that it was the duty of the press 'to interpret the knowledge of the few to the understanding of the many'.[64] Yet despite the claims of these 'new' periodicals of a mass readership, their sixpenny prices were clearly not targeting a working-class market.[65] The periodical press was increasingly read by the middle-class public during their commute into the city for work, which created the demand for accessible short articles.

In its commitment to progress and eagerness to represent all public opinion, the New Journalism might have been the conveyor of modern ideas. Instead it became the watchdog for those forces immediately hostile to anything 'new', particularly in the context of women.[66] J. A. Spender's articles in the *Pall Mall Gazette* under the pseudonym the 'Philistine' exemplified this in his critiques of the New Woman and the New Criticism.[67] Spender argued that he produced what the public wanted to hear and that he engaged in apparent moral and objective criticism of the new fiction. His discussion of the sufficiently scandalous new fiction and its sex mania provided titillation for the general public with moral undertones. In addition, Stead's sensationalist description of purchasing a 13-year-old girl in an attempt to publicize child prostitution and white slavery exposed the hypocrisy inherent in the high moral tone of his 'democratic' journalism.[68] In her 1895 article, 'The New Journalism', the journalist and art critic Evelyn March Phillipps asserted that in existing journals attacks were made, skits written and ridicule lavished 'on woman as a body'. She called for writers to give a fair share of intelligent attention to the doings of women rather than the satire and derision they suffered in the press.[69]

Despite the anger expressed by members of the women's movement over the New Journalism's attitude towards their work, some of its methods were utilized by women. Women's magazines quickly adopted the interview technique which enabled them to focus on important individuals as role models for other women and illustrate the accomplishments of dynamic women. Journals like *Lady's Pictorial, Woman's Signal, Woman's World* and *Young Woman* found interviews beneficial to magazine sales. Many of these

articles encouraged women to look beyond traditional roles, and the panoply of professional women presented to the reader included women artists. [70]

Towards the end of the century journalism moved away from centring on the editor to centring on the contributor.[71] The shift from editorial control to a focus on recognized individuals was part of a broad-based trend in late Victorian periodicals that paralleled the increasing professionalization of the field. Art writers after 1880 were part of what Harold Perkins has called the rise of professional society, individuals turning human capital rather than property into visible wealth.[72]

This devolution of authority was also a welcome change for women writers who were particularly restricted by journal editors. However, women still had to abide by the prescriptions of the journal market, since the value of exposure overrode its limitations. Working piecemeal and under constant supervision, monetary gain and economic survival were at stake. This dependency threatened the content and the purpose of the writing by women for more lucrative journals.[73] Several successful feminist women writing unsigned reviews for the *Athenaeum*, such as Dilke, had to weigh their convictions against their need for the job and the power it entailed. Some women reviewers gained a powerful place in the legitimate discourse about the work of art at the expense of cancelling or even losing their gender when they wrote reviews anonymously.[74]

Signatures became increasingly important in providing greater professional recognition and individuality for journalists, particularly in the advent of the New Journalism. For women art critics the textual linkage and guarantee of the signature offered new possibilities;[75] they were no longer masked by the policy of anonymity invariably kept by journals in the decades when Elizabeth Eastlake and Anna Jameson began contributing. The question of signature is absolutely crucial in understanding the relationship of women to art criticism in the 1880s; indeed it is only by unravelling the variety of signatures that women published under that one is at all able to discern the considerable contribution women in fact made. For women were forced to grapple with decisions concerning their own names and individuality. As a young person, Emilia Dilke was known as Francis Strong – she utilized her second name which had been her godfather's. During her first marriage, she signed her name 'E. F. S. Pattison', thus acknowledging her family name Strong with an initial. Charles Dilke suggested that this was a result of her wish for some recognition of the independent existence of women and resistance against the old English doctrine of a complete merger with her husband.[76] The use of initials also made her gender indiscernible and she maintained the initial with her second marriage to Charles Dilke. However, at this point her reputation was established and her gender was more often evident in her bylines, 'Emilia S. Dilke' or 'Lady Dilke'. When Florence Fenwick Miller married, it was

announced in *The Times* that by mutual desire the bride would keep her name. An attempt was made to upset her next School Board election on account of her decision but, according to a contemporary interview, 'the highest authorities' declared her action perfectly legal.[77] After her marriage Julia Cartwright alternated between her own name and that of her husband, Henry Ady; however, the majority of her publications utilized either Cartwright or both names. Presumably, like Fenwick Miller, her career was already established when she married and therefore she was known as Cartwright professionally.

The adoption of pseudonyms or initials was a common practice for women writing during the late Victorian period, thus enabling women to conceal their gender.[78] The use of male pen-names enabled women to write about intellectual subjects considered unsuitable for women and presumably allowed greater access to publication. British women writing in the nineteenth century frequently adopted male pen-names as exemplified by George Eliot (Marian Evans) and George Egerton (Mary Chavelita Clairmonte) – the latter's *Keynotes* addressed issues of sexuality.[79] Although the existence of this tactical gender-switching was known to the general public by the latter part of the century, women journalists continued to remain veiled behind male pseudonyms. Amongst art critics these women included Lucy Baxter and Violet Paget who published as Leader Scott and Vernon Lee respectively. This practice obviously allowed these women to adopt a male persona and therefore allowed greater access to publication. Yet, while masking the gender specifics of the text to make it more marketable, a male pen-name undermined female authority in the process.[80] For these texts the critical voice appeared male to members of the reading and viewing art public unversed in authorial identities.

Other women critics developed a more complex array of signatures that signified multiple subject-positions; for example Alice Meynell occasionally utilized a female pseudonym, Alice Oldcastle, which corresponded with her husband's pseudonym John Oldcastle.[81] Tamar Garb questions how disguise, display and collaboration function in the creation of feminine subjectivities. More specifically, she suggests that during the same period in Paris, the artist and writer, Marie Bashkirtseff, masked her intellect in public through a reversal of her own intellectual position.[82] However, for Meynell, female signatures enabled her to claim authority, through the guise of femininity, while subverting and problematizing masculine authority to address issues such as women's legal rights.[83] This strategy allowed Meynell to articulate her position as a female and feminine authority in discussions of artistic, literary and political matters relating to women. At the same time she reinforced a masculine identity to speak about art issues more generally. Still other art critics who adopted female pen-names included Ella Hepworth Dixon, who

sometimes became 'Margaret Wynman', and Gertrude Campbell, who published as 'Vera'. These aliases were not completely unknown to the public, and by 1900 a list of significant pseudonyms was published in the *Englishwoman's Year Book*.[84]

Yet the masking of signatures presented a significant hindrance to women, as signatures became increasingly important in the 1880s with New Journalism's emphasis on recognition and individuality for journalists. Additionally, as an art critic, the frequent absence of a woman's signature negated her status in a field increasingly dominated by the names of professional men. The critics F. T. Palgrave and W. M. Rossetti established their reputations as authorities on art through periodical essays and published collections of these articles in the 1870s. Similarly during the 1880s the art critic Edmund Gosse wrote extensively on his friend, the sculptor Hamo Thornycroft.[85] F. G. Stephens's 'Fine Art' column in the *Athenaeum* (1861–1901) was anonymous, although his authorship was known within the art world and his reputation was also expanded through the publication of collected essays and biographies. Nonetheless, an anonymous periodical format could also be advantageous to both critic and artist as exemplified by Stephens's promotion of Pre-Raphaelite artists.[86] Likewise, the male pseudonyms utilized by critics such as Meynell enabled a masculine performance; the gender of the writer was transformed for the reader. Similarly, anonymous texts concealed the nature of the performance; gender was absent or assumed to be masculine. Judith Butler identifies that, because gender is created through sustained social performances,

> There is no gender identity behind the expressions of gender; that identity is performatively constituted by the very 'expressions' that are said to be its results ... the very notions of an essential sex and a true or abiding masculinity or femininity are also constituted as part of a strategy that conceals gender's performative character and performative possibilities for proliferating gender configurations outside restricting frames of masculinist domination.[87]

Here she sees gender as constructed through performativity, or the process for individuals of repeating and mimicking societal markers of gender, rather than as a pre-existing identity. In their writing women critics similarly performed disparate gender configurations. As we can see from female journalists' use of male pen-names, gender identity was tenuously constituted in nineteenth-century journalism. Many professional women created the illusion of a feminine identity, while appropriating the benefits of a masculine pen-name. The texts of women art critics reveal a complexity of masculine and feminine performances, concealing and revealing named identities, a tactic which enabled women to claim discursive authority in a variety of contexts. Readership, editorship, familial and economic conditions all added to the influences on women art critics' choice of a masked or unmasked voice.

Signatures were directly linked with another characteristic of the New Journalism, self-referentiality.[88] Journalists interviewed journalists, periodicals reviewed other periodicals and columnists became celebrities. Evelyn March Phillipps wrote, 'I am told that the readers of these papers are largely journalists themselves, who buy them to see what is in vogue, and that they all patronise each other's [magazines].'[89] During the 1880s and 1890s, periodicals ran an increasing number of articles which featured the writer as subject. The lives of professional journalists, whether writing for dailies, women's magazines or art periodicals, were deemed good copy. This trend toward the contributor as an individual rather than the anonymous mouthpiece of a journal was directly linked to the increasing professionalism of journalism. It not only provided the journalist with professional recognition, but also it produced him/her discursively as a public figure, the prototype of a media personality. Many women journalists were interviewees as well as interviewers, particularly in women's magazines.[90] However, the writing woman was represented as essentially feminine rather than professional.[91] Professional women were interviewed in their home, thus conjoining their public lives and domestic environments. Interior decoration and the domestic duties of Florence Fenwick Miller were conflated with her feminist activities in several features.[92] Nonetheless, as a journalist, Fenwick Miller was an interviewer herself and was able to utilize the appearance of domesticity to position her own persona within the matrix of femininity whilst promoting her cause.[93]

This period of transition in periodical publishing presented advantages as well as disadvantages to women writers. One way in which women were excluded from certain Victorian periodicals was through the subject matter addressed, for example the science, religion and philosophy covered by the *Nineteenth Century*. By including literature and the arts in the last quarter of the century, the *Nineteenth Century* and *Contemporary Review* became more accessible to women readers and writers.[94] However, scholars have examined the hegemony of professional patterns for non-fiction writing. It was difficult for women writers to assume the role of the 'man of letters', with its claims to broad learning, original thought and spiritual authority.[89] The canon of these men of letters, with figures such as John Ruskin, was a 'fellowship of discourse' or a hegemonic group that controlled the production of discourse by formulating and enforcing 'rules of exclusion' for who could speak to whom, when, and on which topics.[96]

In the sub-category of art writing specific parameters or 'rules of exclusion' had already been established. P. G. Hamerton, art critic and editor, outlined the new prerequisites for becoming a professional art critic: 'he' must 'travel to see pictures ... And to grasp the whole mind of a great artist we must see *all* his works, for every great artistic nature is so large that each picture is a new revelation of ranges of power before unknown to us.'[97] Although Hamerton's

language was gendered, his assertion did not eliminate women as professional critics. In fact in the early nineteenth century, travel was the preferred mode for women to communicate their knowledge on art, and travel and guidebooks were an avenue through which women interpreted the visual arts.[98] By the late nineteenth century, women art writers were very familiar with this already established convention for conveying the acquisition of art knowledge and expertise, and drew on travel experience in their extensive contributions to periodicals and books.[99]

Academic titles were not easily obtainable by women art critics during this period; degrees were only granted to women at the University of London beginning in 1878, and at institutions like Oxford and Cambridge women were not awarded degrees until the 1920s.[100] Although a definite trend was difficult to establish, there was evidence of proprietors and editors of Victorian newspapers showing a preference for university men. The growing tendency between 1830 and 1914 for periodical critics to be of public school and/or university background was a reflection of the growing respectability of journalism and the growing number of university graduates seeking jobs.[101] Male non-fiction writers were more likely to have university degrees and utilize titles such as BA, MA and Professor whereas academic titles did not accompany the names of fiction writers.[102] Several papers developed strong links with Oxford, benefiting from graduates' ability to write well, understanding of socio-economic policies and political contacts.[103] This system was mutually beneficial; the post J. A. Spender obtained at the *Pall Mall Gazette* in 1892 was most envied by the young Oxford men of his generation. Ironically, although he possessed university qualifications, Spender continually attempted to play the part of one of the populace in his column, feigning no special knowledge or training, using the cognomen the 'Philistine'. The male art critics associated with the New Criticism which emerged in the 1880s all had academic training. They included Oxford graduates, just as Ruskin had been. Some also held academic positions: R. A. M. Stevenson had a Cambridge BA and MA and held the Roscoe Chair of Fine Art at University College, Liverpool from 1888 to 1892; D. S. MacColl had degrees from London and Oxford where he studied under Mark Pattison.

Elizabeth Prettejohn highlights the new class of professional critics emerging in the 1860s, alongside the generalist critics who had dominated the field, intent on establishing both new professional credentials and a new critical value system. Yet rather than the new professionalized art criticism superseding the generalist, the two continued to coexist. This was certainly a factor in enabling women to enter the journalistic marketplace in the late nineteenth century. They could be and were employed by mass-circulation newspapers and periodicals as generalist art and women's columnists.

Prettejohn contends that generalist critics emphasized general cultural values rather than a separate sphere for art.[104] However, some women, such as Elizabeth Robins Pennell, prioritized the latter, as one of the new professional critics, and so articulated distinctions allied with critical expertise.

Indeed several women journalists were encouraged to specialize in art, rather than attempt to become 'jack of all trades' journalists. Mark Pattison advised his wife (later Emilia Dilke) that she must specialize and become an authority on a subject in order to command respect.[105] In 1877 Appleton, editor of *Academy*, counselled Julia Cartwright to stick to art because it was necessary to specialize.[106] However, it was another 13 years before this was economically feasible for her. After the turn of the century, articles in the *Woman Journalist*, the organ of the Society of Women Journalists, repeatedly advised members to specialize in a particular area.[107] Specialization was also considered necessary to counteract the idea that women could write about nothing but dressmaking and babies.[108] This advice was not always easy for women to follow, as they were often lacking in a specialized education and most did not possess the income to be selective about the work they accepted.

In the 1890s and the 1900s the increasing importance of professionalized art criticism and the trend towards modern connoisseurship reduced the access for women to art critical authority. After the turn of the century several of the male new critics became curators of national collections. D. S. MacColl was Keeper of the Tate from 1906–11 and then the Wallace Collection from 1911–24; Roger Fry was appointed Curator of Painting at the Metropolitan Museum in New York in 1906 and offered the Directorship of the National Gallery. Thus, these new professional art critics developed direct links with both academic and institutional structures, links which women did not possess.

The status of writing as a profession was improved by the formation of various organizations. The Society of Authors, organized by writers to work collectively towards better contract terms and better protection against American infringement of copyright, only admitted women to the early dinner by invitation.[109] Walter Besant, spokesman of the Society, argued for changes to the perceptions of writers. He asserted that women were now joining the professional ranks and could be 'Men of Letters', but failed to recognize that the role of writer as professional was masculinized.[110] In fact in his own *Palace Journal*, he firmly opposed women's suffrage: 'Let the men resolve to keep women out of men's work: and let us all resolve to keep women from ruling over us.'[111] Analogously, Andrew Stephenson notes that amongst male artists, in the face of growing economic insecurity and competition from women, there were calls for greater professionalization and more specialized male-dominated career hierarchies in order to maintain professional standards.[112]

Another organization was formed specifically for journalists, indicative of the increasing demand for professional recognition.[113] The Institute of Journalists was incorporated by Royal Charter in 1890 with aims to improve the status and training of journalists, to collect professional information for members, devise provident schemes and watch legislative proposals that affected the profession.[114] The Institute was able to articulate these demands as a professional body. The growing professional power of the organization was exemplified in Spielmann's 1892 series on 'Press Day and the Critics'. The underlying purpose of the series, which became evident at the end of the second article, was modifications to the Press Day organized by the RA so that it was more humane for critics. This included extending the viewing period set aside for the press to two days, providing a lunch on the premises, and heating the building in cold weather so that coats were not necessary. Letters signed by renowned critics appealing for these changes had been forwarded to the Academy by Spielmann, but to no avail. A more pressing representation from the Institute of Journalists was answered with the result of a concession of an extra half-day for press viewing. Spielmann pointed out that it was the Institute that had made the difference by adding force to the demands from journalists, thereby illustrating the strength of union and the value of combined effort.[115]

Although women were eligible to join the Institute of Journalists if they had been practising journalists for three years, Spielmann's powerful body of journalists remained dominated by men and a separate organization was founded for women in 1895. The objective of the Society of Women Journalists was to unite women journalists for mutual protection and advancement.[116] However, amateur or freelance journalists were not welcomed: a membership required a woman to have been a paid contributor for two years to the artistic or literary department of a journal. The yearly subscription included advice on journalistic matters and the use of a suite of rooms for tea, toilette and writing purposes. The society established a Benevolent Fund which granted permanent pensions to members and assisted others in temporary distress. It also had an Honorary Medical Officer and Honorary Legal Advisers to assist members in the recovery of fees for manuscripts and drawings. In the 1897–98 Annual Report, L. Basil Thomas was thanked for the money recovered from editors who had refused to give up articles or pay for them.[117] Art critics were well represented in the society. Alice Meynell was president in 1898, and Gertrude Campbell and Julia Cartwright were also among the members. By 1900 the Society's Annual Report had expanded to list books published by members during the year, which included four art volumes by Julia Cartwright and Evelyn March Phillipps.[118] Thus it was an organ of publicity as well as providing education and support, but one whose members were already reasonably successful.

Bulley and Whitley recognized the need in 1894 for clubs for women writers, noting 'each writer works to her own fashion, and for lack of meeting-places there has hitherto been little interchange of thought or experiences among literary women.'[119] The Women Writers' Club, formed in 1888, provided a new network for women authors and journalists. Their annual dinner was reviewed in the *Sketch* by Honnor Morten, who reproduced table plans and lists of members in attendance. Under the heading 'Where Man is Never Missed', the 1895 dinner guests listed included Ella Hepworth Dixon, Alice Zimmern, Alice Meynell, Elizabeth Robins Pennell, Clara Collet, Mona Caird and Helen Zimmern, and it was reported that 'cigarettes were enjoyed after dinner!'[120] The cigarettes, alluded to by many, including Besant in a mocking review, indicated to the reader the advanced or alternatively 'dangerous' nature of the gathering.[121]

To summarize, women art journalists had a number of networks and organizations available to them by the 1890s. In these meetings and gatherings they gained support from one another and discussed professional issues, many identifying themselves as 'new women'. Yet these women did not represent a univocal professional body, for they offered differing interpretations of art and femininity. Rather these women were unified by relative success and financial position because membership fees and experience profiles made admittance for fledgling young journalists impossible. Although women's involvement in organizations dominated by men was often peripheral, the growing presence of women in a variety of professional organizations, both single and mixed sex, did little to allay the fears of the likes of Besant. Women art journalists were involved in the very establishment of the profession, while their experiences underline the fractured realities of the new 'professional society'.

Salons and influence

In the late Victorian art world various networks existed – between artists and writers, writers and editors, as well as writers and writers – to which gender added an additional dimension. The relationships and networks that existed between artists and women art writers revolved around friendships, kinships and professional contacts. Letters and diaries of women writers document their experiences of the spaces for these interactions: salons, clubs and professional societies, as well as the negotiations of artists desiring press coverage. Women's alliances functioned to compensate for the professional male strategies of self-preferment and networks already discussed. The portraits of women art critics reveal the intricacies of these exchanges and interactions in their visual representations and significations. Women critics

were depicted by family members, by friends, by renowned artists and through the medium of photography; these images were viewed in homes, periodicals, books and exhibitions. The images signified various social, cultural and political meanings of women's participation in the art world of the period. Although women were denied access to men's spaces in clubs, friendships with other critics and artists offered a politically empowering network for women writing on art in the late nineteenth century.[122]

Julia Cartwright's diaries document her membership in a circle of both male and female colleagues who shared her interests in Italy and in art criticism. They included Constance Ffoulkes, Vernon Lee, Maud Cruttwell, Mary Kingsley, Bernard Berenson and Roger Fry. There was also a network of influence amongst women art critics; Cartwright records a meeting with Lee in which they not only discussed Berenson and art, but book contracts, comparing figures and publishers.[123] On another occasion, Cruttwell expressed the importance of Cartwright's influence: 'Miss Cruttwell tells her that it was *I* who first made her take up art as a serious study (!) And is much struck with my generous appreciation of other critics, which she seems to think is very unusual.'[124] On another occasion Cartwright noted meeting 'all manner of celebrities, Mrs Meynell – very *precious* but gracious to me over *Burne-Jones.*'[126]

As Helene E. Roberts observes, the fact that artists and dealers tried to court or bribe critics was a testimonial to the widespread belief in their influence.[126] Already established artists like Edward Burne-Jones, G. F. Watts and Lawrence Alma-Tadema cultivated professional relationships with women art critics, and Cartwright's diaries reveal the interconnectedness of these negotiations. In 1890, she wrote a two-part article on Burne-Jones and the artist provided the illustrations; this was accompanied by considerable effort on the part of Burne-Jones to establish a professional rapport with Cartwright. She wrote:

> Burne-Jones had been surprisingly kind and taken great trouble to find illustrations, and more than this has read my articles and says he is not only pleased at my appreciation but that there are passages which show a *deep* insight into his true meaning and he would like to show me some of the work he is now doing and he added, 'That is sincere'– in his quaint way. I never expected to live to see that, and it is worth all my labours to feel I have really understood him.[127]

This article was followed by letters from Burne-Jones in which he claimed to detest editors and seeing his name in the papers.[128] Despite his supposed hatred of publicity, Burne-Jones was eager for Cartwright to continue writing on his work. In the following letter he was very apologetic and concerned that he had offended her, 'anxious to explain that he did not at all mean that he dislikes my writing about him and declared his letter had been a joke'.[129] As a result of Cartwright's article on Burne-Jones, Watts also suddenly took an

interest in her writing and wished to make her acquaintance. He wrote a series of letters negotiating meetings and articles with Cartwright: 'I had a letter ... to say Mr Watts was very much struck by my paper on Burne-Jones and would like to see me and I must go up on Friday.'[130] Watts praised her work on several occasions. 'He said my papers on him were admirable, one of the best things he ever read, and he told Mr Mead directly they must be by *Julia Cartwright*!!'[131] Two years later she described a social gathering at Watts's where he introduced her as the 'great art critic before whom he trembles!'[132] Cartwright's relationship with Burne-Jones and Watts resulted in her completion of biographies on these two artists and their work.

In addition to networking with male artists and writers, women art critics were involved in networks made up exclusively of women. The women's movement offered a network of contacts to women critics, several of whom became active in the women's suffrage movement during the 1880s, 1890s and after the turn of the century. The petitions and campaigns produced by the women's movement were signed by many women artists, writers and journalists during the last two decades of the nineteenth century. Two thousand women signed the *Declaration in Favour of Women's Suffrage*, published in the *Fortnightly Review* in 1889; the art writers F. Mabel Robinson, Amelia B. Edwards, and Sophia Beale were amongst the signatories.[133] However, there were also divisions within the women's movement and not all women critics were involved in the suffrage network. Although Julia Cartwright was in favour of women's education, she signed the initial declaration *An Appeal Against Female Suffrage* published in the *Nineteenth Century* in 1889.[134] In the decades following, more women critics became involved in the suffrage movement; in honour of the 1897 Queen's Golden Jubilee, an address on women's rights was presented to the Queen signed by Alice Meynell and Florence Fenwick Miller among others. It aimed to 'encourage the good work of extending to your women subjects the legal protection, the educational opportunities, and the equality of civil rights for which they have so long and ardently striven.'[135]

Emilia Dilke's depiction at a women's rights meeting in 1872 shows how women involved in politics and suffrage were pictured for the public in journals like the *Graphic* (Figure 2.1). Another woman whose image frequently appeared in the press was Florence Fenwick Miller. Small portraits headed articles detailing her biography and accomplishments in women's magazines. An early photograph of Fenwick Miller was obtained by Helen Blackburn, probably during Fenwick Miller's time on the London School Board around 1880 (Figure 2.2).[136] Blackburn was also involved in the women's movement and amassed a collection of portraits of eminent women shown at the Columbian exhibition. Blackburn's possession of Fenwick Miller's portrait indicates their mutual suffrage interest, which was to

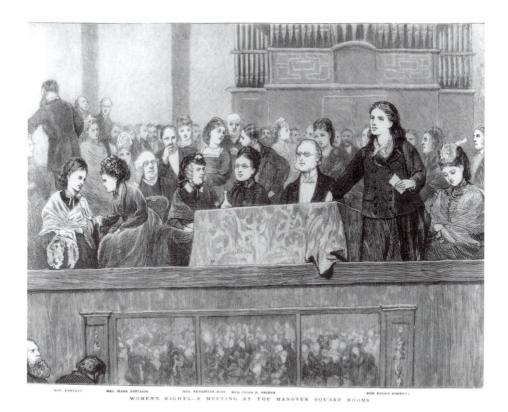

WOMEN'S RIGHTS—A MEETING AT THE HANOVER SQUARE ROOMS

2.1 'Women's Rights', *Graphic*, 25 May 1872

bifurcate later, and also a mutual interest in collecting images of women. Fenwick Miller acquired images of famous women which she hung as a portrait gallery in her study. The display of these images of women signified a public network of women involved in achieving a common political agenda and presented a counterpoint to portrait chronicles of great men.[137]

During the 1890s, many of these women began to frequent other newly formed women's clubs which provided social interaction as well as places to meet male colleagues without impropriety. However, like the professional clubs, fees made them accessible only to the well-established or well-to-do and, as Vicinus notes, the Lyceum Club membership read like a *Who's Who* of women's journalism, writing and the arts.[138] Cartwright enjoyed the heated discussions on art or politics at meetings and lectures in the Sesame Club; Meynell, Vernon Lee and Maud Cruttwell were also amongst the art critics and journalists in this network of professional friends.[139] Jane Harrison described the Sesame Club's 'high-toned' Ruskin room with hard chairs, pens,

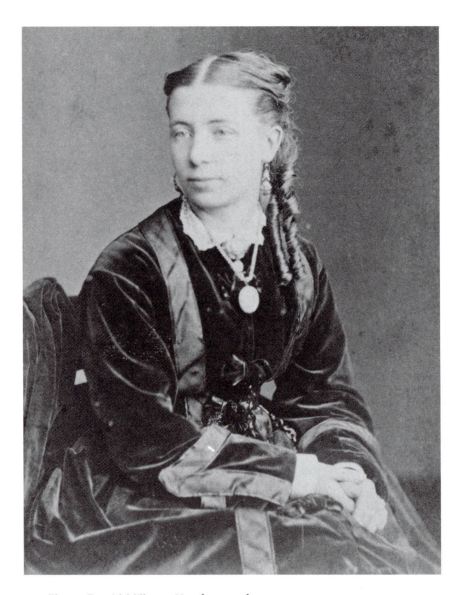

2.2 *Florence Fenwick Miller, c. 1880,* photograph

maps, desks and every manner of austerity.[140] These private clubs in conjunction with professional organizations for writers and journalists provided independent professional women with a much-needed network and with accessible space in London.

Cartwright described a club-going afternoon: 'Went on to the Empress Club and met Beatrice Cust. Violet Hunt was very lively and proud of her club

which is a very smart place but too hot and noisy and crowded for my taste. On to the Pioneer which is much quieter with Adam doors and ceilings. It's delightful.'[141] Another meeting at the Sesame was more eventful: 'Emmy Fane was in a state of collapse after the Sesame crowd and heard nothing of the lecture. Miss Jane Harrison fainted and had to be carried out … I stayed on talking to Will Rothenstein who … is on the committee of a new International Gallery which opens in May to which Gilbert and Whistler both belong.'[142] Lunches and gatherings included Cartwright, Meynell, Lee, Hunt and Olive Schreiner. Afternoons at clubs were often combined with attending shows and galleries: members of this group of independent women, such as Cartwright and Lee, would make a meeting point in front of a Raphael in the National Gallery.[137]

Correspondence between Gertrude Campbell and Alice Meynell over an invitation to be President of the Society of Women Journalists indicates the networks that existed amongst art critics. Campbell wrote, 'I suggested the self-evident idea that you were *the* fit and proper person to be our President.'[144] Meynell described the occasion to her mother: 'About seventy or eighty people were there and it was very brilliant. It was given to me in recognition of my work in literature. My health was drunk after the King's, and there were laudatory speeches to which I made a brief reply.'[145]

Likewise, Pennell's description of her Thursday evening salon indicates the overlap and interconnectedness of these various groups of women writers:

I cannot imagine a Thursday night without Rosamund Marriott-Watson, – Graham R. Thomson as she was then, – beautiful, reminiscent of Rossetti … Violet Hunt was almost as faithful. And both contributed, as I did, a weekly column – mine that amazing article on cookery – to the *Pall Mall*'s daily *Wares of Autolycus*, written by women and I daresay believed by us to be the most entertaining array of unconsidered trifles that any Autolycus had ever offered to any eager world. Graham Thomson was even moved to commemorate our collaboration in verse the inspiration of which is not far to seek, but of which all I remember now is the beginning:

> O, there's Mrs. Meynell and Mrs. Pennell,
> There's Violet Hunt and me!

For Mrs. Meynell contributed a fourth column, though she never contributed her presence to Buckingham Street.'[146]

The salon occupied a hybrid space, open to the spectacle and public display of the publishing industry, while maintaining the interiority of home. For literary women these transitional spaces had an economic function combining the social with publicity and self-promotion.[147]

Different kinds of visual representations of women art critics were in circulation: portrait engravings, photographs, paintings and sketches were visible to the public in art exhibitions and in the press. In the latter these accompanied biographical articles and public events. Portraits were evidence

of the links between artists and critics – in some cases these portraits revealed a direct economy of exchange between critic and artist, but in others they signalled a more indirect complexity of friendship and/or professional networks. At the beginning of their literary and artistic careers, Alice Meynell was sketched and painted by her sister, Elizabeth Thompson Butler. One such portrait was a small oil bust-length profile of Meynell as a young woman, holding an open book.[148] Although Meynell was not in the act of reading, her sister's use of a book signified Meynell's literary ambitions. Around the same period, the artist Adrian Stokes, later associated with the Newlyn School, completed a watercolour of Meynell in a similar bust-length profile view, along with a companion portrait of her husband, Wilfrid Meynell. Stokes inscribed the portrait 'to his friend AM' marking the already established friendship network of the artist and critic. The later portrait of Meynell by John Singer Sargent more clearly adopts this mode of society portraits of women during the 1890s, and signalled to the public her position in a world of literary and artistic elites (Figure 2.3). Meynell wrote about these artists and in turn they drew her portrait, Sargent the year he was elected an Associate of the RA.[149] In Sargent style, Meynell is presented as a tall, slim, curvaceous figure; she turns slightly, her hands are clasped and she gazes directly at the viewer. However, the image is distinct from the frothy fabrics, open arms and *décolletage* evident in his portraits of society women; the high-necked blouse and closed stance challenge, rather than invite, the viewer's gaze. The portrait in a sense replicates her position as a woman art critic within fashionable art circles, to be looked at and looking. Meynell's portrait was completed by Sargent at the poet Coventry Patmore's request.[150] The image projects confidence and professionalism and was used as a frontispiece to her collected essays. In 1903 Sargent requested that she write an introduction to a volume of his work, and the result was a glowing essay on the artist's skill in portraiture.[151] Likewise the portrait head by Rothenstein, done three years after Sargent's, was circulated as a professional image; Meynell was dressed similarly in a high-necked blouse and the portrait was included in a collection of lithographs of notable literary and artistic figures accompanied by short biographies (Figure 2.4). Meynell was one of only three women alongside men such as Grant Allen, Walter Crane, George Gissing, W. E. Henley, Henry James, Sargent and George Bernard Shaw.[152]

The most numerous images extant of any art critic are probably those of Elizabeth Robins Pennell. Whistler completed a lithograph portrait of Pennell, signalling a symbiotic relationship between critic and artist, as did Sargent's picture of Meynell. But also depicted by her husband whilst cycling around Europe, images of Pennell rarely resemble society portraiture. She appeared in his illustrations for their travel articles and books on tricycling trips in the 1880s and similarly, in the 1890s, Pennell was depicted on her bicycle (Figure

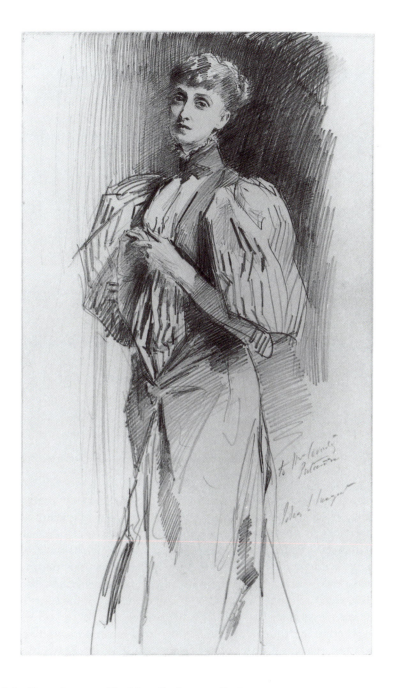

2.3 John Singer Sargent, *Alice Meynell*, 1894, pencil, 36.2 × 21.0 cm

2.4 William Rothenstein, *Alice Meynell*, 1897, lithographed drawing, from *English Portraits* (1898)

2.5). Pennell was the only woman art critic depicted in the more practical attire enabling freedom of movement for cycling that signified women's independence in the press. Furthermore, in the sketches of Pennell, she is active, thereby resisting the modes of portraying women as passive and the meanings associated with these images in late Victorian portraiture. In comparison to the travel writing and images by other critics, Pennell, as traveller, featured centrally in text and image, instead of the focus being on people and places visited.

The art critic Gertrude Campbell was depicted in various society portraits; she was notorious as a result of her celebrated divorce case which added a controversial layer to the reception of her portraits by Whistler and Giovanni Boldini. The latter portrait, completed two years after the death of her ex-husband, Lord Colin Campbell, is in the style of Sargent's society portraiture: Campbell is strikingly depicted as a seated curvaceous form, attired in a

A SENSATION IN A HUNGARIAN VILLAGE.

2.5 Elizabeth Robins Pennell, 'From Berlin to Budapest on a Bicycle', *Illustrated London News*, 1892

swirling black dress with *décolletage*, gazing directly at the viewer with an arm behind her head (Figure 2.6). Her sartorial presence and pose combine to signal her position in late Victorian artistic and cultural circles. However this image was too redolent with risqué meaning even in 1911 when it was donated to the National Portrait Gallery on her death, and was the cause of much dispute amongst the board.[153]

Several portraits were completed of Emilia Dilke; an early portrait of Dilke painting fresco was painted in 1864 by her friend Pauline Trevelyan (Figure 2.7). This portrait is discussed in Charles Dilke's memoir of his wife as unlike her in appearance, rather her 'decided chin and heavy brow' were painted away in accordance with contemporary conventions of beauty.[154] Kali Israel addresses the complexity of this image of Dilke, caught in the act of representation, by a female friend: the image of the artist, in a dress decorated with fleur-de-lis, was produced by a 'collaboration of two women influenced by wider social currents initiated by men'.[155] Yet the image can also be read to reveal the complexity of her/their self-representation, for these women were also self-consciously positioning themselves visually within an aesthetic milieu. Dilke not only participated in the Little Holland Park circle, she had

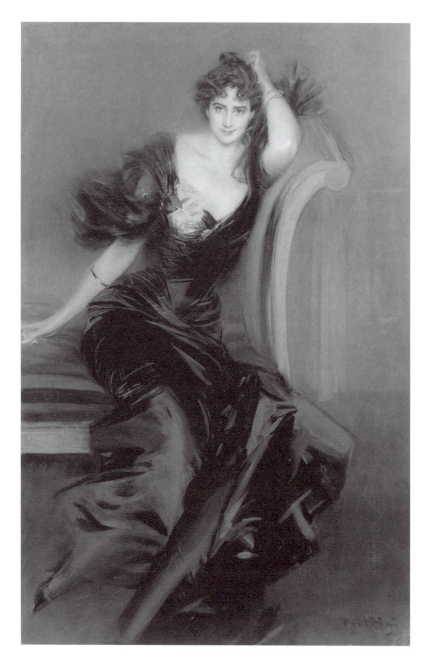

2.6 Giovanni Boldini, *Lady Colin Campbell*, 1897, oil on canvas, 182.2 × 117.5 cm

2.7 Lady Pauline Trevelyan and L. G. Loft, *Lady Emilia Frances Dilke c.* 1864, oil on millboard, 25.4 × 18.1 cm

already been active in the formation of discourses around art and women's dress.[156] A much later portrait, by Herkomer, follows the format of a traditional Academy portrait (Figure 2.8). It was commissioned for £500 in approximately 1888, although it was possibly requested earlier as an engagement portrait; the full-length image of Dilke signalled respectability and functioned to reassert her/their society status in the wake of Charles Dilke's scandalous 1885 divorce case.

A portrait bust of the art critic Emilie Barrington was completed by the sculptor Mary Thornycroft in 1881 (Figure 2.9). The bust indicates their interaction within the art world at the time; Barrington was already writing about art and socializing in the Holland Park artistic circle. The portrait was also an indicator of status for Barrington: Thornycroft had sculpted many women and her portfolio included royal commissions. They were also neighbours; the Thornycrofts had lived in Moreton House and the adjoining property was acquired by the Barringtons.[157] However, the portrait does not represent a professional reciprocal exchange, as with Sargent's portrait of Meynell. Barrington's art writing focused exclusively on renowned male artists: Rossetti, Watts and Leighton.

In their publications, women positioned themselves within these networks by various means. Barrington cited links to male artists in order to signal her professional authority. Her relationship with Leighton and Watts was complex, ranging from student, financial adviser, neighbour, friend, patron and editor. Indeed, her book on Watts consisted mainly of correspondence from the artist to Barrington and her husband documenting their friendship from 1876 until Watts's death in 1904. Her networking abilities made for a symbiotic relationship with both Leighton and Watts, and she continued applauding them long after their deaths.[158] Insider information was highly prized in the art world as exemplified in the writings of Dante Gabriel Rossetti's brother William Michael Rossetti.[159] Although no professional women critics were family members of any artists, Barrington adopted a similar function for the Holland Park circle.[160] However, Barrington's *modus operandi* was not without its detractors, in particular Watts's second wife, Mary Fraser-Tytler.[161] By utilizing an autobiographical approach to her writing, Barrington clearly positioned herself amongst the privileged artistic elite and underlined her personal authority in documenting the lives of these two artists. Her mode of access to this authority was in distinct contrast to that of the 'objective' scholarly approach generally favoured by contemporary professional art critics. Similarly, Helen Zimmern's writing was largely adulatory and her discussion indicated her direct knowledge of the family of her subject. Zimmern was able to write from within the network of Alma-Tadema's friends. Zimmern wrote of Gosse, 'He is generous, genial, warm-hearted, a lover of jokes and anecdotes good and bad, a cheery optimist, a

2.8 Hubert Herkomer, *Emilia Dilke*, 1887, oil on canvas, 139.7 × 109.2 cm

boon companion in the best sense of that term. He is also the truest and most faithful of friends, and the kindest and most large-hearted of teachers.'[162] Zimmern was a member of the Gosse and Alma-Tadema circle (Laura Epps Alma-Tadema was the sister of Ellen Epps Gosse). One of Edmund Gosse's letters, written in 1881, attested to this relationship: 'Helen Zimmern came

2.9 Mary Thornycroft, *Mrs. Russell Barrington*, 1881, bronze, h 22 in.

round to dinner. We had our coffee on the balcony and were smoking our cigarettes quite in the bachelor style when Mrs. Crosse [neighbour] came by and faltered and evidently could not tell what to make of it.'[163]

Although women critics were rarely cited within male networks, the process of self-citation was common practice in this period; as a strategy it enabled women art critics to promote their previously published work,

thereby effecting their own press network. For example, Dilke quoted her own criticism which had been previously published in the *Academy* or in the *Athenaeum*. In 1895, she wrote articles on her friend, Randolph Caldecott, in which she quoted from their correspondence, reproduced many of his unpublished drawings and a sketch by herself.[164] In an article on art education for the *Fortnightly Review* in 1890, Dilke quoted her own article written 12 years earlier in the *Pall Mall Gazette* outlining these possible changes which, she observed, bore great resemblance to a recent speech by Mr Hodgson at the Art Congress.[165] By this time her text carried more weight for she was by now an acknowledged specialist on the history of French art.

The work of women critics was rarely mentioned in texts by contemporary male art writers, although Percy Cross Standing's biography of Lawrence Alma-Tadema indicated the importance of women art critics to his success as an artist, specifically the writings of Alice Meynell, Helen Zimmern and Gertrude Campbell. Yet Standing's evaluation of their work was contradictory: a combination of patronizing commentary on their texts and long quotations from their articles on Alma-Tadema. In the case of Zimmern he wrote, 'Miss Zimmern, whose writings on art topics have attained considerable dimensions, has been aided perhaps more by a fluent pen and an apt and attractive manner of jotting down her impressions than by a discriminating estimation of the artist's work as a whole,' even though Standing had cited her review of *Hadrian Visiting a Pottery in Britain* 13 pages earlier.[166] On the other hand, F. G. Stephens more favourably acknowledged the work of a woman critic in his artist biographies; in the *Artists at Home* essay on Leighton, Stephens declared his indebtedness to Emilia Dilke's biography of the artist.[167] Women's networks are more difficult to trace in published texts: Katherine De Mattos's article on women flower painters quoted a 'leading critic' directly, who, although unnamed, was in fact a colleague, Lucy Baxter.[168] Concomitantly, the rarity of such textual linkages and women's positioning by/in relation to male artists and critics underscore the importance of women's networks, revealed through unpublished papers and visual representations, to professional women journalists.

The dramatic rise in newspaper and periodical production, conjoined with the New Journalism, afforded new career opportunities for women as journalists. The question of authorship in this period lays open a complex dynamic at work in the texts of women art writers who frequently adopted male personae in order to assert the authority of the male gaze, but also wrote under a female cognomen. Thus individual women worked tactically across this new array of signatory possibilities. As the field of journalism became increasingly professionalized women art critics were involved in the development of formalized organizations as well as informal artist and writer

friendship networks. Gender intersected with culture in this shifting arena of art journalism – portraits disclose the torsions in women critics' performances as objects and owners of the professional gaze.

'Art Critic' I never called myself: Re-visiting the 'Angel in the House'

Alice Meynell

Today Alice Meynell is best known as a turn of the century poet, the friend and colleague of the poets Francis Thompson, Coventry Patmore and George Meredith. Yet Meynell's career was far more diverse. During her lifetime she wrote for over 23 different periodicals, wrote, edited or translated over 40 books, and co-edited three periodicals.[1] Approximately three-quarters of her articles listed in the *Poole's* and *Wellesley* periodical indices were art criticism, to which can be added dozens more never indexed. It is Meynell's art writing that forms the basis of my discussion. This chapter documents her production and publication of art criticism from 1878 until 1905.

Meynell's impressive publishing record is not merely a reflection of her abilities and interests, it was also shaped by familial, financial and professional constraints which necessitated and determined Meynell's need for constant publication. Meynell moved within the art network of journalists, editors, artists and dealers while simultaneously occupying a variety of subject positions. She utilized pen names and co-wrote and co-edited articles and journals with her husband; thus her identity was often ambiguous to nineteenth-century readers. In order to define the conditions for the production of her texts, I will consider her position within art journalism in relation to issues of authorship and authority during this period. Not only is her writing presence difficult to track, her own subjectivity was shifting; she took up contradictory subject-positions to intervene in art discourses. She wrote for a diverse readership, specialist and general, while addressing the changes in contemporary art production and exhibition at the RA, the Grosvenor Gallery and the New English Art Club (NEAC). An analysis of the heterogeneity of her writings will include her contributions to art discourses

through texts on art and artists associated with the RA, such as her sister Elizabeth Butler, as well as artists associated with French Impressionism, such as Edgar Degas. Additionally, I will position her writing within the RA debate on the nude and analyse how in her own periodicals, in the art press and as art critic for the *Pall Mall Gazette*, Meynell actively supported the French-influenced Newlyn artists and situated the group within contemporary art discourse. Meynell's interests in socialism, Catholicism and the women's movement also informed her art criticism. Not only were the Meynells' periodicals, the *Weekly Register* (1881–99) and *Merry England* (1883–95), written for a largely Catholic readership, her religion and political involvement were at least as important to her choice of subject matter as were the artist circles she knew and discussed.

Born in 1847, Alice Meynell grew up in Italy, returning to England as a teenager in 1861. Meynell's mother, Christiana Thompson, was a musician and painter, well-known within the network of mid-nineteenth-century art and literature. Her circle of friends included John Ruskin, John Everett Millais, Felix Mendelssohn, Jenny Lind and Matthew Arnold.[2] The combination of home environment, tuition and travel certainly provided Meynell with a substantial amount of artistic knowledge. Meynell's first book, *Preludes*, was published in 1875, containing poems illustrated by her sister, the artist Elizabeth Butler, and she began writing for the *Architect* and the *Tablet* in 1876.[3] Following her marriage to Wilfrid Meynell in 1877, Alice Meynell's journalistic career expanded to encompass a variety of freelance and editorial work. Her entry into the field coincided with a period of enormous growth in art journalism. Meynell utilized her knowledge of the artistic sphere to take advantage of the opportunities in this widening field and quickly became established as a regular contributor to the art press.

It is highly probable that Alice Meynell began contributing unsigned freelance articles to the *Magazine of Art* from its inception in 1878: the pseudonym John Oldcastle, utilized by both Meynell and her husband, appears in the first volume. In 1879, an article appeared bearing another of her pseudonyms, Alice Oldcastle, on the art critic and writer Anna Jameson, while an article signed John Oldcastle detailed the biography of Meynell's sister, Elizabeth Butler.[4] Meynell wrote for two *Magazine of Art* article series, 'Our Living Artists' and 'Artist's Homes', between 1881 and 1883. After 1883 her contributions were less frequent; in 1882 she had begun to contribute to the *Art Journal*. Her artists' biographies and studio articles became a regular feature of the latter periodical for the remainder of the decade. During the 1880s, Meynell also continued to contribute exhibition reviews and articles to the Catholic periodical, the *Tablet*.

In 1880, the Meynells made their first attempt at editorship with a short-lived weekly review called the *Pen, A Journal of Literature*. The following year

the editorship of the *Weekly Register*, a Catholic periodical largely concerned with ecclesiastical affairs, was offered to Wilfrid Meynell by Cardinal Manning.[5] Their other periodical, *Merry England*, was started in partnership with the publishers Burns and Oates but after 1883 was owned solely by Wilfrid Meynell: a shilling monthly dedicated to arts and literature with illustrations, it immediately sold 5000 copies with its first number.[6]

The art and literary criticism written by Alice Meynell for the *Pen*, the *Weekly Register* and *Merry England* is masked by an array of anonymous and pseudonymous identities that are difficult to unravel.[7] Correspondence and marked periodicals give some indication of this diversity of authorships. The *Pen* was essentially an anonymously published review written jointly by the editors. Yet further analysis of the text indicates that the Meynells were able to employ strategies to benefit from this lack of named authority. The editors claimed the *Pen* was 'grasped by experienced editorial fingers', and contained criticism written 'without favour and without fear'.[8] Furthermore, the *Pen* in an 1880 review of the new art periodical, the *Magazine of Art*, declared, 'The biographies … contain points of information which are not to be found elsewhere, and which in its pages are always given with good taste; the detached essays are unequal, some being of really high excellence, with a tone that is neither Philistine on the one hand, nor affected on the other.'[9] These highly recommended biographical essays in the *Magazine of Art* were, of course, written by the Meynells themselves; Alice and Wilfrid Meynell were both regular contributors to the periodical by 1880. Obviously as editors they had not maintained their detached impartiality, since anonymity enabled the Meynells to publish overwhelming recommendations of their own freelance work elsewhere. However, these practices were not unusual in nineteenth-century journalism and the Meynells continued to capitalize on the marketing potential of their multiple journalistic affiliations. It was finance rather than log-rolling and favouritism that spelt the *Pen*'s demise after seven issues.

Not only did pen-names and anonymity allow for an objective or distanced voice, they also permitted editors to provide extensive copy for journals. Both Meynells utilized pseudonyms – Francis Phillamore or John Oldcastle – to mask the voluminous amount of writing they did, particularly for their own periodicals. This was further complicated by the blurring of individual voices, as they jointly proof-read, wrote and published articles and books. Even Meynell's sister could not tell them apart: 'Did you write that most beautiful article on the silent sisters in the last W. R.? How excellent you (or Wilfrid) were on the Pigott scandals.'[10] Moreover, the boundary between their own periodicals and freelance writing was confused by the reappearance of articles in other periodicals. This tactic of rewriting texts enabled them to be paid more than once for the same work.

However, Meynell's strategic disguises were not always successful. Her publication of her sister's correspondence presented occasional problems despite the anonymous system of publishing material in their own periodicals. Butler expressed particular concern over her identity being discovered when extracts of her letters were published:

about my letters to Mama as regards printing extracts from them. I know that in 'Merry England' such extracts were printed, <u>anonymously,</u> but from something I have heard it wd. [sic] appear that paragraphs have appeared in other papers from them. Many people – especially in the army – know that Will's brother-in-law writes for the papers.[11]

Nonetheless, the benefits of this sisterly system outweighed the negatives, as we shall see later in the chapter. In both the art press and in her own journals Meynell utilized strategies of anonymity or pseudonymity to strengthen the authoritative power of her writing. As was the case with many women, Meynell remained unidentifiable early in her career before she had established a readership. In addition to the pen-names she used interchangeably with her husband, Meynell's use of 'Alice Oldcastle' in, for example, the article 'Sketching for Ladies' in *Merry England*, enabled her to utilize Victorian constructions of femininity to her own advantage.

In May of 1893 Alice Meynell began writing anonymously for the daily *Pall Mall Gazette* a column, 'Wares of Autolycus', named after the Shakespearean 'snapper-up of unconsidered trifles'. Dedicated to the tastes of women, it contained a pot-pourri of material written by women journalists.[12] These same articles reappeared elsewhere in periodicals and volumes, and were later collected together as *Wares of Autolycus*.[13] The essays touched on art and literature with topics ranging from Charles Dickens to Harriet Martineau and fashion in Academy pictures.[14] Here she also published in the guise of a female writer. Her column occasionally utilized the first person 'I'; the 'I', although anonymous, was clearly feminine. For example, in 1894 she refers to her travel with her child across London to deliver the column to the editor:

child taken for drive that had for its end the leaving of copy for this column in the *PMG* letter box – some time after child … pointed with a larger gesture to the whole of the West-Central district of London, and said, 'That's the way to your column-place, mother.'[15]

These feminine autobiographical references identified the writer as a mother and professional journalist. The anecdote about differing child and adult urban geographies revealed her own weekly movement through these metropolitan public spaces. The personal subject was however distanced from the reader through lack of signature. Her strategy reflects an understanding of her readership's awareness of her mother–author status, yet her distancing from the personal suggests a desire to legitimize her observations as objective.[16]

Despite the demise of the series in 1898, Meynell continued writing for the *Pall Mall Gazette* and became its art critic after the death of R. A. M. Stevenson in 1900, a position she then held until 1905.

Throughout her career Meynell also wrote articles which revealed her religious convictions; these texts overlapped and informed her art writing. Catholicism not only provided a medium through which to write about art, but also played a part in the content of Meynell's texts, whether published in or out of the three Catholic periodicals, *Merry England*, *Weekly Register* and *Tablet*.[17] Meynell's Catholicism was explicitly linked to her advocacy of particular artists, such as 'Mr Herbert, the only Catholic artist who holds Academical rank'.[18] She also supported ecclesiastical subject matter, for example writing on the 'Nativity in Art' for the *Art Journal* and contributing two articles entitled 'Religion in the Galleries' for the *Tablet*. In the latter she wrote in 1886, 'there was, year by year, a little gleaning of pictures on religious subjects which spoke for the courage of contemporary painters.'[19] In *Merry England*'s 'Leaves from a Lady's Notebook', Meynell announced in 1890 that two Catholic women were eminent in the exhibitions, 'though neither their sex nor their religion separates their work in any way from that of their contemporaries'.[20] Meynell revealed to the reader that Butler's *Evicted* was 'painted from painful personal witness in Ireland',[21] while Marianne Stokes's important picture that year at the Grosvenor had given life again to another long tradition, that of Virgin and Child. Meynell continued by explaining that, although all four eyes were closed in the picture, it was not deprived of the usual centre of interest and light of life because it was so suggestive of that 'profound communion of sleep partaken'.[22] It was this image, *Light of Light*, that was utilized among other similar pieces to illustrate Meynell's biography of the artist in the *Magazine of Art* (Figure 3.1). The following year, Meynell introduced a volume which traced the visual historiography of the life and death of the Madonna and included more than 500 images of paintings and sculptures.[23]

Eileen Janes Yeo contends that for feminists from the 1850s onwards, Catholicism offered resources for feminizing divinity, role models through icons, and provision for dignified public work through sisterhoods. Many feminists, including the early art historian Anna Jameson, embraced the Madonna, rather than the single-gendered godhead.[24] This dimension of art writing was continued by Meynell; in addition to her volume on depictions of the Madonna in art history, she also completed a volume on *The Poor Sisters of Nazareth* and an essay titled *Mary, the Mother of Jesus*.[25] In fact, like Jameson's, Meynell's career encompassed art writing on religious subjects and feminism.

Meynell also published many freelance articles, where her editorial contacts were very important; she was able to make professional links with several newspaper and periodical editors. By combining the various pieces offered

LIGHT OFI LIGHT.
By Marianne Stokes.

MRS. ADRIAN STOKES.

By ALICE MEYNELL.

IN England, where there is no primitive art, the search of a modern painter for mediæval method and the self-inspiration of mediæval feeling lead him not only into the past but far a-field; and perhaps a suspicion of something like insincerity attends the English painter who is both foreign and ancient, and thus in two ways alien and strange. An English painter cannot be altogether English unless he study in the late schools and take for his masters those men of the eighteenth century who were the only great men in the art of their own age in Europe, and were English. As the nineteenth century drew towards its midst France was beginning her modern art of landscape, and from the death of Turner onward there is more international exchange, or at any rate the beginning of the modern common understanding to which we are now well used amongst the art students of many nations. With

other things that England has borrowed from her neighbours, they have lent her their Middle Ages; for, artistically speaking, we have none of our own. The modern English painter who would paint like Burne-Jones, or even like a "Preraphaelite" of 1850, is obliged to be exceedingly modern in two articles; he must be a restorer, and he must be travelled—a vexatious thing for men who do not profess to love what is of the later age. English art is more naturally mature, late, and devoted to Reynolds, Gainsborough, Constable, and Turner—men of their own day, and that an adult day. But the Continental painter has at least his past on the spot, or across the narrow frontier which hardly changes a language, and across which villagers meet.

In Flanders, in Tuscany, or in Venetia the Middle Ages are a very natural matter to painters

346

3.1 Alice Meynell, 'Mrs. Adrian Stokes', *Magazine of Art*, 1901

through these connections, whether daily or monthly paragraphs or articles, she was able to generate a more regular income. Already a regular contributor to the *Magazine of Art*, she continued to publish extensively for the journal during the editorship of W. E. Henley and maintained close contact with him after his departure in 1886 due to conflict with the publishers, Cassells, over his sympathy with modern French movements. Meynell's move to publishing with the *Art Journal* rather than the *Magazine of Art* from 1886 coincided with Henley's resignation. The rival *Art Journal* proprietors decided to utilize Henley's association with New Criticism to enliven the periodical and he was appointed Consulting Editor in 1888.[26] Henley was then appointed to the editorship of the *Scots Observer* (which became the *National Observer* in 1890), a position he held from 1889 until 1894, and Meynell also contributed essays on arts and culture to this paper. Through Henley, Meynell was also put in contact with John Lane, publisher of Bodley Head, who reprinted collections of her articles from the *National Observer*.[27] One resultant publication, *The Colour of Life, and other Essays on Things Seen and Heard*, received a mocking review by Max Beerbohm which situates Meynell in this eminent literary and journalistic sphere by 1896: 'The crowd is the reading public; the mounted policeman is Mr. John Lane; the guardsmen are the literary critics; the lady is Mrs. Meynell; the homely carriage is her new book; the stalwart Highlanders are Mr. Coventry Patmore and Mr. George Meredith.'[28] These figures became not only professional but also personal friends who attended social gatherings at the Meynells' house, as the evidence of her correspondence makes clear.[29] Through this network, and particularly through Henley, Meynell obtained a great deal of freelance work for the *Magazine of Art*, followed by the *Art Journal* and the *National Observer*. Her essays were published in several collections by Lane, whilst, as Beerbohm noted, Patmore and Meredith wrote enthusiastic reviews of her work in the press.[30]

The Meynells' editorial work offered certain advantages over freelancing, particularly those of greater freedom of expression and welcome economic stability. The latter aspect was vital in their difficult pecuniary circumstances. There were obvious financial reasons for Alice Meynell's constant and widespread publication, for in the Meynell household, money was never in abundance and, in order to support their ever-increasing family, both parents had to work full-time. An inheritance from Alice Meynell's father in 1881 allowed them to build a house for what would become a family of nine; however, this exhausted their funds and a daughter, Viola Meynell, revealed that family finances were consistently 'precarious in the extreme'. The average profit of the *Weekly Register*, which occupied and supported the Meynells for 18 years until 1895, was £300 per annum. In 1891 the profits for *Merry England* without the editorial fee were £37 15s 9d.[31] The joint editorship of the journals by the Meynells meant that they never took business or holiday trips together,

rather each parent travelled alone or with children, writing articles *en route*. Their separation for professional endeavours included Alice Meynell's year-long lecture tour of America in 1902. The correspondence between Meynell and her husband during these periods apart invariably concerned expenses and articles sent home for publication. During 1897 and 1898 Wilfrid Meynell made two trips to Rome during which Alice was left to edit the periodicals and wrote to him in detail of their meagre weekly earnings. Later, he was out of London for a few days and she wrote to say that she had informed the debt collector that he was 'abroad' and would return soon. Meynell added that she would willingly sell her diamond crescent the following day if things were pressing.[32]

As a freelance contributor Meynell maintained a good relationship with various editors although, by virtue of their position, editors exercised control over the content and placement of columns and articles. Edmund Yates was editor of the *World*, a paper for which Meynell regularly wrote anonymously in the 1880s and 1890s; he was sympathetic to the Meynells' plight as a young married couple needing work.[33] Meynell contributed paragraphs weekly on the arts as evidenced in an 1880 letter from Yates, 'The Frederick Leighton paragraph is only held over for next week. I hope to hear often from you during the autumn. Your husband's book on journalism will be noticed shortly.'[34] Clement Shorter, editor of the *Sketch*, outlined the requirements regarding a series on 'Child-Life': Meynell was instructed to send an 'article every week, not more than 1200 wds ... I do not want a column suggestive of a fashion newspaper'.[35] Although Meynell was contracted by H. W. Massingham for the *Daily Chronicle*, and Henry Cust for the *Pall Mall Gazette*, to write articles on subject matter associated with women, her willingness to write for a wide non-gender-specific audience maximized her possibilities for publication. W. T. Stead, most prominently associated with the New Journalism, was another editor who figured in the Meynells' circle, and the Meynells contributed to the *Pall Mall Gazette* during his editorship from 1883 to 1890. Some newspapers and journals offered better rates than others, necessitating careful planning in article distribution. Meynell wired home from France with instructions to stop an article on French cathedrals destined for the *Pall Mall Gazette*, for it 'would make a good one for Harpers and if so, pay my expenses'.[36]

After her early, often anonymous, writing and editing, she gradually established her own individual reputation with editors as an art critic and journalist. Yet she was still not always granted equal pay by editors for comparable work, as exemplified by the Meynells' paragraphs for the *Daily Chronicle*'s 'Office Window' column considered *vis-à-vis* pay scales. Alice Meynell's paragraphs were edited and received the common rate of pay, whereas Wilfrid Meynell's paragraphs passed directly to the printers and

were given a higher rate.[37] On the other hand, by 1898, she was commissioned to write a volume analysing Ruskin's writings, which was more lucrative. The *Blackwood's* editor wrote,

The honorarium we propose for the copyright of each volume of the series is, I should mention, one hundred pounds. I would like to say also that when you write any essay which you think likely to suit my Magazine I shall be glad to hear from you or having any subject in view for an article.[38]

Blackwood's ingratiating letter indicates her status as a critic for the periodical press by the turn of the century.

Elizabeth Butler – sisters' support

Although Meynell and Butler did not produce another joint publication after *Preludes*, their alliance continued to be played out in the press for the remainder of the artist's career. Meynell's bibliography of publications and her correspondence with Butler demonstrate the significance of this sibling relationship. Butler regularly exhibited her battle paintings at the Academy, peaking in popularity during the 1870s and 1880s, and Meynell repeatedly championed her sister's work through art reviews, columns and articles in various periodicals. However, Meynell's support for her sister in the press was not evident to the majority of late nineteenth-century readers for her identity was hidden beneath an array of anonymous and pseudonymous bylines.[39] The exact nature of this relationship requires examination; it appears perhaps to have been commensal rather than mutual with Butler reaping the benefits of having her own personal press agent. However, their surviving correspondence demonstrates that Butler in turn offered her sister emotional and financial support, particularly during the earlier, more precarious, stages of her career. In letters of encouragement to Meynell about her journalistic endeavours around 1880 Butler wrote, 'I was delighted to get your letter this morning to hear that you were going to be a Saturday Reviewer. I hope when once you get a footing on that solid foundation you will remain to achieve great things and make a pot of money.'[40] Two years later she wrote, 'The first number of Merry England is indeed brilliant.'[41] However, in their correspondence, these milestones in Meynell's career often centred on finances. Butler wrote expressing support for her new periodical projects, although she was concerned about her economic welfare: 'I should be glad to know how the [monthly] Register gets on financially.'[42] As an already established artist, Butler had access to the information network of artists, dealers and buyers necessary for art journalism. She wrote to Meynell with news of key patrons, like Blanche Fitz-Roy, wife of Sir Henry Coutts Lindsay, proprietor of the Grosvenor Gallery: 'Lady Lindsay has asked me to be one of

the Committee of her "Lady Painters Society" and I have accepted. Have you heard about it?'[43] These patrons also included royalty: 'The Prince of Wales was, as he always is, very friendly and he said he had seen the comment of my picture (no doubt in the *World* [by Meynell]) and he looked forward to seeing the picture with very great interest.'[44] It is clear that their relationship was complex and founded increasingly on a principle of reciprocity. Elizabeth Butler enclosed a cheque with a letter of 1880 to the impoverished Meynells, writing to Wilfrid, 'you can pay me some day when you are a big journalist sitting at the head of a paper dinner or better yet bring some favourable link at "Far Out" next month and the acct [sic] will be more than balanced.'[45] As Alice Meynell's financial remuneration increased, Butler congratulated her on success, 'We were very glad to hear of your £100 haul. Well done! I suppose it was your first three figure cheque? Let me know any Art Gossip you can, however small.'[46]

As Meynell's reputation grew, she became increasingly important to Butler as her key art contact in London. They attended exhibitions together and Meynell provided vital information on events, exhibitions, catalogues and reviews from the centre of the London art world, as is exemplified in a letter concerning Butler's royal commission *Rorke's Drift*, illustrating the defence of Rorke's Drift in the Zulu War of 1879 (Figure 3.2). Butler had resisted painting the controversial subject, but the Queen had insisted. Butler writes,

I was glad of the Grosvenor catalogue but gladder of the RA one, especially as you had put the little word 'crowd' against 'Rorke's Drift'. You put it also against the 'Sappho' but you must have meant its next door neighbour 'Cinderella' a much more popular party to the multitude. I much enjoyed your letter on the RA. I shall, I hope, have a good day with you there at the end of the month. … I should so like to see some of your critiques on the RA. Please keep the 'Art Journal' for me to see. I hear from all sides that it is a difficult matter to see 'R. Drift'.[47]

Not surprisingly, Butler also ensured her sister was present at private views:

If all goes well my picture 'To the Front', will be shown for a few of our friends on Thurs or Fr 28th and 29th at Graves. If you and Wilfrid come to see it you wd [sic] kindly give your card to Graves and he would show you the picture. I think you will like some of the old women and please tell me what your impression of the lady is.[48]

Clearly Butler was grateful for Meynell's reviews and reported on other authors who admired her writing,

I have been reading your remarks on my Academy picture in Merry England for June, which I missed on account of my absence that month. I feel you are very first in your criticisms and that you really take pains to think them out, which I seldom find other critics do. I like your article on landscape in that number also very much. … We were talking much of you, Mrs. Blundell and I this afternoon: she is always telling me what a veneration she has for your mind and its culture.[49]

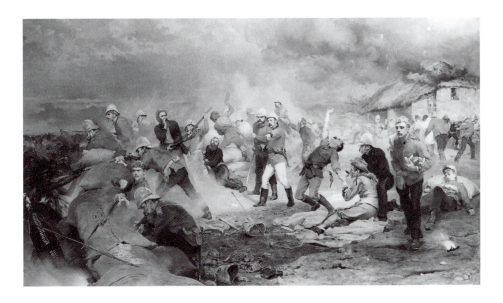

3.2 Elizabeth Butler, *Rorke's Drift*, 1880, oil on canvas, 119.3 × 213.3 cm

Butler provoked controversy in 1881 by breaking an agreement with the Fine Art Society regarding one of her pictures, *Scotland for Ever!*, and was forced to pay £500 in an out-of-court settlement. This marked the end of a strained, but lucrative, association with the Society as the producer of engravings of her pictures.[50] However, Butler's political wrangles with the Fine Art Society continued and her frequent absences from London meant that she needed her sister's publicity in the press. In a letter to her sister, Butler indicated anxiety over a related Fine Art Society matter concerning reproductions of the *Roll Call*,

I was much interested in the disclosure of the false 'Roll Call' doings, in the Weekly Register. But it is unsatisfactory to be left in ignorance of the answer the F. A. Society gave ... that the picture was my work. Can you tell me whether such guarantee was withheld? Have you heard anything about the Walker Gallery this year?[51]

Alice Meynell acted as Butler's personal agent in London when Butler travelled with her husband; in the 1880s and 1890s William Butler's military appointments included South Africa and Egypt. Although it was these travels that provided 'authentic' imperial subject matter for her work, they also limited Butler's participation in the patron and press networks integral to artistic success. As a result Meynell's advice was sought on technical aspects of reproduction as well as specific ideas about images, and illustrations were sent for publication.[52]

Detailed descriptions of paintings filled their letters and presumably these were to be utilized as notes for articles, as the completed pieces were later reviewed by Meynell. This pattern is exemplified by her letters outlining the exact detail of her 1882 piece, *Floreat Etona*,

'Floreat Etona' represents a characteristic episode from Laing's Nek where two young officers who had been Eton boys rushed to the front with the usual idea of the brave British subaltern that riding straight to the front and being to the fore is the sole aim in fighting as it is in fox-hunting, one of them Lieut Elwes shouting to the other … 'Come along, Monck! Floreat Etona! We must be in the front rank!'[53]

Poor Elwes was shot dead immediately after, but I have him … shouting and waving his sword forward, whilst disengaging himself from his fallen horse in order to turn forward in front … Wet earth reflecting an evening sky.[54]

The *Weekly Register* notice about the piece was virtually a direct quotation of these letters.[55] In fact *Floreat Etona* documented an unsuccessful battle during the Transvaal War of 1881, and it received few accolades. A month later Meynell's anonymous RA review primarily focused on contemporary military painters, including most notably an extended analysis of *Floreat Etona*. She began with the assertion that the great increase in the number of military subjects, year on year since Butler's first success, failed to add interest to the collection.

Our military painters should take to heart the fact that troops are artistically interesting in ther units alone. The genius of modern art is nothing if not realistic, and realism deals intimately with the unit. War is stupid in its generalities, infinitely noble, pathetic, and significant in its detail, dull in its history, keenly interesting in its anecdote; the loss of a thousand leaves us cold, while the death of one absorbs us.[56]

Not surprisingly for Meynell, it was Elizabeth Butler who had perfected this technique, with an innovative field study.

Mrs. Butler, in her 'Floreat Etona' – a little picture in which the artist has encompassed much beauty of light and climate – centres her interest as usual in the individual …There is nothing of the studio or the model in this fresh and brilliant work.[57]

Not only was Butler's method innovative, but as Hichberger has observed, Meynell emphasized the humanized aspect of her sister's military painting and the anti-violent nature of the subject matter.[58] Meynell's reading of the work revealed the anti-imperialist viewpoints of their liberal Catholic family circle.[59] Her review conjoined a humanitarian interpretation of the contemporary subject with a positioning of her sister's work within developments in contemporary painting predicated on a *plein-air* methodology. Here Meynell highlights her sister's commitment to field study for her pictures, linking her work to debates increasingly emerging in new painting circles.

However, other periodicals were not as encouraging of Butler's work. The *Athenaeum* reviewer, probably F. G. Stephens, declared that *Floreat Etona* displayed some of the least pleasing of Butler's mannerisms:

Even a pot-boiler need not be so mannered, and should contain at least the germ of a thought. This is but a spirited sketch of horses with animated actions galloping towards us, and of one of the painter's heroic soldiers demonstratively encouraging his steed and his school comrade. The stumbling charger is the better of the two prominent horses. This specimen is one of an increasing class in the Academy exhibitions, mere sketches made into pictures by dint of large canvases, broad frames, and sounding titles.[60]

In direct contrast to Meynell's review, it was precisely her submission of a 'mere' sketch rather than a finished studio picture that was criticized. Similarly, the *Art Journal* deemed her colour treatment to be crude, although the design was vigorous.[61] These negative reviews were also discussed by the sisters; after one positive pronouncement from the *Athenaeum*, Butler wrote, 'I am so glad about the Athenaeum and Academy. The former is certainly seldom genial.'[62] In fact, as battle painting experienced a decline in reputation during the 1880s, so did Butler. Stephens's criticism indicates the nature of Butler's decreasing popularity in the press. Although he remained an RA supporter in the 1880s, his texts also reveal the schisms emerging around academic painting which compounded Butler's rapidly deteriorating status. As a further indicator Meynell became increasingly involved with artists and editors associated with new movements. By 1882, she was producing articles on Impressionist work for Henley at the *Magazine of Art*.

Later in 1883, an unsigned article on Butler from the *Demorest's American Monthly*, entitled 'A Catholic Artist', was reprinted in the *Weekly Register*.[63] Meynell may have written the article or at least played a part in its original publication. The Catholic content of the Meynells' journals provided her with a non-filial reason for supporting her sister's painting which, as a result, continued to be positively reviewed in some quarters.[64] However, by the 1890s, Butler's reputation was increasingly tenuous, in part probably due to the failure of colonial wars, and her sister's access to reviews and gossip became more important to her. Anxious about her lack of press she wrote, 'Do tell me all about your At Home at the Art Club. Will returned yesterday from the Leveé and brought me his views of the Academy. I have not seen a single notice of my picture!'[65] Although positive reviews of her work were guaranteed from her sister, she requested specific publicity for certain matters: 'The 57th (Die-hards) have bought my "Steady the Drums and Fifes". ... Do you think it might be made known in a paper who are its possessors?'[66]

The sisters' commentary extended to decisions regarding exhibitions segregated according to gender. Rejection of a separation of male and female art practice was a viewpoint that Meynell had articulated implicitly in

the press by reviewing predominantly mainstream exhibitions. Although early in her career Butler had exhibited with the Society of Female Artists, by 1874 she was exhibiting at galleries that were non-gender-specific such as the RA.[67] Butler relayed her news regarding the Chicago International Exhibition:

I shall be represented at Chicago by my French Cavalry picture 'To the Front'. The American Authorities have invited the 'most eminent' European Lady Artists to send each one picture. Of course Rosa Bonheur will represent France. I do not know who the others will be. This special invitation is instead of the idea of having a separate Woman's Art Exhibition, which was a bad idea.[68]

Butler conveyed her disapproval of 'women-only' exhibitions and was clearly pleased that this idea had been rejected in Chicago.[69] Although on more than one occasion Butler expressed her reluctance to present her work in such gender-specific exhibitions, she sought Meynell's advice regarding the 1897 Jubilee exhibition. 'Do you or Wilfrid take any interest in the Victorian Era Exhibition at Earl's Court? I have promised 3 pictures to it. Can you tell me if it promises to be a well-managed and successful or important affair?'[70] Presumably, she was referring to the exhibition of women artists organized by Henrietta Rae in honour of the Queen's Jubilee. Meynell evidently determined the exhibition was an 'important' enough 'affair' because Butler was included in the catalogue, but only one piece by her was listed, *Halt on a Forced March*, instead of the promised three.[71] The sisters' correspondence and Butler's exhibition portfolio suggest that despite her non-gendered exhibition strategy Butler recognized the importance of the women's networks that organized and supported national and international exhibitions of women's work. This seems even more likely given that her career was established through matronage; Queen Victoria's early purchase of the *Roll Call* was reiterated with each mention of her career in the Victorian press.

In 1897, the *Art Journal* wished to consider Butler's biography for the *Art Annual*, for which Butler made a request to Wilfrid Meynell,

A Mr. Thomson of the Art Journal wants to have a 'sympathetic article' on me and my works and asks me if I could name anyone I thought he could apply to on the subject. I know no one better qualified to write a 'sympathetic' article such as he requires than Wilfrid and I took upon myself to mention his name. Of course, if he can spare the time and make satisfactory terms with the Art Journal, I should be very glad.[72]

The Meynells' authorship of her biography allowed Butler more control over technical aspects of the production, as well as ensuring an appropriately hagiographic narrative.[73]

Reviewing biography

In her art writing, Meynell championed several artists in contemporary art reviews and biographical articles. The *Weekly Register* and *Merry England* enabled her regularly to interpret British art exhibition trends anonymously. Art periodicals, on the other hand, offered the opportunity for extended analyses of particular artists or groups of artists. Artists' biographies became a fundamental format for late Victorian art writing. Although many biographical volumes published on single artists were written by men and about men, and published by experts, like *Athenaeum* critic F. G. Stephens, who had access to the art world and artists' lives, periodicals uniquely afforded spaces for women critics also to contribute to this phenomenon.[74] Thus, although Meynell published biographical articles rather than monographs, and her articles featured female as well as male artists, her essays were also part of the array of authors and texts involved in the late-nineteenth-century articulation of art history as a discipline.[75] Here I will consider the protean nature of Meynell's interventions in contemporary art discourse, incorporating women artists, the Royal Academy and Pre-Raphaelitism.

Biographical profiles emerged in the 1840s with the Art Journal series 'Portraits of British Artists', but it was not until the 1880s and 1890s that artists' biography became a central focus of art writing. Magazines, albums, biographical volumes and exhibition catalogues related the lives of artists. Memoirs, letters, interviews, engravings and photographs drew on the New Journalistic focus on personalities and contributed to a new art discourse that popularized and venerated the individual painter or sculptor.[76] The heroes of nineteenth-century art were honoured and celebrated: Frederick Leighton, Dante Gabriel Rossetti, George Frederick Watts, and Edward Burne-Jones were presented and represented to the art public. A plethora of literature was produced which participated in the construction of the masculine artist. The literature presented different versions of the artist as upstanding Royal Academician or eccentric genius – all were facets of the prestige and status of Victorian artists as individuals. A corresponding development was the growing attention to artists' studios and homes. Beginning in 1878, a *Magazine of Art* series, titled 'Half-Hours in the Studios', provided brief descriptions of the latest pieces to be contributed to the RA Exhibition, and the *Art Journal* soon followed suit, offering descriptions of various artists' residences in 'The Round of the Studios'. In 1883, Helen Zimmern articulated this new theoretical linkage between home and artist in an article on Hamo Thornycroft: 'fully to understand an artist we must see his studio; fully to understand a man's house we must have looked into his mind.'[77] Through these various forms of artist biographies the periodical reader could gain access to the subtleties of the artist's creative mind and thereby obtain the

meaning of the work. These biographical texts constructed the artist as subject, articulating the character, background and beliefs guiding her or his artistic expression; biographers presented themselves as textual mediators, functioning as translators of artists' minds, personalities and moral values for the public.[78]

Women artists rarely featured in biographical articles on single artists: Meynell was among the few critics to include women in this format. Her 1883 *Art Journal* article on Laura Alma-Tadema expressly addressed the theme of marriage partnerships (Figure 3.3). In reviews and articles, Alma-Tadema was invariably discussed in comparison to her artist husband; he had formerly been her tutor, hence she was constructed simultaneously as pupil and wife – her small canvases done in the style of seventeenth-century Dutch painting were contrasted with his large neo-classical pieces. Meynell attempted to position her art as distinct from that of her husband: 'As a colourist Mrs. Alma-Tadema shows the influence of her master, but without imitation' and she 'possesses her own beautiful studio'.[79] She also emphasized her success and professionalism, whilst a working mother: 'although like most women Mrs. Alma-Tadema works with interruptions'.[80] Another indicator of her independent success was international recognition. A large number of Laura Alma-Tadema's pictures had been shown at the Hague, and Meynell observed that by virtue of these exhibits abroad she had won approval in France. In 1878 Alma-Tadema was one of the two or three Englishwomen who were invited to contribute to the International Exhibition in Paris.[81] Nonetheless, Meynell followed the pattern of many critics by drawing her readers' attention to the feminine nature of her art practice. As Pamela Gerrish Nunn notes, Alma-Tadema's works functioned as feminine, sentimental and conservative, thus reaffirming a separate sphere of female art practice.[82] However, in the 1880s the discourse of femininity was a valuable strategy from which to articulate the authority of women artists. Hence, although Alma-Tadema's art was positioned within a separate sphere, Meynell referenced her knowledge of these feminine aspects to give authority to the artist's work and the specificity of her historical research on seventeenth-century Holland: 'In accordance with this familiarity of knowledge and feeling is the homeliness of her subjects which are such as might pass before a lady's eyes at home ... Mrs. Alma-Tadema is incapable of anachronisms in children's games as in everything else.'[83] Alma-Tadema's very detailed painting of *The Sisters* in a seventeenth-century bedroom interior illustrated the article. Thus, Meynell presented a reading which tactically positioned Alma-Tadema's deployment of feminine knowledges and production of work in terms of her expertise and, by extension, professional status.

In *Artists' Houses in London 1764–1914*, Giles Walkley identifies the artist's desire for a home in London during the latter part of the nineteenth century as

3.3 Laura Alma-Tadema, *The Sisters*, engraving, *Art Journal*, 1883

the result of the rising professionalism among artists, increasing remuneration for pieces, their reproduction fees, and a larger, wealthier buying public. The competitiveness of the art market was coupled with a desire for social advancement.[84] Studio articles became increasingly important in the 1880s as indicators of the growing status and wealth of the profession.[85] In 1888 Meynell transformed the usual artist studio format by contributing an article on a woman actor/artist's studio, that of Sarah Bernhardt. Meynell discussed her work and her collection of art and artefacts, which were displayed and reproduced with the article on her studio. These studio-type articles were accompanied by numerous prints or photographs of artists' works and artists in their homes. In his essays on photographic histories, John Tagg has defined the portrait as a sign whose purpose is both the description of an individual and the inscription of social identity.[86] Through this use of artist portraits in periodicals, the art produced by the artist became directly identified with the imaged personality and was representative of their rapid gains in professional status. In the typical studio article these portraits were inscribed with the new public prestige of professional artists. However, this article differed from the standard format in that Bernhardt's dress was described and she was repeatedly featured within the views of her studio; Bernhardt's own image was conflated with and overlapped the interior decoration of her studio to create her identity for the reader. In comparison to the single studio portraits of Royal Academicians that accompanied such articles, here Bernhardt's body was replicated in interiors and text. In this feminized interior she occupied a unique celebrity status; her portrait was already a signifier of her fame and identity as an actor. The positioning of the artist within the studio facilitated a personalized and intimate reader relationship with a celebrity, a feature of the New Journalism in the 1880s and 1890s.[87] Meynell's studio biography of Bernhardt indicates her wariness of the publicity journalism offered to celebrities; she criticized Bernhardt for caving in to her 'legend' and regretted that more and more she found 'a fine artist doing things to be expected of a mountebank'.[88]

While acting as a proponent of women artists, Meynell wrote from within the mainstream, reinforcing academic discourses, and championing the work of Royal Academicians, such as Herkomer and Leighton, in national art journals.[89] Writing articles in support of the RA was an advantageous professional career strategy for women writing about art in the late Victorian period because it afforded an established network of publishing opportunities. In spite of Hubert von Herkomer's victory over her sister in the race for Associate membership of the RA in 1879, Meynell wrote a biographical article on him in the *Magazine of Art*.[90] She had conducted an interview with Herkomer in his studio at Bushey, and praised plans for the new school he was planning to open there the following year. At the time a

full-scale biography of Herkomer's life and work had not been released, and Meynell's article was reprinted in the *Modern School of Art*, a collection of artist biographies edited by Wilfrid Meynell. Although an already esteemed Associate Academician, Herkomer was grateful for her publicity and wrote from Boston to thank her for the resultant article.[91] His architectural vision of the family house and school was the focus of much of his life (he had begun to build up a portrait clientele in 1881 primarily as a fund-raising campaign for construction of the house).[92] Press coverage contributed to Herkomer's rapidly advancing wealth and reputation during this period, and more specifically that of his school.[93]

Meynell was one of several women critics to write about the President of the RA.[94] In 1884 she reviewed Leighton's Academy piece, *Cymon and Iphigenia*,

Sir Frederick Leighton's latest picture, … which forms the principal feature of this year's Royal Academy Exhibition, is also one of his most serious – not only in the sense of the artistic responsibility that attends the execution of a ripely representative work, but in the sense of importance and deliberateness of intention.[95]

Meynell emphasized the importance of Leighton's academic technique – his 'serious study of drapery … of course done from the living model'. The article was richly illustrated by clay figures and chalk studies.[96] The importance of study from life models, as demonstrated by the work of Leighton, substantiated her article on the nude the following year in the *Tablet*.

Leighton was particularly influential in positioning the nude as subject matter at the pinnacle of late Victorian painting (Figure 3.4).[97] As long as academic history painting maintained pre-eminence, the academic nude signified prestige. It also became a locus for contention in art criticism, particularly with regard to gendered viewing and art production. Women critics contributed effectively to the debate around the nude during the 1880s. In 1885 a debate erupted in the *Times* and the *Pall Mall Gazette* concerning what was perceived as the disgraceful and unethical presence of nudity in contemporary art. Under the alias of 'A British Matron', a letter was written to the *Times* to protest the display of nudity at the Grosvenor and the Academy, 'flaunted before the public from the pencil of male and *female* artists':

at an exhibition purporting to be for general edification or entertainment, no picture should find place before which a modest woman may not stand hanging on the arm of father, brother, or lover without a burning sense of shame? … Women artists as yet seem content to shame their sex by representation of female nudity; it needs but pictures of unclothed men, true to life, executed by the same skilful hands, to complete the degradation of our galleries and walls.[98]

There are two interesting points here. The first is that this is an example of a letter written under a pseudonym. In most cases it appears that taking either an anonymous or masculine identity lent greater authority to women's

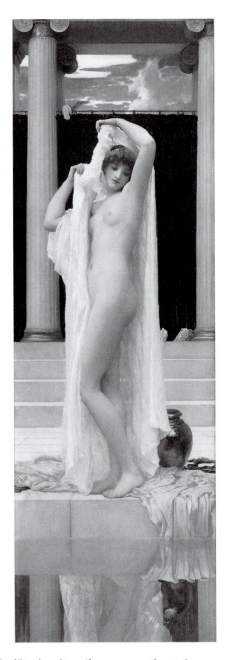

3.4 Leighton, *Bath of Psyche*, 1890, oil on canvas, 189.2 × 62.2 cm

writing. However one way in which female identity could give authority to writing was when it expressed moral outrage, as is the case here with 'A British Matron'. This makes it all the more interesting that the author behind this 'British Matron' was identified in the contemporary press as J. C. Horsley, Treasurer of the RA, who had been a longstanding opponent of the nude. Alison Smith has observed that it was no coincidence that Horsley appropriated a woman's voice for his attack; the language of outrage provided a powerful weapon for women to challenge the male establishment. Playing into this discourse, 'The British Matron' praises the 'noble crusade of purity … combating a giant evil'.[99] A myriad of pseudonymous letters were penned in response, but amongst the melee of cross-gendered *noms de plume* the actual voice of women viewers is more difficult to ascertain. However, the responses of women critics add another layer or perhaps remove a layer from Horsley's critical cross-dressing.

In the conservative Catholic periodical, the *Tablet*, Meynell's article, titled 'A Question of Propriety', criticized the person who had written the initial letter to the *Times*, under the 'absurd signature of a British Matron', for opening an irresponsible discussion of a difficult matter.[100] She utilized her position as a Catholic journalist and art critic to dispute with 'The British Matron'. Siding with the Academician E. J. Poynter, she declared the polarity of opinion concerning the nude a matter of metropolitan approval and provincial protest, analogous to Matthew Arnold's distinction between the centre and the provinces. Having dismissed Horsley as parochial, she was intent on confirming the legitimacy of the exhibition and production of nude works. She proceeded to discuss an issue which might have seemed somewhat tangential to the Academy debate – access to life study by artists of both sexes. Her argument responded to the letter to the *Times* from 'XYZ, a member of the Church of England Purity Society', who had vehemently condemned what he termed as the 'promiscuous' entry of students of both sexes into life classes.[101] Societies linked with social purity employed a discourse of morality and purity, as exemplified by the National Association for the Repeal of the Contagious Diseases Acts and its offshoot the National Vigilance Association. For many purity campaigners, depictions of female nudes violated codes of propriety for the female painter and the female spectator. They were also seen to be representative of a larger social and moral discourse around female sexuality.[102] Yet as Lucy Bland has observed, social purity advantageously provided a forum in which women could speak openly and authoritatively about sexuality and morality.[103] Meynell challenged XYZ's claim with the assertion that in the study of the undraped model in public art schools, the discipline, gravity, example and routine of business were excellent safeguards even to thought, and her only objection to the public life class, as conducted in most schools, was the 'foolish inconsistency of the rules':

For instance women students are not permitted the use of even the half-draped female model, whereas the men students have both female and male models entirely undraped – which is always quite unnecessary, for a slight draping would spoil no study. On the grounds, therefore of conventional propriety, women are deprived of an advantage which could not possibly do them any harm, while men receive, with altogether unnecessary abundance, facilities which might conceivably be dangerous.[104]

Here Meynell cleverly draws on social purity discourse to reach a diametrically opposite conclusion to that of XYZ, contending that, in contrast to men, life study for women implicated no such moral risks. Furthermore, she underscored the inequity, asserting that women deserved access to comparable study. While Meynell clearly attempted to dissuade her readers from accepting the argument of XYZ, she recognized the deeper significance of the debate for women artists. Training in life study was necessary for the practice of high academic art and in the *Times* not only were women artists being blamed for the degradation of the RA Exhibition, but the educational ambitions of women artists were being called into question. Moreover, by writing in her own name, Meynell added a genuinely female voice to the debate. The signature 'Alice Meynell' re-appropriates female moral authority weaving social purity arguments with egalitarian feminism. She was aware that the scandal here was not about nudity in art *per se*, but about women as spectators, consumers and indeed producers of art.

Other women art critics took issue with Horsley's outrage. Published texts do not indicate that art critic and historian, Emilia Dilke, intervened in the debate around the academic nude and women artists, but she did privately participate in the debate. She corresponded in 1885 with Leighton, RA President, urging him to give women access to life study.[105] Florence Fenwick Miller reintroduced the 1885 debate involving Horsley in the *Illustrated London News* on several occasions in conjunction with a discussion of women's art education at the RA Schools. Elizabeth Robins Pennell criticized Horsley directly with an anecdote that overturned the gendered stereotype constructed through the 'British Matron'. In a report of the Edinburgh Art Congress in 1889, she wrote:

While if the seventh [Horsley] has attained notoriety, it is not by his work, but because of his fad about the nude in art – a fad which he aired at Edinburgh, where he was indignantly silenced by a respectable Quaker lady, who told him and the delighted audience that the study of medicine in her youth had knocked all such old-woman's nonsense out of her. If these men are really to be accepted as Great Britain's leading artists, one begins to understand better all the talk about the degeneracy of British art.[106]

Although Pennell did not address the dimension of women artists' production of academic nudes and opportunities for study she did turn Horsley's argument on its head, blaming the established Academician, rather than the

aesthetic nude, for degeneracy.[107] Despite these efforts by women critics, many critics remained dismissive: 'Since only an insignificant proportion of the female students become professional artists, it has been thought unnecessary and undesirable that in the Ladies' Life School there should be any study of the undraped model.'[108] Women RA students were not granted a separate class for life drawing until 1893, though the more progressive Slade School allowed women to draw the half-draped model.

Alice Meynell also contributed to the resurgence in writing about Pre-Raphaelitism in the late Victorian period. Articles, exhibitions and volumes on Pre-Raphaelitism multiplied in the 1880s and 1890s; several women art writers contributed to this late-nineteenth-century construction of the category of Pre-Raphaelite and Pre-Raphaelitism in art history.[109] The contradictory narratives of W. M. Rossetti and the Pre-Raphaelite painter Holman Hunt, concerning the leadership of the Pre-Raphaelites, incited a great deal of controversy.[110] Meynell entered this debate by writing the *Art Annual* on Holman Hunt for the *Art Journal*, in implicit opposition to W. M. Rossetti's promotion of Dante Gabriel Rossetti.[111] The format was unique in that it was co-written by Alice Meynell and W. Farrar, Archdeacon and Canon of Westminster. Meynell wrote the sections outlining the life of the artist and his studio, whereas Farrar contributed the middle and longest section on Hunt's principal pictures (Figure 3.5). Farrar specified in the introduction to his essay, 'I have made no attempt to estimate the technical qualities of Mr. Holman Hunt's art. I have no qualification which would enable me to assume the role of an Art critic, and I neither endeavour nor desire to speak as though I were one.'[112] Rather his role was as interpreter of religious meaning in the work, while Meynell acted as the art critic by discussing the artist in keeping with the format of other *Art Annuals*. It is probable that Farrar and Meynell combined forces because of Hunt's desire to emphasize the religious value of his images.[113] Three decades earlier F. G. Stephens had written such a pamphlet on Hunt's *The Finding of Christ in the Temple* and Farrar had written an article on Hunt's *May Day, Magdalen Tower* in 1891 for the *Contemporary Review*.[114] Additionally, Archdeacon Farrar lent Anglican authority to the interpretations of the work; Hunt was adamantly evangelical in his beliefs and Meynell was Catholic. Initially, the Biblical interpretations in his images had been controversial and the Tractarian affiliations of the Pre-Raphaelites had been questioned.[115] However, they were soon absorbed into English popular culture and religious writing, particularly *Light of the World* (1853–56).[116] Whilst Farrar outlined his religious interpretations for the reader, Meynell provided factual details of Hunt's travels in the East and the resultant pieces, and described the interior design and handicraft of Hunt's house. In conclusion, she offered an explication of Pre-Raphaelitism, which by that time had been compared unfavourably with 'modern' art, by attempting to

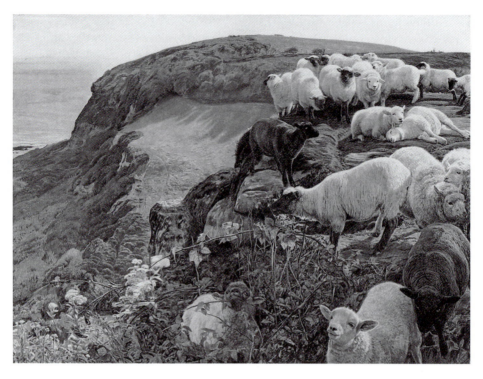

3.5 Holman Hunt, *Strayed Sheep*, 1852, oil on canvas, 78.5 × 94.0 cm

position the art in a positive light within its own era: 'It ill becomes the
Impressionists to break with the Pre-Raphaelites, who would have been their
comrades but for the most delusive accident of time … The curious
boastfulness of the period was working towards the Exhibition of 1851.
England was convinced that she had but to be seen to be admired.'[117] She went
on to assert that it was Holman Hunt, as the first Pre-Raphaelite, who made
this break with the art production at mid-century, and she observed that
Holman Hunt would not have been the leader in those days had he been
swayed by the flux of ideas. In this assertion, Meynell explicitly subscribes to
Hunt's re-writing of the Pre-Raphaelite narrative during the 1880s with
himself as the leader, rather than Rossetti.[118] In 1886, Holman Hunt had
written 'Pre-Raphaelitism: A Fight for Art' for the *Contemporary Review*,
presenting himself as the chronicler of the Pre-Raphaelite Brotherhood and its
ideologies. Meynell announced in her article that he was currently writing the
authoritative account of Pre-Raphaelitism, thus re-affirming his self-
positioning as its official voice and historian. This project was his primary
focus in the 1890s and the resultant volume was published several years later
in 1905.[119]

Analogously, Meynell was active in the construction of the Pre-Raphaelites as an 'English School' and she participated in the discourses of nationalism to construct a Hunt-centred Pre-Raphaelite history. Julie Codell maps Hunt's own reinforcement of this history through codification of supposedly national and racial traits into stylistic traits, and Meynell's text similarly played into this modelling of artistic production on a heroizing ideology contributing to the systematized and masculinized networks of origins and influence.[120] Although in Meynell's own criticism of contemporary art she aligned herself with artists like Bastien Lepage, she posited them against Hunt in the *Art Annual*, and applauded Hunt for retaining his principles.

Not all women critics were willing to jump on the Pre-Raphaelite bandwagon in the 1890s. Elizabeth Robins Pennell wrote more cynically about the creation of a Pre-Raphaelite historical narrative:

> The main facts are too well known and have been the inspiration of too much 'copy' to be in need of repetition. The Pre-Raphaelites were rebels – rebels against Academic convention and tradition … But whatever neglect or insult was offered to the work of the Pre-Raphaelites was always sure in the end to prove the kindest of advertisements. Better, after all, to have one's painting called an atrocity, or abomination, or any other hard name, than to have absolutely nothing said about it.[121]

Here Pennell pinpoints the recent inundation of periodical literature and books on Pre-Raphaelitism: during 1898 alone numerous articles were published concerning the exhibition of works by J. E. Millais and D. G. Rossetti.[122] Ironically, Pennell, like Meynell, contributed to this trend because this over-abundant 'copy' included her own articles in the *Star*, the *Nation*, and the *Fortnightly Review*.

The art critic most prominently associated with the Pre-Raphaelite Brotherhood, John Ruskin, had been a friend of Meynell's mother and, although he refused to write for the *Pen*, Meynell wrote an article on him in the first issue.[123] Nearly two decades later, Meynell's commission to do a short book on Ruskin for Blackwood's 'Modern English Writers' series initially seemed a windfall, but it proved to be a long and difficult project.[124] Finally it was completed and released in 1900, the year of Ruskin's death. Meynell wrote in the preface that the volume was intended to be principally a handbook of Ruskin.[125] Although Meynell wrote the majority of the book when Ruskin was still alive, she did not refrain from disagreeing with certain aspects of his work. Blackwood realized the challenging nature of this position; he wrote in 1899, 'I am sorry that you cannot have it ready for October, but I realise the difficulty of your task, especially as Mr. Ruskin is still living, and I would not wish you to hurry over it.'[126]

In the volume Meynell adopted an objective style to map out a critical guide to his work; in general, the text offered favourable explications of Ruskin's scholarship. For example, she attempted to dispel popular mythologies by

historicizing his writing, most notably his 1851 articles on the Pre-Raphaelites. Meynell pointed out that these letters to the editor were not eulogies of talented young men.[127] Yet she was not in complete agreement with his criticism of painting. Meynell took issue with his lack of appreciation for reflected light. By 1900 this was a quality evident in much contemporary painting and Meynell had initially praised the study of light in impressionistic work nearly two decades earlier: 'Incidentally I must avow that amongst the griefs that a reader of Ruskin has to swallow is the contempt of reflected light that is but the outcome of his suspicion and distrust of the schools of light and shadow.'[128] However, Meynell had written encouragingly of a diversity of painting styles, including the Pre-Raphaelites, and in this respect they were in agreement. Despite the contentiousness of Ruskin's writing at this time, she endeavoured to provide a comprehensive reader for his work rather than a critique signalling their many differences. The book was not given a good reception in the press which was a great disappointment to Meynell. Her letters to her husband discussed the reviews of the volume in the press: 'I am glad to see in the *Academy* that my Ruskin is in the third edition ... but the careless *Academy* in its own review of the year says that it regrets not being able to dwell on my Ruskin.'[129]

Impressionism and Newlyn

Although Meynell aligned herself with the more established approaches to art practice, she also had an interest in new artistic developments. As early as 1882, Meynell wrote an article series for the *Magazine of Art* on the Hill collection, which included British and French works by Frank Holl and Val Prinsep, as well as Edgar Degas and Claude Monet. She viewed the collection just before the death of Hill; Christie's first sale from his collection, in June of 1882, coincided with the last portion of her article series.[130] Diane Sachko MacLeod documents Hill's prescient support of Degas, who was represented by seven works in Hill's home.[131] Meynell deemed Degas' studies of the opera and the *corps de ballet* 'supremely clever canvases' and she praised Monet's 'charming garden-orchard scene'. The text did not include titles or illustrations of the works by Degas and Monet, but it did include an extended description and analysis of the works by Degas. She labelled Degas as both 'realist' and 'impressionist':

> The union of these titles may be a puzzle to those who see nothing but detail in the realistic school, and nothing but vagueness in the impressionist; and in effect the extreme precision and deliberation of the realistic would seem to place it altogether on different lines from those of the vivid but momentary and optically confused manner of impressionist painting. But in fact there is an essential unity in the aims of

impressionary art and naturalistic literature, inasmuch as both proclaim a complete denial of the ideal ... M. Degas is by no means extreme in his dislike of precision, outline or explanation, he is, in fact, a master of his technique, but no artist has ever gone further in his refusal of beauty or the ideal.[132]

What Meynell is appealing to here is not 'truth to nature' in a Pre-Raphaelite sense, but realism in the sense of a representation of social reality, a definition of realism having more in common with literary realism than pictorial naturalism. One can therefore identify in her work the complexity of definitions of Impressionism in Britain at this time, for it combines an appreciation of the formal qualities of the Impressionist method with an understanding of the significance of its shift away from traditional subject matter. What makes Meynell's contemporary interpretation of Degas particularly interesting was that she offered through the comparison with naturalistic literature a reading of his work to an audience decidedly uneasy with this seedy element of Impressionist work. Degas's 'realistic' depictions of modern life were later studied and admired by the London Impressionists, specifically Walter Sickert.[132] Although Impressionist works were commonly criticized for their slapdash technique and lack of finish, Meynell argued that 'A sketch brushed in half an hour by M. Degas would be more finished than a less admirably lighted and balanced work with additions and super-impositions of the labour of months and years.'[134] Thus, she defended the Impressionists' rejection of 'finish', a quality espoused by Ruskin and British RA painters such as Frith which was hotly contested four years previously in Ruskin v. Whistler. She could not resist a comparison of Degas to the Scottish academic painter, Robert Walker Macbeth:

Man's rural labour does not disfigure the land, but man himself – English man, at least – undoubtedly requires idealising, unless our national sentiment will allow us to reach M. Degas' point of stoical indifference to the beautiful. Macbeth ... deals with the British peasant in a manner which would fain to be realistic but cannot; the subject is too unmanageably unpicturesque.[135]

Evidently, she was not convinced that British artists could replicate Degas' 'realism'. In the collection Val Bromley and Paul Falconer Poole were also described as lesser artists, and it was clear that Meynell was more interested in the French pieces Hill had acquired. In 1882, Impressionism was just beginning to have an impact on English artists, and the New Critics, who would later become the voice for Impressionism in the press, had not yet exerted their full forces on academic art. It was not until the following year that Sickert met Degas for the first time in Paris, and in 1889 he purchased Degas' *Rehearsal of the ballet on stage*, from a sale of works from Hill's collection; this was shown at the NEAC in 1891.[136] Meynell's article appeared more than a decade before the press furore over the London exhibition of another Degas originally from the Hill collection, *L'Absinthe*, in the Grafton Gallery.[137] Her

article provides the only substantial contemporary discussion of the collection and description of the Degas paintings from the Hill collection which were to have a considerable impact on the NEAC.[138] This early discussion of Impressionist paintings in Britain was published by the new editor of the *Magazine of Art*, W. E. Henley. Liela Rumbaugh Greiman suggests that although he encouraged coverage of French art, particularly the Barbizon School and Rodin, Henley and his staff had reservations about French Impressionism;[139] however, Meynell's article demonstrates quite the opposite.

Thus it entirely follows that, in spite of her support for British academic artists, Meynell supported the French-influenced Newlyn School.[140] This group of artists started the move towards *plein-air* painting in England, setting up studios in Cornwall in the 1880s. Members included Frank Bramley, Stanhope Forbes, Elizabeth Armstrong Forbes, W. Fortescue, Norman Garstin, T. C. Gotch, Fred Hall, Edwin Harris, Walter Langley, Marianne Stokes, and Henry Scott Tuke. Meynell has been credited with the conception of the label 'Newlyn School' and with bringing the group to the attention of the art world with her *Art Journal* articles in 1889, wherein she asserted, 'the Newlyners are the most significant body of painters now in England'[141] (Figure 3.6). Stanhope Forbes originally expressed his apprehension about her *Art Journal* articles, writing on 18 October 1888, 'It will be a joke I fear. What can she know about us?'[142] However, subsequently he expressed his thanks and wondered if the phrase Newlyn School was not the Meynells' invention. Wilfrid Meynell later claimed that Alice Meynell had coined this term in 1888.[143] It is likely that he was referring to her work in the *Weekly Register*, *Merry England*, and the *Tablet*, all of which highlighted the youngest artists at the RA, the Newlyn group, as the most important work in the exhibition. By this time Meynell's strongest criticism was reserved for RA painting; nonetheless, she promoted the Newlyn School's appearance at their annual exhibition. In *Merry England* she had declared in 1888 that,

The Academy ... having the freshest and most vivid of new movements best represented on its walls, is the most interesting of the exhibitions. What it would have been without Mr. Bramley, Mr. Hall, Mr. Stanhope Forbes and Mr. Adrian Stokes and the rest of the Newlyn contingent, cannot be surmised without depression.[144]

Likewise, in the *Weekly Register*, Meynell compared the insincerity and conventionality of the other paintings to the Newlyn School's 'open-air work'. She claimed, 'emancipation from the studio and its detestable northern light, its models and its make-believes, is complete.'[145] In the Academy review for the *Tablet*, she gave precedence to the works by 'the Newlyn School' and the following year pointedly observed that all 'authoritative critics' had followed her example.[146]

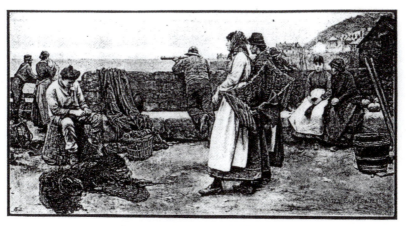

Departure of the Fleet for the North. By Walter Langley.

NEWLYN.*

IS very easy to take a too exclusive view of any movement in Art or literature which interests us not only for its own sake, but as a sign of the coming and going of contemporary tendencies. For the truth is, that in so various, multitudinous, and complex a time as ours, all the movements are at flux and reflux together. Classicism has never passed out of sight, and Realism was never begun. Romanticism did not appropriately spring to life in France among the "roaring forties" of the century; it had never died away from European letters since the unknown day of its birth; but it had incessantly supplanted the classic method, and had been as constantly supplanted by the naturalistic. There is no new way to be discovered in literature. There is no new system of æsthetics in Art. In painting from nature with a certain pictorial care in the selection of the materials which she presents, and yet with an accurate fidelity to those truths with which Art has especially to deal, the Newlyn school repeats an old formula. Nevertheless, in the one point of open-air painting, we have assuredly a novelty in the schools of Art. It is a detail, perhaps, and only one part of a great system of truth, a development from that study of illumination which has been the definite pursuit of the masters of Holland, Venice, and others of the later schools. But to have invented so important a detail is no small boast of an age which has seen such a number of repetitions that it has actually become conscious of them! It would be difficult, therefore, to give too much importance to the young work before us. Other painters may be more conspicuous individually; the "Newlyners" are the most significant body of painters now in England.

The fact that they avoid emotional subject, as a rule (but we saw last month that one of their chiefs has not done so in his most beautiful and most characteristic work), is hardly a point upon which it is well to insist. Story-telling has been a great bane of painting in England, because it seemed to excuse and to popularise poor work, but chiefly because the story told was weak, unrealised, sentimental, and readymade; not because it was good emotion, but because it was simulated, unconvincing, and essentially mediocre. A picture really dramatic is the rarest thing in the world, and if any artist in England achieved it, the most grotesque injustice possible would be to condemn him for making Art tell a story. And there has been a little danger that our younger painters should be tempted to congratulate themselves on the absence from their work of a dramatic interest, which, if they had known themselves, they would have been obliged to confess was beyond their achieving. This was very curiously instanced a season or two ago at the Grosvenor Gallery. It is not necessary to cite names, but it will be easily remembered that one or two painters who had been in word and practice propagandists of the Théophile Gautier principle, and had insisted that all emotional expression belonged to letters and the drama, and had nothing whatever to do with the picture, suddenly produced works full of movement of mind and matter, before which we were tempted to echo the feeble exclamation which a bad picture evoked from a great poet, "Oh, 'tis a passionate work!" For, in fact, the passion was a blank failure, and it became too evident that the greater number of our artists avoided dramatic subjects for the good reason that they could not compass them. They were a degree wiser than their predecessors of the early Victorian period.

And with all our delighted acknowledgment of the beauty of the younger work in England—I shall not be accused of slighting it—we are now and then constrained to recognise

* Continued from page 102.

1889.

N N

3.6 Alice Meynell, 'Newlyn', *Art Journal*, 1889

Meynell's vigorous support of the Newlyn School appears to have been the result of a variety of factors. Newlyn artists had early associations with the NEAC, an avant-garde group linked with French Impressionism, formed in 1886. For Meynell, the chief innovation exhibited by the artists was that they were following in England what had already been studied in France, the rendition of light rather than narrative. She praised the

subtle study of light rather than ... the obvious study of colour, and that they have style but not manner – these characteristics are sufficiently distinctive in England now, and the many differences of the Newlyn school among themselves do not prevent their ready classification.[147]

As a critic with an already established knowledge of French Impressionist art Meynell was able to articulate this new aesthetic discourse within the mainstream press. While acknowledging the differences within the group, including their production of open air painting as well as interiors, Meynell insisted on their collective commonalities. She realized the ambiguity and instability of her terminology in current public discourse and recognized the difficulties in classifying such a disparate group of artists as a single category. In an attempt to demonstrate the usefulness of this new taxonomy, she referred to Linnaean systems of nomenclature.

Earlier in the century the term 'School' had been used to categorize art according to nationality; Meynell's usage of the term 'School' departed from Gustav Waagen's familiar label, 'English School'.[148] By 1875 the label 'School' was being used to describe another continental regional group: the Hague School, a group of painters in Holland between 1870 and 1900.[149] Griselda Pollock demonstrates how modern art has been mapped by modernist art history in a series of movements, each presided over by a named artist.[150] Meynell's presentation of Newlyn under the leadership of Stanhope Forbes exemplifies this emerging modernist pattern, as does her focus on the 'new', artist and movement (Figure 3.7). Her situating of a style, rather than nationality, as the unifying factor in the School articulated a form of critical writing that attempted to establish new mappings and categorizations for 'modern' art. Notably, Meynell also called the group the Newlyn brotherhood, a term which presented awkward associations with the earlier secret Pre-Raphaelite Brotherhood, but signalled a distinctively English art movement. Brotherhood also suggested the group was a masculine entity, despite the fact that Elizabeth Armstrong, later Forbes, was included in the articles, and Caroline Gotch and Marianne Stokes were also identified with the group by this time[151] (Figure 3.8).

Meynell's essays began a wave of articles that appeared in the art press: the *Magazine of Art* for example published 'Newlyn and the Newlyn School' in 1890.[152] Thus, by the 1890s the Newlyn School attained mainstream status and

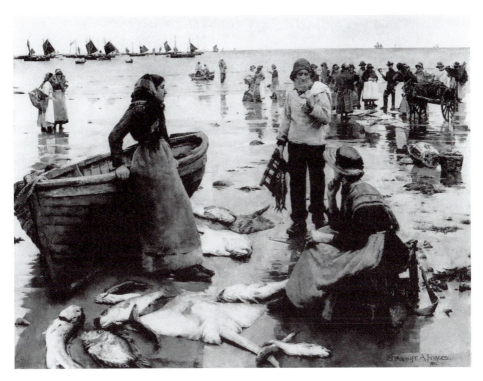

3.7 Stanhope Forbes, *Fish Sale on a Cornish Beach*, 1885, oil on canvas, 121.0 × 155.0 cm

Meynell continued her advocacy of the group whilst proclaiming their 'newness'.[153] In 1893, writing the prefatory note to a *Catalogue of a Collection of Watercolour Drawings illustrating Fisher-Life* by Walter Langley, she declared that the 'deliberate and open-aired' school had 'for years borne the name of Newlyn'; Langley, one of its first painters, was, as a Newlyner, 'chiefly a painter of light'.[154] A decade later in a *Pall Mall Gazette* review, she criticized the Royal Society of Painters in Watercolours for being out of date and not enrolling more than a few of the 'newer' school: Swan, Clausen, Edmund Sullivan, Armstrong Forbes and Anning Bell were amongst the few who introduced this 'look of change'.[155] By 1903, however, 'new' was a rather relative term – many of the Newlyn School were by then Academicians.

One woman artist associated with the group received long-term support in Meynell's art writing. Over two decades Marianne Preindlsberger Stokes and Adrian Stokes, two painters now associated with the St Ives group, were widely praised in her writing on Newlyn as well as elsewhere in her work. Although more recent writing has distinguished between the Newlyn and St Ives groups, Meynell did not utilize the phrase to signify a restricted geography, rather she included those who resided in St Ives, Lelant, Falmouth

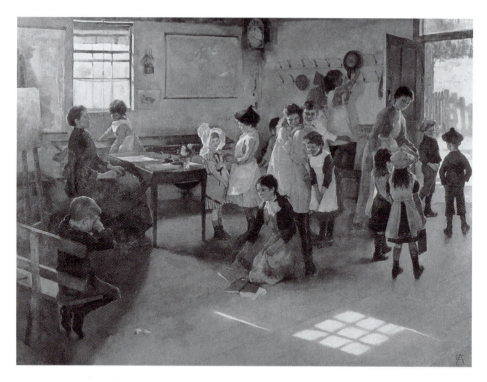

3.8 Elizabeth Armstrong Forbes, *School is Out*, 1889, oil on canvas, 105.5 × 118.7 cm

and the Newlyn area.[156] By 1888, the Stokes were singled out in Academy reviews. Adrian Stokes' *Upland and Sky* was considered 'powerful' and 'preeminent in landscape'; readers were reminded that Marianne Stokes was also 'excellently represented' at the British Artists and NEAC.[157] Meynell's 'Wares of Autolycus' column admonished the New Gallery for misprinting the title of Marianne Stokes 'charming' work, *Faun and Squirrel*, in its catalogue.[158] In 1901 Meynell contributed a biographical article to the *Magazine of Art* on the work of Marianne Stokes in which she asserted that 'no man or woman ... could have a fresher spirit than hers, a clearer heart, or sincerer sympathies'.[159] Three years later she particularly praised the 'brilliant and beautiful' works of Adrian Stokes and Marianne Stokes at the New Gallery; the latter's portrait of 'Mrs. Garrett Anderson M.D.' had 'brilliant tone and charming colour in the flesh'.[160] Additionally, Meynell wrote the catalogue essay for an exhibition of pictures painted in Austria-Hungary by Adrian and Marianne Stokes in 1907.[161] Her praise for the artists was consistent and unstinting despite institutional shifts, and was due at least in part to her long-standing friendship with the Stokes.

Political involvement

Early in her career Meynell contributed an anonymous review of *Mary Wollstonecraft's Letters to Imlay*, published by Kegan Paul, in the *Spectator* of 1879, in which she defended both Wollstonecraft and her writings.[162] In an 1884 article, 'Sketching for Ladies', Alice Meynell utilized her Oldcastle pseudonym to praise contemporary ideas about what was suitable for ladies in comparison to her grandmother's days. Here she drew on an essentializing rhetoric associated with social purity feminism, pointing out that feminine qualities such as sympathy, fineness of feeling and delicacy of mind suited the spiritual in art.[163] Yet she also clarified that she did not want to make an arbitrary distinction between the work produced by men and women, rather to describe the unavoidable difference in the facilities for its production.

The difference is all against the weaker sex, they are heavily handicapped … a matter in which there is no redress, for it would hardly be desirable that women's work should be judged with indulgences or allowances … we disclaim all separation of masculine and feminine art, but it is certain that while women continue to be in a measure influenced by delicate physical powers, and more or less hampered by habits of dress … and these things will probably continue 'à tout jamais' … art for ladies must be in a thousand respects a different thing from art for men.[164]

A decade later, in 'Wares of Autolycus' she mockingly parodied the RA position on female membership with a veiled reference to her sister's experiences:

when one woman was very near getting the honours … the question was whether the Royal Academy should or should not be 'altered' to allow for her election. It is, however, to make the present custom of exclusion legal that the laws would have to be altered … the Royal Academy might put itself into order by a law incapacitating for membership all painters who are women, or all painters having blue eyes, or all painters, say born in Kent. One non-artistic and non-technical exclusion will be as reasonable as another.[165]

Here she highlights the ridiculousness of the continued exclusion of women from the Royal Academy on legal grounds. During the 1890s, she contributed several signed columns on the arts, culture and politics to the *Album*, the *Woman*, and the *Daily Chronicle*. In an 1895 article, Meynell inserted a comment on woman's historical relationship to art production: 'women were the earliest artists, for they scratched the first decoration on the pitcher, fringed the first cloth and plaited the first pattern into the strands of wickerwork.'[166] Another essay, titled 'My Faith and My Work', elaborated on Meynell's political philosophy:

Individualistic as is my Faith in regard to thought and Art, I am politically rather inclined towards Socialism than towards Individualism … The State is welcome to order my affairs far more closely that it has ever done yet, for the good of the majority, and especially for the good of the unfortunate.[167]

'A Woman's Fancies' was the title of a column that Meynell wrote for the *Daily Chronicle* in 1896; she used the column as a forum for discussions of women's rights in relation to the arts and politics. One column, on 'Daughter's Portions', addressed the need for a fairer distribution of family funding, rather than endowments for sons only. Meynell argued that this system did not allow for contemporary variables, specifically the myriad of women left without financial provisions:

a family of which all the daughters marry ... by a marriage of inclination ... and equal. Who would have guessed this to be the typical family ... the ideal of a country that is actually largely peopled by unmarried women, and a country in which unprovided girls have their inclinations greatly prompted by the hope of prosperity and ease, and the fear of privation, hardship and solitude? ... If daughters were better portioned there would be a difference of distribution that would injure not one.[168]

In another article, she spoke out against the gendered expectations of philanthropy, arguing that, as they supposedly possessed distinctly compassionate sensibilities, women were seen as givers of casual alms to the poor; yet, she contended, 'The actions of women are human actions, and not necessarily perpetually feminine.'[169]

In 1897, *The Woman* canvassed some women on whether the State should create an Honours List to recognize the 'services of women'. Alice Meynell replied,

I should be opposed to the institution of any order or decoration exclusively for women; and in favour of enlarging and opening the existing orders, so that women should share them on occasion, as is the case with the Legion of Honour.[170]

The artist Louise Jopling agreed: 'We are told on very good authority that the workman is worthy of his hire. Merit is always merit, by whichever sex it is deserved.' In a later *Daily Sketch* article, Meynell responded to a similar question regarding the Honours List with the statement, 'The refusal of honours to women is a comedy; but the refusal of equal wages to poor working women for work equal to men's is a tragedy.'[171] Although not a 'poor working' woman, in her own professional career Meynell had not received equal pay for equal work. This was made obvious to her by the fact that she wrote for the same papers as her husband.

In addition to disagreeing with the Honours List, Meynell found fault with Ruskin's *Sesame and Lilies*, which was the most popular of his texts, in her 1900 handbook. His lecture is renowned in the twentieth century for its pronouncements on the role of women as imitators rather than originators: 'woman's power is not for rule, not for battle – and her intellect is not for invention or creation, but for sweet ordering, arrangement and decision.'[172] Meynell's less than enthusiastic response towards these lectures appears hardly surprising in light of her writings in support of the women's movement in the 1880s and 1890s. Yet previously her articles advocating women's rights

had been either unsigned or not intended for general readership.[173] Meynell disputed his homiletic passage on woman's role, 'in "Lilies" the teaching is addressed particularly to women of a kind and class that acknowledge conscience and are concerned with private duty, though they can hardly be charged with intellectual responsibility for the national condition.'[174] Meynell touches on an aspect of Ruskin's writing which has been the subject of much feminist analysis. She observed, 'the examples proposed to them by Ruskin are those of heroines who have never questioned the privilege – moral, mental, bodily – into which they were born ... even though they may vaguely avow that some obligations are implied by their unexplained rights.'[175] Meynell wanted to position clearly Ruskin's model female in association with his intended female audience/reader as distinct from the majority of his readership. Additionally, she distanced herself and her reader from Ruskin's ideal female readership.

After 1900, Meynell became more directly involved in the women's movement. She continued to write journal articles in support of women's rights and encouraged her children to do likewise. In 1902 she conveyed her disagreement with the opinion of Caleb Saleeby (her daughter Monica's future husband) regarding another daughter's bookbinding work: 'He thinks it is injurious, especially to Dimpling [her daughter Madeline]. That seems strange when women do such much harder things, in athletics, with advantage.'[176] Rather than art criticism, Meynell devoted herself increasingly to regularly attending Catholic Suffrage Society meetings and mass demonstrations, and in 1913 she edited the first issue of the *Catholic Suffrage Journal*.

Conclusion

In her art texts Meynell did not present a unified voice; rather she contributed to various discourses pertaining to art in the late nineteenth century. Despite new trends appearing in the Grosvenor Gallery and the NEAC during the 1880s, the RA Exhibition and artists still dominated art discourse. The paintings shown by Elizabeth Butler benefited from dazzling reviews in Meynell's periodicals, but other women artists, such as Laura Alma-Tadema, were also promoted in her writing. Royal Academicians figured heavily in art periodicals and Meynell contributed articles on numerous members and associates including the President, Frederick Leighton, but also challenged the Academy's authority on access to life study. W. M. Rossetti and F. G. Stephens ensured that the Pre-Raphaelites remained a focal point in Victorian art writing and Meynell (re)presented the veneration of these artists and historiography of the movement. Yet she also showed acute awareness of new

developments, supporting French Impressionists and the Newlyn School in the 1880s.

By the turn of the century, Meynell's art criticism was being reviewed and praised by other journalists. Artists wrote to request her support for their work, as evidenced by this letter she wrote in 1905:

Many thanks for your letter and the cards. I am much in hope of seeing your paintings and also of going to see you if it is any way possible ... I have given a card to my son Everard, who has it in his power to say an appreciative word in a paper or two. But – as to me, I have altogether given up the task of writing on the galleries. 'Art Critic' I never called myself; and I know about nothing except literature. I do not hear brilliant things about my successor on the Pall Mall Gazette. My visit to your exhibition will unfortunately be more delightful to myself than useful to you.[177]

In the *Art Journal* article 'Art Critics of Today', Meynell was featured amongst the regular art critics of well-known weekly and daily journals. However, she was relegated to the small paragraph on lady critics, indicating that her status as a professional authority on art was always unstable and contested. After an influential quarter-century of art writing, Meynell discontinued publishing art criticism in periodicals in 1905, instead devoting her time to literary publishing and suffrage. Although this sudden shift in her profession appears at first disjunctive, by this time several of her children were no longer at home so she was not so constrained by financial matters; her art reviewing work was passed on to her son, Everard, who was pursuing a career in journalism, and her daughter, Viola Meynell, also followed this route, writing as art critic for *Time and Tide* after 1910. Art journalism was also becoming more professionalized, a development which paralleled a decrease in the number of women art critics contributing to the periodical press. Additionally, Meynell's work as an active member of the Catholic Women's Suffrage Society allowed her to combine her career in journalism, her interest in the women's movement and her church involvement. Meynell utilized an array of publications to articulate a diversity of subject-positions relating to the 'academy', the 'modern', and feminism through the overlapping spheres of art criticism, journalism, and social activism. The occupation of multiple subject-positions, which enabled her to write about a broad range of contemporary art, is also symptomatic of the tactics deployed by women art critics in this period.

'There is no sex in art': Art and Feminism

Florence Fenwick Miller

Florence Fenwick Miller was a highly prolific journalist; like Alice Meynell, she contributed to over a dozen different periodicals from the 1870s until the 1910s. However, their contributions to the periodical press differed in terms of the actual spaces in which they published texts and in the content of the articles themselves. During the last two decades of the nineteenth century, Fenwick Miller wrote about art in conjunction with women's issues in mainstream and women's journals, most notably in the *Art Journal*, as columnist for the *Illustrated London News* (1886–1918), and as editor of the *Woman's Signal* (1895–99). Fenwick Miller pursued careers in medicine and education before journalism and, more controversially, she combined the pen with the platform. Unlike Meynell's, Fenwick Miller's life and work has not been the subject of several biographies. Therefore the first three sections of this chapter will draw on biographical material in order to analyse the unique nature of her career path alongside the conditions and strategies of her work. This phase will map a career trajectory founded on her involvement in women's issues. The fourth and fifth sections will consider her tactical interventions in the late nineteenth-century artistic sphere, specifically her coverage of work by women artists, and will address how her feminist politics directly informed her art writing.

Politics, the platform and the pen

In contradistinction to Meynell, Florence Fenwick Miller was not born into a well-travelled family that already moved in elite cultural circles. Rather her writings about art were the result of her involvement in the shifting and

volatile campaign for women's rights. In an unpublished autobiography of the first 25 years of her life, she explained how her mother, Eleanor Fenwick, married her second husband, John Miller, a Captain in the Merchant Navy, and had a daughter, Florence, in 1854 and two sons.[1] Fenwick Miller's parents tried to provide for their children the formal education they had lacked, and her father was an early supporter of equal access to education. Thus when, at the age of 16, Fenwick Miller wanted to study medicine, they funded her stay at Edinburgh University with the early medical education campaigner, Sophia Jex-Blake. However, despite Jex-Blake's efforts, the university authorities would not award degrees to women, so Fenwick Miller returned to London and completed her studies at the Ladies' Medical College in 1872 and 1873.[2] After practical training at the British Lying-in Hospital, she graduated with a first-class honours certificate in the 'practice of midwifery and diseases of women' and set up a practice for women and children that took charity patients at her parents' home in Victoria Park.[3] In 1873, she attended a wealthy patient in the country, Catherine Tomasson; her resultant friendship with the Quaker circle of Tomasson, Margaret Bright Lucas (sister of the MP John Bright) and Helen Priestman Bright Clark, led to work on the Repeal of the Contagious Diseases Acts and Suffrage campaigns.[4] Additionally, she linked up with another radical circle by becoming a member of the London Dialectical Society in 1873; Fenwick Miller described the society: 'all advanced views on politics, sex and religion were discussed at its meetings with complete freedom, the speaker had to submit to heckling and face questions'.[5]

In 1876, a bill was passed in Parliament which granted women the right to become medical practitioners. However, this meant that Fenwick Miller and other women who had been practising without a legal permit would have to seek retraining for certification. Fenwick Miller had neither the time nor money to return to medical school and a letter requesting her candidature for the 1876 London School Board elections presented her with an alternative career.[6] After their municipal enfranchisement in 1869, several 'advanced women' stood successfully on Poor Law boards and school boards during the 1870s and 1880s. Fenwick Miller, at the age of 22, ran for Hackney and was elected with 15 000 votes. She became a renowned speaker, advocating non-sectarian education and equal opportunities on behalf of women teachers.[7]

As a member of the London School Board, by virtue of her participation in municipal government, she was a public figure. Campaign appearances were covered by the press, as were her platform performances at school board meetings. The reaction to her speeches was later described by an interviewer in the *Woman's Penny Paper*: 'From my place in the gallery of the London School Board, I have seen men grow visibly paler as she dissected – or rather vivisected – their halting arguments with her pitiless logic; she would leave nothing but shreds behind.'[8] In his autobiography, Frederick Rogers described

her as 'young, good-looking, brilliant, and daring enough to talk frankly on public platforms on matters relating to physiology ... very much of a demagogue.'[9] Her position on the London School Board was in danger of being jeopardized when a letter indicating her support of birth control advocate, Annie Besant, was released to the press in 1877. Despite her medical knowledge on the subject of obstetrics, her sex and marital status were utilized to unpick her authority. The press called for Fenwick Miller to resign her seat over the matter, but she responded with a letter of defence and retained her seat.[10] Although this satisfied the public, she could not remove the layer of controversy that now overshadowed her reputation. Perhaps surprisingly, the Besant incident affected Fenwick Miller's reputation within suffrage circles, as she wrote in her autobiography, 'I clearly now ceased to be persona grata as a result of Besant Bradlaugh' because a faction sought to 'ostracise those with more advanced opinions.'[11]

In fact her autobiography identified this incident as a turning point, 'to think of marriage with my chosen friend as desirable for my public work as for my private comfort.'[12] Later in 1877, Fenwick Miller married Frederick Ford, her colleague in the Dialectical Society, an Honourable Secretary for her London School Board campaign and a suffrage supporter.[13] After two more successful elections to the London School Board and the birth of two daughters, Fenwick Miller sought work in journalism, which offered a more stable income; the London School Board position had offered no remuneration, and her husband's earnings alone could not support their family.[14] In June 1886, Fenwick Miller began contributing 'The Ladies' Column' to the *Illustrated London News*, a position she maintained until October 1918. She also wrote a column, 'Filomena's Letter', which appeared in provincial newspapers between 1883 and 1890. Her other periodical publications included work as a correspondent for the *Echo* and writing for the *Art Journal*, *Lady's Pictorial*, *Fraser's Magazine*, *Modern Review*, *National Review*, *Outward Bound*, *Woman's World*, *Young Woman*, and *Universal Review*. Additionally, in 1895, she took up the editorship of the *Woman's Signal*, 'a weekly record and review of woman's work and interests at home and in the wider world', a position she held until 1899.[15] However, the *Woman's Signal* editorship was unpaid and this was a source of financial struggle during the 1890s. In a call for readers to extend the circulation of the paper she wrote, 'I have never concealed from my readers ... that the paper does not yet pay me for the work I give it.'[16] During the 1880s and 1890s Fenwick Miller published *Readings in Social Economy* and two books relating to famous women: *Harriet Martineau*, as part of the 'Eminent Women' series, and a collection of biographies, *In Ladies' Company*.[17]

From 1873 onwards, Fenwick Miller also lent her dynamic platform skills to the women's suffrage movement. The lecturing market was more remunerative

than writing, and during the 1870s and 1880s, her annual public lecture tours in Birmingham, Newcastle and Scotland were her chief source of income.[18] The *Women's Suffrage Journal* reported on her exhausting schedule of speeches around the country and announced a lecture in Hackney was 'the nineteenth London workmen's club at which resolutions in favour of giving women representative government by the present Bill have been carried all but or quite unanimously within the last few months, after lectures by Mrs. Fenwick Miller.'[19] The Women's Franchise League was formed in 1889 'to extend to women, whether unmarried, married, or widowed, the right to vote at Parliamentary, Municipal, local and other elections, on the same conditions which qualify men' and 'to establish for all women equal civil and political rights with men'.[20] Fenwick Miller joined Elizabeth Wolstoneholme Elmy, an early member of the women's enfranchisement committee in Manchester and the Married Women's Property Committee secretary, in advocating a Women's Electoral Franchise Bill to be brought before Parliament. On behalf of the League, in a meeting at Westminister Palace Hotel, she moved a resolution in support of 'The Women's Disabilities Removal Bill' and in 1890 delivered an address 'On the Programme of the Women's Franchise League' to the National Liberal Club.[21] Party loyalties began to complicate the Franchise League in 1890 with the interest expressed by Liberals Ursula Bright and Emilia Dilke; Elmy did not approve of the partisanship, nor Fenwick Miller's supposed attempt to supersede her as Secretary, and resigned.[22] Extant documents and letters do not give a clear account of the disagreement, yet at the time, Wolstoneholme Elmy wrote a damning letter on Fenwick Miller's financial status and class to Harriet McIllquham:

one must remember that her upbringing has been that of slaves and that it will take generations of freedom to eradicate the vices of slavery and in Mrs. Miller's case that she had at too early in life, as a mere girl of 18 or 19, personal successes – which turned her head – and that for the rest she lives on and by rich people, mixes with them whilst poor – and is corrupted thereby. She *longs* to be rich.[23]

Ironically, despite Fenwick Miller's apparently intolerable working-class origins, her financial status was not dissimilar from that of Elmy; both depended on earning an income for a living. Clearly Elmy did not consider herself to be corrupted by some of the same rich people, the Quaker circle, notwithstanding her also financially straitened circumstances.

In 1893 Fenwick Miller spoke at the World's Congress of Representative Women in Chicago on the demands of the Franchise League for educational, legal, professional and marital equality: 'That can only be done, ladies and gentlemen, as I fully believe, by the women themselves having a voice in the making of laws which shall govern all.'[24] Four years later the Women's Franchise League was subsumed into the National Union of Women's Suffrage Societies and Fenwick Miller began to focus on the international

organization of women's suffrage. In 1899 she was elected to the Press Sub-Committee for the International Congress of Women in London.[25] Nearly a decade after the Chicago Congress, Fenwick Miller again represented England at an international congress in the United States in 1902; this Washington conference would evolve into the International Woman Suffrage Alliance. It is this continued suffrage involvement which necessarily informs our understanding of her journalism.

Making a name and reputation

Fenwick Miller's election to the London School Board enabled her to combine her training in medicine with her new-found interest in education, but it also had another advantage – a title – 'Member of the London School Board'. Although she was not allowed to acquire the letters MD, her new position lent authority to her texts: 'Mrs. Fenwick Miller, member of the London School Board, and authoress of *Readings in Social Economy*' or 'Mrs. Fenwick Miller M.L.S.B.' gave her lecture on 'Women and the New Reform Bill'.[26] She continued to utilize these letters after her name long after she had left the board.[27]

In Fenwick Miller's unpublished autobiography she recalled how her first article, 'Palmam qui Meruit Ferat', addressed the unfairness of men in criticizing the work of women on a sex basis, observing that George Eliot, George Sand and Currer Bell had assumed their masculine names so their work would obtain fair and equal criticism. She quoted her 1872 text, 'Let not the praise drawn forth by the beauties or the genius of a work be marred by the contemptuous addition of the phrase "for a woman".'[28] This early article presaged a lifelong struggle for Fenwick Miller concerning authority and equality in relation to the gendered practices of naming as well as portending her later focus in her art-writing. Interestingly, her own attempt at a three volume novel, *Lynton Abbott's Children*, published at no profit by Tinsley, was anonymous, whereas her textbooks and journalism were often signed.[29]

Upon her marriage in 1877, Fenwick Miller maintained her own name, for by this time her name already signified her professional existence as an obstetrician, London School Board Member, suffrage worker, platform speaker and journalist. Her name was a public trademark, signalling a reputation crucial to her work on both a political and financial level. In the ensuing decades, Fenwick Miller's argument for an independent nomenclature in marriage materialized in her biographical writings on professional women. Women artists who retained their own name after marriage exemplified the advantages of a distinctive identity. In 1897 she quoted an unnamed daily newspaper's column in which Lord Leighton

announced he would retain his name despite the peerage because 'the name is the trade-mark that the worker cannot afford to lose.'[30] Leighton's remark offered the perfect opportunity for a gendered counterpoint; if the President of the RA could retain his copyright so could women artists. She pointedly observed that Henrietta Rae was one of a growing number of women who were retaining their maiden name, with which they had become famous, after marriage. Similarly Louise Jopling added her husband's name to her own.

Precisely the same feelings arise in a woman's mind when she is asked to give up the name which she has made known in some branch of artistic, literary, musical, or public work; with the difference that very rarely is a male celebrity invited to take a title, while every successful woman professional worker, making a good income, is quite sure to be invited to assume the undistinguished name of some obscure lover![31]

Fenwick Miller questioned why women should be required to resign their 'trademark', and her column was regularly interspersed with examples of women who had done otherwise, such as German artist Frau Bieber-Boehm.[32]

Fenwick Miller's *Illustrated London News* columns were not anonymous, although at first they were only signed with the initials 'F. F. M.'. As we have seen, she was already well known because of her public work on the London School Board. Her full name was revealed to the readers in 1888; presumably by this point she was established enough as the ladies' columnist on the *Illustrated London News* for the disclosure of her full identity.[33] After this trial period, Fenwick Miller was not afraid to acknowledge her own voice within the columns despite the often controversial nature of her position. She frequently wrote in the first person and reinforced her own opinions on the matter in question. This mode of writing was allied with the New Journalism's conversational tone and emphasis on signature rather than anonymity; in adopting this style of writing she was able to act as her own publicity agent and, by extension, publicize the need for woman's rights and suffrage. By contrast, in the *Woman's Signal*, much of her work was anonymous; presumably, like the Meynells, she wished to conceal her own authorship of the journal's contents. Additionally, her identity became veiled midway through her tenure at the *Illustrated London News*: in 1898 her columns were signed with her *nom de plume*, 'Filomena'.[34]

The radical nature of her reputation meant that Fenwick Miller's signature was both a benefit and liability to the *Illustrated London News*. Female authorship was favoured in the women's press and indeed some men adopted female personae when writing for women's magazines or columns.[35] However, Fenwick Miller's political involvement made her rather a wild card for such an otherwise fairly conservative periodical as the *Illustrated London News*. In the 1890s her signature moved from the bottom to the top of the column and changed from 'Florence Fenwick Miller' to 'Mrs. Fenwick Miller': presumably the alteration was meant to denote respectability through marital

status. Fenwick Miller was all too aware of the disapproval and controversy that arose when unmarried women discussed medical issues and she utilized the same title when she began editing the *Woman's Signal* in 1895. As we have seen, before her appointment to 'Ladies Column' she had to defend her radical viewpoint in the press on more than one occasion. Already doubly inscribed by class and controversy, Fenwick Miller's later movement in London's high art salons, unlike Meynell's, was disabled rather than enabled by birth and upbringing. Her movement within and without various circles was the result of both shifting strategies and personal factions, and indicative of questions within the women's movement about the nature of feminism and its relationship to discourses around maternalism and separate spheres.[36]

Self-representation

More often than most women art writers during the 1880s and 1890s, Florence Fenwick Miller described aspects of her own life history for her readers. Additionally, she was interviewed on several occasions for women's magazines, wherein her life as a female journalist celebrity was detailed for readers. She presented herself to the reading public in various guises by utilizing multiple strategies; these provide diverse, but often repetitive, versions or constructions of her self/selves. In 'How I Made My First Speech' in the *Woman's Signal* she relayed the origins of this latter public career path to the readers and detailed her own genesis as a public speaker.[37] She began by explaining to her reader that she was born on the day of the Crimean Battle of Inkerman, and thereby equated military battle with the ridicule endured by the first women speech-makers. Yet, by making it explicit that she spoke publicly only when it was requested and with paternal permission, this narrative remained within the remit of acceptable feminine behaviour. Indeed, the need to validate her first speech was a priority in terms of column space; the actual conditions of her speech-making were described in the last eighth of the article. Moreover, Fenwick Miller excluded another reason for her platform work, namely that it was her primary source of income for over a decade. A reputation already touched by controversy provoked Fenwick Miller to justify her speechifying to the reader although, as Lilian Lewis Shiman has demonstrated, by the 1890s 'platform women' were no longer a novelty.[38]

Several interviews with Fenwick Miller were published in magazines, and Van Arsdel demonstrates that Fenwick Miller's familiarity with journalism enabled her to actively fashion her own biography through interviews.[39] Likewise, key aspects of her public biography, such as her background in medicine and membership of the London School Board, were similarly recited

in her introduction as 'New Editor' to the *Woman's Signal* in 1895; she utilized a similar weaving of Victorian femininity with masculinist patterns of life successes and individualist celebration.[40] In addition, the introduction conveniently leapt over the intervening years between her birth and adulthood. It is this void, her childhood years, which were also glossed over in her interviews. On the one hand, several chapters of her later (unpublished) 'Autobiography' re-present the 'public' presentation of her selves, for example: 'Pioneer Women in Medicine', 'My First Election to the London School Board', 'Author and Publisher'. On the other hand, some of the chapters in her 'Autobiography' allude to the lacunae in her public narrative, notably the chapter relating to her childhood, 'An Uncommon Girlhood', female networking in 'Some Woman Friendships', and her finances and family, 'Lecturing as a Profession' and 'I Succumb to Matrimony'. The former chapters detailed her unhappy childhood years, particularly her relationship with her mother, as well as the importance of her friendships with numerous women involved in medicine, journalism and politics.[41] The latter two chapters complicated the rationale for her lecturing and journalism presented in her earlier texts; 'Lecturing as a Profession' related the financial reasoning behind her public speaking circuits, whilst 'I Succumb to Matrimony' revealed her desire to leave the family home and the independence that marriage enabled in her political career. Yet Fenwick Miller also reflected on the financial hardships that resulted from her 'love-match': marriage had garnered her political respectability, particularly on health and sexuality matters, but no economic stability. The autobiographical narratives she presented later in life emphasized her multiple careers and feminist politics as well as her ability to succeed despite personal, political and pecuniary obstacles. Her 'Autobiography' offered a new version, filling in details not published in magazines during the 1890s, revealing gaps between her public interviews and private experience.

Valerie Sanders' analysis of late-nineteenth-century women's autobiographies offers a theorization of this gap in Fenwick Miller's autobiographical narratives. She points out that only a few women subscribe to the theory of sustained self-writing established by the tradition of male critical theory; these women attempted to follow the masculine pattern of self-writing and biography which focused on individual development and achievement.[42] This nineteenth-century bourgeois individualism evident in 'masculine' autobiographies emerged from the combination of capitalism and the eighteenth-century revolutions. Like Martineau's, Fenwick Miller's 'masculine' form of self-presentation to the public and presentation of other women as 'heroines' attempted to utilize this discourse of individualism, whilst interweaving discourses of femininity with nationalism; thus her discussions of home and sexual difference were intersected with appeals to

'British' sensibility and achievement in her earlier autobiographies. Sanders also maintains that women were keen readers of one another's works – certainly Fenwick Miller featured in Besant's *Autobiography*, and she studied this individualist pattern in Martineau's *Autobiography*, which arguably directly influenced her own imaginative recreation of her public speaking self.[43]

Tactics 1: Great women artists

Biography also featured in Fenwick Miller's art writing; however, unlike Meynell, she focused specifically on women. The category 'woman artist' problematized the concept of late Victorian artist biography. Women could not possibly possess the status of the eminent late Victorian male artists featured in biographies. Women were not allowed membership of the RA, nor were they admitted equally to those artists' societies which conferred professional status and prestige. Various strategies were exercised by critics of the time to locate women within this critical category of analysis. Women artists were presented as 'rising' rather than established artists;[44] single articles, rather than several, were devoted to a successful late Victorian woman artist. Women artists were consistently positioned in relation to male artist teachers, partners or fathers; they were presented as followers or imitators of a master's style. Articles were also published which grouped women artists together, thereby categorizing their work separately as 'women's art'.[45]

Fenwick Miller's interventions in art journalism followed distinct patterns. In order to position women within the artistic sphere she developed two major approaches in her writing about art. Firstly, she wished to locate and present to the public those women qualified to be 'Great Women Artists'. Secondly, she wished to praise the successes of women artists in establishment terms. These strategies were exemplified in her celebration and promotion of Rosa Bonheur, Louise Jopling and Henrietta Rae – Rae's painting in particular offered the possibility of women's entry into the RA. Unlike Meynell, Fenwick Miller had no previous experience in the art world; rather she discovered art writing as a relatively safe, non-controversial space (as distinct from the overt contestation of medical and platform spaces) from which to put forth her concerns about the advancement of women. Her tactic employed the late Victorian imbrication, particularly in arts and culture, of women's social fashionability and professional status.

On the one hand, Fenwick Miller occupied a seemingly more traditional role for women journalists by writing a woman's column and editing a woman's journal, rather than writing for the mainstream press.[46] She

articulated this apparent dichotomy in the *Illustrated London News* in 1889 with the assertion that the work by the 'best women writers will be sent' to general interest journals rather than 'woman's papers' where their writing would not be successfully considered.[47] Deborah Cherry observes that Fenwick Miller's statement indicated her view that to contribute to separatist institutions or publications was to invite marginalization.[48] Ladies' columns were a regular feature of newspapers by the 1890s. However, a contemporary woman journalist complained these were confined to the 'ladies' page' and elsewhere these papers ridiculed every other kind of 'women's movement'.[49]

On the other hand, the positioning of Fenwick Miller's column within a mainstream newspaper meant that it was available to a broad non-gender-specific readership. As a woman she had the authority to speak from a 'woman's column' on a variety of political issues that concerned men and women, and unlike women's papers this column was not completely marginalized. Did this medium allow her more journalistic freedom in terms of subject matter and personal beliefs? Chow's consideration of Michel de Certeau offers useful insight into Fenwick Miller's 'strategy'. His formulation of a 'strategy' encompasses the ability to transform history into 'readable spaces'; in contrast to a 'tactic', knowledge derived from a strategy is 'sustained and determined by the power to provide oneself with one's own place'.[50] The *Illustrated London News* column functioned as her 'own place', from which Fenwick Miller's long-term contributions to a mainstream newspaper effected a more 'sustained strategy'. Interspersing art, suffrage and educational issues, Fenwick Miller developed a method for foregrounding contemporary women's issues by centring her debates and discussions around a recent event involving women. Although she discussed women in acting, education and science, women artists by comparison offered celebrity and respectability in an already established profession less impinged on by controversy. The cultural and economic wealth of artists, as discussed in the previous chapter, meant that the art world occupied an elite social status in the late nineteenth century.

ILLUSTRATED LONDON NEWS

The *Illustrated London News* 'Ladies' Column' began on March 6, 1886. It was announced that to the 'traditional woman's sphere' of 'Society, Dress, Domesticity and Charity' could now be added 'Culture, Thought and Public Welfare', so, 'though every topic will be touched here with a light hand, it is not proposed to make this column constantly a mere record of frivolity and fashion'.[51] Thus, although the first column mainly discussed dress styles, Fenwick Miller had indicated to her readers that the column would contain serious rather than frivolous journalism. The column's editorial statement

portended her radical intention to focus on culture and politics, enabling texts to reveal the complex overlappings of art and politics in the late nineteenth century. Fenwick Miller's integration of fashion and society with women's achievements in art, as well as suffrage-related topics, is exemplified by a page from an 1888 column (Figure 4.1). Her work relates particularly to women in art because she focused almost exclusively on female artists; aside from occasional mentions in listings of artists represented at Show Sundays or Private Views, male artists or their work were rarely considered.[52]

Fenwick Miller parallelled her emphasis on the success, the respectability, and the 'greatness' of women artists with a discussion on their access to Royal Academic training and membership. This egalitarian feminist argument was linked to her focus on women artists; she wished to prove to her readers and to the RA committee that women deserved to be elected as members, and therefore had to demonstrate that they were 'great' artists. Conversely, in order for these women to be 'heroine' artists they needed to achieve formal status within the Academy, as had Angelica Kauffman and Mary Moser.[53] Thus, Fenwick Miller equated success with RA membership and launched a campaign for the inclusion of women, in her *Illustrated London News* column.

Fenwick Miller's criticism of gender bias at the Academy began early in her column: in 1887 a review of the dresses at the RA private view included this bracketed comment on the art:

[Note: Mr. Alma Tadema's picture is to my thinking *the* picture of the year ... But can it be true, as a little bird whispered to me at the private view, that the artist who has lavished such care on painting women, in so noble an attitude as that of these matrons, and of so lovely an aspect as that of these girls, can be in practice accustomed to exert all his influence against the admission of women's work to the Academy, and against its prominence of place? Surely it cannot be so!][54]

At this stage she was still writing as an 'unknown' reviewer, but this commentary already places her within a network of feminist artists and writers. Her full identity was revealed the following year and her criticism of the RA committee in the *Illustrated London News* gradually became less subtle. By 1897, she was questioning whether the exceptional showing of women's work at the Academy Exhibition (contributing nearly one-fifth of the exhibits) was the result of the women producing better work or the new President's regime (Edward Poynter) being more favourable to women.[55] Thus Fenwick Miller tangentially referred to the politicization of the committee process and questioned its value as a measure of quality. Similarly, in 1900, she wrote that women's pictures at the Academy were not very numerous, but added that it was probably the fault of the Hanging Committee, 'for women artists are a noun of multitude', hence implying that the process was not entirely anonymous. Then, as evidence of their excellence, she proceeded to detail the few women's works they were willing to hang.[56]

THE ILLUSTRATED LONDON NEWS, May 12, 1888.—502

A LONG CAUSE : FLIGHT OF KING JAMES II. AFTER THE BATTLE OF THE BOYNE.
A. C. GOW, A.R.A.

A GOLDEN AFTERNOON, ISLE OF WIGHT (NEAR LUCCOMBE).—G. H. BOUGHTON, A.R.A.

THE LADIES' COLUMN.

AT THE PRIVATE VIEW OF THE ROYAL ACADEMY.
One great advantage, at least, over all other galleries for the purposes of private views cannot be denied to the Royal Academy—that of size. It is possible to see and be seen there, so that one instinctively puts on one's newest and most charming of gowns or bonnets for the occasion. This observation does not apply to certain people who, forbidden by circumstances to effect greater wealth than they possess, take refuge in the opposite affectation, and emphasise their millions by plainness, cheapness, and antiquity of attire. To name names would be invidious ; but to avoid noticing the fact would be impossible. There are so many ways of making yourself remarkable in society, given a little courage and a certain originality. If an actress be young and handsome,

lace and blue ribbon bows. In contrast to this sort of thing, who can help noticing the young Marchioness who is mistress of millions, but who chooses to appear in a tumbled black lace gown and a last-summer's tulle bonnet, showing traces of much wear !—or the Manchester merchant's wife who goes out, year after year, in the same brown velvet dress and bonnet to match, while her husband pays ten thousand pounds for a masterpiece of art ? Those be not sketches from imagination, but from life. 'Tis a witty world, my masters, and many a social goal is approached by tortuous tracks !

half hidden by a falling piece of black lace, made an effective finish. Mrs. Bernard-Beere was in black, with a full frill of white muslin tumbling down the middle of the bodice, and long white kid gloves. Mrs. Bancroft had a long coat of cut black plush.

Black was worn by Lady Rosebery, in the form of a striped velvet long mantle, relieved by a red tulle bonnet. Maria, Marchioness of Ailesbury's youthful figure was displayed by a closely-fitting black cashmere dress trimmed with jet and worn without a mantle. Lady Salisbury was in brown velvet ; Lady Greville in a striped polonaise of two shades of green silk ; Lady Randolph Churchill in tan cloth, tailor made. Amongst the many other interesting figures were those of Mrs. Louise Jopling, in foulard having lightning stripes of white on a black ground ; Miss Emily Faithfull, in a dark red tailor-made dress ; Miss Genevieve Ward, in blue cashmere, with panel and vest of silver passementerie ; Mrs. Newman Hall, in Gobelin blue plush ; and Mrs. James Maclean in brown moire. A striking dress was a Directoire coat of black moire, with long basques on the hips and pockets there marked out with big cut steel buttons, which also emphasised the edges of the coat where

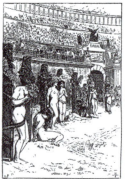

OUR BABY KING.—MRS. SEYMOUR LUCAS.

NIOBE.—S. J. SOLOMON.

FAITHFUL UNTO DEATH.—HERBERT SCHMALZ.

she can appear in a bright green plush coat, with a broad-brimmed leghorn hat lined with green and turned up behind with pink roses. If her personal case be otherwise, she can dress like a sensible old lady, in black velvet coat and black bonnet, but attract attention by a big white lace fichu, with red ribbon bows dotted round it, put on atop of the unobjectionable mantle, and covering it nearly to the waist. Or if she be neither young nor handsome, but have not " the grace to know it," no sumptuary law forbids her wearing a trained silk dress of brightest blue and a girlish hat of transparent white

Splendour and brightness of garb at Private Views being a little overdone, some of the most notable ladies have of late taken to appearing in black. This was apparent at the Grosvenor, and yet more so at the Academy. Nothing can surpass in effect a well-made black costume amidst a lightly tinted crowd. Lady Colin Campbell wore black at the Academy ; her fine, tall figure showing conspicuously in a redingote polonaise of striped black cloth, trimmed with jet ; while a Directoire-shaped bonnet of drawn rounds of black tulle, and under the high brim, so as to rest on the hair, a row of roses

is turned back from a white sash and vest. Grey was much worn, a rather pretty young girl's gown being of pale grey cashmere, with a pink ribbon passing like an order from left to right on the bodice, and variously-disposed straps of the same ribbon appearing on the skirt.

Women who work decidedly get a distinctive expression from it : a look of earnestness and of self-reliance, I think it is, which to me is very charming. It belongs to all classes of women-workers, but it struck me the other night that it is

CAPTIVE ANDROMACHE.—SIR F. LEIGHTON, P.R.A.

" RATS, TONY ! "—G. H. SWINSTEAD.

THE ART SEASON : SKETCHES OF PICTURES AT THE ROYAL ACADEMY EXHIBITION.

4.1 Florence Fenwick Miller, 'Ladies' Column', *Illustrated London News*, 12 May 1888

During the 1890s, Fenwick Miller repeatedly discussed the idea that women should be considered for membership of the RA. Clara Montalba, Louise Jopling, Lucy Kemp-Welch, Marianne Stokes and Helen Allingham were listed as among those showing 'strong work that ought to be a revelation to the outside world' and she wondered how long Rae's claim to be elected could be overlooked because her seven works at the Victorian Era Exhibition were so varied in character and style, yet all so 'beautiful' and 'strong'.[57] Despite the fact that the Victorian Era Exhibition appeared to have had no effect on RA policy, Fenwick Miller continued her campaign undeterred, whereas in comparison the feminist periodical, *Englishwoman's Review*, virtually ceased to cover women artists. The following year Fenwick Miller informed her *Illustrated London News* readers that four leading women artists had formally been nominated for the Associateship of the RA. She stated that no one would quarrel with the selection of Rae, Montalba, Butler and Ward as candidates; all were quite worthy to be counted as peers of the average Royal Academician: 'They have the strong precedent that the beautiful Angelica Kaufmann and Fuseli's friend Mary Moser were two of the original "Forty".'[58]

In 1903, Fenwick Miller argued this point further, asserting, as had Meynell, that in fact it was not illegal for women to be elected to the RA because George III had given a Royal Charter to two women painters amongst the first Academicians. The original Charter offered *de facto* status for women, thereby nullifying the RA argument employed against the election of Elizabeth Butler (they claimed that existing laws did not provide for the election of women as members of the RA). She quoted a recent observation that '[if] Queen Victoria had been more supportive of feminine ambition then she might have pointed out the law for Lady Butler. Particularly since the Queen exerted her authority over the RA by having the "Roll Call" taken to Windsor mid-season.' Here Fenwick Miller presented a veiled criticism of Queen Victoria's lack of support for feminism despite her role as a female monarch.[59] Legally the RA was *a priori* open to women and Fenwick Miller mapped out the implications of such exclusion:

A.R.A and R.A. are weighty letters, a hall-mark as to the possession of talent. Men find it useful to have this hall-mark affixed to their names, and women would find it of the greatest value in impressing outsiders with their merit and in adding infinitely to the market-value of their work.[60]

Fenwick Miller was fully aware of the benefits of establishing a trademark; the letters ARA and RA were comparable with the MLSB she utilized whilst sitting on the London School Board. Although the influence of the RA had waned by 1903, Sargent had been elected a member and the letters still lent considerable prestige. In 1910 Fenwick Miller again asked, 'When will there be a woman artist RA I wonder?'[61]

Fenwick Miller's continued espousal of RA membership as the pinnacle of achievement for women artists indicates one of the problems in establishing a collective feminist politics during this period. Unlike Meynell and Pennell, she did not address work in the NEAC and modern developments in art practice; rather she was concerned with positioning women artists within the establishment. Tamar Garb's analysis of the women's artistic culture in late-nineteenth-century Paris maps a similar conservatism in campaigns for women's professional advancement. The *Union des Femmes Peintres et Sculpteurs* tapped into conservative thinking while at the forefront of a campaign for institutional reform and the struggle for women to gain entry into the *Ecole des Beaux-Arts,* which in fact occurred when the *Ecole* had relinquished its power in the Parisian art world.[62] Fenwick Miller's RA campaign in the press mirrored these contradictions temporally and ideologically. She was critical of institutional structures, particularly the RA committee, while simultaneously reinforcing them by valuing their judgment. Her tactics in promoting 'great' women artists were conservative and her desire to position women within the establishment, implicitly linked to her work on women's suffrage, was at the same time a conservative affirmation of the traditional art world.

Fashion and dress formed a substantial component of Fenwick Miller's column: this aspect of private views and Show Sundays was vital to the positioning of women artists within a professional milieu. In this case Fenwick Miller conjoined dress and art, slipping between the two discourses as fabrics and studio personalities overlapped. The Aesthetic Movement had as much to do with fashion and decor as with fine art; writers like Oscar Wilde, Mary Elizabeth Haweis and Lucy Crane wrote and gave instructional lectures on the aesthetics of daily life.[63] At the Grosvenor Gallery, the epitome of high culture, women artists and women patrons were integral to the aesthetic publics who spelt the Grosvenor's success. A quarter of the 1028 artists in the Summer Exhibitions were women and one artist who had attained professional success in this artistic sphere was Louise Jopling.[64] Jopling exhibited 30 paintings at the Grosvenor between 1877 and 1890, and her studio showings were a high point in Fenwick Miller's art season. Invariably the wealthy and fashionable present were described in her column. 'In Mrs. Jopling's studio there were several dresses of such silk ... Miss Alice Havers, the artist, had a costume of black silk broché in rounds, with a short mantle of brown plush ... Mrs Jopling herself had a charming costume of golden-brown plush.'[65] Jopling was both painter and painted. Her portrait by Millais, exhibited at the Grosvenor in 1880, positioned Jopling within this fashionable network. In her discussion of Millais' society portraiture, Kate Flint posits that portraits and press reviews were part of a shifting visual matrix that offered the knowledge to read others and fashion oneself.[66] *Illustrated London News* readers absent from Jopling's

studio Sundays and exhibitions accessed this matrix through the 'Ladies' Column'. The detailed cataloguing of dresses and personalities signalled both femininity and fame within an artistic elite. It was here that Fenwick Miller translated her gaze, the visual into the textual.

This tactic enabled Fenwick Miller to integrate art networks and fashion in her columns, whilst simultaneously positing the status in society of professional women artists. In 1888 Fenwick Miller noted,

Here, in Mrs. Jopling's Studio (where the popular painter, who says frankly that she loves her own sex, always has on these occasions a gathering of most interesting women) are at one moment four well-known literary ladies and two pretty actresses one of them charming Miss Norreys, in a softly-draped gown of brown cloth, with a cape to match, relieved by a vest of pink crêpe, and a big brown velvet hat above her red-gold hair.[67]

The question of what modern woman should wear was complicated by questions around how women should stage themselves. Fenwick Miller's documentation of the high fashion worn to RA and Grosvenor functions adds a layer of meaning to women's performances of femininity in cultural arenas. Jopling's positioning in the centre of her preferred female friendship circle signals the importance of this gender-specific context for her negotiation of an array of cultural and economic exchanges. Unlike Fenwick Miller, Jopling traversed the boundaries of middle class to upper middle class and aristocracy: 'Her studio parties are always interesting, for she knows so many people who are "somebody" in literature and art.'[68] Jopling was surrounded by a powerful network of beautiful and charming women, a mixture of friends, patrons and publicity agents; they performed a multiplicity of functions in the larger art market. Fenwick Miller mapped this new Grosvenor milieu of bourgeois wealth and aristocracy that crossed and conflated class boundaries.

Another celebrity artist engaged in antithetical gendered performances was the French painter Rosa Bonheur, whose successes, lifestyle and sartorial presence were also the subject of myriad columns by Fenwick Miller. Bonheur's painting, the *Horse Fair* (Figure 4.2), was exhibited in London by the art dealer Ernest Gambart in 1855. The reaction to her work was sensational and she became a representative icon for the women's movement. Frances Power Cobbe's 1862 essay, 'What Shall We do with Our Maids?', referred to Rosa Bonheur as an example of a new strength amongst women artists, writing, 'We seem to have passed a frontier, and entered a new realm wherein Rosa Bonheurs are to be found'.[69] Bonheur remained the most renowned woman artist and continued to be written about in English and French in the 1880s and 1890s, both within and without the women's movement. René Peyrol published *Rosa Bonheur; her life and work* in 1889 and Bonheur was included in Elbert Hubbards's 1897 series, *His little journey to the homes of*

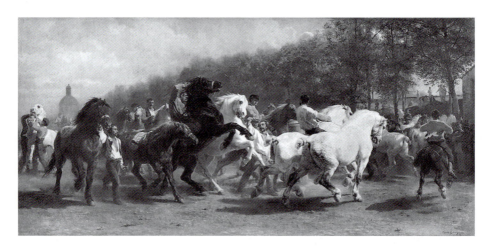

4.2 Rosa Bonheur, *The Horse Fair*, 1853, oil on canvas, 244.5 × 506.7 cm

famous women.[70] Several memoirs were also published after her death in 1899. During her lifetime Bonheur was also the subject of numerous articles in a diversity of periodicals including the *Academy* and the *Athenaeum*.[71]

Bonheur was a central figure in Fenwick Miller's lectures and writing about suffrage and art. At an 1883 lecture it was reported of Fenwick Miller, 'It was often said that women were not great writers or artists, but she would only point to Rosa Bonheur and George Eliot in refutation of this.'[72] In her art writing she also articulated this now established mode of writing about Bonheur in the context of the proof and triumph of female genius. When Bonheur was awarded the French Legion of Honour in 1894, Fenwick Miller announced that, although she had been refused the order 40 years previously because of her sex, Bonheur was finally the first female '*officier*' of the Honour.[73] In 1896, Bonheur reappeared in Fenwick Miller's column because the Queen had commanded the new picture by Bonheur to be taken to Windsor Castle for Her Majesty's inspection and Fenwick Miller noted that, although 74, Bonheur's force had not abated.[74] Upon Bonheur's death in 1899, the 'Ladies' Column' emphasized her financial success as a professional artist and the significance of her collection. Bonheur had bequeathed her entire fortune of nearly £38 000 to her friend Anna Klumpke and gave her work to the National Collection of France. Fenwick Miller trenchantly observed that without these newly donated works the presence of Bonheur in French galleries would have been poor because the French government never gave Bonheur a commission and only owned two of her pictures.[75]

For Fenwick Miller, Bonheur's younger English peer, Henrietta Rae, exemplified the fashionable professional status available to contemporary women artists (Figure 4.3). In the last decade of the nineteenth century

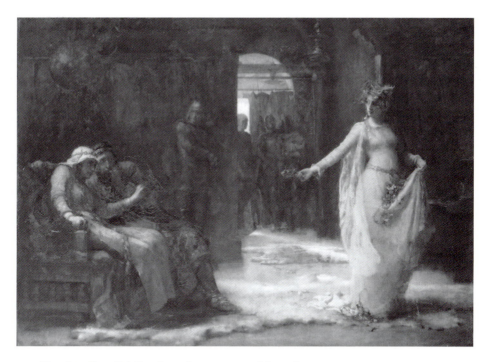

4.3 Henrietta Rae, *Ophelia*, 1890, oil on canvas, 158.8 × 226.5 cm

Henrietta Rae, like Bonheur, was also featured in numerous articles including a biography by Frank Rinder in the *Art Journal* in 1901.[76] In 1887 Fenwick Miller announced that 'Miss Henrietta Rae and her husband, Mr. Normand, discarded most adventitious aids to effect to make room for their four large pictures – her two daring and effective studies of the undraped female figure, and his portraits of Mr. Routledge's daughters and an Egyptian harem scene.'[77] Four years later she noted that it was women who painted the undraped female figure, such as Anna Lea Merrit or Henrietta Rae, who achieved distinction. (Merritt's *Love Locked Out* was purchased by the Chantrey Bequest, and Rae's *Ophelia* by the Walker Art Gallery.) After setting out for her reader this controversial path to artistic success – painting nudes – Fenwick Miller denied the correlation: 'I do not mean to say, of course, that these ladies have so succeeded because they respectively painted "Ariadne" and "Eurydice"; or that any woman who wants to succeed should start painting similar subjects.'[78] Rather than admit the obvious connection between subject matter and prestige, Fenwick Miller attempted to stress the 'courage and self-reliance' of Merritt and Rae in choosing subjects which challenged their artistic 'genius', stepping lightly over social purity debates which conflicted with their success, in an effort to maintain the propriety of

the artists. Thus, in Fenwick Miller's texts, Rae's work on the female nude was integral to her construction of a courageous and adventurous artist. Rae's 1894 picture, *Psyche before the throne of Venus*, based on Morris's poem 'The Earthly Paradise: Story of Cupid and Psyche', of 16 undraped and semi-draped female figures was illustrated in *Royal Academy Pictures* and Fenwick Miller ironically reminded her readers of the scandal concerning the subject matter a few years previously: it was works by Rae and Anna Lea Merritt that were such a shock to Mr Horsley and 'British matrons', according to his testimony. Fenwick Miller's wry observation corresponded with Meynell's: he was not so much shocked that the female figure was painted, but rather that 'women instead of men should have painted it'. She similarly invoked social purity discourse with the assertion that Rae continued her art with 'grace and purity, Mr. Horsley and the British matron notwithstanding'.[79] The large painting of Psyche (193 × 305 cm) put her on a plane with Leighton and the *Times* declared, 'The picture of this class [nudes] which will be most discussed and probably most admired is the very ambitious performance by Mrs. Normand.'[80] Yet Rae received negative reviews in the press for her lack of comprehension of the mythological subject matter and by extension her portrayal of the female nude. These critics, along with Leighton, complained of its 'over-prettiness', although Leighton quickly backtracked on this criticism, perhaps realizing this could also be said of his own work.[81] However for Fenwick Miller it was Rae's subject matter allied with price that helped to validate artistic success: Henrietta Rae's 'new and great picture' was purchased, before it was exhibited, for £1000 and £200 copyright.[82] Commercial success framed many of Fenwick Miller's discussions of women artists. The example of Rae enabled Fenwick Miller to demonstrate a defining triumph for a 'great woman artist'; women breaking into the marketplace and the RA. Yet as Cherry notes, by painting female nudes Merritt and Rae exemplified the dichotomies evident in late-nineteenth-century power relations; the nude signified their academic status and was simultaneously the principal signifier of women's subordination.[83]

Fenwick Miller's participation in art networks did not always mean she obtained the correct information about women's involvement in the arts. An obituary mention of Mary Thornycroft in 1895 demonstrated that Fenwick Miller was clearly misinformed about women sculptors. She highlighted Thornycroft's career successes, most notably her sculptures for the Queen. These latter pieces began with a commission to sculpt a bust of Princess Alice in 1843, a professional coup facilitated by the famous English sculptor John Gibson. Although she mentioned the American Harriet Hosmer, Fenwick Miller concluded her column with the comment, 'it is rather surprising that more women have not turned their attention to sculpture'.[84] In fact several women had been involved in sculpture during this period, including Princess

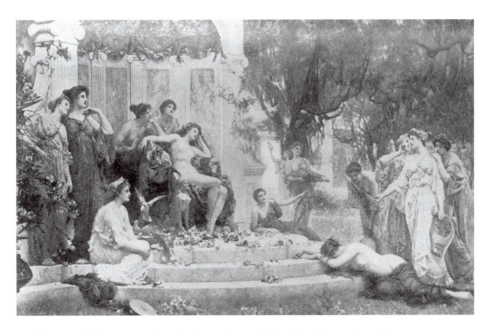

4.4 Henrietta Rae, *Psyche before the throne of Venus*, Royal Academy, 1894, oil on canvas, 193.0 × 304.8 cm

Louise, Henrietta Montalba, Mary Grant, Feodora Gleichen and Sarah Bernhardt.[85]

By extension, Fenwick Miller was occasionally critical of women artists in her Academy reviews; in 1896, referring back to Rae's 1894 painting, she asserted that although there was a fair proportion of women in the Academy exhibition catalogue, there was no picture by a woman artist that would secure attention equal to Henrietta Rae's *Psyche before the throne of Venus*. She considered Rae's new RA pictures to be, although 'admirably painted', 'totally unlike her style and unrecognizable as her own'.[86] Thus she implicitly urged Rae to produce a large Academic nude painting that was comparable to her earlier piece. This would gain her renown equivalent to her 1894 piece and further the case for 'great' women artists. Likewise, in 1890 she registered her disappointment with Louise Jopling: 'several pictures this year, but not one large or very important'.[87] Similarly, a year later in the *Englishwoman's Review*, Robson's summation of the work of Rae, Swynnerton, Butler, Forbes, and others was cautious praise: 'the breadth of treatment, good drawing, strong brush work, and in some cases "quality" must be a revelation' in comparison to 'feminine pictures' of the past, when truth, force and originality were sacrificed to prettiness.[88] Fenwick Miller and Robson expressed concerns about the quality of women's art in relation to that of the 'masters' – they had to strive to equal the 'genius' of Burne-Jones, Rossetti and Leighton.[89] For

Fenwick Miller the lives of these women artists had a distinct purpose: it was only through proving themselves as great that women could achieve equivalent status. These criticisms indicated feminists' anxiety regarding the perceived failure of women artists to match the establishment successes of male artists like Leighton. But always success in art is equated with mimicking the works of the art establishment. Therefore it is a question of the political or social advancement of women that drives Fenwick Miller's art criticism rather than art *per se*.

WOMAN'S SIGNAL

Nine years after she began the *ILN* column, Fenwick Miller took up the editorship of a woman's periodical. It was during this period that magazines for women moved to the centre of popular publishing with over 120 new magazines for women appearing between 1880 and 1900.[90] Fenwick Miller was responsible for broadening the mandate of the *Woman's Signal*, which had been a temperance periodical. In the Editor's Address she presented the periodical as 'A journal for all women, dealing with all their interests, both in the home and in the wider world.' She was careful to specify, 'We do not pretend to lead women into the new field; we perceive that they are there already in great force and strength', hence the periodical was not radical, but following an established trend. The programme of the journal included sections on 'All Public Affairs', 'Women's Questions', and 'What Can my Daughter Be', in addition to the familiar 'Dress-Up and Fashion'.[91] A woman's magazine offered not only a forum for in-depth articles on feminist issues, but also the opportunity to present an editorially self-controlled feminist agenda that was not contradicted by the surrounding text of an ordinary newspaper. The first issue of her editorship alluded to her intentions to address homemakers as well as 'the women who follow the professions that in the last generation were not open to them – the Doctors, the Chemists, the Lecturers, the Journalists, the Clerks in Government or private offices'.[92] Although artists were not included in this list of addressees, the periodical also discussed careers of women artists. As in the *Illustrated London News*, Fenwick Miller delivered a combination of dress and fashion, as well as cookery, gardening and public affairs.[93] Yet in the *Woman's Signal* there was space for extensive coverage of the last item including women's access to education and the franchise.[94] Fenwick Miller's editorship functioned as a radical alternative to a 'Ladies' Column'; this tactic represented a local intervention in the segregated world of women's journalism. Through a feminist journal she was more able to make a narrow and controlled intervention in women's reading material to concentrate on converting the woman reader to her feminist political view.

Snippets of women's biographies and lives were included in her regular *Woman's Signal* column 'Signals from the Watchtower' which contained a pot-pourri of current news of interest to women. Here, Fenwick Miller gave women artists coverage in a manner comparable to her *ILN* column, in conjunction with events like exhibitions or appointments. Additionally, the *Woman's Signal* ran a character sketch as a weekly feature in 1895 and 1896 which presented women of accomplishment, including artists, as role models for the reader, and incorporated interviews into these features. In comparison to the *Illustrated London News*, the art writing was clearly aligned with a feminist mandate and addressed the specificity of women's lives as artists. The periodical gave much more detail and utilized women's own words rather than the reportage format of the column. In this context the *Woman's Signal* celebrated professional and commercial success for women artists, debated the quality of women's art practice and their absence from the RA, and mapped the interrelationships of professional and domestic careers.

In the journal, Fenwick Miller signalled to her readers the essential overlap of art and politics through an obituary for the artist, writer and suffrage worker, Mary Haweis. Memorial articles were a common feature in art journals; women artists, however, rarely rated more than a paragraph amongst the obituaries.[95] The *Woman's Signal* announced that Haweis had attained such professional excellence in painting that, at 16, she exhibited at the RA and was hung on the line, unprecedented in the annals of the institution. Fenwick Miller added that in the last 10 to 15 years of her life she became involved in the movement to extend the franchise to women. This work absorbed her and she lost interest in her artistic occupation, frequenting women's clubs and all circles where women's interests were discussed.[96] Although a prodigy in fine art, Haweis had turned to suffrage and Fenwick Miller eulogized the integrity of her career strategy. Haweis pre-dated the suffrage career shifts of many women artists and art writers, such as Meynell, in the ensuing decade.[97]

Louise Jopling, the woman artist repeatedly featured as a paragon of fashionable society in the *ILN* column, appeared in the *Woman's Signal* as an example of commercial success. Fenwick Miller underscored the financial accomplishment, as opposed to the social acumen, of Jopling's 1896 picture, *Blue and White*, showing two girls dressed in the style of the early part of the century washing up fine china. Fenwick Miller observed, 'It is a sign of the times that this pretty picture has been bought for an advertisement of a soap.'[98] This picture was purchased by William Lever, who renamed the piece *Home Bright, Hearth Light* and added a carton of Sunlight soap to the items on the table (Figure 4.5).[99] Lever clearly intended to capitalize on the burgeoning market of women consumers and brand-name domestic products.[100] This shows the relationship between art and consumers of art, fashion and household goods.

4.5 Louise Jopling, *Home Bright, Hearth Light*, 1896, 123.5 × 84.0 cm

In comparison to her *ILN* column, Fenwick Miller's full-page character sketches enabled her to reflect journalistic trends by pursuing a more concentrated discussion of women artists than the column format allowed; rather than interspersing them with other topics, she was able to focus on the accomplishments of individual women and the conditions of their lives as professional artists. The American sculptor, Adelaide Johnson, was the subject of a character sketch which typified Fenwick Miller's feminist ethos (Figure 4.6). Fenwick Miller noted that she came from the same land as did the only two women who had gained a worldwide reputation in sculpture, Anne Whitney and Harriet Hosmer, and remarked on her career of indomitable courage and perseverance. She also utilized the character sketch to elaborate on Johnson's recent 'modern' marriage, quoting from the service performed by Rev. Cora L. V. Richmond, after which the couple took Johnson's name.[101] Johnson represented not only a professional status, but a more emancipated instance of naming for professional women and was an exemplary model for the journal's agenda. Two women artists who had also been celebrated in her columns, Bonheur and Rae, were again featured in *Woman's Signal* character sketches in conjunction with exhibitions. Fenwick Miller regaled her readers with Bonheur's renowned status, yet impressed upon them that in France it was a woman, the Empress Eugénie, who, despite opposition, had bestowed upon Bonheur the Legion of Honour.[102] The 1897 Victorian Era Exhibition at Earls Court, curated by Henrietta Rae, gave Fenwick Miller a reason to interview the artist for the *Woman's Signal*.[103]

The periodical format allowed Fenwick Miller to conjoin the 'artist in their studio' model found in the art press with a feminist journal.[104] This dual strategy enabled her to celebrate the life of a great woman artist whilst emphasizing her position as an egalitarian feminist in domestic life: Fenwick Miller discussed domestic matters relating to Rae's unusual position as a professional woman artist and mother. For example, she asked Rae's opinion about her marriage to another professional artist – Rae viewed it as a partnership rather than a tutorship:

I think that if a husband and wife who are both artists can agree, they are always very much better as workers for their marriage. There are quite a number of women in whom I have perceived an advance after they have married artists and it does men just as much good; because they generally have different artistic qualities of excellence, and they can criticise one another with a freedom which, if they are both prepared to stand it, is better than anything that they get from outsiders.[105]

The question of how professional married women managed their house and children was still very much an issue in the 1890s, although this matter was left implied but unsaid. When queried about managing her housekeeping Rae answered that she had a 'good old nurse' who looked after things,

The Woman's Signal, April 9, 1896.

THE
WOMAN'S SIGNAL

A Weekly Paper for all Women

ABOUT ALL THEIR INTERESTS, IN THE HOME AND IN THE WIDER WORLD.

EDITED BY
MRS. FENWICK MILLER.

Vol. V., No. 119. APRIL 9, 1896. [Registered as a Newspaper.] One Penny Weekly.

Character Sketch.

ADELAIDE JOHNSON
The American Sculptor.

A NOVEL WEDDING.

Miss ADELAIDE JOHNSON holds an important place amongst the rising women sculptors of America—the land from which came the only two women who have as yet made a world-wide name in this branch of art, Harriet Hosmer and Anne Whitney. The career of Adelaide Johnson has been one distinguished by indomitable courage and perseverance. She determined when a child to become an artist. A small sum of money was saved which enabled her to leave the farm home near Plymouth, Illinois, and journey to Chicago, where she intended to study art; but on arriving there she found to her dismay that her purse had been stolen, and under these distressing circumstances this young girl beheld herself alone and friendless in the great city. Adelaide Johnson was not to be daunted; she sought and obtained employment as a dress-maker, and, by steady industry, at length succeeded in saving sufficient money to open a studio, and devote herself to studying her profession; and her works showed the touch of the true artist. This courageous young lady was, however, again hindered by a fall through an open door of an elevator—an accident causing her many months' suffering, which she endured bravely, and still continued teaching.

Adelaide Johnson's great talent and charming personality had now won many friends, so a concert was arranged for her benefit. Funds were thus raised, enabling the young artist to travel, and study at Rome under the great masters. On her return to the States her genius became known by the beautiful sculpture she has exhibited, which the critics have described as "Life in perfect stillness—speech in silence."

Miss Adelaide Johnson has recently been married in a very "new" fashion to a young Englishman. This distinguished artist is to have the privilege of retaining in marriage the name she has made already famous, her husband having shown his appreciation of her genius by adopting her name, instead of asking her to resign hers and assume his own. The marriage was a unique and picturesque ceremony. Some of Miss Johnson's most intimate friends were invited to an "At Home" at her studio in Washington, which has been quaintly called the "White Nest." They were requested to "wear their whitest dresses, and bring their best wishes." On the evening the guests assembled

and found the "White Nest" beautifully decorated with white draperies and flowers. A poem was read for their entertainment, and then, while the wedding chorus from "Lohengrin" was softly played, the Rev. Cora L. V. Richmond entered the studio, followed by Miss Adelaide Johnson, who was dressed in white satin draped with pearl embroidered net, and carried a bouquet of white roses; she was escorted by Mr. Jenkins, who wore a suit of white cloth with white satin vest and white shoes. Then, to the surprise of the assembled friends, Mrs. Richmond performed the marriage ceremony in the following unusual manner:—

"Dear friends," she said, "at the altar to-night we have our friends, Alexander S. Jenkins

MISS ADELAIDE JOHNSON.

Johnson and Adelaide Johnson." It is not often that love brings such a tribute as this to the queen of his heart. Heretofore knights have brought victory from many fields of fame and prowess; royalty itself borrows other names and disguises itself for the sake of the beloved ones. But life itself is the tribute that love brings. The royal gift of this bridegroom is his name to the queen of his choice; it is the tribute love pays to genius; that he is willing at this hour, and has, in legal form, taken her name as announced.

"Dear friends, from out the altar of the soul, where love abides in its purest and holiest sense, you have already heard the declaration of your hearts. You have registered in the heaven of heavens, in the whiteness of your

souls, that which at this hour you solemnise before those silent witnesses that gather around the sacred throne of love; your names are traced in the whiteness of the perfect sacrament of that marriage. No blind deity is here, but wide open vision, full of prophecy, of divinest and holiest inspiration; the new love closes not the eye, but opens the inner vision, and we greet you upon this altar, we announce this sacrament and we reveal unto others that which the revelation of your hearts hath made known to each other.

"Because of this, and because marriage is the holiest estate known unto the human soul when thus endowed (join hands) 'do you, Alexander, take her whom you now hold by the hand to be your lawful wife, sustaining, strengthening and abiding with her in sickness and in health, in joy and sorrow, and in all ways fulfilling that which your own heart hath already pledged, the duty and perfect love of a faithful husband?'" "I do."

"Do you, Adelaide, take him whom you now hold by the hand to be your lawful husband, sustaining, strengthening, uplifting in every hour of joy and sorrow, and fulfilling unto him the duties of the faithful wife?" "I do."

"Do you each, with this mutual pledge, uniting together hearts and lives, agree to fulfil, before the law of God and man, and in the presence of these loving witnesses and the angels the words that we shall now declare in the name of this law of the District of Columbia, that you are husband and wife?" "We do."

The guests, who were slow to recover from their complete astonishment, pressed forward to greet Mr. and Mrs. Johnson. Miss Anthony, for whose presence in Washington the wedding had been timed, was, perhaps, the first to take in the full import of the situation, and in a few well-chosen remarks she expressed her gratification at the fact that a man was willing to do for a woman of genius what society and custom expect every woman to [do—that is, to give up the name that that of the other might be retained. She thought this was the beginning of a new order of things when husband and wife would consult together and retain the name for the family which was most pleasing or illustrious.

Mrs. Johnson is a most remarkable woman in many respects beside the art which has won her fame, and, as Miss Anthony said, her spiritual insight is such as to give her friends all confidence that she has made no mistake in this important event. Mr. Johnson is a young Englishman who once spent nine months alone on a ranch in Arizona in meditation and study,

4.6 'Character Sketch: Adelaide Johnson', *Woman's Signal*, 9 April 1896

I give orders in the morning and I know no more about it until evening – interruptions, oh no! I never must be interrupted when I am at work – I start at 9 and work till 4, only stopping for a light lunch, no real stop, and in that time no one must disturb me.[106]

Thus, although Rae's workplace was within the home, she maintained a distinction between her space and time as a mother and as a professional artist. Her two children did not hamper her career or disrupt her rigorous schedule. Fenwick Miller invariably asked this question of working women presumably to demonstrate that a professional career was compatible with family life, thereby invoking the intense debates around marital relationships during this period.[107]

The article also revealed how Rae managed her relationships with nearby professional artists. Rae related a story from her residence in Holland Park, in close proximity to artist-instructors, which Fenwick Miller gladly reprinted. Rae lived next door to Leighton, Prinsep and other artists,

the men who used to come in used to make me feel as though I could not do anything. There was one in particular who used to find very great fault and upon one occasion he surpassed himself by walking up to one of my pictures just finished and saying that the background was not dark enough to show up the flesh tints. 'You should have cobalt blue close against it,' said he, and with that he dipped his huge thumb into the cobalt blue and drew a great line with it all round the edge of my beautiful figure that I had to clear out again the next day. 'Weren't you angry?' I asked. 'Oh! I should think I was, but could not say anything, because he was a great man or thought he was and was being so kind, or pretending to be, but I will tell you what I did. I put his new hat in the stove, by accident of course.'[108]

Not only had Rae found her revenge but through Fenwick Miller's publication of the interview she had exposed to a community of women readers the artist's audacity. Furthermore, the story illustrated how as a woman she found ways of responding to over-zealous members of the artistic elite while still operating as an active professional member of that community. Two decades later her husband, Ernest Normand, wrote in correspondence to the Walker Art Gallery that the two artists involved in an argument over the piece were William Blake Richmond and Val Prinsep. Richmond was named as the painter that smeared paint all over the surface of the picture and Normand added that it took two days to remove.[109] Normand's letter also provides further evidence of the determination of the neighbouring artists to impose their opinions on Rae:

Leighton who at that date dominated my wife's work, disagreed with the subject and method of execution entirely. Alluding to alterations in the design of the left hand group, he one day sarcastically observed, 'There is still one place where you have not tried the King's head, why not put it on the floor.'[110]

Caroline Dakers locates Rae's delicate negotiations within the complex Holland Park network of artists, academicians, models and clandestine

lovers, and documents their subsequent move away in 1893 due to house restrictions, but also to escape the strong influences of Kensington.[111] For Fenwick Miller, Rae's experiences underscored her call for Rae's admission to the RA.[112]

Tactics 2: Exhibiting 'women's work'

A further tactic employed by Fenwick Miller for promoting women artists was to review paintings by women in national and international exhibitions. Her reviews implicitly and explicitly articulated an engagement with feminist politics; however they also revealed slippages in her professed egalitarian position. For her the inadequacies of the RA Committee's treatment of women artists were further highlighted by the Chantrey Bequest purchase of a piece by a woman artist. As she had in the *Illustrated London News*, so in the *Woman's Signal* Fenwick Miller praised the high proportion of women in the 1897 exhibition, announcing that two of the leading pictures were by women: Elizabeth Butler's *Steady the Drums and Fife* and Lucy Kemp-Welch's *Colt Hunting in the Forest* (Figure 4.7). Kemp-Welch's picture, full of action and movement, was comparable to the great works of Bonheur and the success of the picture was validated by its purchase for the nation by the trustees of the Chantrey Bequest.[113]

However, Fenwick Miller's enthusiastic response to the Kemp-Welch purchase, and the resultant championing of women artists as yet unrecognized in the Academy, needs to be considered within the context of the art press. The *Athenaeum*'s critic, F. G. Stephens, the voice of the establishment in the 1890s, presented a radically different perspective on the unusually high ratio of women artists, proclaiming that there was a gap left in the exhibition with the deaths of Leighton and Millais, and none of those renowned painters remaining were adequately represented. As for the women artists' work, it was not until the end of the 'Third Notice' that he noted Butler's piece contained 'many marks of slovenliness'.[114] The purchase of Kemp-Welch's piece was announced in the 'Fine Art Gossip', but was not considered until the fifth review, six weeks later, where the writer thought it to be a wise purchase, although 'rougher than required'.[115] The *Art Journal*'s A. C. R. Carter was less critical of Kemp-Welch, suggesting that 'at last the promised woman painter has arrived', but this laudatory comment at the end of the 23-page review rather contra-indicated the existence of great women *painters*.[116] The *Magazine of Art* declared Kemp-Welch possessed a 'vigorous craftsmanship rare in a young lady', whereas Butler's work was deemed a 'travesty of painting, wrongly hung in a place of honour, to the discredit of the Academy'.[117] This review is representative of the negative responses to Butler,

4.7 Lucy Kemp-Welch, *Colt Hunting in the Forest*, 1897, oil on canvas, 153.7 × 306.0 cm

apparent by the 1890s, and discussed in the previous chapter, which underlined the impracticality of utilizing Butler to strengthen Fenwick Miller's argument for women Academicians in 1897.

Fenwick Miller supported women artists who exhibited in the big London exhibitions, but she did not generally review lady artists' shows. She criticized lady artists' exhibitions as comprised of work which could not get into any large general exhibitions and hence most 'misleading and injurious' to the position of women in art. She asserted,

We all know that the feeble, commonplace, timid work that is on the whole what is shown there does not represent in fact the attainment of women in art, yet we cannot clear our judgment of the illusion and the third rate shows give an impression that women's work is inevitably third rate. There is no sex in art.[118]

In 1899 the Society of Lady Artists became the Society of Women Artists, but despite this name alteration Fenwick Miller did not observe a change in the display. She further commented that it seemed a mistake to emphasize the sex of the artists when the best work by women was not shown there.[119] Paula Gillett demonstrates the lack of professional recognition for women artists who exhibited at the Society of Lady Artists, a viewpoint reinforced by the exhibition entry patterns of Elizabeth Butler and Anna Lea Merritt. Merritt wrote in 1900, 'Recent attempts to make separate exhibitions of women's work were in opposition to the views of the artists concerned, who knew that it would lower their standard and risk the place they already occupied.'[120] This exhibition debate was part of a wider egalitarian argument that extended beyond art and culture to education and suffrage.[121] However, Fenwick Miller

was not always consistent in her response to exhibitions of work by women. A comparison of her coverage of the 1893 Columbian Exposition in Chicago and the 1897 Victorian Era Exhibition in London reveals discrepancies in her position.

Fenwick Miller wrote an extensive review of the Women's Building as part of a feature on the Chicago World's Fair in the *Art Journal*.[122] There were numerous problems that arose when the Women's Building was in its planning phases. In the initial stages of the Columbian Exposition one group of women, the Queen Isabella Association, campaigned unsuccessfully for the unsegregated representation of women at the Exposition. Similarly, the renowned American sculptors Anne Whitney and Harriet Hosmer, as well as art curator Sara Hallowell and art critic Mariana Griswold Van Renssalaer, argued against a segregated exhibition of fine art.[123] After unsuccessful negotiations to obtain work by Rosa Bonheur and other women artists, it became clear to the chief organizer, Bertha Potter Palmer, that the men's committee had taken the best things for the Fine Art Palace. In the end, to the displeasure of Whitney, Adelaide Johnson and Ream Hoxie, their sculpture pieces ended up in the Women's Building. Women directly involved in the women's movement did actively participate in the activities surrounding the Women's Building at the Columbian Exposition, although, as Paul Greenhalgh points out, the labelling of certain practices as feminine and the acceptance of women's role within the family reduced its credibility.[124]

In Fenwick Miller's article for the *Art Journal* she was immediately critical of the lack of expenditure on the Women's Building at the Columbian Exposition, which had been unable to acquire the funding to compete with the lavish edifices on the site: it only cost the state $130 000, less than was spent on the decoration of a doorway for some buildings, and it was only 398 feet by 198 feet. However, she proudly noted that a woman architect from Boston, Sophia Hayden, had been awarded the contract, but neglected to mention that she was heavily criticized in the press and reportedly suffered a nervous breakdown before the building's completion.[125] On the contrary, Fenwick Miller wrote, 'She supervised the builder's work, and in every respect acted as the architect of the building should do, from its inception to its completion.'[126] Thus she edited out the tribulations, refashioning the story to suit her ideal narrative of a professional 'great' woman architect.

Fenwick Miller deemed the fresco of *Modern Woman* by Mary Cassatt (see Figure 4.8) a complete failure, adding that it was one of the few pieces actually commissioned rather than voluntarily donated:

Mural decoration is not within the competence of every good artist; but the singular failure of one of these frescoes can hardly be accounted for by any reasonable theory. The subject is supposed to be 'Modern Woman'. The artist is Miss Cassatt, and this is one of the few things in the building which has been paid for; the majority of the works

4.8 Mary Cassatt, *Modern Woman*, 1893, central panel (detail)

of Art which decorate here and there … being voluntary contributions from women moved by the great idea of doing something to raise their sex in general estimation. The garish and primitive character of the colouring of this fresco cannot properly be appreciated from the description, and it is hardly possible to convey an idea of what the composition is.[127]

In Fenwick Miller's opinion the style of the fresco did not elevate the status of women. Regarding the central panel of *Modern Woman* she wrote, 'Now we are all too sadly aware that Eve herself gathered apples, and there is nothing whatever modern about this group of women.'[128] She concluded that the images of modern women gathering apples, dancing and flying while nude were intended as sarcasm by the artist.[129] The mural offered signifiers of modernity that were elusive to both American and English critics. As Pollock demonstrates, the colour and bold execution affirmed Cassatt's alignments with the new painting in France. Additionally, the fashionability of the women in the mural signalled a new modernity of women's dress, however at variance to that proposed by the advocates of Rational Dress at the Exposition.[130] Despite Fenwick Miller's expertise on the cultural significance of fashion, she could not appreciate it in this context, disconnected from her own ideals of artistic professionalism. As a proponent of women's admission to the British RA, Fenwick Miller would not have been interested in the Impressionist style or the 'modern' women depicted by Cassatt.[131] The image of woman, as well as the academic style, in the canvases in the vestibule – *Needlework* by Anna Lea Merritt and Annie Swynnerton's *Florence Nightingale in the Crimea* – were more appreciated by Fenwick Miller, although she took issue with the smallness of the viewing space. In contrast to the Cassatt, these pieces conveyed the image of 'great' women, such as Nightingale, that Fenwick Miller desired.

In addition to the murals, Fenwick Miller reviewed the paintings, claiming that the most important picture was *Eurydice caught back to Hades* by Henrietta Rae: '[other] notable pieces include, *To the Front*, a large picture by Elizabeth Butler, Clara Montalba's picture of Browning's old palace in Venice, and Helen Allingham's "sweet" drawing of *A Sussex Cottage*.'[132] In comparison she felt the French and German women had contributed good work, but the Spanish women's 54 pictures did not include one of special note. In sculpture, Fenwick Miller singled out for praise the works by Whitney including her *Puck* fountain, *Ericsen* and *Harriet Beecher Stowe*, but added, 'Miss Hosmer is, strange to say, not represented by any work'.[133] Nonetheless, according to Fenwick Miller, in the Fine Art Exhibit in the Women's Building, English women were far behind those of other great countries, but this was explained by the fact that the best women artists had entered their work in the general Fine Art section, 'in that open competition of work without regard to sex which all great workers desire and prefer'.[134] Fenwick Miller's essay for the *Art Journal* was unusual as the Women's Building received little mention outside of women's presses in Britain. In the *Englishwoman's Review*, Florence M. Roberts-Austen, member of the Women's Committee of the Royal Commission, gave her impressions of the British section of the Women's Building. Although she did not discuss the work of artists from other

countries, as had Fenwick Miller, she focused on the content of the murals by Swynnerton and Lea Merritt.[135] On the Fine Art work in the building, Roberts-Austen contradicted Fenwick Miller, declaring that 'British women more than held their own, alongside of the continental artists'.[136] Both women presented reviews geared to a British audience; however, Fenwick Miller was not only writing specifically for an art periodical but, clearly informed by egalitarian feminism, she was more concerned about the quality of the work displayed and, by extension, the professional status of British women artists.

However, one segregated exhibition in particular gained Fenwick Miller's enthusiastic support: the Woman's Work section in the Victorian Era Exhibition at Earls Court organized in 1897. She covered the preparation and exhibition of this show in the *Illustrated London News* and *Woman's Signal*. Much of her writing on the show was in praise of the woman artist curator; she announced in the *Illustrated London News* that its excellence was due to the judgment, devotion, and energy of Henrietta Rae.[137] The Woman's Work section, claimed Fenwick Miller, was the first time that a 'genuine display was available that showed the best work by the best women artists'.[138] She acknowledged that in the past the best women artists had sent their work to more important exhibitions, like the RA or New Gallery, and detailed for her readers Rae's innovative curatorial strategy.

The Woman's Work section was arranged by a committee of titled ladies; 'the only name of a really working woman upon the committee was that of the distinguished woman artist, Henrietta Rae.'[139] Florence Fenwick Miller felt that this ratio defied reason and suggested in her 'Ladies' Page' that it would be more logical to add to the committee an equal number of actual working women, although she did not doubt, in such an 'aristocratically organised country', that the role of the peeresses was important to its success.[140] Not only did Fenwick Miller refer disdainfully to the hierarchal structures of the committee but she clearly considered the aristocracy to be useful as a political tool only. Their uselessness as non-working women further emphasized Rae's credibility as a professional artist-curator.

The works were chosen by invitation; sometimes a particular work was requested, and in other cases it was left up to the artist. Some women were very pleased with the idea but others, Rae revealed, ignored the request until they received a letter in the Duchess of Devonshire's name.

Some expressed their strong objection to showing their pictures in an exhibition of women's work alone, but this I had provided against by stipulating before I undertook the task of selection and hanging that the men's and women's section should be entirely distinct, so that no women's pictures should be hung in the men's gallery.[141]

This was an issue that Fenwick Miller had debated repeatedly and she congratulated Rae on her foresight in avoiding a collection of 'leavings' of the

general exhibition, as with most exhibitions, which discredited women in the process.

Rae wrote an introductory essay for the exhibition catalogue in which she confirmed her unique curatorial mandate for gallery patrons:

Every previous attempt to organize a separate exhibition of Woman's Art Work has from one cause or another been attended with humiliating failure, so when I undertook the management of this one, I was prepared to encounter many objections. I knew that all women artists of standing would, under ordinary circumstances, be averse to jeopardising the position they had step by step won in open competition on the walls of the Academy, and I knew that they would prefer to exhibit their works in the man's section, in order to measure the result of their labours by the highest obtainable standard.[142]

The catalogue listed 376 works by women artists and according to Fenwick Miller, the leading women artists were 'represented by works so good and so various as to make one feel that in art, just as in literature, it is now possible to claim that women have justified a demand to have their work judged as work'. She asserted that Rae organized and hung the women's pictures 'giving the fullest possible display to the work of others and chose with equal conscientiousness and generosity the leading women artists to invite to contribute.'[143] Several of the artists had previously been included in the Chicago Exposition. Fenwick Miller pointed out this provenance as a sign of eminence. Rae's *Eurydice* 'bore well the test of exhibition with the work of the women artists of all the world at Chicago.'[144]

In the exhibition, Rae included Jane Benham Hay's *The Florentine Procession* of 1867, a large painting of a procession in medieval Italy. The piece was negatively received when it was originally exhibited in Henry Wallis's French Gallery.[145] In her catalogue, Rae revalued the painting, considering it was 'probably the most unexpected revelation to the student of modern art' in the exhibition. A footnote to her essay discreetly referred to Benham Hay's career: 'though the picture in question was painted before she was yet in the mid-centre of life, unpropitious circumstances ordained that she should never attempt another work.'[146] Rae's curatorship and Fenwick Miller's reviews in the *Woman's Signal* and *Illustrated London News* succeeded in reinserting the piece into contemporary discourse as a historical example of women's achievement in art. Their contestation of the bias evident in its initial reception was simultaneously a veiled criticism of more recent art writing which regularly dismissed women who attempted large-scale history pieces, as we have seen – including Rae's own work.

The exhibition was reviewed in the *Englishwoman's Review*, where H. H. Robson acknowledged the objections to an exhibition of women's pictures but praised the exhibition's demonstration of the progress and success of women artists as worthy of careful study.[147] However, the art press was not so

enamoured with Rae's efforts. It was announced in the *Art Journal's* 'Passing Events' that a section of the Victorian Era Exhibition at Earls Court would be devoted to women's work, containing an art gallery filled with productions by women artists of the Victorian era under the control of Rae. 'Among the other exhibits will be a series of portraits of mothers of men and women who have become famous during the Queen's reign, a happy idea which we feel sure will meet with general approval.'[148] Similarly, the 'Chronicle of Art' in the *Magazine of Art* made only a brief reference to the Earls Court exhibition, but declared that the exhibition justified the prediction that the Victorian era would henceforth be synonymous with the advancement of women in art as in other fields.[149]

In Fenwick Miller's discussion of the Victorian Era Exhibition she maintained her support of successful women artists, particularly Rae. However she also supported a completely segregated exhibition of women's art, which was unusual for her. Fenwick Miller's seemingly contradictory aim in her enthusiastic reviews of the exhibition was one strand in a complex matrix of interventions linked to her egalitarian feminist politics, intent as she was on gaining equal access for women to artistic institutions and organizations. The gender divide at the Victorian Era Exhibition, albeit contrary to her ideal, succeeded where the Chicago Exposition had not, and, in so doing, the very deliberate grouping of 'great' women artists at the Victorian Era show paralleled her own agenda in championing women artists.

Conclusion

For Fenwick Miller art presented yet another profession through which to promote the equal status and rights of women in the workforce and institutions; her tactic in promoting women artists as 'heroines' and professionals was a strategic extension of her own feminist politics and it related to her own biographical experiences. Women artists did not evoke the same controversial responses she had already experienced with medicine, and painting and sculpture offered a professional and societal status that was not accorded to women in education. Fenwick Miller conceived of art as part of a broader, politicized culture of the visual. Furthermore, high culture during this period was allied with fashionability and celebrity status: periodical press coverage located readers as spectators of artists' lives, as well as their paintings. It is possible that Fenwick Miller had an additional agenda in foregrounding specific women artists: not only did she present the case for professional women artists, but she also promoted women artists involved in the suffrage networks she occupied. Louisa Starr Canziani and Louise Jopling signed the 1889 'Reply' petition in favour of women's suffrage and Henrietta

Rae, Helen Allingham and Elizabeth Butler were listed as supporters of the women's suffrage movement in an 1897 list.[150]

Unlike Meynell, Fenwick Miller had a clear feminist agenda which was already firmly established in her public political work by the time she began writing about art. Nor was she concerned with new debates around aesthetics – rather her perspective was steadfastly cultural. She participated in a network of suffrage women and became the voice, successively, of the Central Women's Suffrage Association, the Women's Franchise League and the International Suffrage Committee. On the platform she was a dynamic and formidable public speaker, and a powerful advocate of women in education and suffrage, whereas with her pen her feminist interventions occurred through a diversity of means and tactics. In her writing she utilized different journalistic forums to interrogate the position of women in education, medicine, politics, parliament, marriage and art. As a columnist for the *Illustrated London News* she capitalized on each opportunity to combine feminist commentary with, and of, fashion and culture reviews, whereas her editorship of the *Woman's Signal* functioned as a more tactically direct intervention, a 'calculated action' as Chow suggests, in women's journalism and feminist politics. The *Illustrated London News*, unlike the platform or the feminist journal, offered opportunities for a more subtle strategy of filtering the political through the cultural: it enabled the integration of feminism within a mainstream press aimed at a broad readership.

New Woman, New Criticism

Elizabeth Robins Pennell

A period of revolt against decadence, of insurrection, of vigorous warfare it seems to me who lived and worked through it. The Yellow Nineties, Glorious Nineties, Naughty Nineties, Rococo Nineties, are descriptions I have seen. The Fighting Nineties would be mine.[1]

This recollection of the art critic and journalist Elizabeth Robins Pennell throws into relief the interplay and contestation of discourses during this period. The following chapter explores the experiences and writings of Pennell, who published extensively as the art critic for a London daily, the *Star*, and as the art correspondent for the American periodical, the *Nation*. She combined professional art journalism with cycle trips through Italy, France, Switzerland and England and wrote books about her experiences. In the latter she identified herself in print with one of the markers of New Womanhood – 'the bicycle' – and wrote a guide to cycling for women in 1894, the year that the phrase 'New Woman' was coined.[2] Pennell was also one of the key contributors to the New Criticism, which advocated 'modern' art. As one of several literary Americans living in London who maintained transatlantic careers, her writings were instrumental in disseminating French and English modern art discourses to a diversity of reading publics. During the 1890s, women art critics accessed and contributed to debates about the New Woman and the New Criticism, and Pennell can be positioned variously in relation to both. While during this period there was a vogue for labelling everything 'new', the sobriquet 'new' was not a unified signifier; there were contradictions and shifting definitions, as exemplifed by her work.[3] Pennell's interventions reveal dichotomies between discourses and demonstrate her central position in shaping the debates of the period.

New Woman

In 1884, Elizabeth Robins Pennell moved to London with her husband, the artist Joseph Pennell. In London she wished to continue her career as an art journalist and complete research for a book on Mary Wollstonecraft. She was already writing as art critic for the weeklies, the *American* and the *Press*. Joseph Pennell had forged British contacts through the *Century*'s agent, Edmund Gosse, while on a previous European assignment.[4] The Pennells' move to London was further facilitated by her uncle, Charles Godfrey Leland, who provided an introduction to the London literary world.[5] The Pennells had met whilst preparing an article together, on Leland's recommendation, for *Scribner's* in 1882. Elizabeth Robins had begun her career in Philadelphia, by writing in 1881 for the *Atlantic Monthly* and *Scribner's* and assisting in the administration of Leland's manual art class. Educated in a convent in Conflans, France, and a second convent at Eden Hall, Torresdale, a suburb of Philadelphia, she was born in 1855 to Margaret and Thomas Holmes Robins, both practising Catholics. Her father was a prominent member of the Philadelphia Stock Exchange.[6]

Pennell's relocation to London coincided with profound cultural changes in the metropolis. Controversial debates took place about the role of women, from employment opportunities, voluntary spinsterhood, gains in women's higher education, new roles in public life, to discussions about women's sexual destiny and urban female 'lifestyles' (Figure 5.1). The advanced or wild woman was young, middle class, eschewing fashion for masculine dress and severe coiffure, with emancipated habits such as smoking, riding a bicycle and traversing the city unescorted. In the eyes of the press, these women were financially independent, educated, read Ibsen and spoke at public meetings, preoccupying themselves with issues of equal opportunity, venereal disease and sex education. The term New Woman was coined in 1894 by novelist Sarah Grand, and Sydney Grundy's play *The New Woman* dramatized the dangers of independent, smoking and latchkey-toting women.[7]

Women journalists were included in the New Woman stereotype frequently considered in *Punch*. In 1894 it published verses 'suggested by a recent debate at the Pioneer Club':

> Have our lords and masters halted?
> Do they Humbly take a back-seat, wearied out with Madame SARAH GRAND?
> We take up dual garments, and the eyeglass and the cycle
> Pioneers! O Pioneers ...
>
> Literary dames are we,
> Singers, speakers, temperance readers, artists we, and journalists
> Here and there a festive actress (generally to be found in our smoking room),
> Pioneers! O Pioneers.[8]

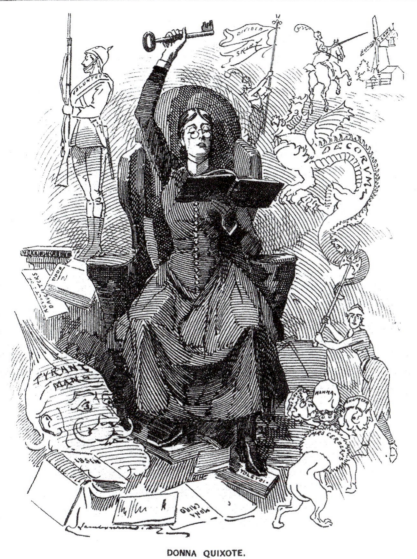

DONNA QUIXOTE.

[" A world of disorderly notions *picked out of books*, crowded into his (her) imagination."—*Don Quixote.*]

5.1 'Donna Quixote', *Punch*, 28 April 1894

Despite the prevalence of the stereotype in the press, the New Woman was not a stable category nor was its relationship to the women's movement without contradiction. In New Woman novels, women were identified with such disparate positions as anti-motherhood, purity, motherhood and free love. Victorian culture could not find a consistent language by which the elusive New Woman could be categorized: as Sally Ledger comments, 'all that was certain was that she was dangerous, a threat to the *status quo*.'[9]

However, not all of the press represented the New Woman as dangerous: periodicals like the *Woman's Signal* and *Shafts* regularly featured articles about advanced women.[10] Even periodicals that were not directly associated with the women's movement, like *Young Women* and *Lady's Pictorial*, published articles and interviews that highlighted the achievements of New Women in fields like journalism and medicine. In her article on women's newspapers in 1894 Evelyn March Phillipps wrote, 'we are almost astonished at the constant successes chronicled, and the excellent standard attained in art, music, literature, medicine and university degrees.'[11] The Girton-educated girl was celebrated rather than mocked and women's educational successes were frequently documented. The *Lady's Pictorial* ran photographs of recent college and university graduates in addition to the debutantes.

In publishing, attention to women's biography materialized in an Eminent Women Series for which Pennell wrote her first book, the biography of Mary Wollstonecraft. Her contract for a book on Wollstonecraft was the result of extensive negotiations with publishers, editors and researchers to obtain information and contacts during her 1884 year in America and England. Kegan Paul was less than forthcoming with information or support: 'My strong impression is that you will find no more to be said on Mary Wollstonecraft than has already been said ... No one of course, except really students of Mary's character, read her writings.'[12] However, T. Niles of Roberts Brothers in Boston encouraged her to write the biography for their 'Famous Women' series, although he was concerned about the possibility of controversy. He wrote, 'I am more than pleased with the two chapters of "Mary Wollstonecraft" ... You will however be getting into delicate ground soon ... her course of life requires deft treatment.'[13] Notably, it was an American publisher that initially commissioned the biography for an American readership; the historiography of feminism and societal structures in the United States differed considerably from that in Victorian England. It is apparent, for example, that there were a variety of ways in which nineteenth-century American women resisted stereotypical Victorian sex roles.[14] Despite the scepticism, Pennell's research and writing were completed in London; the book was finally released by the American publisher, Roberts Brothers, and she was paid the agreed sum of $200.[15] The book was released in an English edition the following year, but John H. Ingram reduced the book to two-thirds

of its size and changed the title to 'Mary Wollstonecraft Godwin' without consulting Pennell. Not surprisingly Pennell was infuriated with the results and she soon made Ingram aware of her tenacity and professional standards, resulting in at least four letters of apology. Ingram's explanation was a mix-up in communication with the American publishers: 'Let me reiterate, that I never, for an instant deemed but that you had given your consent until I received your first letter.'[16]

Both Ingram and Kegan Paul had misjudged the expanding interest in Wollstonecraft's work: Pennell's volume became a key text. It was republished five times before 1910 and it was the first of several reconsiderations and republications of Wollstonecraft's work during the latter part of the nineteenth century.[17] As a consequence of her biography of Wollstonecraft, Pennell was considered an authority on Wollstonecraft's work and was asked to write an article in the *Fortnightly Review*.[18] In this article, Pennell asserted that a new edition of the *Vindication of the Rights of Woman* would 'remind women of the old state of slavery from which they have so recently been freed'.[19] In fact, two new editions were released the following year and in the preface to the second, Pennell declared,

[Wollstonecraft] saw the evils in the conception of woman's sphere and duty then accepted even by her own sex. Because she had the courage to say what she thought and knew at a time when women were not expected to think or to know anything, she must always be remembered and honoured. One need not agree with her to appreciate her strength and independence.[20]

As an American, Pennell offered an alternative perspective. Not only was Wollstonecraft less controversial in the United States, but her ideas, such as her scheme for national education, had been virtually achieved in the public school system there. Pennell's reintroduction of her writings contributed to the reclamation of Wollstonecraft by the women's movement in the 1880s and 1890s.[21]

Early on in her career, Pennell also reviewed the Ibsen plays which came to be identified with New Womanhood because of their attractions for women actors and the representations of New Women in these dramas as projecting both positive and negative feminist images.[22] Nevertheless, Pennell was not overwhelmed by the plays. In the conclusion to her article on Wollstonecraft, Pennell referred to the recent playing of Ibsen's *Nora* in London with the observation that the moral of the play was not a new one in England. As proof, she listed those of Wollstonecraft's demands which had been achieved for women in the past hundred years, particularly their triumphs in education and medicine.[23] In her review of *Nora* for the *Nation* she was quick to point out that moralists in England and America already took for granted Ibsen's calls for women's self-development and moral independence, as exemplified by Karl Pearson and others who demanded recognition of women's right to

'industrial, social and moral equality'.[24] Pearson was a founding member of the Men and Women's Club which in the 1880s addressed issues of sexuality, socialism, evolutionary biology, Wollstonecraft, and Ibsen. His writing on the woman question was claimed as authoritative by contemporary feminists.[25] Not only did Pennell's writing pick up on Pearson's work, but her diary during this period considered the morass of debates around radical–liberal individualism and Fabian socialism. Here she regularly documented social events and discussions, which often included issues relating to women's rights, morality of the sexes, and unemployment. She discussed with Bernard Shaw the 1888 Bryant and May strike, and the way in which women, unable to live on the low pay, turned to the streets. She observed in her diary that 'big factories put a premium on prostitution' and later attended Annie Besant's lecture on the subject at the Fabian Society.[26]

Additionally, bicycling and tricycling adventures with her husband, Joseph Pennell, were central to Elizabeth Robins Pennell's career as a journalist and travel writer. Pennell and her husband continued their partnership in print, publishing numerous travel articles and books which she wrote and he illustrated. For Pennell, as for Meynell, freelance articles consistently provided an invaluable source of income to supplement more regular column work. Although cycling was still a controversial mode of travel for women in the 1880s and 1890s, she documented their remarkable experiences in *An Italian Pilgrimage*, *Our Sentimental Journey Through France and Italy*, and *Over the Alps on a Bicycle*. This last book included her breathtaking description of crossing a pass (Figure 5.2):

I got on, I pumped up my pneumatic brake, I backpedalled hard ... When I reached the first curve I had a bad time. The road doubled straight back on itself, on one side, the pine forest, on the other a drop of some thousand feet. Every yard or so a stone post, just high enough to hit my pedal, was to save me from grim death. I steered from the precipice and tried to come round with the dignity that befits my twenty years of cycling. But the road was not banked up. I ran into the gutter, and sat down in the bushes. I picked myself up and looked over the side.[27]

In London she was considered an authority on cycling and in 1884 she was already asked for an article on Rational Dress for women cyclists by the editor of *Outing*. Her diary records that at a dinner for the Society of Authors, George Allen (Ruskin's publisher) asked her if she was 'Mrs. Pennell of cycling fame', as he knew all her books.[28] The often sensational responses to her adventurous pastime did not dissuade her from continuing to cycle around England, and her excursions on the Continent were similarly greeted with astonishment by both residents and travellers. One spectacular performance was later described by her husband:

E. there, as in several other cities on the way, made a sensational entry. She had a fashion, in the beginning of her bicycling, not of dismounting from her wheel, but

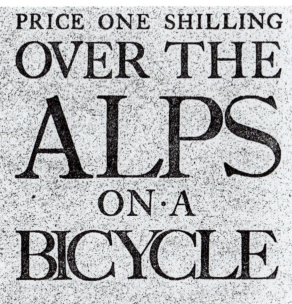

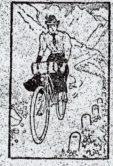

5.2 Elizabeth Robins Pennell, *Over the Alps on a Bicycle*, 1897

letting it run down in smaller and smaller circles, and then sitting down herself in the center with the front wheel sticking up in front of her. There is a drawing of this feat in the *Illustrated London News*. She performed it before the Sun Hotel at Bayreuth, right in front of Mark Twain, who could only remark, by way of greeting, 'Lord Almighty!'.[29]

It must be noted that Pennell had been raised outside the restrictions of English society, and she arrived in London in 1884, already a professional journalist with an interest in cycling. This difference helped to facilitate her success in gaining access to the increasingly professionalized artistic and journalistic networks in London, while continuing to publish articles in America such as 'Around London by Bicycle'. A contrast in transatlantic perspectives on Advanced Women is exemplified in the periodical press: where the English press portrayed the New Woman as threatening, the American popular press, by comparison, regarded her with humour.[30] Pennell often moved around the city independently when her husband was away on his sketching trips, and not only did her writing present a new mapping of the metropolis, but these new spatial practices also offered an alternative lifestyle.[31]

By 1894, Pennell had cycled all over Europe, including across central Europe to the Romanian border on a safety bicycle.[32] In her guide to cycling for women, she advocated the safety bicycle for women as opposed to the outdated tricycle, writing, 'women, until very recently, have seemed absurdly conservative in this matter … A few of the more radical – 'wild women' – saw what folly this was, and many have now become safety riders'.[33] Thus, Pennell positioned herself as a radical or 'wild woman', and she also stressed the advantages of cycling to women, specifically adventure and independence:

Hers is the joy of motion, not to be under-estimated, and of long days in the open air; all the joy of adventure and change. Hers is the delightful sense of independence and power, the charm of seeing the country in the only way it can be seen … And, above all, cycling day after day and all day long will speedily reduce, or elevate, her to that perfect state of physical well-being.[34]

This independence allied with power could be gleaned from traversing urban and rural spaces at home and abroad. Lynda Nead has argued that beginning in the mid-nineteenth century women of all classes and identities used and transformed the spaces of London – many middle-class women enjoyed and participated in the 'ocular economy' of the metropolis.[35] The bicycle provided an empowering new independent mobility and visuality for middle-class women.

In addition to being a journalist and cyclist, Pennell's private lifestyle reflected other facets of New Womanhood. Like the Meynells, both partners shared the publishing workload and the financial burdens. When they married they made a resolution that they would let nothing get in the way of Joseph's drawing or Elizabeth's writing.[36] Whitney Chadwick and Isabelle de Courtivon have recently presented a rethinking of conventional

assumptions around artist and writer partnerships; the Pennells' working arrangements similarly offered advantages to both parties, while their entangled identities and contributions are difficult to unravel.[37] On the one hand, a problem encountered by illustrators was the complexity of the author–illustrator relationship, and Joseph Pennell explicitly alluded to this in his papers. The status of the illustrator was inevitably subordinate to the status of the author yet, by jointly publishing with his wife, he not only avoided secondary ranking as illustrator, but also benefited in a way that other illustrators could not.[38] In contrast to the books and articles Joseph Pennell illustrated for other authors, such as Henry James and P. G. Hamerton, books jointly produced with Elizabeth Robins Pennell often listed both names as authors. Even when the book was 'authored' by her on the spine, her name, 'Pennell', by extension signified and thereby publicized his.

On the other hand, unlike her contemporary Alice Meynell, Pennell did not have a house filled with children so she was able to pursue projects more independently. Annual pilgrimages to the Salons were sometimes without the accompaniment of her husband, as indicated by her 1888 letter to him: 'I will certainly be back tomorrow evening and then perhaps you will do something besides ride bicycles and dine ... Yesterday I spent morning and afternoon at the Salon – It is too much – ... I am going back this morning.'[39] Publishing opportunities took priority, as noted when in 1890 she informed her husband that she would remain in London on her own to undertake research for a possible new article.[40] However, her correspondence indicates that life as an independent female journalist meant the negotiation of delicate social intricacies even in her liberal-minded circle; when her husband was absent on sketching expeditions she had to forgo her usual Sunday attendance at Edmund Gosse's.[41]

During the 1890s, her social calendar included a Thursday evening at-home. Buckingham Street made 'an extremely convenient centre for talk, and its convenience was so well taken advantage of that, at this distance of time, I am puzzled to see how we ever got any work done'. The group included artists, journalists and editors like W. E. Henley, Rosamund Mariott-Watson, Violet Hunt, R. A. M. Stevenson, Walter Sickert, George Moore and George Bernard Shaw. As hostess she offered minimal provisions for her guests: 'we attempted no formality ... If eventually I provided sandwiches ... it was because I got too hungry not to need something to eat before the last of the company had said goodnight.'[42] However, the weekly late-night event in her drawing room/office did cause Pennell considerable stress:

I too often spent my Thursday nights oppressed by other cares. For one thing, I could seldom keep my weekly article on Cookery out of my mind. Without it ... my bank account, I knew would grow appreciably less, and Friday was my day for writing it. A

serious question therefore was, how, if I did not get to bed until two or three or four o'clock on Friday morning, was I to sit down at my desk at nine … Another distraction grew out of my mistaken sense of duty as hostess, my feeling of responsibility in providing for all a share in the cheerful smell of powder and the stimulating sound of strife. Also, men being at best selfish animals, their wives, whose love of battle was less, were often an anxiety.[43]

This remark highlights many of the tensions between her position as hostess and her working life as a journalist operating in a complex professional network.[44] Her Thursday salon also functioned as a space for those competitive and argumentative male New Critics of the 'Fighting Nineties' to engage women in their 'vigorous warfare', an alternative to the men's clubs.[45] Non-club spaces, such as salons and restaurants, made the banter and disagreement associated with the circle of New Critics more accessible to women on the same terms.

Her work as an art critic was central to her output and it is this crucial material that remains unexplored in studies of this period. She and her husband annually joined the New Critics, Stevenson and MacColl among others, during the nineties to review the Salons in Paris.[46] She describes this intense period of exhibition reviewing in *Nights*:

Journalism has led me into pleasant places but never by the path of idleness. Rare has been the month of May that has not found me in Paris, not for the sunshine and gaiety that draw the tourist to it in that gay sunlit season, but for the industrious days, with my eyes and catalogue and note-book, in the *Salons*. Few have been the International Exhibitions, from Glasgow to Ghent, from Antwerp to Venice, that I have missed … Even in London when I might have passed for the idlest stroller along Bond Street or Piccadilly … oftener than not I have been bound for a gallery somewhere with the prospect of long hours' writing … the result … duly appeared in the long columns of many a paper, in the long articles of many a magazine.[47]

However, unlike the male writers associated with the New Criticism, she was not well known as an art critic. Established as a travel author, she invariably wrote under her husband's pseudonym and to readers outside the London art world her identity would have been largely 'Unknown'. Some of the initial commissions for articles were for Joseph Pennell, rather than Elizabeth Robins Pennell, although by the late 1880s she invariably wrote the articles. It is likely that the editors soon became aware of her role, but it was determined that a pseudonymous 'masculine' author was preferable to a named female. Like Meynell, and in contrast to Fenwick Miller's column, Pennell was aware of the advantages of masculine authorship, specifically in relation to art and cycling journalism. In a letter to her husband, Elizabeth Robins Pennell indicated that she considered that his signature lent more authority to their publications: she wrote, concerning an article, 'I have signed your name because I think if you are willing to own the paper, it comes better from you than from me.'[48] They also corrected and edited one another's work; however at least one letter

indicates that Joseph Pennell encouraged her to take credit for her own work: 'I send back the mss – with lots of corrections and much surprise as usual at your knowledge – sign your name – I don't want the credit for what I haven't done.'[49] An 1889 letter to her husband reveals the complexities of juggling multiple publishing responsibilities in his absence, for the *Pall Mall Gazette* cycling columns and *Penny Illustrated* exhibitions:

All my cycling notes are off – proofs came from PMG last night – and now I can draw a breath of relief. Everyone will say how serious C.Y.C. and A. Wheeler has suddenly grown … this morning came a note from [Clement] Shorter with a card for an exhibition he wants you to puff, he says your contributions to the Penny Illustrated are charming. He asked you to dine with him last Wednesday … so I had to write and tell him you were away.[50]

Pennell's letter implies that, unbeknownst to Shorter, *she* had been writing the *Penny Illustrated* columns. She also wrote criticism for the *Daily Chronicle*, *Woman* and the *Fortnightly Review*; in addition she took over the *Star* column 'Art and Artists' her husband acquired in 1888. The latter appeared under her husband's pseudonym, 'Artist Unknown' or A. U., fortnightly for the next 17 years.[51]

During the 1880s, Pennell continued to act as a correspondent for American periodicals, including the *Critic, Harper's New Monthly Magazine, Littel's Living Age, Nation, North American Review, Outing,* and *St. Nicholas,* on topics such as cycling, art and politics. The editor of the *Nation,* Wendell O. Garrison, was initially resistant to Pennell's offers for contributions in 1888. He wrote, 'my foreign correspondence is greatly expanded, and I am afraid to encourage it. So I will only say – Do not write except when you feel that you must.'[52] Nonetheless, by the following year, he had changed his mind: 'your request to be allowed to notice London exhibitions coincides with the winter absence of my regular correspondent in this line, and I am willing you should try your hand. But to distinguish you I must give you a conventional signature.'[53] Thereafter, the signature 'N. N.' appeared beneath Pennell's London exhibition reviews, which presumably Garrison had designated as an abbreviation for Pennell and 'No Name'.

Not only were Pennell's periodical pieces printed anonymously and pseudonymously, they were also edited and reprinted in other American publications. This exponential output of reviews and articles was tracked by her father-in-law, Larkin Pennell, and even he could not keep track of her prodigious output, as an exchange of letters in 1888 indicates. He carefully copied and sent an article from the New York *Evening Post* on the 'London Socialists and William Morris'. His next letter read, 'I suppose you will have a good laugh at me for copying and sending you, your own article on W. Morris and the Socialists … the New York Observer of 12/12/88 has 'Wells and its Cathedral' by Elizabeth Robins Pennell taken from the *Magazine of Art*. It is cut

down to about half a column.'[54] Although Pennell's columns were regularly cut, copied and quoted in other periodicals and newspapers, more often her identity remained unknown, as indicated by the *Hartford Courant* report, 'N. N. writes for the *Nation* a notice of a new English 'International Society of Sculptors, Painters and Gravers,' which he terms the most "powerful attack ever brought to bear against the academy".'[55] Clearly the writer for the *Hartford Courant* was unaware of *her* identity as art critic for the *Nation* under the pseudonym 'N. N.'. Reprinting copy from other papers was common practice in nineteenth-century journalism and, of course, financially benefited the publishers rather than the contributors.

Unlike Fenwick Miller, Pennell was not aligned explicitly with the women's movement, nor did she write extensively on women's issues. She felt there had already been great advances and indeed she was able to achieve financial and professional success as an independent journalist and writer, although not always in her own name. As Lucy Bland has observed, the hallmark of the New Woman was personal freedom.[56] Yet, in some respects, Pennell did not challenge conventional attitudes towards independent movement; for example her cycling trips were always in the company of her husband. There was a multiplicity of feminisms accessed and constructed by women during this period and, as Lisa Tickner has identified, the new fiction's association of women's emancipation with sexual emancipation and personal rebellion was carefully avoided by many feminists.[57] Furthermore, the New Woman's focus on personal fulfilment in some respects contravened the establishment of a collective feminist politics. Pennell's career and writing exhibited these tensions but also revealed the mobile borders of the category 'New Woman'.

For 'the people': art in the new press

The New Journalism's desire to represent the opinion of the masses, as discussed in Chapter 2, did not necessarily correspond to the conveyance of the modern ideas associated with the New Woman and the New Criticism.[58] In some ways Pennell's writing followed trends in the New Journalism; she wrote an art column for the *Star*, a newspaper that was aligned with the New Journalism's focus on mass readership and investigative journalism. The *Star* was a halfpenny evening newspaper founded in 1888, which had achieved a large circulation of over 360 000 that same year. The *Star* was inspired by W. T. Stead, editor of the *Pall Mall Gazette*, and it was intent on 'judging all policy as it influences … the lot … of the masses of the people';[59] its combination of radical politics, crime, sport and gossip included extensive coverage of Home Rule, the Trafalgar Square demonstrations, the Factory Act and the Jack the Ripper murders. Although the gendered nature of New Journalistic discourse

limited its availability to women journalists, Pennell employed its personalized writing style and her articles had links with the 'democratic' aims of the New Journalism. Pennell's investigative activities as a journalist included examinations of movements linked with socialism, radical politics, theosophy, positivism, the Arts and Crafts, Aestheticism, and the unemployed.[60] Her New Journalistic writing included a series of articles addressing the recent philanthropic efforts to bring art and culture to the East End.

Pennell frequently wrote her columns in the first person singular, unlike Meynell who invariably utilized the second person plural in her art reviews. Using the first person allowed Pennell to comment to her readers about the trials and tribulations of an art reviewer and critic, thereby personalizing her texts and making her own opinions more explicit, and was in line with the personal and conversational tone of the New Journalism.[61] On one occasion, for example, the reason for Show Sunday's absence from Pennell's review was relayed to the reader: 'My desk is littered with cards of all shapes, sizes and conditions … if one goes to these public private views in artists' studios, one is expected to put upon paper the sentiments one may have expressed in an unguarded moment under the influence of weak tea.'[62] Pennell positioned herself within the present, commenting on her interactions with the art market and institutions. She also discussed the hazards of interacting with dealers and buyers at a press view: 'I found myself entangled in a mess of intending purchasers, while my enemies and friends, the critics, were conspicuous by their absence.'[63] In 1899 a 'Mr. R. M. D.', who wrote to tell her what he would do if he wrote her column, was quickly rebuked. He was unequivocally informed that he did not write the column and she doubted that he would follow his own advice if he did. Moreover, she proceeded to defend both her column's alternative critical perspective and the predominance of art issues over RA reviews.[64]

Pennell regularly became embroiled in conflicts as a result of her forceful presentation of controversial ideas. The issue of philanthropy through art became a focus of her art column and indeed caused complaints from her readers. In the American weekly magazine, the *Nation*, Pennell instigated a debate regarding the recent attempts to bring art to the working classes in the East End of London by Samuel and Henrietta Barnett at St Jude's Schoolhouse and Walter Besant at the People's Palace.[65] Pennell supported the accessibility of the exhibitions at St Jude's and the People's Palace with their Sunday openings and free admission. However, Pennell contended that, both at St Jude's and the People's Palace, 'as a rule, the genuine workman is conspicuous by his absence'.[66] Letters to the editor, such as Walter Besant's adamant denial of her latter claim, testify to the British readership reached by the *Nation*. Besant wished to 'point out the grave mistake made by the author':

Permit me to say that the whole of the audience on Sunday morning, almost without exception, consists of genuine workmen ... The men in corduroys, whom 'N. N.' found outside, are not the sort of men for whom the Palace is designed. They are the lower class, the men who hang about bars and drink all their wages.[67]

Clearly only certain members of the working class were worth 'elevating' in the People's Palace.

Besant elaborated on his disgust in his own *Palace Journal*: 'Some one wrote a most foolish letter to a paper the other day, asking scornfully whether the Palace attracted the "class for which it was intended" ... What is the attitude of this man's mind towards the People's Palace? Of course there is no such thing with us as class.'[68] Frances Borzello's work suggests that actually Pennell was correct, in that those who attended the exhibitions were not the poorer members of the working class, but more likely artisans. This is made obvious by the fact that the catalogue text was seen as the main link between the pictures and the viewing public, thereby implying literacy.[69]

Pennell found fault with the management of the Palace. Rather than having been given to the people, the Palace 'is in the hands of trustees who do not consult the workingman even when his interests are most vitally concerned. A veto has been passed against beer, but his opinion on the subject has not been asked.'[70] Pennell's assertion that the People's Palace was in reality administered by Besant and the gentlemen of the West End seems accurate again, for in 1890 E. H. Currie admitted that they felt the need to institute rules and regulations as well as fees to exclude undesirable elements.[71] In the *Century*, Pennell cynically identified the actual ethos behind the movement's popularity, as having more to do with recent events in the East End: 'The hungry workman will forget his hunger, by looking at pictures ... by the practice of the minor arts ... and the rich ... will have nothing more to fear from socialists and anarchists, who are beginning to cause them some uneasiness.'[72] Here we see glimpses of Pennell's previous involvement in a far more radical class politics than Fenwick Miller.

However, the class bias of the exhibitions was not Pennell's only complaint. Another debate was around the type of art that was being exhibited in the East End and its accompanying interpretation. She described the organizers' construction of the ritual for viewing:

Pictures whose beauty is that of holiness, whose greatness is that of intention, are exhibited in a dim religious light, while before them are ranged chairs, where the initiated sit and worship in solemn silence; and if the mystery is too deep for them, as it assuredly was in the Triumph of the Innocents, leaflets full of Mr. Ruskin's sayings are scattered here and there.[73]

Pennell attempted an ethnography of visitors to the St Jude's exhibition by spending hours within earshot of parties of 'workmen', and the results were outlined for her readers. One painting was Burne-Jones' *The Mill*, which had

an extended catalogue entry explaining its deeper meaning: 'In the quiet hush of the evening, an old mill, its busy day's work over, its wheel at rest, stands reflected in the stream. Pigeons settle down to rest, and while the men refresh themselves in the water, after the day's toil, the girls dance gravely to the music' (Figure 5.3). The responses to *The Mill* included: 'Where's the bloody mill?' asked one to-be-reformed British workman. A second greeted it with, 'There ain't no dress improvers wanted there', and a woman exclaimed 'It isn't!' when she was read the title.[74]

Pennell went on to document that images by Watts and Rossetti were deserted; pictures that told a story were much more popular than 'Burne-Jonesy mythicism'. Here she was offering an alternative ethnography; other reporters are recorded as on the look-out for art in action, civilizing, refining and working miracles on visitors.[75] Rejecting these glowing narratives, Pennell was determined to demonstrate that paintings chosen for spiritually uplifting meanings were ignored by the working classes. This was at the opposite end of the spectrum to Henrietta Barnett who insisted that, with the aid of talks and a catalogue, the spiritually uplifting paintings were more popular, although in correspondence even her husband admitted that the Watts pieces were too demanding.[76] Seth Koven observes that rather than a morality tale of everyday life working people tended to link what they saw to the concrete economic and political struggle of daily life in London. [77]

Pennell also suggested that the People's Palace had metamorphosed into a palace of technical instruction for the working classes:

The theory so enthusiastically advocated to-day by many Englishmen is, that once the minor arts are taught to the masses, factory-girls and sewing women, workmen and labourers, will no longer crowd the streets and saloons of the East End, but, coming home tired from factory or shop, will fill their leisure hours carving wood, beating brass, setting mosaics, and by so doing make life worth living ... decorative art is not play but work.[78]

Her argument was founded on personal experience, for she had taught manual art at her uncle's School for Industrial Art in Philadelphia where efforts to bring decorative arts to the masses had been less than successful. Thus Pennell summarily questioned the efficacy of the same experiment 'tried with men and women who are up many hours every day in mill and factory, shop and warehouse'. Pennell's articles are surprising given that her uncle Leland was a close friend of Besant. Undeterred by Besant's response, her criticisms of the East End exhibitions were followed up by another controversial article in the *Star* two years later.[79] Pennell refuted the motives and outcomes of cultural philanthropy while employing ethnographies to posit resistances to its ritualized viewer instruction.

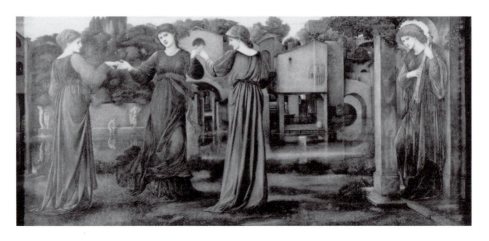

5.3 Edward Burne-Jones, *The Mill*, 1870–82, oil on canvas, 90.8 × 197.5 cm

New Criticism

The New England Art Club was formed in 1886 to promote French art and to oppose the RA. As art critic for the *Star*, Elizabeth Robins Pennell was amongst a group of critics associated with this circle and their alliances with 'modern' art. In 1893 they were termed the 'New Critics' by J. A. Spender or the 'Philistine'. As John Stokes has demonstrated, these critics employed the dictum 'It's the treatment not the subject' in their interpretations of contemporary art.[80] They identified a French-influenced production of 'modern' art which, broadly, incorporated new painting techniques involving light and contrasting colour, *plein-air* painting, and modern life. However, aside from Pennell, this group of New Critics did not include women; the three figures best known for their New Criticism in the press were Moore in the *Speaker*, Stevenson in the *Saturday Review* and *Pall Mall Gazette*, and MacColl in the *Spectator*.[81] These men also published articles in journals dedicated specifically to art such as the *Magazine of Art*, *Art Journal* and *Studio*. The artist Walter Sickert also published criticism in a wide range of contexts including the London edition of the *New York Herald*, *Whirlwind*, and *Art Weekly*, in addition to interviews and catalogues, and Frederick Wedmore wrote reviews for the *Academy* and the *Standard*.[82]

New Criticism rejected the history, narrative, and moralistic painting exhibited at RA exhibitions during the 1880s. This group of critics spurned variously, but not consistently, the writings of Ruskin, narrative paintings, neoclassicism and the studio-based, highly finished technique of academy painting exemplified by Leighton. In contrast, they supported work associated with contemporary developments in Paris during the 1870s, ranging from the

Impressionist artists to British/American artists who had been influenced by French Impressionist art.[83] In reviews, this encompassed a broad and shifting category that, at times, included the French artists Manet, Monet and Degas; the American painters Whistler and Sargent; the Scottish artists Lavery and Guthrie; and the English artists Sickert, Forbes, Steer and Stokes, the latter group dividing into the Newlyners and London Impressionists. The opposition constructed between the RA and the 'modern' by the New Critics produced contradictions when critics supported artists such as the Newlyn School and Sargent who became Academicians. This polarity was discursively constructed on the surface, obscuring overlaps in techniques and influences between and among these categories.

The interpretative methods of Pennell and the rest of the New Critics, and the fact that their work appeared in widely read newspapers and magazines as well as in specialized art periodicals, broadened the possibilities for serious art criticism in England.[84] Yet, however advanced their criticism of art, the New Critics did not align themselves with Advanced Women. George Moore's *Modern Painting*, published in 1893, included a chapter on 'Sex and Art' in which he offhandedly remarked that he had heard that some women held that the mission of their sex extended beyond the boudoir and nursery. However, this matter was not to be discussed, and instead Moore expounded on the mediocrity of all women artists: they were only capable of imitating the work of men.[85] Women artists were characterized by the New Criticism as old-fashioned and the antithesis of the modern, in keeping with its inherent polarities.[86] In this context Elizabeth Pennell was dissimilar to Fenwick Miller because she seldom wrote about the work of women artists in her reviews. However, like Fenwick Miller, she was anti-separatist and contended that exhibitions of work by women artists needed to reach the same standards as non-segregated exhibitions.[87] The new 'Society of Women Painters' received a mixed review. For Pennell the replacement of 'lady artists' with 'women artists' suggested 'common-sense', but the society was wholly superfluous: 'If women are painters, well and good. But let them take their chances accordingly, and not with clamorous reminders that they are women after all, and therefore to be treated with the tenderness and chivalry due to their sex. If they cannot paint, they should not exhibit.'[88] Women who could paint were to be judged by their work and not by feminine qualifications – which so often meant 'incompetence'. Thus the exhibitions of women artists did not receive Pennell's attention; she felt both sexes should be judged by work alone. Women seldom merited inclusion within her large gallery reviews.

In contrast to Fenwick Miller's stress on the exclusion of women from the RA, in the *Star*'s early reviews of the RA, Pennell set out problems with the institution, one being its lack of acceptance of outsiders or foreigners, such as:

James McNeill Whistler, Francis Seymour Haden, Alfred Parsons, and John S. Sargent – men who have produced in their different lines work which has had far more influence in the art world than that of any Academician, shows how little use it is either to toady to, or be independent of, this body … – it makes no difference if they are Englishmen or not, for several of the most notable members are foreigners.[89]

Unlike Meynell and Fenwick Miller, Pennell was adamantly anti-establishment. The RA received the majority of her criticism, as Pennell repeatedly demanded a reorganization of British art's oldest surviving institution. In an 1891 review of the Royal Academy Exhibition, Pennell wrote: 'the inevitable ballet girl of Degas may never lose her vitality, but the Greek and Roman ladies of Frederick Leighton and Mr Alma-Tadema are at times nothing more than academical pot-boilers.'[90] Two years later her review of the 1893 Academy Exhibition began, 'There are now no depths of the vulgar or commonplace which the Academy has left unexplored. It has laid bare, as never before, the full measure of its own incompetence.'[91] This was in agreement with another New Critic, R. A. M. Stevenson, who had asserted in the *Magazine of Art* five years earlier, 'We prefer in England the pictures of gentlemen who paint as they would conduct a bank, only more imperfectly … The buyer searches for accuracy, and not only the laymen but half the Academicians approach work this way.'[92]

A related debate in the press, concerning the annual Chantrey Bequest purchase, was linked to yet another aspect of the RA administration: the President and Council of the RA had been in charge of purchasing works, out of funds from the 1875 Bequest, to build up a public national collection of British art. Pennell was particularly critical of this system which favoured those who exhibited at the RA, rather than modern contemporary artists or those who exhibited outside London, including the Scottish painters. Therefore, the purchase of Lucy Kemp-Welch's work, *Colt Hunting in the New Forest*, by the Chantrey Bequest, which as we have seen was supported by Florence Fenwick Miller, was rejected by Pennell who wrote acerbically in 1897,

one purchase of the Chantrey Bequest this year seems to prove that there is some truth in the Prime Minister's assertion. The Royal Academy does encourage undeveloped geniuses. The purchase of Miss Kemp-Welch's picture and the passing over of men like Mr. Abbey, Mr. Mark Fisher or a dozen others – to say nothing of Mr. Whistler – is but another link in that long chain of blunders in which the Academy is rapidly entwining itself. I should be interested to know the names of the purchasing committee.[93]

Finally in 1902 public protest resulted in the appointment of a House of Lords Select Committee to investigate the administration of the Chantrey will; the unbalanced purchasing policy was mockingly summarized by D. S. MacColl in the *Saturday Review*:

In a word, suppose the Trustees in the witness-box, and obliged to answer the question: 'Are or are not Stevens, Madox-Brown, Rossetti, Holman Hunt, Burne-Jones, Cecil

Lawson, Dalou, Legros, Fantin-Latour, Whistler, Matthew Maris among the most eminent artists who worked in Great Britain from the time of Chantrey's Will till the present?' It is inconceivable that they should answer 'No'; and suppose them asked: 'Were Joseph Clark, Val Prinsep, Walter Hunt, W. Small, P. H. Caldron, A. Hacker, G. Cockram, L. Rivers, H. S. Hopwood, Mildrid Butler, Lucy Kemp-Welch, A. Glendening, Jun. J. Young Hunter, Chas. Maundrell, to name only a few among those whose names figure in the Chantrey catalogue, among the most eminent artists whose works could be contained during this period?' it is inconceivable that the answer should be 'Yes'.[94]

After the editor of the *Burlington Magazine* called for a Ministry of Fine Arts in order to solve the problems associated with the administration of art museums like the Chantrey Trust and the RA, Pennell pointed out to her readers that *she* had urged this idea many times.[95] She had already attempted to instigate a press boycott of the RA Exhibition; her 1899 review accused editors and the press of uncritically worshipping established institutions and bolstering up the Academy.[96] Pennell cited Stevenson's revelation about the florid abuse and bitter ridicule, present on varnishing and press days, that never found its way into print, and declared that if two or three other honest critics in England would only say what they knew about the Academy, 'we would upset this insufferable display of artistic horrors'.[97] Clearly she was asking for the network of New Critics to join forces in disrupting the Academy.

Pennell's views were at odds with the critics who allied themselves with the RA. These critics, including F. G. Stephens and J. A. Spender, championed an academic technique predicated on attention to detail and moral content. Despite Pennell's call for action the exhibition was still covered by the press, and reviews by established members of the art world could not be more removed from Pennell's boycott. M. H. Spielmann writing in the *Magazine of Art* acknowledged the difficulties encountered by critics: his discussion of the Academy presented the critic's role as conflicted, torn between the public, the artist and the editor. He asserted that, from the art writer's perspective, the critic ought to be independent of purely journalistic interest and purely technical considerations. Pennell might well have agreed with him on this point, but the rest of his text demonstrated that his interpretation of the critical role was vastly different to hers. 'The Academy Exhibition offers me a full dozen of texts on which I would write a full dozen essays – each one of them more entrancing than the last.'[98] Clearly Spielmann's opinion on the opportunities for criticism offered by the Academy was diametrically opposite to that of Pennell. Both Spielmann and the *Athenaeum* critic, probably F. G. Stephens, conceded that the 1899 exhibition was deficient, but this was due to the absence of several painters, and the fact that few of those who contributed had sent subject pictures (Poynter, Orchardson, Herkomer, Yeames, Watts and Fildes had sent portraits).[99] This was distinctly contrary to Pennell's

perspective on the failings of the Academy; she considered these subject pictures to be 'inevitable Academic performances', useful only to the critic in search of copy.[100] Spielmann continued to defend the increasingly scorned show, insisting that, unlike the Salon, as an Academy it had to be academic and thus could not display works which departed from its teaching.[101] This argument could have been directed at Pennell, who was repeatedly comparing the Academy unfavourably to the Salon in her May reviews. Although she returned to reviewing the Academy show, she qualified her decision by explaining that tradition had given it precedence, even if reason did not.[102]

In general, Pennell's writing supported the artists associated with French Impressionism and the NEAC. More specifically, through her critical writing, widely read by men and women, she defined and articulated the new movements within the modern.[103] While much of her writing was in agreement with the ethos of the New Critics, unlike MacColl and Sickert, both artists and critics, she was not in danger of proselytizing about her own work.[104] As an artist, MacColl was a regular contributor at the NEAC from 1892 and the Goupil Gallery opened with a show of his works in 1893. Furthermore, the coherence of the NEAC artists group soon broke down into factions; Pennell identified these new coteries in the press. The three resultant groups were the Newlyners, the Glasgow Boys and the London Impressionists. Despite the splits and defections, Pennell did not immediately side with either the Newlyners or the London Impressionists, but continued to write about the work of all of these modern artists.

The Newlyn artists were most successful in entrenching themselves in the RA and this made for an obvious mark against the school. In spite of her incessant pejorative commentary on the RA, Pennell, like Meynell, was initially supportive of the work of Newlyn artists who exhibited there. Divisions within the NEAC were already being made explicit by Sickert who launched a crusade in 1889 on behalf of the London Impressionists' painting in the *New York Herald*.[105] In contrast, the *Star* described the work of Adrian Stokes as 'true and poetic rendering' and the following year it was, 'Mr. Stanhope Forbes takes the lead'.[106] However, Pennell did not retain her enthusiasm for Newlyn, feeling that their work became increasingly pedantic and sentimentalized whilst losing its *plein-air* prerequisite. By 1893, a work by Stanhope Forbes received a caustic review summing up the results of his new-found academic status:

Mr. Stanhope Forbes, in his portrait, shows that he understands his duty as an Associate, and is as complacently commonplace as the rest; in his big subject picture, he brings together all the worst faults of the Newlyn School, which scorns the study of Nature outside of the studio and knows not the meaning of harmony in design.[107]

This illustrates the intersecting positions in her work – here it was not only a question of style and method, but a more immediately political opposition to the RA.

In 1889, a group of NEAC artists exhibited separately, as the London Impressionists, at the Goupil Gallery: these were Francis Bate, Fred Brown, Francis James, Paul Maitland, Theodore Roussel, Bernhard Sickert, Sidney Starr, Philip Wilson Steer, George Thomson, and Walter Sickert. The latter artist, now renowned for his depictions of modern life such as *Minnie Cunningham at the Old Bedford* (Figure 5.4), sent three music hall pieces to the Goupil. In her analysis of the show's extensive reception in the press, Anna Gruetzner Robins has identified Pennell as one of four reviewers who remained firm supporters of the group. Like many critics, Pennell was, however, uneasy with the influence of Degas and Monet on the artists: she said Steer had utilized Monet's method and subject matter, and that Bernhard Sickert and Thomson had also relied too heavily on Monet.[108] Gruetzner Robins finds, in this coterie of supportive critics, the origins of the new critical response to London Impressionists: their unpleasant and unsightly images of London received hostile responses elsewhere in the press and even their supporters gave precedence to light effects and the arrangement of form and colour.[109]

Although Pennell wrote favourable reviews of their work she was not impressed with Sickert's political wrangling within the NEAC. This became particularly evident in her reviews of the Glasgow Boys, a group of 23 painters formed in 1887, including James Guthrie, John Lavery, Arthur Melville, George Henry, E. A. Walton and E. A. Hornel. They were united in hostility towards the Royal Scottish Academy and several members of the group had studied in France, adopting the style of Bastien-LePage. The artists had joined the NEAC in 1887, but had also exhibited in 1890 at the Grosvenor Gallery, which was followed by a successful show at the Glaspalaste in Munich. Pennell, Stevenson and MacColl were early supporters of the group in the press.[110] Stevenson praised the Glasgow artists in the press at an early stage – he had written for the *Scottish Art Review*, the Glasgow artists' short-lived periodical – and the New Critics all gave considerable attention to Sir Coutts Lindsay's coup exhibition of the Newlyn artists and the Glasgow men in 1890.[111] At the 1891 NEAC, Pennell denounced the exclusion of the Glasgow school, 'an important element in contemporary British art'.[112] MacColl's review of the same show was less critical of the club's politics; he commented, 'a club of this kind is necessarily a fluctuating body'.[113] The factions within the NEAC eventually resulted in the Glasgow artists' mass resignation in 1892.[114]

An exhibition at the Grafton Gallery included work by Glasgow artists and offered Pennell another opportunity for a discussion of the recent failings of the NEAC:

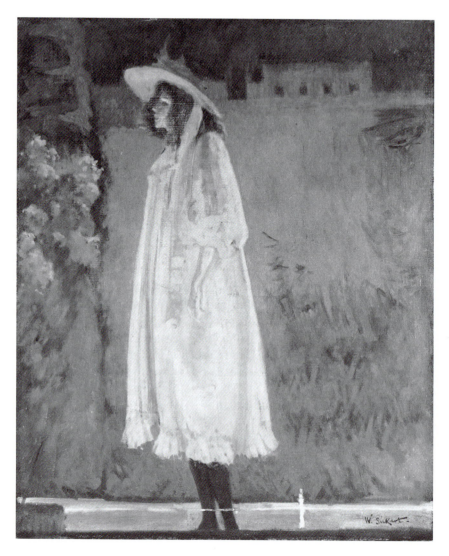

5.4 Walter Richard Sickert, *Minnie Cunningham at the Old Bedford*, 1892, oil on canvas, 61.0 × 61.0 cm

The stunning show which they [the Glasgow School] now make emphasises the mistake of the New English Art Club in losing them as exhibitors. Indeed, if the Grafton Gallery perseveres as it has begun it threatens to cut the ground from under the feet of our London Impressionists; not only does it exhibit, as they have always sought to, work which is original, individual, and distinguished, but it has the advantage of representing masters while they are still, as they would be the first to admit, but students.[115]

In the *Nation*, Pennell contributed a review of the Grafton Gallery which similarly focused on the Glasgow work. In this context she was more critical of the NEAC, highlighting the ramifications of their political upheavals and recent neglect of 'French influenced' Glasgow painters. According to Pennell, the Glasgow school

represent all that is best and healthiest and strongest in contemporary British art, but it has been well-nigh impossible for them to find a London gallery in which to show their work ... Several of them had exhibited with the New English Art Club, but the growing determination of a little inner group to run that club for their own benefit gradually alienated the Scotchmen.[116]

Pennell's continued praise of the Glasgow school was linked undoubtedly to their French training and Impressionist tendencies in their painting style. Their network within the art world was also a factor, for not only had they associations with the NEAC but, like Pennell, they also had great admiration for Whistler and several eventually served on the council of his International Society.[117]

French Impressionist work was shown in conjunction with NEAC exhibitions and subject to comparative analysis in the press. In the *Star* of 1891, Pennell praised the exhibition of work by the French Impressionists Monet and Degas at the NEAC show; of a piece by the latter artist she wrote: 'the unflinching realism, will reveal to those who have never seen them before the source of much of Mr. Steer's and Mr. Sickert's inspiration, and the first cause for their interest in the music halls of London.'[118] In contrast to her view of Degas and Monet, Pennell was not impressed by their English followers, writing that the groups had fallen under the spell of Monet, 'none of them wholly original in aims or methods'.[119] She commented:

But the great fault to be found with almost all the men of this club is that they seldom venture to be themselves on canvas ... they have borrowed, not only the methods but the eyes, of the first of the modern protestants in art; either they have nothing to say for themselves, or else they have no desire to do anything more than re-echo that which has been already said in paint by the men they have chosen as masters ... But even in criticising them it is only fair to admit they succeed in giving the most interesting shows of contemporary work in London.[120]

This matter was readdressed in Pennell's *Fortnightly Review* articles on the Paris Salons. In her 1892 articles, she set up a comparative framework which pitted French 'modern' against English 'modern', and her criticisms of the French Impressionist followers were similar to those she had launched against the English: the latest trends amongst the Paris avant-garde were, she thought, problematic, with the old Salon exchanged for incompetent cleverness and self-conscious eccentricity. 'It was to the artist in France what mawkish sentiment proved to the English painter.'[121] The artist was not concerned with his impressions and their artistic rendering, but rather with the jury, the

buying public, and the prejudices of the critic to whom his art must be conspicuous. Pennell asserted that the modern movement inaugurated by Manet and strengthened by Degas and Monet had brought forth this crisis which resulted in stagnation of the art market. She also noted a prevailing lack of originality in subject matter as artists copied the compositions of Monet, Whistler and others: 'What will come out of the present decadence, or interregnum, it is too soon to predict ... The stage of uncertainty through which the picture-buying public is passing may make that public realise the value of originality.'[122] At this particular exhibition she declared the English/American 'modern' artists to be superior to the French 'modern' painters. According to Pennell, Whistler, Sargent, Burne-Jones, Henry Moore, Alexander Harrison, and Guthrie (Figure 5.5) were the men who stood out as genuine artists rather than charlatans.

It was not until 1893 that an exhibition of French Impressionist work at the Grafton Gallery prompted widespread reviews in the press. In the *Star*, Pennell found it upstaged the only other venue for French-influenced art exhibitions, the NEAC. Two pieces by Degas accompanied the show and Pennell declared the arrival of Impressionist work in London was not to be missed,

The *Rehearsal* by Degas was hung in the Bond Street Gallery but little more than a year ago: it is, therefore, useless for me to repeat to-day all that I then had to write about it: its distinction, its truth, its beauty impress one but the more now that it is seen a second time ... No less masterly, and even stronger in character, is *L'Absinthe*, grim with its realism, incomparable in its art.[123] (Figure 5.6)

Her *Nation* review offered a more explicit discussion of the contemporary British art scene and of the impact of Edgar Degas in London:

never hitherto have such a number of the men who have revolutionized art on the continent been gathered together in a large and fashionable English gallery... Now that the much-hated, much-dreaded French art – for in England all Continental work belongs under this heading – has appeared in an English stronghold, one waits curiously to see what effect, if any, it may have on the English artists.[124]

The piece, *L'Absinthe*, would be the subject of a six-week-long furore in the press and earned for her colleagues the label New Critics. Pennell's initial review of the piece in the *Star* preceded the Grafton review by MacColl, 'The Inexhaustible Picture', which incited the wrath of the 'Philistine'.[125] The 'Philistine', J. A. Spender, writing in the *Westminster Gazette*, was opposed to what he considered to be the moral depravity of the piece. MacColl's original assertion that the 'inexhaustible' picture at the Grafton, by this 'master of character, form and colour', should be equated with beauty, infuriated him.[126] In an anthology of articles and letters involved in the dispute, Spender summarized what he saw as the contentions of the New Criticism: the subject

5.5 James Guthrie, *Midsummer*, 1892, oil on canvas, 99.0 × 124.5 cm

of the picture was unimportant and the handling was all important; painting and appreciation of painting was a matter for those experts only; pictures which conveyed meaning or a moral were to be condemned, and above all art had nothing to do with morality nor with popular conceptions of beauty.[127] According to Spender, the result was that artists produced a large number of works unintelligible to the public with trivial subjects that were occasionally vulgar or repulsive.[128] MacColl rebuffed Spender's charges in angry letters to the editor. He declared that the Philistine 'will never know what painting is. As a weather gauge of popular fancy for pictures he is, however, most valuable.'[129] The debate continued in the press for six weeks and was summarized in verse in the *Westminster Gazette*:

> Philistine
> Oh, why should I be bullied by the very newest school,
> And sniffed at, if I differ, as a missing-worded fool?
> And is it merely ignorance to think a painted tree
> Should bear some faint resemblance to a thing I sometimes see?
> And can't a thing be beautiful to look upon unless
> Its most distinguishable mark is wilful ugliness?[130]

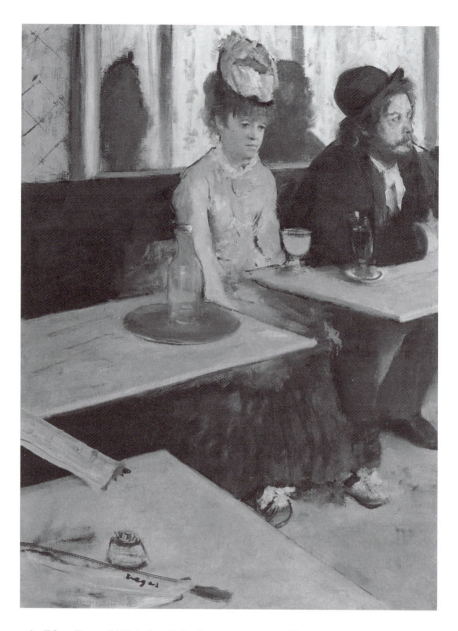

5.6 Edgar Degas, *L'Absinthe*, 1876, oil on canvas, 92.0 × 68.0 cm

The various parties to the debate included Charles Furse and George Moore on the side of MacColl, and Harry Quilter and Walter Crane on the side of the Philistine. In the *Star*, Pennell also joined in the debate:

The Philistine ...was parading his deplorable infirmities in the *Westminster Gazette* of Ruskinian proclivities – the organ of moral sentiment and mistaken appreciation in art, and so, a fitting asylum for him. His voice was raised against the 'new art criticism', of which he selected the *Spectator*'s 'D. S. M.' as chief proponent ... altogether there might be a pretty quarrel to join in, if the Philistine were but worth it ... Why ... should artist or art critic trouble to argue with one who, by the title of his own assuming, admits that he knows nothing of art.[131]

Here Pennell identifies the already conservative ethos of the *Westminster Gazette*, backward-looking and Ruskinian, thereby framing the Philistine's text. In addition she reinforced the opposition that defined authority in art criticism; those that 'know' about art command the expertise. The debate questioned critics' recent attempts to establish specialist knowledges, but at the same time the repeated articulation of the binary, by both sides of the dispute, revealed the growing stability of the profession.

In spite of her claim that Spender was not worth the trouble, Pennell had entered the fray and reminded her readers that 'the *Star* was a pioneer in the good cause' of New Criticism.[132] The following week her addition to the escalating dispute was the identification of a 'curious British characteristic', a refusal to distinguish between the artist and the work. This was in reference to an accusation that 'D. S. M.' had insulted respectable 'Royal Academicians and gray-headed painters'.[133] Interestingly, her comment attempts to discredit the conflation of art and artist common in late-nineteenth-century art journalism, as exemplified by studio biographies. Ensuing *Star* columns expanded on the debate, predicting the end of the 'old critics'.[134] Her review of the RA Exhibition a month later explicitly fuelled the controversy over new Impressionist art versus the Academy with the assertion that

with the opening of exhibitions like the Grafton, and the intelligent criticisms published in many papers, the public begins to doubt, and hence the Academicians' work to decrease in monetary value, their only standard. Not even the initials 'R.A.' have been able to save more than one canvas brought into the auction-room of late from selling for one-half, or one-third, of its original price.[135]

The monetary value of pictures was seldom discussed by Pennell but, in this case, her position offered even greater influence, for she had the 'statistics' to sway the art market in favour of 'modern' artists.

Gilded Americans: The butterfly and the society portraitist

An older artist promoted by Pennell and the New Critics was the American painter James McNeill Whistler. He was one of the most vocal advocates of the new painting, having studied and exhibited in France before moving to London where he gained renown with his 'Nocturne' series, denounced by

Ruskin, in the 1870s.[136] In the 1880s he continued to produce paintings and etchings whilst promulgating his aesthetic theories in his 'Ten O'Clock' lecture and in print. In 1886 he was elected President of the Society of British Artists, and he also exhibited with the NEAC. Whistler's retrospective exhibition at the Goupil in 1892 received extensive praise from Pennell, who titled her *Nation* article 'Whistler's Triumph'. Here she declared that Whistler was an Impressionist 'before the name Impressionism had been heard' because his works from the 1860s pre-dated the work shown at the NEAC or even Monet's haystacks. She asked, 'but what are most of Mr. Whistler's Nocturnes but impressions of the river … his wide, far-reaching influence over modern painting is only beginning to be felt, and probably it has never been so emphasized as it is now by the collection at Goupil's'[137](Figure 5.7). Whistler's celebrity status garnered not only reviews in the press; the attendance at the retrospective exhibition, a thousand visitors on the first day alone, also indicated his popularity.[138]

Like Elizabeth Robins Pennell, Whistler was an 'outsider': an American living in London. As the European correspondent for the *Nation*, Pennell occupied a unique position as publicizer of Whistler's art for the English and American audiences simultaneously. She contributed to the growing recognition and industry around Whistler in the 1880s and 1890s in America, a market which became increasingly lucrative through commissions and collectors. For her American readers, Pennell carefully constructed an identity for Whistler as an American artist; in her art reviews in the *Nation*, Pennell paralleled her support of Whistler in the *Star* and elsewhere. In the aforementioned Goupil review, Pennell drew attention to Whistler's American heritage, admonishing the American public for neglecting to commission his work: 'It should not be forgotten in America that Mr. Whistler is an American of Americans; it may therefore be appropriately asked – What has America done for him? It has treated him with – if possible – even more ignorance and coldness than England.'[139] The reason for Pennell's appeal to American nationalism was made clear in her conclusion: Whistler's work – the portrait of his mother – had been acquired by the French government the previous year, rather than by an American collection.[140] Moreover, she felt he had been neglected in a recent large-scale building commission:

There is in Boston, I believe, at the present moment a public building in process of decoration by Americans. Has Mr. Whistler, the greatest decorator America has ever produced, been asked … – it is at least not too late for Americans at once to endeavor to obtain from him one, if not more, of the few examples of his work still in his possession, which, however, before long may be distributed among galleries everywhere except in his native land.[141]

The reason for Pennell's campaign was almost certainly that Whistler's compatriot, Sargent, had been commissioned to do murals for the Boston

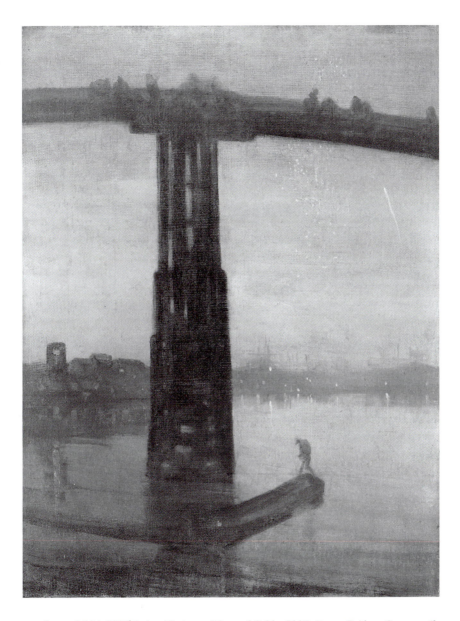

5.7 James McNeill Whistler, *Nocturne: Blue and Gold – Old Battersea Bridge*, 1872–77, oil on canvas, 68.3 × 51.2 cm

Public Library in 1890.[142] In fact Whistler was asked to do a mural for the Boston Public Library, but this was never completed further than an oil sketch of the landing of Columbus.[143]

Similarly, in London, Pennell emphasized Whistler's victimization by the press and the establishment, positioning Whistler as an 'outsider', foreign to the country and the Academy. She described the Grafton exhibition of Whistler's *Lady Meux* (Figure 5.8):

the beautiful harmony in black and silver, though it is one of the most masterly paintings in the collection, and though the fact that a centre of honour in the largest room has been reserved for it is as significant as the absence of all Academicians save two – Mr. Watts and Mr. Orchardson – from the gallery. The old idols are being gradually dethroned.[144]

Likewise, in a note on a RA dinner, Pennell asserted that

the President had neglected to mention the leave-taking of Whistler from Britain. The fact that he shook the dust of London off his feet, owing to the systematic and increasing persecution that he received at the hands of the Royal Academy individually and collectively, will be about the only reason for their names to be remembered for posterity.[145]

Along with his brother-in-law, Seymour Haden, Whistler played a key role in the etching revival in England in the latter part of the nineteenth century, with their emphasis on the importance of the original etching as opposed to the illustration.[146] It was through Whistler's etching that the Pennells became directly involved with the artist: Joseph Pennell had helped Whistler print etchings in Paris in 1893.[147] In addition, the Pennells entered into debates in the press and in court about methods of printmaking and the new status of the printmaker as artist. The first debate, which ensued in and out of the *National Observer*, centred on the authenticity of the etchings in Hubert Herkomer's luxurious tome, *An Idyl: A Pictorial Music Play*, and involved, among others, Francis Seymour Haden and Joseph Pennell versus Herkomer and Leighton as President of the RA. Elizabeth Robins Pennell ensured the debate extended to the *Nation*:

Prof. Herkomer's 'Idyl' 'illustrated by 16 etched plates' ... is announced in the circulars and by the publishers, and yet it has been seriously questioned in the *National Observer* (all other papers are following its lead) whether these illustrations are etchings or photogravures. ... when it comes to the least doubt being thrown upon the artistic and commercial veracity of a man of Mr. Herkomer's position, it is time indeed to protest.[148]

The campaign was a sensational success in the London art world. In a letter to her husband describing the press view of the New English Art Club, Pennell wrote, 'I had talks with Whibley, who is still excited over the Herkomer business ... Everybody wanted to know about Herkomer.'[149] Eventually, Herkomer wrote to the *Times* to protest the 'baseless insinuations' about his book, but acknowledged that 9 out of the 16 plates in *An Idyl* were mechanically transferred to the plate; however, the incident had already branded him a 'charlatan'.[150]

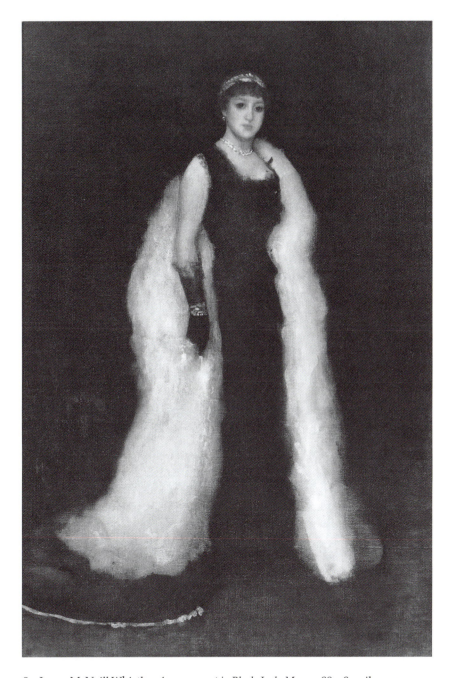

5.8 James McNeill Whistler, *Arrangement in Black: Lady Meux*, 1881–82, oil on canvas, 194.1 × 130.2 cm

In 1896 the Pennells became involved in another debacle, a libel case involving Joseph Pennell's lithographs of the Alhambra which were exhibited at the Fine Art Society and appeared in an illustrated edition of the book by Washington Irving, prefaced by Elizabeth Robins Pennell. Joseph Pennell sued Sickert and Frank Harris, Editor of the *Saturday Review,* for writing that Pennell's transfer lithography (drawing on paper before transferring it to stone) was not a genuine artistic process. Sickert responded in the *Sun* where he alluded disparagingly to artist critics, namely Joseph Pennell; he was in fact misinformed because the *Star* column was written by Elizabeth Robins Pennell, a critic not an artist.[151] She also wrote a signed article for *Scribner's* which positioned Whistler as the master of lithography in Britain and highlighted his use of the transfer process.[152] The article, no doubt intended to bolster her husband's case, was picked up by Sickert who countered, 'Mr Whistler could more properly be called "master of the transfer lithograph".'[153] Not surprisingly, Whistler was called as a witness, which only added to the spectacular nature of the case and it was avidly followed in the press. Sickert was found guilty of libel and he and Harris were fined £50.[154] The Pennell versus Sickert trial resulted in a permanent rift between Sickert and Whistler, as well as Pennell. Harris was furious with the verdict, and delivered a scathing attack on Pennell in the paper, in which he attempted to reveal the true identity of the *Star* columnist:

He signs, we understand, his valuable contributions to the 'Star' with the initials A. U., and sometimes, led away by the praiseworthy desire to enlighten, he writes 'Artist Unknown'. There can be no doubt that his signature will one day be his epitaph.[155]

Harris, like Sickert, wrongly attributed the column's authorship; however his revelation no doubt limited the possibilities for Elizabeth Robins Pennell's anonymous support of print artists. Nonetheless, the controversies that surrounded the technicalities of printmaking and reproduction not only effectively delivered publicity to black and white art, but also increased its marketability as a luxury commodity.

She promoted the 'black and white' work which flourished during the 1890s and repeatedly bemoaned the lack of support for this new development at the RA.[156] In the *Star* she regretted the fact that 'the men who draw for the magazines and whose names are known far better than those of the Academicians, and whose work is far more honored, are … entirely absent from the Royal Academy Exhibition.'[157] The Academy, she observed, also effected spatial discrimination by positioning the Black and White gallery 'beyond the stairway leading down to the refreshment room, just where it is most convenient to turn one's back upon its open door'. She surmised that the illustrator's work was seldom seen to advantage in London shows in contrast to Paris because illustrated magazines and papers were considered the

exhibition galleries of the illustrator.[158] As well as publicizing shows relating to illustration work, Elizabeth Pennell promoted the illustrator's aspirations for professional status in the institution. This had been a long-standing source of friction – only painters, sculptors and architects were recognized as full members.[159]

In 1898, the *Nation* critic enthusiastically presented to her readers an alternative exhibition: the International Society of Painters, Sculptors and Gravers, formed by a small group of men with Whistler as their President. She particularly praised his new works, *Gold and Brown*, *Blue and Coral*, and *Grey and Silver*, for their rhythm of colour and poetry.[160] In her review the following year Pennell once again raved about Whistler's new society and, although she claimed it was 'not to revolutionize or reform or represent or rival anything', she immediately invoked a comparison with the RA. 'Here you have a President who not only is useful as a figurehead, but is a painter accepted by all other painters as a master.'[161] The show included pictures by Renoir, Monet, Pissarro, Sisley and the Glasgow artists, and etchings by Whistler and none other than Joseph Pennell. Her support for the group stemmed from her husband's membership of the Executive Council.[162] The society's function as a showplace for black and white work was central to her reviews. In 1899 she wrote,

> The prints and drawings are still more distinguished as a collection, and they are as admirably hung as the black-and-white work at the Academy is chucked carelessly together … A room – a white room – is set apart for Mr. Whistler's etchings, among them two beautiful little impressions of the Jubilee Naval Review, now seen for the first time; … etchings by Herr Klinger, Mr. Pennell, Mr. Strang.[163]

The separate Whistler print room was organized by Joseph Pennell. Her enthusiasm for the venture was also predicated on their friendship with Whistler, who by 1895 had realized the value of Elizabeth Robins Pennell's criticism and contacts. In a letter to his sister-in-law he instructed, '[Y]ou should be sure to send cards to Mr and Mrs Pennell – they could put anything in the papers – and she would do it very nicely.'[164] Sarah Burns identifies Whistler as the point in America where artist and image become interdependent, where the commodified self became a vital marketing tool.[165] The sensational reputations of artists such as Whistler (and Joseph Pennell) are played out in the array of reviews and articles that appeared in the 1890s, through which Elizabeth Robins Pennell, often anonymously, contributed vitally to this commodification of the artist as 'spectacle' on both sides of the Atlantic. After Whistler's death in 1903, she continued to expand the Whistler archive she had carefully amassed, collecting clippings, and writing articles and exhibition reviews, and ultimately Pennell and her husband published their first of three books on Whistler in 1908.[166]

Pennell supported another American artist living in London, Sargent, who exhibited at the RA and the Grosvenor Gallery from 1882, but was also a founding member of the NEAC. As with Whistler, Pennell enthused about Sargent's work in both the English and American press. In 1889, his *Ellen Terry as Lady Macbeth* was much lauded in the *Star* (see Figure 5.9):

Sargent's Ellen Terry as Lady Macbeth is a disappointment, but this is more the fault of the hanging committee than of Mr. Sargent ... What the picture needs is to hang alone, not with the everyday work which hems it in ... Now you can tear yourself away from this awful face and marvel at the cleverness with which it all is painted. There is no use in saying this man is going to do something: HE HAS DONE IT. But year after year one greets with interest and amusement and enthusiasm the great variety in Sargent's work. He has no receipt for the dull background and the glittering head: his only method is to go to nature and try to get something new every time.[167]

As she had with the Newlyn artists who exhibited at the RA, Pennell praised Sargent's work over and above any by Academicians.[168]

Sargent's breakthrough came in America in 1887, with a portrait commission in New York, as well as a long flattering article by Henry James in *Harper's Magazine*.[169] In the *Nation* in 1889, Pennell had positioned Sargent at the forefront of the London art world and the following year he returned to America to paint over 40 portraits in nine months, demonstrating the valuable American patronage.[170] In 1891, Pennell declared that at the RA:

It is no exaggeration to say that the one picture which stands out from the rest, startling in its vigor and animation and cleverness, is Mr. Sargent's 'La Carmencita.' To turn to it from the lifeless canvases which surround it, is like reading a song by Swinburne after a course of average magazine verse ... The portrait overflows with actuality. Even those who may not like it must admit that the brilliant yellow satin gown holds inside it a living human body, and is not a mere stuffed bag like the suit of clothes Prof. Herkomer calls Sir Sydney Waterlow immediately opposite.[171]

Sargent was fortunate in having Pennell as a supporter on both sides of the Atlantic during a crucial period in his career, the late 1880s and 1890s, and in particular as a European correspondent writing for prospective patrons in the burgeoning American marketplace. Although his 'Americanness' was repeatedly addressed in the press, James's 1887 article asserted that distinctions concerning Sargent's nationality were useless, and Marc Simpson observes that neither British nor American critics claimed him as their own.[172] Nonetheless, in the interplay of art and texts circulating during this period, it appears that nationality was a factor, perhaps more implicitly than explicitly, in the London community of artists and critics including James, Pennell, Sargent and Whistler. Yet in Pennell's art writing identity was continually constructed around nationality, however tenuous the link might be in the case of Sargent, born in Florence.

During the 1890s, Sargent achieved popularity with both the British commissioning public and the art establishment, such that from a yearly

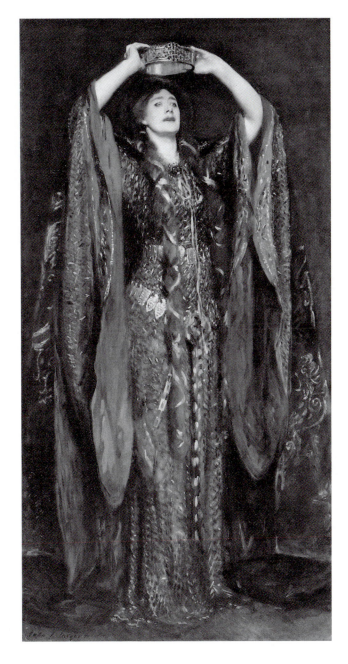

5.9 John Singer Sargent, *Ellen Terry as Lady Macbeth*, 1889, oil on canvas, 375.2 × 198.1 cm

average of two or three English commissions prior to 1893, his output increased dramatically to six in 1894 and 20 in 1898.[173] In 1894 Sargent was made an Associate of the RA and a full member in 1897. Despite his collusion with the 'enemy', Pennell's support for Sargent did not dramatically alter after his election into the RA. Like Meynell, Pennell preferred the work of Sargent to the standard Academy pictures. For Pennell, Sargent was the representative of the modern in an otherwise stagnant and corrupt institution. It was with self-congratulatory bemusement that she wrote in 1901 that 'everyone had now declared the year's Academy meant Sargent'. She could not resist pointing out the irony to her readers that even the *Athenaeum* had said so too:

I shudder to think of the effect on the *Athenaeum*'s retired critic [F. G. Stephens], when in the columns over which he so long presided, he reads a First Notice of the Academy devoted almost entirely to Sargent. He must wonder why the earth does not open and swallow up the false prophet, with the once orthodox paper now fallen into heresy.[174]

However, she observed that Sargent's new-found status was hardly to his own credit, rather the 'anaemic performances' of the average Academician made his work inevitably appear a masterpiece. In order that his work be instead judged by the highest standard, the reader was instructed to jump in a hansom and drive directly to Guildhall where the rooms containing the portraits of Velasquez provided a more suitable comparison than the commonplaces of the Academy. In this space, Pennell proclaimed, Sargent's vivacity, accomplished cleverness and facile brushwork would seem flippant beside the subtle drawing, modelling and harmony of Velasquez. However, Sargent was not completely dismissed in favour of the New Critics' archetypal painter; Pennell felt *Carlyle* would stand the test, while the reserve and pictorial unity of *Mrs. Charles Russell* came close to Velasquez.

Pennell's assertion that Sargent was the single contemporary artist approaching the acclaimed status of Velasquez was a familiar theme in New Criticism. Stevenson had been a fellow student of Sargent's in Carolus-Duran's studio, where they both studied Velasquez's methods; in his shift to art criticism, Stevenson became an enthusiastic proponent of Sargent's work. In 1888 he wrote an article on Sargent for the *Art Journal* analysing the work in terms of poetry and light, and it was his book on Velasquez in 1895 that solidified the New Critics' genealogy of historical precedents for Sargent's and Whistler's work.[175] Again in 1902 Pennell wrote a similar discussion about the dramatic superiority of Sargent's work in comparison to the remainder of the Academy, deeming him a giant among weaklings. She remarked on the 'astonishingly ingenious composition' of *The Ladies Alexandra, Mary, and Theo Acheson*, but added, 'I do not think Mr. Sargent quite lets you forget the ingenuity. There is beauty, it is true, its deliberate artificial elegance, in the – I cannot help feeling – equally artificial animation of the figures'.[176] The Academy

reviews of MacColl and Fry, appearing four days later, were in agreement –
both criticized Sargent's contrived arrangements and 'fake poses'.[177]

In the first decade of the twentieth century, there were many
transformations taking place in the art press, and corresponding changes
occurred within New Criticism. Pennell's definitions around New Criticism
and 'modern' were shifting and being refined. She discussed and commented
on these changes in her column; 1904 brought an end to the popular *Magazine
of Art* which she announced with the proclamation that a young genius would
no longer be presented to the public each month and that the Academy had
lost its greatest ally.[178] This was clearly a reference to none other than the
editor, M. H. Spielmann, and his predilection for artist profiles of academic
artists. Obviously, Pennell would not mourn the magazine's passing. She also
documented and commented on the development and evolution of the
Burlington Magazine. The new periodical did not meet with her immediate
approval despite its articles by Roger Fry. After reading a 1904 issue of the
magazine, including Fry's contributions, she questioned why most art
historians and critics considered dullness to be the first essential quality of
their work. She pointedly observed that R. A. M. Stevenson was never dull,
nor was Morelli. However, she could not say the same for his followers who
were to be found in the *Burlington Magazine*. She considered an article in the
latter, entitled 'What Modern Pictures are Worth Collecting?', which
suggested a method for collecting paintings by choosing those which both the
Athenaeum and the *Saturday Review* agreed upon. 'If the results thus obtained
were confirmed by the *Daily Telegraph* or the *Standard* and not absolutely
condemned by the *Star*, anyone who turned them to practical account would
have the benefit of the best modern expert opinion available.'[179] Pennell was
obviously pleased to have herself ranked with the best expert opinion, and
wrote: 'from a delicate little compliment to the *Star* I also gather that even I, as
a sort of Devil's Advocate, play my part in producing this delightful unity.'[180]
Nonetheless, the compliment did not win her support for the *Burlington
Magazine*, for she announced that she did not agree with much in the article
but did not have the space to elaborate further. Despite her criticism, Pennell
regularly reviewed the latest issue of the *Burlington Magazine* in her column, in
particular the magazine's coverage of modern art collectors.[181]

As critic for the *Star*, Pennell clearly contributed to the introduction of a
New Critical discourse in art writing. Her texts defined and mapped the
multiple factions and coteries that emerged around the 'modern' French art
espoused by the NEAC, and emphasized the blurring of divisions between the
Academy and NEAC, as Sargent and the Newlyn artists acquired membership
of the RA. In her writing during the 1890s, Pennell charted this expansion of
the academic elite and registered her disappointment when this did not result
in their conversion to modernity. Elizabeth Robins Pennell was a strong

proponent of the new painting, even preceding MacColl. Her writing did not simply reflect accepted conceptions of the rhetoric of the New Critics; rather, as an already established advocate of new painting she constructed the discourse labelled as New Criticism. Unlike MacColl, she had not exhibited at the NEAC and was at times critical of NEAC shows. Her writing for the *Nation* enabled a more distanced perspective on Academy doings. Here Pennell discussed the RA as an 'outsider' from an American perspective for an American audience, although clearly her writings were available to British readers. This appeared to give her even more latitude for criticism, at least in the beginning, as an outsider voice. Additionally, she utilized this unique forum to promote the work of the American artists Whistler and Sargent, and thereby influence the market for their work, both within and without England. Furthermore, by the 1890s, the Pennells and Whistler had become close friends and had established a parallel agenda. Pennell positioned herself as the unofficial Whistler publicity agent and became a leading authority on his work. By extension, black and white art, and more specifically her husband, benefited from her reviews and her authorship in their illustrated publications. Elizabeth Robins Pennell's role in the partnership was often elusive to the 1890s public more familiar with her contentious husband, yet her insider knowledge of the London and Paris art worlds made her a formidable critic.

Conclusion

Pennell defined the discourse around the image and movement of New Women in public space. Cycling was considered one of the primary indicators of a New Woman in the press and she actively encouraged independent travel for women. Yet, although in some respects her career and personal life typified the unconventionality of the New Woman, she did not associate herself with the more radical aspects of free love and sexual emancipation labelled as dangerous by the establishment in the press. Moreover, while she retained her position as art critic for a daily with mass readership, the *Star*, and accepted the 'democratic' aims of New Journalism, she addressed cultural philanthropy rather than the sensationalism of its stories. Her account of 'civilizing' projects in the East End engaged with socialist critiques of these attempts to 'improve' the working classes through technical education and art exhibitions. During the last decades of the nineteenth century Pennell participated in the discourse around the New Criticism by repeatedly interrogating the positioning of the RA at the pinnacle of English art production, and by articulating modernity, in the form of French Impressionism, in the London press. Although there were overlaps amongst these three categories and the 'New', they were neither compatible nor closed constructions.

Furthermore, while Pennell contributed to the discourse around the New Criticism, she generally did so pseudonymously and with her identity conflated with her husband's. Ironically, even as Elizabeth Robins Pennell left the sphere of art criticism, with plaudits in the press from her successor at the *Star*, it was Joseph Pennell who was credited for her work. Although Elizabeth Robins Pennell had been the critic responsible for the column, the new columnist began by praising the work and long tenure of Joseph Pennell. 'He has drawn the eyes of the whole world to his column ... even those who disagree with him in many things feel the utmost respect for his courage and for the fearless way in which he has dared to stand alone.'[182] During the 1880s and 1890s, Elizabeth Pennell was able to negotiate professional positions which accessed this overlay of discourses, while capitalizing on and contributing to the growth of these new developments in art criticism, the press, women's lifestyles and careers. Yet Pennell also revealed the slippages within and amongst these new categories, which alternately offered and withheld possible spaces for the texts and careers of women art critics.

Epilogue

'Women have . . . gone very thoroughly into journalism. You only have to go to one of the press views in a London art exhibition to find out how many are art critics' (London, February, 1891).[1]

In 1891 Pennell described the 'Woman's World of London' for her American readers. Not surprisingly she identifies art critics as particularly key examples of the new professionalism among women. However, not only does she signal their importance as art journalists in London as well as Paris, but she goes on to list the reasons why by 1890 it was possible for middle-class women to work in the capital. As Pennell explains it was the confluence of social spaces, such as the Dorothy restaurant and the Somerville club, professional guilds and classes, and ways of moving about the city – 'even cycling!' – that facilitated women's participation so 'very thoroughly' in art criticism. We can of course read these same changes through Pennell's own history – an art correspondent in London and Paris, a cycling New Woman who met colleagues in clubs and dined in restaurants. However, Pennell's article underlines the changes in the 1880s and 1890s experienced by numerous women art writers – hence their attendance in vast numbers at press views at the London art exhibitions.

After 1880, the increased market for art writing paralleled women's growing access to professional journalism and they became major contributors to the press. Women art writers negotiated new developments in the profession alongside shifting educational, economic and social conditions. Journalistic success was imperative to the financial welfare of middle-class women, hence their need to ensure the marketability of their writing within the periodical industry.

Due to their anonymity and the ephemerality of women's contributions to newspapers and periodicals, rather than luxurious art historical tomes, they have been largely left out of art history as it was codified in the twentieth century. As individuals, women were positioned across the sphere of

professional journalism, publishing signed and pseudonymous articles in specialized journals, as well as in the more popular press. In the former, both Meynell and Pennell were acknowledged as critics, using their husband's names, in the *Art Journal* image of 1892. The *Punch* cartoon offers a counterpoint to the 'invisible' women in the specialist periodical image – in the earlier *Punch* illustration the women critics are highly visible and it is implied in great numbers 'Turning an Honest Penny-a-Line' (Figure 6.1). These professional art journalists, although mocked, are writing about the London art world for a diversity of readerships. Although they were seemingly erased from the profession in subsequent accounts, what Pennell's article and these images tell us is that women were in fact present at private views and more importantly looking *and* writing.

In both the *Art Journal* article and the *Punch* image women were grouped together as 'lady' critics and in fact occupied some of the same professional and social circles. However, despite this structural grouping and the benefits of these female networks, they were not occupying the same political, religious or friendship circles, nor did they present an intrinsically female response to contemporary art. Rather, women critics through their individual interventions in art discourse made a fundamental difference to the construction of the discipline, just as it was being professionalized and institutionalized.

Women did not present a unified perspective on contemporary art, but rather voiced a multiplicity of perspectives, revealing dissonances as well as commonalities. The three case studies reveal very different interpretations of art, presenting a wide range of questions. All three women were born between 1845 and 1855 and began their journalism careers between 1872 and 1882, but Fenwick Miller wrote her first article at the age of 18, whilst Pennell and Meynell did not begin their careers until their late twenties. These three women offer interesting contrasts in their attitudes towards the establishment, modern art and religion. For example, for Meynell, Roman Catholicism was a guiding principle in her writing, whereas although Pennell's parents were Roman Catholic, religion was not a declared position, but a more private matter. They were all married, yet had different ways of juggling responsibilities. Meynell, Fenwick Miller and Pennell were very involved in the changing ideology concerning the role of women during that era; these late-nineteenth-century women subscribed to differing versions of feminism as it evolved over the ensuing three decades. Meynell wrote for suffrage papers, presided over suffrage societies and participated in marches. Fenwick Miller advocated the rights of women in various spheres, particularly through the *Woman's Signal*, and Pennell wrote on Wollstonecraft and Ibsen, though Pennell seemed to simply reinstate the boundaries between male and female art practice in her writing by not deigning to write about women – as if only art produced by men merited criticism.

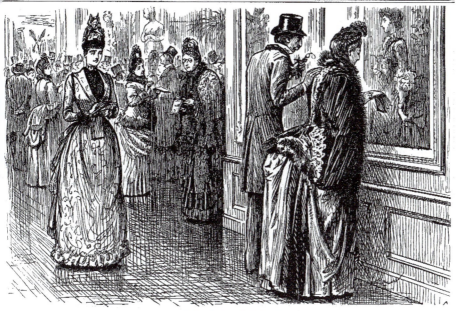

A JUBILEE PRIVATE VIEW.
(*Turning an Honest Penny-a-Line.*)

The Duchess of Dilwater (Art-Critic to the South Pentonville Gazette) writes in her Note-book :—"THE FUNDAMENTAL THEME OR LEIT-MOTIF OF MR. SOAPLEY'S EXQUISITE PORTRAIT OF MRS. BLAZER, IS AN IMPASSIONED *ADAGIO* IN THE MINOR KEY OF BLUE, TENDERLY EMBROIDERED WITH A SUB-DOMINANT FUGUE IN GREEN AND GRAY AND GOLD!" &c., &c.

Lady Slangboro (Purveyor of Social pars to the Bermondsey Figaro) :—"IT'S ALL TOMMY ROT ABOUT THE DUCHESS OF DILWATER NOT BEING ON SPEAKING TERMS WITH HER LEARY OLD BLOKE OF A SPOUSE. BOTH THEIR GRACES WERE PRESENT, DARBY-AND-JOANING IT ALL OVER THE SHOP." &c., &c.

Viscountess Crewelstown (who does the Fashions for the Barnes and Putney Express' :—"LADY SLANGBORO WAS THERE, LOOKING LOVELY IN A RICH SALMON ÉCRU POULT DE SOIE MATELOTTE RUCHÉE À LA BARIGOULE, WITH POINTES D'ESTRAGON PANACHÉ, AND BOUILLON-AISES OF THON MARINÉ EN JARDINIÈRE, FROM MADAM ALDEGONDE'S (719, PICCADILLY)." &c., &c.

6.1 'A Jubilee Private View', *Punch*, 18 June 1887

Although Meynell, Fenwick Miller and Pennell considered some of the same issues, such as the Royal Academy, Newlyn, the nude and attitudes to women artists, they did so from disparate viewpoints. In their writing on life study, women artists and exhibitions, these critics on the one hand iterated discourses based on sexual difference, claiming specific advantages for female expression, and on the other hand drew on egalitarian arguments in critiques of segregated exhibition practices. Alice Meynell's writing and correspondence constitutes a vital archive around one particular artist, her sister, disclosing the familial relationship and concomitant attempt to resuscitate Butler's career in the press. One unique facet of Meynell's career was its diversity, the sheer volume of her publishing; she wrote for a variety of editors, publics and markets. Her writing crossed movements and subject positions, praising Royal Academic neoclassicism and French Impressionism alike. These seemingly contradictory

interventions represent an interest in a kaleidoscope of artists, editors, critics and buyers that discloses a more realistic portrayal of the late Victorian art world than has traditionally been mapped through art history. Individual journalists, as exemplified by Meynell, registered a diversity of loyalties to artists; critics, like artists, slipped between and among overlapping circles, revealing the permeability of the borders around artistic groupings and categorizations during the period. Loyalties were dependent on a diversity of factors that encompassed family links, periodical editors, professional and friendship networks, religious and political affiliations and economic constraints.

Florence Fenwick Miller's political actions on platform and in pen were constitutive to both her name and reputation, and to her promotion of the cause of women both in art education and as practising artists. She recognized the economic and social status of women working in elite culture, realizing the opportunities that this cultural capital offered to the women's movement. However, her writing on Rae in particular reveals the instability of the egalitarian feminist position. While demanding that 'great women artists' be judged on the same terms as men, Fenwick Miller identified the educational and institutional disparities with regard to gender. Writing for the *Illustrated London News* in the 1880s, she had a far wider readership than specialist art periodicals, not only within Britain but throughout the empire. Fenwick Miller's 'Ladies' Column' regularly advocated women's work and women's rights to an audience that few art critics would ever address.

In contrast, Elizabeth Robins Pennell was not concerned specifically with women artists. Rather she addressed the history of feminist thought and traversed London, the modern metropolis, and its continental periphery as a New Woman, reifying her independent public persona in print. Furthermore, her contribution to art criticism was vital to contemporary understanding of 'modern' French painting. Like Fenwick Miller's, her writing addressed a broad audience beyond the specialist press. The high-circulation *Star* proclaimed it was reaching the 'masses', while her writing for numerous American periodicals, especially the *Nation,* implied a transatlantic readership.

Why have these early women art critics disappeared from the history of art criticism? The answer in part relates to the question of signature, as I have outlined in the case of, for example, Elizabeth Robins Pennell alias A. U. or N. N. However another compelling reason is simply that the significance of the art journalism of this period to the wider history of art criticism has been vastly underestimated. The writing of art history in Britain has more often alluded to volumes, be they biographical or historiographical. Books are more easily accessible and available to art historians and consequently so are their 'authors' – more often male and named. However it is only by studying the art criticism contained in the periodicals of this period that we reveal the close

involvement of women in interpreting contemporary art. Furthermore, the art journalism of this period is of particular significance given how closely allied artists and critics were during the late nineteenth century. As I have shown, art journalism was vital to the construction of the public personae of artists and the operation of the burgeoning art market. We have examined the importance of art journalist for artists, for example, in relation to Meynell's studio profiles of artists such as Holman Hunt and Herkomer (see above, Chapter 3). We have also seen the close relationship between art journalists and contemporary art movements such as the Newlyn School and the NEAC. Artists and critics colluded in critical projects which were, in part, constructed through art journalism. Arguably it was particularly necessary for artists working on the edges or margins of the art establishment (that is, the Royal Academy) to cultivate strong relationships with art journalists in order to present their art to the buying public. We have seen this dynamic at work, for example, in the relationship between Pennell and Whistler (above, Chapter 5). Ironically it is frequently these marginal movements that are now at the centre of our understanding of nineteenth-century art history. Yet the role played by art journalism in the construction of these movements is often itself now marginalized. One casualty of this marginalization is the contribution of women art journalists to art history.

In fact, reflected in the work of these women writers is a microcosm of the tensions within the art of the period. For example, one commonality in all three critics was their particular awareness of the problem of the Royal Academy at the end of the century. However, they each identified very different aspects of this problematic. For Meynell it was a question of her sister's exclusion, as well as the position of the Newlyn School. For Fenwick Miller it was the RA debarring women members. Pennell, on the other hand, is most critical of the polarity between the Academy and the NEAC, or French Impressionism. However, historically this overlap in questioning the power, judgment and fallibility of the RA is significant.

There is a second important question raised by the case histories of these women writers: why, given their significant contribution at the end of the nineteenth century, did women disappear from prominence in art writing in the twentieth century? One answer is that, as in other fields, women had taken advantage of opportunities when the profession was open and risky; as art criticism became more established, it became more male-dominated. The opportunities for specialist publishing had diminished with the demise of the *Magazine of Art* in 1904. The new *Burlington Magazine* and the *Connoisseur* did not publish comparable levels of women's writing. After the turn of the century, avant-garde art criticism acquired an increasingly masculine status, linking new periodicals with individual critics and institutions.

In addition, by this point in time, established women critics, such as Meynell and Pennell, were shifting to book projects which did not require the rigours of regimented gallery-going. The poems and essays for which Meynell is more widely known were published in several editions. Pennell continued to revisit her own experiences as an art critic at the *fin de siècle* in various volumes, including her biographies of Whistler and Joseph Pennell. The court cases and vicious feuds of the 1890s did not dissipate; perhaps appropriately, the 1908 Whistler biography was only published after an unsuccessful suit by the executrix of Whistler's estate, Rosalind Birnie Philips. In 1916 Pennell again returned to this period; her title, *Nights: Rome, Venice in the Aesthetic Eighties; London, Paris in the Fighting Nineties*, embodied the whirlwind of interactions with artists and literary figures in the salons and exhibitions of the day.

The suffrage movement presented other priorities for women: Meynell was one of many journalists, both of her own generation and younger, to turn her pen to organizations calling for the vote. She became increasingly active in suffrage work, as did her children. She wrote to her husband detailing the children's suffrage activities: 'Lobbie [Viola] is selling at the Bank ... I went to her corner and bought two "Votes". She does not mind the remarks "Go home and mind the kids" and "Go home and burn your papers". They are not too frequent.'[2] Not only was Viola selling 'Votes', Meynell's article on 'Daughter's Portions' was rewritten for *Votes for Women* in 1914, under the title 'Votes for Duties'. Elizabeth Pethick Lawrence sent a telegram to thank her for her involvement: 'We felt very honoured to have your article in our summer Double Number of "Votes for Women". I thank you most warmly for giving us so very valuable an expression of your sympathy and support for all that is best in the Woman's Movement.'[3] Her family correspondence also referred to this activism: 'This morning the Catholic Suffrage Society made a good demonstration in the Cathedral. We mustered a great company, and a good many of the W.S.P.U.[Women's Social and Political Union] came and added to our apparent number.'[4] Similarly, Fenwick Miller remained very involved in the women's movement and was elected president of the Women Writers' Suffrage League in 1915. Like Meynell, her daughter became involved in suffrage. In fact, Irene was arrested in 1906 for her part in the Women's Social and Political Union demonstration in the Lobby of the House of Commons.

In the 1914 periodical *Blast* the Vorticists blasted 'Clan Meynell' as representing – along with the years 1837–1900, the British Academy and Codliver Oil – all that this new avant-garde art movement hated (Figure 6.2). Rather than speaking for new art movements, Meynell was positioned in opposition to them. Here Meynell's entourage and the reading public lampooned by Beerbohm were further derided. However, in placing 'Clan Meynell' in this binary opposition, the Vorticists also signalled her importance in defining the artistic and cultural developments that preceded Vorticism. In

BLAST

The Post Office Frank Brangwyn Robertson Nicol

Rev. Pennyfeather Galloway Kyle
(Bells) (Cluster of Grapes)

Bishop of London and all his posterity

Galsworthy Dean Inge Croce Matthews

Rev Meyer Seymour Hicks

Lionel Cust C. B. Fry Bergson Abdul Bahai

Hawtrey Edward Elgar Sardlea

Filson Young Marie Corelli Geddes

Codliver Oil St. Loe Strachey Lyceum Club

Rhabindraneth Tagore Lord Glenconner of Glen

Weiniger Norman Angel Ad. Mahon

Mr. and Mrs. Dearmer Beecham Ella

A. C. Benson (Pills, Opera, Thomas) Sydney Webb

British Academy Messrs. Chapell

Countess of Warwick George Edwards

Willie Ferraro Captain Cook R. J. Campbell

Clan Thesiger Martin Harvey William Archer

George Grossmith R. H. Benson

Annie Besant Chenil Clan Meynell

Father Vaughan Joseph Holbrooke Clan Strachey
21

6.2 *Blast*, 1914

a sense, and for all its acidity, Meynell's appearance in *Blast* offers us a glimpse
of the significant role this generation of women played in the construction of
art history both within the Victorian–Edwardian period and beyond it.

Notes

Chapter 1

1. M. H. Spielmann, 'Press Day and the Critics', *MA* (1892), pp. 222–28.

2. The 1880s coincided with the beginning of the New Journalism, identified by Matthew Arnold, and associated with W. T. Stead and the *Pall Mall Gazette*. This new mode of popular publishing was defined by interviews, mass readership and the professionalization of the industry. On the importance of periodicals as primary research materials, see Joanne Shattock and Michael Wolff (eds), *The Victorian Periodical Press: Samplings and Soundings* (Leicester: Leicester University Press, 1982). Periodicals have been identified as constructive, rather than reflective, of meaning, and as active and integral parts of culture, drawing on Barthes' definition of the text as a methodological field and site of interdisciplinarity. Lyn Pykett, 'Reading the Periodical Press: Text and Context', *Investigating Victorian Journalism*, eds Laurel Brake, Aled Jones and Lionel Madden (London: Macmillan, 1990), pp. 3–19.

3. Alvar Ellegård, 'The Readership of the Periodical Press in Mid-Victorian Britain', *Göteborgs Universitets Årsskrift*, 63 (157), p. 17–36; Richard Altick, *English Common Reader* (Chicago: Chicago University Press, 1957); *Daily Chronicle* 1893 155 000; Liberal–Radical halfpenny evening *Star* claimed 250 000 soon after it was launched; Lucy Brown, *Victorian News and Newspapers* (Oxford: Clarendon Press, 1985), pp. 26–53.

4. On the *Magazine of Art* see Julie Codell, 'The Artists' Cause at Heart: Marion Harry Spielmann and the Late Victorian Art World', *Bulletin of the John Rylands University Library of Manchester*, 71 (Spring 1989), pp. 139–63.

5. Elizabeth Prettejohn, 'Aesthetic Value and the Professionalization of Victorian Art Criticism 1837–78', *Journal of Victorian Culture* (Spring 1997), p. 72.

6. See Kate Flint (ed.), *Impressionists in England: The Critical Reception* (London: Routledge, 1984), *The Victorians and the Visual Imagination* (Cambridge: Cambridge University Press, 2000); John Stokes, *In the Nineties* (New York: Harvester Wheatsheaf, 1989), pp. 33–54; Elizabeth Prettejohn, 'Out of the Nineteenth Century: Roger Fry's Early Art Criticism 1900–1906', *Art Made Modern: Roger Fry's Vision of Art*, ed. Christopher Green (London: Courtauld Institute of Art, 1999), pp. 31–44.

7. For female contributors to one periodical, see Marysa Demoor, *Their Fair Share: Women, Power and Criticism in the Athenaeum* (Aldershot: Ashgate, 2000).

8. Rosemary Betterton (ed), *Looking On: Images of femininity in the visual arts and media* (London: Pandora Press, 1987), p. 2.

9. See Lee Holcombe, *Victorian ladies at work; middle-class working women in England and Wales, 1850–1914* (Newton Abbot: David and Charles, 1973); Deborah Epstein Nord, *Walking the Victorian Streets: Women, Representation and the City* (Ithaca and London: Cornell University Press, 1995); Judith R. Walkowitz, *City of Dreadful Delight: Narratives of Sexual Danger in Late-Victorian London* (London: Virago, 1992).

10. Claire Richter Sherman with Adele M. Holcomb (eds), *Women as Interpreters of the Visual Arts, 1820–1979* (Westport: Greenwood Press, 1981). The volume included two Victorian art critics who have been the focus of subsequent studies: Adele M. Holcomb, 'Anna Jameson (1794–1860): Sacred Art and Social Vision', and Colin Eisler, 'Lady Dilke: The Six Lives of an Art Historian'; Judith Johnston, *Anna Jameson: Victorian Woman of Letters* (Aldershot: Scolar, 1997); Kali Israel, *Names and Stories: Emilia Dilke and Victorian Culture* (New York and Oxford: Oxford University Press, 1999).

11. Pamela Gerrish Nunn, 'Critically Speaking', *Women in the Victorian Art World*, ed. Clarissa Campbell Orr (Manchester: Manchester University Press, 1995), p. 109.

12. Ibid.

13. Deborah Cherry, *Beyond the Frame: Feminism and Visual Culture, Britain 1850–1900* (London: Routledge, 2000), p. 178.

14. See Michel Foucault, 'The Order of Discourse', *Untying the Text*, ed. Robert Young (Boston and London: Routledge and Kegan Paul, 1981), pp 51–53.

15. The subjectivity of the individual is the site of the battle for power, where the individual is an active but not sovereign protagonist. Being a woman is 'no guarantee that one's writing will challenge hegemonic norms or imply a different, resistant and specifically female discourse.' Chris Weedon, *Feminist Practice and Post-Structuralist Theory* (Oxford: Basil Blackwell, 1987), pp. 41, 170.

16. Michel de Certeau, *The Practice of Everyday Life*, trans. Steven Randall (Berkeley: University of California Press, 1984), p. 36, discussed in Rey Chow, *Writing Diaspora: Tactics of Intervention in Contemporary Cultural Studies* (Bloomington and Indianapolis: Indiana University Press, 1993), p. 16.

17. Lynne Walker, 'Vistas of pleasure: Women consumers of urban space in the West End of London 1850–1900' in Orr, pp. 70–85; Lynda Nead, *Victorian Babylon: People, Streets and Images in Nineteenth-Century London* (New Haven and London: Yale University Press, 2000).

18. Julie Codell, 'When Art Historians Use Periodicals: Methodology and Meaning', *Victorian Periodicals Review*, 34:3 (Fall 2001), p. 286.

19. Fenwick Miller born 1854, journalism published from 1872; Meynell born 1847, journalism published from 1876; Pennell born 1855, journalism published from 1882.

20. Aliquis, 'Art Critics of Today', *AJ* (July 1892), p. 193.

Chapter 2

1. See Carol Dyhouse, *Girls Growing Up in Late Victorian and Edwardian England* (London, Boston and Henley: Routledge and Kegan Paul, 1981); June Purvis, *A History of Women's Education in England* (Milton Keynes: Open University Press, 1991); Phillippa Levine, *Feminist Lives in Victorian England* (Oxford: Basil Blackwell, 1990).

2. June Badeni, *The Slender Tree* (Padstow, Cornwall: Tabb House, 1981), pp. 7–8, 17, 34; Elizabeth Vogt, 'Honours of Morality: the Career, Reputation and Achievement of Alice Meynell as a Journalistic Essayist', (PhD thesis, University of Kansas, 1990), pp. 7–8; Viola Meynell, *Alice Meynell: A Memoir* (London: Jonathan Cape, 1929), p. 52.

3. Florence Fenwick Miller, 'An Uncommon Girlhood', Contemporary Medical Archives Centre (CMAC), Wellcome Library, GC/228/5.

4. Charles Dilke, 'Memoirs', British Library (BL), Add. Mss 43946, p. 27.

5. Rosemary T. Van Arsdel, 'Victorian Periodicals Yield Their Secrets: Florence Fenwick Miller's Three Campaigns for the London School Board', *Bulletin: History of Education Society* (1986), p. 36.

6. Angela Emanuel (ed.), *A Bright Remembrance: The Diaries of Julia Cartwright 1851–1924* (London: Weidenfeld and Nicolson, 1989).

7. Campbell also wrote for the *Saturday Review, Pall Mall Gazette, National Review, Art Journal, Lettres des Artes, Realm, Lady's Field*. See G. H. Fleming, *Victorian Sex Goddess* (Gloucestershire: Windrush Press, 1989).

8. *Athenaeum, Magazine of Art, Yellow Book*. De Mattos was the sister of the New Critic, R. A. M. Stevenson, and the cousin of R. L. Stevenson. See Demoor, *Their Fair Share*, p. 91.

9. Beale wrote for the *Monthly Review, American Architect and Building News, Sunday Magazine, Good Words, Universal Review, Portfolio, Temple Bar, Reliquary* and also ran a School of Art. See M. Clarke,

'Sarah Sophia Beale', NDNB entry on Beale for a biographical account of her life and work (2004); Cherry, *Beyond the Frame*, pp. 19–28. Zimmern's publications included: *Art Journal, National Review, Atalanta, Blackwood's Magazine*, and *Magazine of Art*; Lee's included: *Contemporary Review, Longman's Magazine, Fortnightly Review, Atlantic Monthly, New Review, Macmillan's Magazine, Harper's Monthly, Quarterly Review*; M. Hepworth Dixon's included: *Lady's Realm, Art Journal, Magazine of Art, Fortnightly Review, Architectural Review*.

10. See Diana Maltz, 'Engaging "Delicate Brains": From Working-Class Enculturation to Upper-Class Lesbian Liberation in Vernon Lee and Kit Anstruther-Thomson's Psychological Aesthetics', *Women and British Aestheticism*, eds Talia Schaffer and Kathy Alexis Psomiades (Charlottesville: UP of Virginia, 1999), pp. 211–32; Hilary Fraser, 'Women and the Ends of Art History: Vision and Corporeality in Nineteenth-Century Critical Discourse', *Victorian Studies* (Winter 1998), pp. 77–100.

11. Nord, *Walking the Victorian Streets*, pp. 181, 206. See George Gissing, *Odd Women* (London: Lawrence and Bullen, 1893).

12. Margaret Bateson, *Professional Women Upon Their Professions* (London: Horace Cox, 1895), pp. 130–33.

13. George Romanes, 'The Mental Differences Between Men and Women', *British Medical Journal* (20 August 1887) discussed in Lucy Bland, *Banishing the Beast: English Feminism and Sexual Morality 1885–1914* (London: Penguin, 1995), pp.76–77.

14. Her review of Ludwig Büchner's article, 'The Brain of Women', *New Review* (August 1893), pp. 166–76, questioned the accuracy of his data on female brains and pinpointed the absence of two key variables: the relative weights of regions of the brain, and brain to body weight proportionality. Fenwick Miller, 'The Ladies' Column', *ILN* (26 August 1893), p. 262. Few women had the medical knowledge to argue with this accepted paradigm, and indeed the studies were incomplete and statistically skewed. See Stephen Jay Gould, *The Mismeasure of Man* (New York: W. W. Norton, 1981), pp. 103–107.

15. Mrs. Henry Chetwynd, Mrs. Rentoul Esler and Mrs. Haweis, 'What to do with our daughters', *Lady's Realm* (November 1897) in *Over the Teacups*, ed. Dulcie M. Ashdown (London: Cornmarket Press, 1972), pp. 105–109.

16. Bland, *Banishing the Beast*, pp. 230–31.

17. Clara Collet, 'Prospects of Marriage for Women', *NC* (April 1892), p. 551.

18. Clara Collet, 'The Educated Position of Working Women', (1890) in *Educated Working Women* (London: P. S. King and Son, 1902), pp. 23–24.

19. FFM, CMAC, GC/228/4; GC/228/27; Van Arsdel, 'Victorian Periodicals Yield Their Secrets', p. 30.

20. Emanuel, pp. 7–8.

21. John Oldcastle, *Journals and Journalism with a Guide for Literary Beginners* (London: Field and Tuer, 1880), p. 16; see also Barbara Onslow, *Women of the Press in Nineteenth-Century Britain* (Basingstoke: Macmillan, 2000).

22. 'Lady Journalists', *Lady's Pictorial* (11 November 1893), p. 734.

23. Bateson, pp. 125–28.

24. W. T. Stead, 'Young Women and Journalism', *Young Woman* (October 1892), p. 12.

25. Frances Low, *Press Work for Women* (London: L. Upcott Gill, 1904), p. 13.

26. Laurel Brake, *Subjugated Knowledges*, (London: Macmillan, 1994), p. 75; George Moore, *Literature at Nurse* (London: Vizetelly, 1885), p. 18; Moore, 'A New Censorship of Literature', *PMG* (10 December 1884), pp. 1–2; Gerd Bjørhovde, *Rebellious Structures* (Oslo: Norwegian University Press, 1987), p. 10. See also Kate Flint, *The Woman Reader: 1837–1914* (Oxford: Clarendon Press, 1993).

27. See [W. T. Stead], 'Women and the Study of Contemporary History', *Review of Reviews* (June 1890), pp. 470–71; [E. T. Cook], 'Mr. Cook's Impressions', *Review of Reviews* (February 1893), pp. 155–56 in Brake, pp. 100–101.

28. Margaret Beetham, *A Magazine of Her Own?* (London: Routledge, 1996) p. 122.

29. Stead, 'Young Women and Journalism', p. 12.

30. Bateson, p. 126.

31. E. A. Bennett, *Journalism for Women* (London and New York: John Lane, 1898), p. 98.

32. Ibid., p. 10.

33. 'Mr. Gibbons and the *Lady's Pictorial*', *The Sketch* (30 January 1895), p. 23.

34. James J. Nolan. 'A Few Don'ts', *Woman Journalist* (May 1912), p. 1.

35. Low, p. 91.

36. Stead, 'Young Women and Journalism', p. 12.

37. According to Stead, any girl who had a proper self-respect could go about her business at all hours in English-speaking countries without serious risk of personal safety or reputation. Stead, 'Young Women and Journalism', p. 13.

38. Martha Vicinus, *Independent Women 1850–1920: Work and Community for Single Women* (London: Virago, 1985), p. 297.

39. Walkowitz, *City of Dreadful Delight*, pp. 127–28

40. Nord, p. 183. In a letter to her husband Pennell related her displeasure with the gruesome press furore over the murders: 'Two men outside my window are shrieking "Horrible Murder! Another young lady cut in small pieces!" The pussycat sits sick and downcast on a chair by my side. Melancholy isn't it?' ERP to JP, n.d., LC, PC, box 307. Fenwick Miller wrote in the *Daily News* declaring the murders were not homicides but 'women killing'. Her letter generated responses and called for the economic and political emancipation of women; however, the *Star* disagreed, stating that it was a class question rather than a sex question. *Daily News* (4, 6, 9, 11 October 1888) quoted in Walkowitz, pp. 191, 224–25.

41. Investigation of public life, city streets, workplaces and commercial districts threatened middle-class women's respectability and challenged their authority. Nord, p. 240.

42. 'No editor in his senses wants either mannish women or womanish men on his staff.' Stead, 'Young Women and Journalism', p. 13.

43. Ibid., p. 14.

44. Miss Billington, 'How Can I Earn My Living?' *The Young Woman* (June 1894), p. 308.

45. Walker, p. 79.

46. Aliquis, 'Art Critics of To-Day', *AJ* , (July 1892), pp. 193–97; M. H. Spielmann, 'Press-Day and the Critics', *MA* (1892), pp. 186–88, 222–28.

47. Aliquis, p. 193.

48. Spielmann, p. 224.

49. 'What it Means to be a Lady Journalist', *Young Woman* (8: 1898), pp. 93–94.

50. Bateson, p. 128.

51. Marie Belloc Lowndes, *The Merry Wives of Westminster* (London: Macmillan, 1946), p. 15.

52. Evelyn March Phillipps, 'The working lady in London', *FR* , 52 n.s. (1 August 1892), p. 194.

53. The standard rates for women's columns were: 15s to £ 1 for 1½, 2, even 3 columns. Low, p. 48.

54. Belloc Lowndes, pp. 14–15; see also her 'The Experiences of a Woman Journalist', *Blackwood's Magazine* (June 1893), pp. 830–38.

55. A. Amy Bulley and Margaret Whitely, *Women's Work* (London: Methuen and Co., 1894), p. 7.

56. Low, p. 84.

57. Oldcastle, p. 14.

58. The *Academy* rate was £ 1 / page. C. Appleton to E. F. S. Pattison, (1873), BL Add. Mss 43908, fol. 13.

59. The wage of her intellectual work was her husband's by 'right', but even after the passage of the Married Women's Property Act he tried to claim her inheritance from her mother as his 'moral right'. Through his position as one of Mrs Strong's executors he managed to usurp control of the money despite its intentions for his wife 'notwithstanding coverture'. Mss Pattison 118 fol 40 (EP to ES, 17 March 1880) in Israel, *Names and Stories*, p. 117. See also Eisler, p. 163.

60. Emanuel, pp. 16–17.

61. Sir Francis Meynell, *Catalogue of the Alice Meynell Centenary Exhibition* (1947), p. 11.

62. David Rubinstein, *Before the Suffragettes: Women's Emancipation in the 1890s* (Brighton: Harvester Press, 1986), p. 87. Demoor, *Their Fair Share*, p. 138. Elliott and Wallace identify the paradox of Virginia Woolf's preference for writing for journals which paid well, over the writing which expressed her own point of view, in spite of the former's associations with women editors and a

'popular' feminine marketplace. *Women Artists and Writers: Modernist (Im)positionings* (London: Routledge, 1994), p. 72.

63. Aled Jones, *Powers of the Press: Newspapers, Power and the Public in Nineteenth Century England* (Aldershot: Scolar Press, 1996), p. 132.

64. W. T. Stead, '*PMG,*' *Review of Reviews* (February 1893), p. 151; Stokes, pp. 16–19.

65. Charles Booth's surveys of London indicate that for one-third of the population even ha'penny or penny publications would have been prohibitively expensive. More likely the readership included the expanding lower middle classes. Beetham, pp. 120–25; Walkowitz, *City of Dreadful Delight*, p. 95–96.

66. Stokes, pp. 21–23.

67. The New Criticism will be readdressed in Chapter 5.

68. W. T. Stead, 'Government by Journalism', *Contemporary Review* (May 1886), pp. 653–74; See Brake, p. 94; Jones, p. 133.

69. Evelyn March Phillips, 'The New Journalism', *New Review* (August 1895), p. 187.

70. Florence Fenwick Miller, editor of the *Woman's Signal*, ran weekly interviews during 1895 and 1896. Rosemary T. Van Arsdel, 'Women's Periodicals and the New Journalism: The Personal Interview', *Papers for the Millions*, ed. J. Wiener (New York: Greenwood Press, 1988), pp. 246–53.

71. Brake, p. 60. See also Prettejohn, 'Aesthetic Value and the Professionalization of Victorian Art Criticism 1837–78', p. 78.

72. Harold Perkins, *The Rise of Professional Society: England Since 1880* (London and New York: Routledge, 1990), p. 4.

73. Rita Kranidis identifies the inconsistency in Sarah Grand's portrayal of women in journals and novels as the result of editorial control and Margaret Oliphant's alliance with labour for money rather than artistic purpose: *Subversive Discourse* (London: Macmillan, 1995), pp. 51, 64.

74. Demoor, *Their Fair Share*, pp. 7–8.

75. Jacques Derrida sees signature as a mobile yet regulatory borderline between the text and the author, authenticating the first as a product of the second, whilst also acting as a promise and a guarantee. Derrida, 'Signature, Event, Context', P. Kamuf (ed.), *A Derrida Reader: Between the Blinds* (Hemel Hempstead: Harvester, 1991), pp. 571–98; see Cherry, *Beyond the Frame*, p. 118.

76. B.L, Add. Mss 43946, 'Memoirs', p. 27.

77. Albert Dawson, 'Mrs. Fenwick Miller at Home', *Young Woman* (May 1893), pp. 272–73. The interviewer, Dawson, also noted that her two children took the name of Miller-Ford. As we shall see in Chapter 4 she felt this issue was inextricably linked to that of identity.

78. Kranidis references the findings of Kahler-Marshall that *all* late Victorian women writers published under names other than their own at one point or another. Kranidis, p. 53.

79. See Elaine Showalter, *A Literature of Their Own* (London: Virago, 1982), pp. 58–60.

80. Kranidis, p. 53.

81. In 1879 the *Magazine of Art* exemplified the Meynells' use of varied appellations: Alice Oldcastle, 'Mrs. Jameson', pp. 123–25; Wilfrid Meynell, 'Lawrence Alma-Tadema', pp. 193–97; John Oldcastle, 'Elizabeth Butler', pp. 257–62.

82. Tamar Garb, '"Unpicking the Seams of her Disguise" Self-representation in the case of Marie Bashkirtseff', in her *Block Reader in Visual Culture* (London: Routledge, 1996), pp. 115–28.

83. Alice Meynell, 'A Woman's Fancies: Daughter's Portions', *Daily Chronicle* (30 May 1896), p. 8.

84. See *Englishwoman's Year Book* (1899–1905). For example, in an interesting twist Alice Meynell, writing anonymously in the *Pall Mall Gazette*, registered her cognizance of Leader Scott's *nom de plume* when she reviewed 'her' book *Echoes of Old Florence*. 'Wares of Autolycus', *PMG* (23 February 1894), p. 5.

85. Edmund W. Gosse, 'Our Living Artists: Hamo Thornycroft ARA', *MA* (1883), pp. 328–32.

86. In her analysis of Stephens's role as a critic, Dianne Sachko Macleod has documented that he went so far as to allow Rossetti and Millais to read the proofs of everything he wrote about them in the press. Additionally, as the art critic for the *Athenaeum*, Stephens incorporated texts written by Rossetti describing his own works into his articles. Dianne Sachko MacLeod, ' F. G. Stephens, Pre-Raphaelite critic and art historian', *Burlington Magazine* (June 1986), p. 399.

87. Judith Butler, *Gender Trouble: Feminism and the Subversion of Identity* (New York and London: Routledge, 1990) pp. 25, 141.

88. Beetham, p. 128.

89. Phillipps, 'The New Journalism', p. 187.

90. Meynell, Fenwick Miller and Pennell were all approached by the interviewing press. See for example of Meynell, 'Interview by Mrs Roscoe Mullins', *Sylvia's Journal* (October 1893), p. 549; 'Interview by Isabel Brooke Alder', *Englishwoman* (April 1897), p. 115.

91. Beetham, pp. 127–29.

92. See *Lady's Pictorial* (17 December 1881); *Hearth and Home* (23 July 1891); Dawson, *Young Woman.*

93. Van Arsdel, 'Women's Periodicals and the New Journalism', pp. 253–55.

94. Brake, pp. 56–58.

95. Carol T. Christ, 'The Hero as a Man of Letters', *Victorian Sages and Cultural Discourse*, ed. Tha s E. Morgan (New Brunswick: Rutgers University Press, 1990), pp. 22–25.

96. Morgan, 'Sage Discourse and the Feminine', in *Victorian Sages and Cultural Discourse*, p. 7.

97. Philip Gilbert Hamerton, *Thoughts about Art* (London: Macmillan, 1873), p. 160.

98. See Sherman; Jane Robinson, *Wayward Women, A Guide to Women Travellers* (Oxford: Oxford University Press, 1990).

99. See for example, Helen Zimmern, 'Laon', *AJ* (1884), pp. 233–34; Julia M. Ady, 'Vanishing Rome', *AJ* (February 1890), pp. 33–40; Sophia S. Beale, *The Churches of Paris from Clovis to Charles X* (London: W. H. Allen, 1893); Leader Scott, *Bartolommeo di Paolo and Mariotto Albertinelli, Andrea D'Agnolo* (London: Sampson, Marston, Searle and Rivington, 1881).

100. Carol Dyhouse, *No Distinction of Sex: Women in British Universities 1870–1939* (London: University College, 1995), pp. 12–13.

101. Christopher Kent, 'Periodical Critics of Drama, Music, and Art, 1830–1914: A Preliminary List', *Victorian Periodicals Review*, 7 (Spring/Summer 1980), p. 33.

102. Gayle Tuchman and Nina Fortin, *Edging Women Out: Victorian Novelists, Publishers, and Social Change* (New Haven: Yale University Press, 1989), p. 73.

103. Brown, pp. 78–80.

104. Prettejohn, 'Aesthetic Value and the Professionalization of Victorian Art Criticism', pp. 73–79.

105. Eisler, p. 154.

106. Emanuel, p. 93.

107. This corroborates Perkins' analysis of the period: 'specialization leads directly to professionalization.' Perkins, p. 23.

108. 'What Editors Want', *Woman Journalist* (March 1912), p. 1; L. L., 'The Training of the Woman Journalist', *Woman Journalist* (January 1913), p. 2.

109. Tuchman and Fortin, pp. 9, 174.

110. Beetham, pp. 127–28.

111. 'Notes of the Week', *PJ* (29 May 1889), p. 26.

112. Andrew Stephenson, 'Refashioning modern masculinity: Whistler, aestheticism and national identity', *English Art 1860–1914: Modern artists and identity*, eds David Peters Corbett and Lara Perry (Manchester: Manchester University Press, 2000), p. 135. See also Julie Codell, 'Artists' professional societies: production and consumption and aesthetics', *Towards a Modern Art World*, ed. Brian Allen (New Haven and London: Yale University Press, 1995), pp. 169–83.

113. Stokes, p. 19.

114. 'Literature', *Englishwoman's Year Book, 1899*, p. 120.

115. M. H. Spielmann, 'Press Day and the Critics', *MA* (1892), pp. 227–28.

116. *Englishwoman's Year Book, 1900*, p. 137.

117. *Fourth Annual Report of the Society of Women Journalists* (1897–98), p. 8.

118. *Seventh Annual Report of the Society of Women Journalists* (1900–01).

119. Bulley and Whitely, p. 5.

120. 'Where Man is Never Missed', *Sketch* (12 June 1895), p. 386.

121. '[T]his little demonstration, which points at women working in literature alone, and apart from men, is a thoroughly unhealthy sign ... There are no distinctly feminine lines of literature [that] working women should try to make themselves into a class separate and apart is foolish and unnatural.' [Walter Besant] 'Notes of the Week', *PJ* (12 June 1889), p. 50. Cartwright's account of the dinner in 1900 demonstrated the reverse, in Emanuel, p. 251.

122. See Eve Kosofsky Sedgwick, *Between Men: English Literature and Male Homosocial Desire* (New York: Columbia University Press, 1985), p. 25, on the special relationship between male homosocial desire and structures for maintaining and transmitting patriarchal power.

123. Cartwright, 29 July 1893, in Emanuel, p. 179.

124. Cartwright, 12 October 1900, in Emanuel, p. 252.

125. Cartwright, 5 July 1899, in Emanuel, p. 241.

126. Helene E. Roberts, 'Exhibition and Review: The Periodical Press and the Victorian Exhibition System', *The Victorian Periodical Press: Samplings and Soundings*, eds J. Shattock and M. Wolff (Leicester: Leicester University Press, 1982), p. 87.

127. Cartwright, 25 August 1890, in Emanuel, p. 163. See Cartwright, 'The Art of Burne-Jones', *Atalanta* (October 1890), pp. 18–26; (November 1890), pp. 81–91.

128. Cartwright, 28 November 1890, in Emanuel, p. 164.

129. Cartwright, 2 December 1890, in Emanuel, p. 164.

130. Cartwright, 7 July 1891; Cartwright, 9 July 1891, in Emanuel, pp. 166–67.

131. Cartwright, 10 July 1891, in Emanuel, p. 167.

132. Cartwright, 24 July 1893, in Emanuel, p. 178. See Cartwright, 'G. F. Watts, R.A.', *Atalanta* (October 1891), pp. 12–25; (November 1891), pp. 76–87.

133. *FR* (July 1889), pp. 138–39.

134. 'An appeal against female suffrage', *NC* (June 1889).

135. FFM, 'Ladies' Page', *ILN* (27 March 1897), p. 428. See also *Some Supporters of the Women's Suffrage Movement* (London: National Society for Women's Suffrage, 1897) and Deborah Cherry, *Painting Women: Victorian Women Artists* (London: Routledge, 1993), p. 93.

136. Florence Fenwick Miller, Helen Blackburn Collection, Girton College, Cambridge.

137. 'Mrs. Florence Fenwick Miller', *Women's Penny Paper* (23 February 1889), p. 1.

138. See Vicinus, pp. 297–99; Erika Diane Rappaport, *Shopping for Pleasure: Women in the Making of London's West End* (Princeton and Oxford: Princeton University Press, 2000).

139. Emanuel, p. 17.

140. Jane Harrison to Lady Mary Murray (2 January 1903), quoted in Vicinus, p. 299.

141. Cartwright, 31 January 1898, in Emanuel, p. 223.

142. Cartwright, 9 February 1898, in Emanuel, p. 223

143. Emanuel, p. 18.

144. Lady Colin Campbell to AM, n.d. [1897], quoted in Badeni, p. 141.

145. AM to Christiana Thompson (1898), quoted in Badeni, p. 178.

146. Elizabeth Robins Pennell, *Nights: Rome, Venice in the Aesthetic Eighties, London, Paris in the Fighting Nineties* (Philadelphia and London: J. P. Lippincott, 1916), p. 157. See extended discussion in Chapter 5. Linda K. Hughes documents the importance of this 'autolycus' network in her recent work on Graham R. Thomson. Hughes, 'Rosamund Marriott Watson', *Dictionary of Literary Biography: Late Nineteenth- and Early Twentieth-Century British Women Poets*, vol. 240, ed. W. B. Thesing (Detroit: Gale, 2001), pp. 308–20; *Rosamund Marriott Watson ('Graham R. Thomson'): A Woman of Letters and of the World* (forthcoming).

147. Meynell's practice of writing during her salon functioned as self-publicity, whilst completing articles for the next day. In comparison, Pennell worried about the column she was due to complete the following morning. Ana I. Parejo Vadillo, 'New Woman Poets and the Culture of the *Salon* at the *fin-de-siècle*', *Women: a cultural review*, 10:1 (Spring 1999), pp. 23–25.

148. This painting is now missing. See Meynell, Sitters File, Heinz Archive National Portrait Gallery.

149. Alice Meynell, 'Royal Academy', *WR* (21 May 1887), p. 661–62.

150. James Lomax and Richard Ormond, *John Singer Sargent and the Edwardian Age* (Leeds Art Gallery, National Portrait Gallery and Detroit Institute of Arts, 1979), p. 73

151. 'Life, light, form, and colour in a picture, and indeed in nature, must have our intelligent eyes; but there is something transcendent in the power of him who shows us the great quality of life so plainly that the simplest of us cannot but see.' Alice Meynell, *The Work of John S. Sargent R.A.* (London: William Heinemann, 1903).

152. William Rothenstein, *English Portraits: A Series of Lithographed Drawings* (Covent Garden: Grant Richards, 1898).

153. It was the subject of numerous letters to C. J. Holmes, then Director, and Hawes Turner, Keeper and Secretary, National Portrait Gallery, and trustees. See *Daily Telegraph* (16 May 1912), f. 1603, Heinz Archive, National Portrait Gallery.

154. Charles Dilke, *Memoir*, pp. 24–25.

155. Kali Israel, 'Writing Inside the Kaleidoscope: Re-Representing the Victorian Women Public Figures', *Gender and History* (Spring 1990), p. 46.

156. See Betty Asquith, *Lady Dilke, a biography* (London: Chatto and Windus, 1969), p. 8; Eisler, p. 150.

157. Caroline Dakers, *The Holland Park Circle: Artists and Victorian Society* (New Haven: Yale University Press, 1999), p. 182.

158. E. I. Barrington, *G. F. Watts: Reminiscence* (London: George Allen, 1905); *The Life, Letters and Work of Frederic Leighton*, 2 vols (London: George Allen, 1906); *Essays on the Purpose of Art: Past and Present Creeds of English Painters* (London: Longmans, Green, 1911).

159. See for example, William Michael Rossetti, *Fine Art, Chiefly Contemporary* (London and Cambridge: Macmillan, 1867); *Dante Gabriel Rossetti as Designer and Writer* (London, 1889); *Memoir of Dante Gabriel Rossetti*, 2 vols (London: Ellis and Elvey, 1895); *Pre-Raphaelite Diaries and Letters* (London: Hurst and Blackett, 1900).

160. Like family biographers, Barrington placed the artist on a pedestal, drawing on professional, social and domestic knowledges to shape the meaning of the 'artist'. Julie Codell, 'The Public Image of the Victorian Artist: Family Biographies', *Journal of Pre-Raphaelite Studies* (Fall 1996), pp. 5–24.

161. G. F. Watts tersely summarized Barrington's strategy: 'She knows a great number of the best people of all kinds … I do not say she will repeat confidences, but she has a craze to show how much she knows about everybody.' Quoted in Wilfrid Blunt, *'England's Michelangelo': A Biography of George Frederic Watts* (London: Hamish Hamilton, 1975), p. 186.

162. Zimmern, *Art Annual* (1886), pp. 17–18.

163. Gosse quoted in Anne Thwaite, *Edmund Gosse: A Literary Landscape* (Oxford: Oxford University Press, 1985), p. 215.

164. Emilia F. S. Dilke, 'Randolph Caldecott', *AJ* (1894), pp. 138–42; 203–208.

165. Emilia F. S. Dilke, 'Art Teaching and Technical Schools', *FR* (1890), pp. 231–41.

166. Percy Cross Standing, *Sir Lawrence Alma-Tadema O.M. R.A.* (London: Cassell, 1905), pp. 75, 88–89.

167. F. G. Stephens, *Artists at Home* (London: Sampson Low, Marston, Searle, Rivington, 1884), p. 2. This may have of course been partially linked to both her position as a colleague at the *Athenaeum* and her friendship with the new proprietor Sir Charles Dilke. See Demoor.

168. Katherine de Mattos, 'Flowers and Flower-Painters', *MA* (1883), p. 454.

Chapter 3

1. *Architect, Tablet, Merry England, Weekly Register, Magazine of Art, Art Journal, Saturday Review, Spectator, National Observer, Speaker, Outlook, Illustrated London News, Academy, Dublin Review, London Mercury, Atlantic Monthly, North American Review, Catholic World, Delineator, World, Daily Chronicle, Pall Mall Gazette.*

2. Badeni, *The Slender Tree*, pp. 17, 34; Vogt, 'Honours of Morality', pp. 7–8; Viola Meynell, *Alice Meynell: A Memoir*, p. 52.

3. See [A. C. T.], 'Pictures', *Tablet* (29 April 1876), pp. 553–54.

4. Alice Oldcastle, 'Mrs. Jameson – A Biographical Sketch', *MA* (1879), pp. 123–25; John Oldcastle, 'Our Living Artists: Elizabeth Butler', *MA* (1879), pp. 357–62.

5. Anne Kimball Tuell, *Mrs. Meynell and Her Literary Generation* (New York: E. P. Dutton, 1925), p. 65.

6. Viola Meynell, *Francis Thompson and Wilfrid Meynell* (London: Hollis and Carter, 1952), p. 35.

7. Badeni, pp. 70, 73.

8. *Pen* (22 May 1880), p. 1.

9. 'The Magazine of Art', *Pen* (29 May 1880), p. 45.

10. EB to AM, 19 March 1889, MFP (Meynell Family Papers).

11. EB to AM, 15 March 1886, MFP.

12. Her column appeared on Fridays until 1896 and then on Wednesdays. Tuell, p. 36. Talia Schaffer addresses these columns in her cogent consideration of Meynell as an aesthete: *The Forgotten Female Aesthetes: Literary Culture in Late-Victorian England* (Charlottesville: University Press of Virginia, 2000).

13. Alice Meynell, *The Wares of Autolycus*, ed. P. M. Fraser (London: Oxford University Press, 1965).

14. 'Charles Dickens as a Writer' (11 and 18 January 1899); 'A Woman of Masculine Understanding' (11 October 1895), pp. 8–12; 'Academy Picture Fashions' (4 May 1895), p. 5.

15. [Alice Meynell], 'Wares of Autolycus', *PMG* (18 May 1894), p. 4.

16. See also Maria Frawley, 'Alice Meynell and the Politics of Motherhood' in *Unmanning Modernism: Gendered Re-readings*, eds Elizabeth Jane Harrison and Shirley Peterson (Knoxville: University of Tennessee Press, 1997) p. 35.

17. Tuell, p. 5.

18. 'Royal Academy', *WR* (1882), p. 568.

19. Alice Meynell, 'The Nativity in Art', *AJ* (1890), pp. 353–60; Alice Meynell, 'Religion in the Galleries', *Tablet* (19 June 1886), pp. 964–65; Alice Meynell, 'Religion in the Galleries', *Tablet* (21 May 1887), pp. 803–804. Meynell's positioning was not as explicit as that of Maurice Denis, who argued for a return to Catholic art from the 1890s. See Alicia Foster, *Gwen John* (London: Tate Gallery, 1999), pp. 58–62.

20. Alice Meynell, 'Leaves from a Lady's Notebook. With Thumbnail Sketch of Lady Butler's Academy Picture, 'An Eviction', *ME* (May–October 1890), pp. 67–73. Annotated copy, Burns Library, Boston College.

21. '[A]n eviction took place near here a few days ago and I have painted the ruins while still smelling of smoke.' EB to AM, 29 August 1889, MFP.

22. Alice Meynell, 'Leaves from a Lady's Notebook', *ME* (May–October 1890), pp. 67–73. Annotated copy, Burns Library, Boston College.

23. Alice Meynell, 'Introduction' in Adolfo Venturi, *The Madonna: A Pictorial Representation of the Life and Death of the Mother of Our Lord Jesus Christ by the Painters and Sculptors of Christendom in more than 500 of their works*, ed. and trans. Alice Meynell (London: Burns and Oates, 1902).

24. Eileen Janes Yeo, 'Protestant feminists and Catholic saints in Victorian Britain' in *Radical Femininity: Women's Self Representation in the Public Sphere*, ed. E. Janes Yeo (Manchester: Manchester University Press, 1998), pp. 127–48.

25. Alice Meynell, *The Poor Sisters of Nazareth. An illustrated record of life at Nazareth House, Hammersmith* (London: Burns and Oates, 1889); Alice Meynell, *Mary, the Mother of Jesus* (London: Philip Lee Warner, 1912).

26. Meynell only published one article in the *MA* after 1886, a biography of Marianne Stokes in 1901. See Liela Rumbaugh Greiman, 'William Ernest Henley and the *Magazine of Art*', *Victorian Periodicals Review* (Summer 1983), pp. 60–61; C. Lewis Hind, *Naphtali* (London: John Lane, 1926), p. 51.

27. Henley to Meynell (16 February 1892) in Tuell, p. 78.

28. Beerbohm, 'Mrs. Meynell's Cowslip Wine', *Tomorrow* (September 1896); Alice Meynell, *The Colour of Life* (London and New York: John Lane, 1896).

29. 'Could you not come by an earlier train? The fact is I have said 7:30 to Aubrey de Vere and Mr. Henley and Coventry Patmore; otherwise I would make the hour later, so as to fit your train.' AM to John Lane (3 August, n.d.[1890s]) M. 14, Burns Library, Boston College.

30. See Coventry Patmore, 'Mrs. Meynell Poet and Essayist', *FR* (July–December 1892), p. 76; George Meredith, 'Mrs. Meynell's Essays', *NR* (March–August 1896), p. 762.

31. Viola Meynell, *Francis Thompson and Wilfrid Meynell*, pp. 9–11, 35.

32. Badeni, pp. 141–42. Further correspondence does not indicate whether Meynell was forced to sell her diamond jewellery in order to appease the debt collector.

33. See Badeni, p. 69. On Yates, see Joel H. Wiener, 'Edmund Yates: The Gossip as Editor', *Innovators and Preachers: The Role of the Editor in Victorian England*, ed. J. Wiener (London: Greenwood Press, 1985), pp. 259–74.

34. Edmund Yates to AM, 4 August 1880, MFP, Private Collection.

35. Clement Shorter to AM, 8 February 1895, MFP.

36. AM to Olivia Meynell, n.d. [1906], MFP.

37. Badeni, p. 170.

38. William Blackwood to AM, 31 January 1898, MFP.

39. Alternatively, signed articles about Elizabeth Butler were attributed to Wilfrid Meynell or John Oldcastle. Joan Hichberger contends that the 1879 'Elizabeth Butler' article signed 'John Oldcastle' was in fact by Alice Meynell and in light of her regular discussion of her sister's work it is not unlikely that she wrote or at least co-wrote these articles. *MA* (1879), pp. 257–62. J. W. M. Hichberger, *Images of the Army: The Military in British Art 1815–1914* (Manchester: Manchester University Press, 1988), p. 82.

40. EB to AM, n.d. (c. 1880), MFP.

41. EB to AM, 22 April 1883, MFP.

42. EB to AM, 14 April n.d. [1881], MFP.

43. EB to AM, 24 June n.d [1881], MFP. Butler did not exhibit at the Grosvenor; the Coutts Lindsay marriage broke up in 1882. Colleen Denney notes that Lady Lindsay created an elite circle of admirers for her artists and examines her matronage of women artists: 'The Grosvenor Gallery as a Palace of Art' in *The Grosvenor Gallery*, eds Susan P. Casteras and Colleen Denney (New Haven: Yale Center for British Art, 1996), p. 31; Denney, *At the Temple of Art: The Grosvenor Gallery 1877–1890* (London: Associated University Presses, 2000), p. 127.

44. EB to AM, 14 April n.d. [1881], MFP.

45. *Far Out* was a book by her husband documenting his travels in Canada, the United States, Afghanistan, Cyprus and South Africa. EB to WM, 27 September 1880, MFP.

46. EB to AM, 26 October 1886, MFP.

47. EB to AM, 8 May n.d. [1881], MFP. The two popular works Butler mentions were *Sappho* by Laurens Alma-Tadema and *Cinderella* by J. E. Millais. Paul Usherwood and Jenny Spencer-Smith, *Lady Butler, Battle Artist: 1846–1933* (London: National Army Museum, 1987), pp. 78–79.

48. EB to AM, 19 March 1889, MFP.

49. EB to AM, 13 August 1889; EB to AM, 4 December 1892, MFP. Butler was almost certainly referring to the novelist Mary Sweetman Blundell.

50. In 1877 Butler received the enormous sum of £3000 from the Society; however, the Society extracted conditions from her: she could not paint any battle pictures over a certain size for the next two years or exhibit her new picture *Return from Inkerman* at the RA. This latter restriction may have cost her a membership of the RA in 1879. See Paul Usherwood and Jenny Spencer-Smith, p. 43.

51. EB to AM, 24 Sept n.d. [c. 1882], MFP.

52. 'I have chosen the subject you suggested … I have made it nearly twice the size it will appear in, so that the lines may be particularly clear. It ought to come out fine and delicate on the reduced scale … Please send me back the drawing when done with.' EB to AM, 14 September, c. 1883, MFP. 'Does the H. Nicholls man want original pen and ink sketches? I could send him a parcel of them, but should be anxious to have them reproduced as much in facsimile as possible, as being small, they might easily be murdered in translation.' EB to AM, n.d. [c. 1882], MFP.

53. EB to AM, 20 March n.d.[c. 1882], MFP.

54. EB to AM, n.d. [c. 1882], MFP.

55. 'Men and Things', *WR* (1 April 1882), p. 403.

56. [Meynell], 'Royal Academy', *WR* (6 May 1882), p. 568.

57. Ibid.

58. Hichberger, pp. 80–83; Francis Meynell, pp. 31–32.

59. John Springhill remarks on the paradoxical nature of the Butlers' careers. John Springhill, '"Up Guards and at them!": British Imperialism and Popular Art 1880–1914' in John MacKenzie (ed.), *Imperialism and Popular Culture* (Manchester: Manchester University Press, 1986), pp. 49–72. Paul Usherwood suggests that Butler's subject was influenced by her husband, who felt that General Colley was blamed unfairly for the failures in the war: 'five sixths of our African wars have their beginnings in wrongs done in the first instance by white men upon natives.' Butler, *ix* in Usherwood, pp. 79, 84. In a later article Usherwood is careful to point out that this humanitarianism cannot be understood as a class struggle for hegemony over the army. Usherwood, 'Officer material: Representations of leadership in late nineteenth-century British battle painting' in John MacKenzie (ed.), *Popular imperialism and the military* (Manchester: Manchester University Press, 1992), p. 167.

60. 'The Royal Academy: Fourth Notice', *Athenaeum* (27 May 1882), p. 672.

61. 'Exhibition of The Royal Academy', *AJ* (1882), pp. 237–39.

62. EB to AM, n.d., MFP.

63. 'A Catholic Artist', *WR* (8 September 1883), pp. 310–11.

64. A. M., 'Royal Academy', *WR* (1 May 1885), pp. 557–58.

65. EB to AM, n.d. [1899], MFP.

66. EB to AM, n.d. [c. 1897], MFP.

67. Charlotte Yeldham, *Women Artists in Nineteenth-Century France and England* (New York: Garland, 1984) vol. 1, pp. 61, 92, 320.

68. EB to AM, 4 December 1892, MFP.

69. Contrary to Butler's information, *To the Front* was exhibited in the Woman's Pavilion and *Roll Call* was exhibited in the Fine Arts Pavilion. Florence Fenwick Miller, 'Art in the Woman's Section of the Chicago Exhibition', *AJ* (1893), *xv*. See further discussion in Chapter 4.

70. EB to AM, 14 February 1897, MFP.

71. *Victorian Era Exhibition* (London: Earls Court, 1897), p. 41.

72. EB to AM, 17 January 1897, MFP.

73. 'I have first given him a study of a figure for "Steady the Drums and Fifes" wh. I shd [sic] have no objection to being reproduced if the Art Journal purchased the copyright. But I wd ask that it shd not appear otherwise. I would recommend that all the Egyptian studies be grouped together.' EB to WM, 6 June 1898, MFP. It was also Alice and Wilfrid Meynell who edited her autobiography. EB to WM, 4 January 1922, MFP; EB to WM, 13 February 1922, MFP.

74. From 1880 to 1905, women contributed many biographical articles on contemporary artists to art periodicals; the largest contributors in the *Magazine of Art* and *Art Jourrnal* were:

	Male artists	Female artists
Nancy Bell	6	1
Julia Cartwright	4	(1: artist's wife)
Emilia Dilke	2	
Marion Hepworth Dixon	11	3
Alice Meynell	11	3
Helen Zimmern	12	2

75. In addition, several of her contributions were republished anonymously in the volumes: Wilfrid Meynell, *Modern School of Art* (London: Cassell, n.d.[ca. 1884]). Alice Meynell's contributions are annotated in the Meynell volumes held in the Thompson Collection, Boston College Library, Boston.

76. The contents of the first issue of the *Magazine of Art* in 1878 set a pattern with its monthly series, 'Our Living Artists'. The introduction to the new periodical defined art as the embodiment of a conception of the mind: 'Its operations are as subtle as the power from which it has its first origin.' 'Introduction', *MA* (1878), p. 3.

77. Helen Zimmern, 'A Sculptor's Home', *MA* (1883), p. 513.

78. See Michel Foucault, 'What is an author?' in *Textual Strategies: Perspectives in Poststructuralist Criticism*, ed. J. V. Harari (London: Methuen, 1980), pp. 141–60; Griselda Pollock, 'Artists, Mythologies and Media Genius, Madness and Art History', *Screen*, 21:3 (1980), p. 59.

79. Alice Meynell, 'Laura Alma-Tadema', *AJ* (1883), p. 347.

80. Ibid.

81. Ibid., p. 344.

82. Pamela Gerrish Nunn, *Problem Pictures: Women and Men in Victorian Painting* (Aldershot: Scolar, 1995), p. 110.

83. Meynell, 'Laura Alma-Tadema', pp. 345–46.

84. Giles Walkley, *Artists' Houses in London 1764–1914* (Aldershot: Scolar Press, 1994), pp. xxii–xxiv.

85. Paula Gillett, *Worlds of Art: Painters in Victorian Society* (New Brunswick: Rutgers University Press, 1990), pp. 12.

86. John Tagg, *The Burden of Representation: Essays on Photographies and Histories* (London: Macmillan Education 1988), pp. 37, 56.

87. See Richard Salmon, 'Signs of Intimacy: The Literary Celebrity in the "Age of Interviewing"', *Victorian Literature and Culture* (1997), pp. 159–77.

88. Alice Meynell, 'Madame Sarah Bernhardt', *AJ* (1888), p. 139.

89. See Elizabeth Prettejohn for a persuasive reconsideration of Leighton, 'The modernism of Frederic Leighton' in *English Art 1860–1914: Modern Artists and Identity*, eds David Peters Corbett and Lara Perry (Manchester: Manchester University Press, 2000), pp.31–48.

90. Alice Meynell, 'Artists' Homes: Mr. Hubert Herkomer at Bushey', *MA* (1883), p. 96.

91. Hubert Herkomer to AM, [1883], Meynell Scrapbook, Alice Meynell Collection, Burns Library, Boston College, Boston.

92. Gillett, *Worlds of Art*, p. 115.

93. Meynell's article was a follow-up to an article on Herkomer by her husband that had appeared three years previously: Wilfrid Meynell, 'Our Living Artists: Hubert Herkomer ARA', *MA* (1880) pp. 259–63; see also of the same year, James Dafforne, 'The works of Hubert Herkomer ARA', *AJ* (1880), pp. 109–12. See Gillett, pp. 110–12; Lee MacCormick Edwards, *Herkomer: A Victorian Artist* (Aldershot: Ashgate, 1999).

94. Dilke, Campbell, Zimmern and Beale all wrote essays on Leighton between 1882 and 1896. E. F. S. Pattison [Dilke], 'Sir Frederick Leighton', *Illustrated Biographies of Modern Artists* ed. F. G. Dumas (London: Chapman and Hall, 1882), pp. 3–24; Gertrude Campbell, 'Artist's Studies', *AJ* (March 1890), pp. 65–72; Helen Zimmern, 'Lord Leighton', *Die Kunst Unserer Zeit* (Munich 1896), pp. 97–106; S. Beale, 'The works of Lord Leighton at the Royal Academy Winter Exhibition', *American Architect and Building News* (6 February 1896), p. 43–44.

95. Alice Meynell, 'Cymon and Iphigenia', *AJ* (1884), p. 129.

96. Ibid., p. 131.

97. Alison Smith, 'Nature Transformed: Leighton, the Nude and the Model' in *Frederic Leighton: Antiquity, Renaissance, Modernity*, eds Tim Barringer and Elizabeth Prettejohn (New Haven and London: Yale University Press, 1999), pp. 19–48.

98. A British Matron, 'A Woman's Plea', *Times* (20 May 1885), p. 10. Henrietta Rae submitted two nudes: *Ariadne Deserted by Theseus* and *A Bacchante*.

99. Alison Smith, *The Victorian Nude: Sexuality, Morality and Art* (Manchester: Manchester University Press, 1996), pp. 227–37; see also Gillett, *Worlds of Art*, pp. 176–78.

100. Alice Meynell, 'A Question of Propriety', *Tablet* (6 June 1885), p. 882.

101. In a recent essay Smith reconsiders this material, identifying Alfred P. Ryder, trustee of the Church of England Purity Society, to be in collusion with Horsley, and author of the *Times* response letter from 'XYZ'. Alison Smith, 'The "British Matron" and the body beautiful: the nude debate of 1885',

After the Pre-Raphaelites, ed. E. Prettejohn (Manchester: Manchester University Press, 1999), pp. 217–39.

102. See Judith Walkowitz, *Prostitution and Victorian Society: Women, class and the state* (Cambridge: Cambridge University Press, 1980).

103. Bland, *Banishing the Beast*, pp. 95–123.

104. Alice Meynell, 'A Question of Propriety', *Tablet* (6 June 1885), pp. 882–83.

105. Leighton to Dilke, [c. 1885] BL, Add Ms 43907; in 1885 she 'made an attempt to found a Drawing Scholarship for women at the RA … After a correspondence, these were found unacceptable by the President.' Dilke, 'Memoir', p. 88. During her lifetime Dilke continued to advocate the necessity of drawing from the nude. See Dilke, 'Art Teaching in Technical Schools', *FR* (February 1890), pp. 231–41.

106. N. N., 'Edinburgh Art Congress', *Nation* (28 November 1889), p. 429.

107. As J. B. Bullen observes, in the context of late Pre-Raphaelitism and its successor Aestheticism, 'Lurking behind all these expressions of disquiet is the strongly felt, but metaphorical relationship, between the physical human body and the "body" of the nation.' J. B. Bullen, *The Pre-Raphaelite Body: Fear and Desire in Painting, Poetry, and Criticism* (Oxford: Clarendon, 1998), pp. 195, 215

108. J. P. Brodhurst, 'Our English Schools of Art', *Atalanta* (January 1888), p. 217.

109. Esther Wood, *Dante Gabriel Rossetti and the Pre-Raphaelite Movement* (London: Sampson Low, Marston, 1894). Helen Zimmern, 'Our Painter, Sir John Millais', *Atalanta* (November 1887), p. 99; Emilie Barrington, 'Why is Mr. Millais Our Popular Painter?', *FR* (July 1882), pp. 60–77; 'The Painted Poetry of Watts and Rossetti', *NC* (June 1883), p. 956. Julia Cartwright functioned as one of the primary hagiographers of Burne-Jones during the 1890s, writing for *Atalanta, Quarterly Review, Gazette des Beaux Arts, AJ*, as well as the *Art Annual* for the *AJ*.

110. Deborah Cherry and Griselda Pollock, 'Patriarchal Power and the Pre-Raphaelites', *Art History* (December 1984), p. 484.

111. See for example, William M. Rossetti, 'The Pre-Raphaelite Brotherhood', *MA* (1881), pp. 434–37. 'The Life and Work' series were biographies of various contemporary artists released as Easter and Christmas supplements, beginning in 1884. The format of these essays was largely standardized into a general biography, followed by a discussion of the artist's works, and concluding with a description of the artist's home and studio. Several were by women writers: Mrs A. Lang, *Leighton* (1884); Helen Zimmern, *Alma-Tadema* (1886); Julia Cartwright, *Burne-Jones* (1894); *Watts* (1896).

112. Archdeacon Farrar, 'The Principal Pictures' in Alice Meynell and Frederic William Farrar, *William Holman Hunt: His Life and Work* (London: Art Journal Office, 1893), p. 5.

113. It is likely that Hunt influenced the *Art Journal*'s choice of biographers; the aforementioned Butler correspondence concerning the *Art Annual* indicates that the artist was contacted first. See also Marcia Pointon, 'The artist as ethnographer: Holman Hunt and the Holy Land', *Pre-Raphaelites reviewed*, ed. M. Pointon (Manchester and New York: Manchester University Press, 1989), pp. 22–44.

114. [Frederick George Stephens], *William Holman Hunt and His Works: A Memoir of the Artist's Life, with Descriptions of His Pictures* (London: J. Nisbet and Co., 1860); Frederic William Farrar, 'Mr. Holman Hunt's "May Day, Magdalen Tower"', *Contemporary Review* (June 1891), pp. 814–18.

115. 'The face of this wild fantasy, though earnest and religious is not that of the Saviour', 'The Fine Arts – Royal Academy', *Athenaeum* (6 May 1854), p. 561. See Alastair Grieve, 'The Pre-Raphaelite Brotherhood and the Anglican High Church', *Burlington Magazine* (May 1969), pp. 294–95; Michaela Giebelhausen, 'Academic orthodoxy versus Pre-Raphaelite heresy: debating religious painting at the Royal Academy, 1840–50', *Art and the Academy in the Nineteenth Century*, eds Rafael Cardoso Denis and Colin Trodd (Manchester: Manchester University Press, 2000), pp. 164–78.

116. See Jeremy Maas, *Holman Hunt and the Light of the World* (London and Berkeley: Scolar, 1984), pp. 74–78; Tim Barringer, *The Pre-Raphaelites: Reading the Image* (London: Calmann and King, 1998), pp. 116–17.

117. Meynell, 'The Artist's Home and Studio', in *William Holman Hunt*, pp. 28–30.

118. See Laura Marcus on Hunt's autobiographical strategies: 'Brothers in their anecdotage: Holman Hunt's Pre-Raphaelitism and the Pre-Raphaelite Brotherhood' in Pointon, pp. 1–21.

119. W. Holman Hunt, *Pre-Raphaelitism and the Pre-Raphaelite Movement* (London: Macmillan, 1905).

120. Julie F. Codell, 'The artist colonized: Holman Hunt's 'bio-history', masculinity, nationalism and the English School' in *Re-framing the Pre-Raphaelites: Historical and Theoretical Essays*, ed. E. Hardy (Aldershot: Scolar Press, 1996), p. 212. 'Pre-Raphaelitism could be seen at the end of the century as

an authentically, even uniquely English vernacular art form.' Hunt offered an authentically English corrective to French practices. T. Barringer, '"Not a 'modern' as the word is now understood"? Byam Shaw, imperialism and the poetics of professional society' in Corbett and Perry, p. 77.

121. N. N., 'Millais', *Nation* (27 August 1896), pp. 156–57.

122. W. E. Fredeman, *Pre-Raphaelitism: A Bibliocritical Study* (Cambridge, Mass.: Harvard University Press, 1965).

123. [A. M.], 'Our Living Authors: John Ruskin', *Pen* (22 May 1880), p. 12.

124. William Blackwood to AM, 31 January 1898, MFP. George Meredith wrote to Meynell expressing his jubilation at this new project, 'No more anthologies or examination of minor moths'. Quoted in Tuell, p. 200.

125. Alice Meynell, *John Ruskin* (Edinburgh: Blackwood; New York: Dodd Mead, 1900), p. 7.

126. William Blackwood to AM, 29 June 1899, MFP.

127. Meynell, *John Ruskin*, pp. 117–19; see John Ruskin, 'The Pre-Raffaelites', *Times* (13 May 1851), pp. 8–9.

128. Meynell, *John Ruskin*, p. 196.

129. AM to WM, 8 December 1902, MFP. The editor of the *MA*, M. H. Spielmann, released a Ruskin biography that same year and it was obviously a concern as it was discussed in her correspondence with Blackwood; probably partially as a result, Meynell's volume was not a great financial success. William Blackwell to AM, 15 February 1900, MFP. See Spielmann, *John Ruskin, 1819–1900* (New York: Cassell, 1900). She returned to Ruskin a decade later: Alice Meynell, 'Introduction' in John Ruskin, *Seven Lamps of Architecture* (London: Routledge, 1910), pp. xxi–xxxv.

130. 'Death of Mr. Henry Hill', *Brighton Herald* (8 April 1852).

131. Diane Sachko MacLeod, *Art and the Victorian Middle Class: Money and the Making of Cultural Identity* (Cambridge: Cambridge University Press, 1996), pp. 429–30.

132. Alice Meynell, 'Pictures from the Hill Collection', *MA* (1882), pp. 80–81.

133. Anna Gruetzner Robins, 'The London Impressionists at the Goupil Gallery; Modernist Strategies and Modern Life', *Impressionism in Britain*, ed. Kenneth McConkey (New Haven: Yale University Press, 1995), pp. 87–96.

134. Alice Meynell, 'Pictures from the Hill Collection', p. 82.

135. Ibid., p. 83.

136. Anna Gruetzner Robins, 'Degas and Sickert: notes on their friendship', *Burlington Magazine* (March 1988), p. 226.

137. See Chaper 4; D. S. M., 'The Grafton Gallery', *Spectator* (25 February 1893), p. 256. See also Ronald Pickvance, '"L'Absinthe" in England', *Apollo* (May 1963), pp. 395–98.

138. Degas pieces from the collection exhibited at the Royal Pavilion Gallery in Brighton in 1876 were deemed to be 'remarkably vigorous', 'undoubtedly clever', 'slap-dash' and 'repulsive'. *Brighton Gazette* (7 September; 9 September 1876). Although the critic from the rival paper claimed the Hill works had 'already passed through a more severe ordeal at the hands of metropolitan critics', the Degas would be revisited and reviled in the metropolis nearly two decades later. *Brighton Herald* (16 September 1876).

139. Greiman, pp. 58–61.

140. In 1882 Meynell praised Adrian Stokes's 'French appreciation of the relations and comparisons of light'. 'The Royal Academy', *WR* (1882), p. 568.

141. Alice Meynell, 'Newlyn', *AJ* (1889), pp. 97–102, 137–42.

142. Typescript of a paper read at the Passmore Edwards Gallery 9 June 1939, quoted in Caroline Fox and Francis Greenacre, *Painting in Newlyn 1880–1930* (London: Barbican Art Gallery, 1985), p. 26 n.2; see also Marion Whybrow, *St. Ives 1883–1993: Portrait of an Art Colony* (Woodbridge, Suffolk: Antique Collectors' Club, 1994), pp. 32–33; Tom Cross, *The Shining Sands: Artists in Newlyn and St. Ives 1880–1930* (Tiverton, Devon: Westcountry Books, 1994), p. 53.

143. See Wilfrid Meynell, *Windsor Magazine* (1905), quoted in Fox and Greenacre, p. 26.

144. [Alice Meynell], 'Reviews and Views', *ME* (June 1888), pp. 130–36.

145. [Alice Meynell], *WR* (12 May 1888), p. 598.

146. [Alice Meynell], 'The Royal Academy – I', *Tablet* (12 May 1888), pp. 754–55; 'Our example, breaking with precedent, has had an unexpected following. The only authoritative critics have this season set aside almost the whole body of Academician and Associates ... [for] the 'Newlyners', whom readers of the *Tablet* at least will not wonder to hear.' [Alice Meynell], 'The Royal Academy', *Tablet* (11 May 1889), p. 723.

147. Meynell, 'Newlyn', *AJ* (1889), p. 99.

148. Gustav Waagen, *Works of Art and Artists in England* (London: John Murray, 1838; reprinted London: Cornmarket Press, 1970); G. F. Waagen, 'Thoughts on the New Building to be Erected for the National Gallery of England', *AJ* (May 1853), pp. 101–103, 121–25.

149. See Ronald de Leeuw, *Hague School: Dutch Masters of the Nineteenth Century* (Paris: Grand Palais; London: Royal Academy; Hague: Gemeentemus, 1983).

150. Griselda Pollock, *Vision and Difference* (London: Routledge, 1988), p. 50.

151. Meynell, 'Newlyn', *AJ* (1889), p. 98. Eve Blantyre Simpson later pinpointed Newlyn's erasure of Forbes' identity. E. B. S., 'Elizabeth Forbes', *Studio* (1894), pp. 186–92.

152. W. Christian Symons, ' Newlyn and the Newlyn School', *MA* (1890), pp. 201–205.

153. On the other hand New Critics such as Walter Sickert felt that the London Impressionists had sold out. Interestingly, despite her early praise of Degas, Meynell did not side with the London Impressionists who aligned themselves with Degas' 'realism' during this period contra Monet. See Chapter 5 for a discussion of the NEAC divide.

154. Alice Meynell, *Catalogue of Watercolour Drawings illustrating Fisher-Life by Walter Langley R.I.* (London: Fine Art Society, February 1893).

155. Alice Meynell, 'April Exhibitions', *PMG* (25 April 1903), p. 2.

156. Meynell, 'Newlyn', *AJ* (1889), p. 99.

157. [Alice Meynell], *WR* (12 May 1888), p. 598; [Alice Meynell], 'The Royal Academy – II', *Tablet* (19 May 1888), p. 795.

158. [Alice Meynell], 'Wares of Autolycus', *PMG* (4 May 1894), p. 4

159. Alice Meynell, 'Mrs. Adrian Stokes', *MA* (1901), pp. 241–46.

160. Alice Meynell, 'The New Gallery', *PMG* (18 April 1904), p. 2.

161. Alice Meynell, 'Pictures Painted in Austria-Hungary', *An Exhibition of Pictures Painted in Austria-Hungary by Adrian and Marianne Stokes* (Leicester Square Galleries, London, March–April 1907), pp. 3–7.

162. [Alice Meynell], 'Mary Wollstonecraft's Letters', *Spectator* (22 February 1879), pp. 245–46. Tuell, p. 128. Her 1865 diary and early writing for Emily Faithful's *Women's Work* (1875) and long friendship with Bessie Rayner Parkes (Belloc), a Catholic who wrote for *Merry England*, demonstrates her early awareness and participation in feminist circles. See Tracy Seeley, 'Alice Meynell, Essayist: Taking Life "Greatly to Heart"', *Women's Studies*, vol. 27 (1998), pp. 105–30.

163. Similar arguments were made by Leader Scott [Lucy Baxter], 'Women at Work: Their Functions in Art', *MA* (1884), p. 98.

164. Alice Oldcastle, 'Sketching for Ladies', *ME* (1884), p. 302.

165. [AM], 'Wares of Autolycus', *PMG* (12 January 1894), p. 5. See the following chapter for further discussion.

166. Alice Meynell, 'Lullabies', *The Album* (18 March 1895), p. 134.

167. Alice Meynell, 'My Faith and My Work', *Woman* (12 August 1896), pp. 7–8.

168. Alice Meynell, 'A Woman's Fancies: Daughter's Portions', *DC* (30 May 1896), p. 8.

169. Alice Meynell, 'A Woman's Fancies: Alms-giving', *DC* (8 August 1896), p. 8. See F. K. Prochaska on the shift to organized philanthropy dominated by women, *Women and Philanthropy in Nineteenth-Century England* (Oxford: Clarendon Press, 1980), pp. 182–221.

170. 'Should the Services of Women be Recognized by the State: Some notable replies to our queries', *The Woman* (17 February 1897), p. 13.

171. 'Women and the Honours List; Are Titles Tawdry, Or Should Both Sexes Share Them? Votes First, Say Some, All Say What About Ellen Terry? Why should women not be included in the New Year's Honour List?' *Daily Sketch* (31 December 1913). Scrapbook, Meynell Collection, Burns Library, Boston College.

172. John Ruskin, *Sesame and Lilies*, Lecture 2 of 'Of Queen's Gardens', two lectures delivered in Manchester in 1864 and published in 1865 (republished London: Dent, 1907), p. 59.

173. Meynell wrote on women's issues anonymously in her own periodicals or in signed columns: 'A Woman's Fancies', *DC* (1896).

174. Meynell, *John Ruskin*, p. 164.

175. Ibid.

176. AM to WM, 26 November 1902, MFP. Monica married the eugenicist, Dr Caleb Saleeby, in 1903; they later separated.

177. AM to Miss Stephens [c. 1905] M 23, Burns Library, Boston College.

Chapter 4

1. Florence Fenwick Miller, 'An Uncommon Girlhood', Contemporary Medical Archives Centre, Wellcome Institute for the History of Medicine, GC/228/2. This autobiography serves as the foundation for a recently published biography of Fenwick Miller by Rosemary T. Van Arsdel, *Florence Fenwick Miller: Victorian feminist, journalist and educator* (Aldershot: Ashgate, 2001). Fenwick Miller will be cited hereafter as FFM.

2. FFM, CMAC, GC/228/4, p. 102; see Shirley Roberts, *Sophia Jex-Blake: A Woman Pioneer in Nineteenth Century Medical Reform* (London and New York: Routledge, 1993).

3. FFM, CMAC, GC/228/8; GC/228/9.

4. FFM, CMAC, GC/228/9, pp. 9–11: GC/228/26, p. 17. Sandra Stanley Holton, 'From Anti-Slavery to Suffrage: The Bright Circle, Elizabeth Cady Stanton and the British Women's Movement', in *Suffrage and Beyond: International Feminist Perspectives*, eds Caroline Daly and Melanie Nolan (New York: New York University Press, 1994), pp. 213–33. In the 1880s Fenwick Miller was also a member of the Vigilance Association for the Defence of Personal Rights. Her speech calling for the repeal of the CD Acts (enforcing medical examination of prostitutes) was transcribed in the *Shield*: 'I object altogether to any terms which seem to imply that the women who are in this position stand upon a lower basis than the men who are the cause and the associates of their being in that condition (Applause)', 'The Acts and the Criminal Law Amendment Act', *Shield* (5 September 1885), p. 136. See Walkowitz on this overlap between suffrage, purity and Contagious Diseases Acts campaigns, notably the network of Ursula Bright, Priscilla Bright McLaren and Josephine Butler, *Prostitution and Victorian Society*, pp. 125–29; Bland, *Banishing the Beast*, pp. 97–101.

5. FFM, CMAC, GC/228/16, pp. 1–7. Members included Dr Charles R. Drysdale (medical lecturer), Alice Vickery (colleague, Ladies Medical College), George Bernard Shaw, Louisa A. A. Sims (suffragist), and Frederick A. Ford (stockbroker's clerk, espoused radical and Liberal causes). George R. Sims, *My Life: Sixty Years' Recollections of Bohemian London* (London: Eveleigh Nash, 1917), p. 53; Bland, *Banishing the Beast*, pp. 202–209; Miriam Benn, *Predicaments of Love* (London: Pluto Press, 1992); see Van Arsdel on the formidable membership of the society: *Fenwick Miller*, pp. 41–44.

6. See Van Arsdel, 'Victorian Periodicals Yield Their Secrets', p. 27.

7. Patricia Hollis, *Ladies Elect: Women in English Local Government 1865–1914* (Oxford: Clarendon, 1987), pp. 71–97.

8. 'Mrs. Florence Fenwick Miller', *WPP* (23 February 1889). See also Hollis, p. 91; Walkowitz, *City of Dreadful Delight*, pp. 66–67.

9. Frederick Rogers, *Labour, Life and Literature* (1913), ed. D. Rubinstein (Brighton: Harvester Press, 1973), p. 51.

10. Besant was charged with Charles Bradlaugh for the publication of *The Fruits of Philosophy* by an American doctor, Charles Knowlton, in 1877. Annie Besant, *Autobiographical Sketches* (London: Freethought, 1885), p. 125. The *Daily Chronicle* added to the furore with the bold assertion, 'Miss Miller is an unmarried woman and therefore her acquaintance with the "special subject" treated in the work in question cannot be very intimate … She is a member of the London School Board.' See Van Arsdel, *Fenwick Miller*, pp. 79–83; Bland, *Banishing the Beast*, p. 193.

11. FFM, CMAC, GC/228/31.

12. FFM, CMAC, GC/228/29.

13. Frederick Alfred Ford (1849–1910) was educated at King's College, University of London and was a member of the National Liberal Club and London County Council for Finsbury, 1889–92. Van Arsdel, *Fenwick Miller*, pp. 79–83

14. FFM, CMAC, GC/228/31, GC/228/33. She had already begun writing for periodicals (*Woman, Sunday School Union, Englishwoman's Domestic Magazine, Englishwoman's Review of Social and Industrial Questions*) and published several science textbooks for schools: *Simple Lessons for Home Use* (*Air and Ventilation, How and Why we Breathe, Our Bodily Life, Sicknesses that Spread and How to Prevent Them*) (1877), *House of Life* (1878), *An Atlas of Anatomy* (1879) and *Physiology for Schools* (1880).

15. See Van Arsdel, 'Mrs. Florence Fenwick Miller and *The Woman's Signal*, 1895–1899', *Victorian Periodicals Review*, 15:3 (1982), pp. 107–17.

16. WS (30 September 1897), p. 1. Alice Scatcherd, Ursula Bright and Priscilla Bright McLaren were supportive, yet she denied receiving financial assistance from wealthy suffragists in her autobiography. FFM, CMAC, GC/228/19, pp. 9, 21–22. Holton, *Suffrage Days: Stories from the Women's Suffrage Movement* (London and New York: Routledge, 1996), p. 102.

17. *Readings in Social Economy* (London: Longmans, Green, 1883); *Harriet Martineau* (London: Allen, 1884); *In Ladies' Company, six interesting women* (London: Ward and Downey, 1892).

18. FFM, CMAC, GC/228/32, 33. See for example, WSJ: 'Conference in Birmingham' (1 February 1874), pp. 20–25; 'Ipswich' (1 May 1874), pp. 73–74; 'London' (1 June 1874), p. 85; Fenwick Miller, 'The lessons of Life: Harriet Martineau', 11 March, 1877 (London: Sunday Lecture Society, C. W. Reynell).

19. WSJ (2 June 1884), p. 130. See also Helen Blackburn, *Women's Suffrage: A Record* (London: William and Norgate, 1902, reprinted Kraus, 1971), p. 154.

20. 'Women's Franchise League', Women's Suffrage Collection, Papers of Millicent Garrett Fawcett, Manchester Public Library, M50/2/32/1. Fenwick Miller was a member of its Provisional Executive Committee and was appointed to the Executive Committee and Council. 'Women's Franchise League, Report of Proceedings at the Inaugural Meeting, London July 25th, 1889' (London: Hansard Publishing Union).

21. 'Women's Franchise League, Report of Meeting in support of "The Women's Disabilities Removal Bill"' (London: Hansard Publishing Union, n.d.) from the *Scotsman* (8 November, 1889); F. F. Miller, *On the Programme of the Women's Franchise League* (London: Hansard Publishing Union, 1890). See Sandra Stanley Holton, 'Now you see it, now you don't: the Women's Franchise League and its place in contending narratives of the women's suffrage movement', *The Women's Suffrage Movement*, eds Maroula Joannou and June Purvis (Manchester: Manchester University Press, 1998), pp. 20–22.

22. See Holton, *Suffrage Days*, p. 78; Holton, 'Now you see it, now you don't', pp. 20–22; see also Van Arsdel, *Fenwick Miller*, pp. 136–42.

23. Wollstoneholme Elmy to McIllquham, 27 April 1890 (Elizabeth Wollstoneholme Elmy Papers, BL) Add Mss 47, 499.

24. 'Work of the Franchise League – Address by Florence Fenwick Miller of England', *Congress of Representative Women*, ed. May Wright Sewall (Chicago and New York: Rand, McNally, 1894), pp. 421, 424; *Programme, Chicago Memorial Art Palace, May 15–21 1893* (The World's Congress Auxiliary of the World's Columbian Exposition of 1893: Department of Woman's Progress), pp. 25, 27.

25. Fenwick Miller, 'Effect on Domestic Life of the Entry of Women into Professions', ed. Countess of Aberdeen, *International Congress of Women, London* 1899 (1900), Gerritsen Collection of Women's History; FFM, 'Ladies' Page', *ILN* (8 July 1899), p. 30.

26. See 'Lectures', *WSJ* (1 December 1883), p. 219; 'Summer Lectures', *WSJ* (1 September 1883), p. 165.

27. Van Arsdel, 'Victorian Periodicals Yield their Secrets', p. 28.

28. FFM, CMAC, GC/228/12, p. 6; *Woman* (April 1872), pp. 270–71.

29. This novel was her first and last unpaid literary venture outside of biography. *Lynton Abbott's Children* (London: Tinsley, 1879). See FFM, CMAC, GC/228/31.

30. FFM, 'Ladies' Page', *ILN* (23 January 1897), p. 126.

31. Ibid.

32. FFM, 'Ladies' Page', *ILN* (2 May 1896), p. 566; 'Ladies' Page', *ILN* (23 January 1897), p. 126. See also [FFM], 'Olive Schreiner', *WS* (29 December 1895) pp. 401–402.

33. See FFM, 'Ladies' Page', *ILN* (14 January 1888).

34. It is likely that Filomena refers to the Greek myth in which Philomela was metamorphosed into a nightingale. Fenwick Miller had been named by her mother after Florence Nightingale. FFM, CMAC, GC/228/2. Van Arsdel agrees with this hypothesis, *Fenwick Miller*, p. 6.

35. For example, the male editors of *Woman* and *Woman's World*. Beetham, p. 129.

36. See Jane Lewis, *Women in England 1870–1950: Sexual Divisions and Social Change* (London: Harvester Wheatsheaf, 1984), pp. 81–111.

37. FFM, 'How I Made My First Speech', *WS* (4 January 1894), p. 4.

38. See Lilian Lewis Shiman, *Women and Leadership in Nineteenth-Century England* (London: Macmillan, 1992), pp. 130–37.

39. Van Arsdel, 'Women's Periodicals and the New Journalism', pp. 253–55.

40. 'The New Editor', *WS* (3 October 1895), pp. 209–10.

41. FFM, CMAC, GC/228/ 13, p. 13.

42. Valerie Sanders, *The Private Lives of Victorian Women* (London: Harvester Wheatsheaf, 1989), p. 164.

43. Harriet Martineau, *Autobiography* (London: Smith, Elder, 1877). In fact Fenwick Miller stayed with Jane Martineau, on lecture trips to Birmingham. FFM, CMAC, GC/228/32.

44. Hélène Postlethwaite, 'Some Rising Artists', *MA* (1893), p. 114; Marion Hepworth Dixon, 'Our Rising Artists: Miss Lucy Kemp-Welch', *MA* (September 1899), p. 481; 'Our Rising Artists: Eleanor Fortescue-Brickdale', *MA* (1902), p. 256.

45. Rozsika Parker and Griselda Pollock argued that it was this categorization of women as a homogeneous group that laid the foundations for their obliteration; women were relegated into a category 'distinct from mainstream cultural activity and public professionalism'. Rozsika Parker and Griselda Pollock, *Old Mistresses, Women, Art and Ideology* (New York: Pantheon, 1981), p. 44. Yet, by grouping brief biographies of 14 women artists together, Postlethwaite was able to expand upon her earlier determination to include 'one woman' rising artist. Hélène L. Postlethwaite, 'Some Noted Women-Painters', *MA* (1895), pp. 17–21; 'More Noted Women-Painters', *MA* (1898), pp. 480–84.

46. Anne Higonnet contends that in France, although women's painting was promoted by women's magazines, by representing women's painting in conjunction with other visual practices, including fashion and domestic crafts, high art was associated with what was culturally marginal. 'Imagining Gender', *Art Criticism and its Institutions in Nineteenth-century France*, ed. Michael R. Orwicz (Manchester: Manchester University Press, 1994) p. 156.

47. FFM, 'Ladies' Column', *ILN*, 12 October 1889, p. 480.

48. Cherry, *Beyond the Frame*, p. 52.

49. Beetham, p. 122.

50. Certeau, in Chow, p. 16.

51. FFM, 'The Ladies' Column', *ILN* (6 March 1886), p. 233.

52. See for example a review of Studio Sunday which devoted two paragraphs to women, Jopling and Rae, and two lines to men, Kennington, Schmalz and Solomon. FFM, 'Ladies' Column', *ILN* (6 April 1889), p. 448.

53. Kauffman and Moser were two of the founding members of the RA, as nominated by King George III; however after the death of Moser no further women were admitted. Women constituted a large proportion of the Honorary Members; there were 185 Honorary Lady Members between 1800 and 1867 when this section was abolished. Annie Swynnerton was elected as an Associate Royal Academician in 1922, Laura Knight was similarly elected in 1927 and became a Royal Academician in 1936. Yeldham, vol. 1, p. 71.

54. FFM, 'Ladies' Page', *ILN* (7 May 1887), p. 516.

55. Portraits by Ethel Wright and Louise Jopling were noted as well as works by Henriette Ronner, Alice Manley and Henrietta Rae. FFM, 'Ladies' Page', *ILN* (8 May 1897), p. 648.

56. Louise Starr Canziani's *News from the Front* was 'well hung on the line' and Kemp-Welch had contributed a picture of a horse in sea-waves with a 'life and spirit' reminiscent of Bonheur. Rae contributed a 'striking' portrait of the *Lady Mayoress* and Marie Lucas's *The Hearth Witch* was 'interesting in subject and excellent in technique'. FFM, 'Ladies' Page,' *ILN* (12 May 1900), p. 652.

57. FFM, 'Ladies' Page', *ILN* (5 June 1897), p. 790.

58. FFM, 'Ladies' Page', *ILN* (12 March 1898), p. 380. By 1898 Ward was in fact very rarely exhibiting; the peak in her popularity was decades earlier in the 1860s. She exhibited at the RA only nine times from 1889 until 1921. See Nunn, *Victorian Women Artists*, p. 146.

59. FFM 'Ladies', Page', *ILN* (14 February 1903), p. 244. See S. Hutchison, *The History of the Royal Academy, 1768–1968* (London: Chapman and Hall, 1968). Elizabeth Butler narrowly lost to Hubert Herkomer in 1879, resulting in several debates in the General Assembly and council, wherein it was determined that the phrase 'men of fair moral characters' did not include women. Yeldham, vol. 1, p. 74.

60. FFM, 'Ladies' Page', *ILN* (14 February 1903), p. 244.

61. FFM, 'Ladies' Page', *ILN* (29 January 1910), p. 174.

62. Tamar Garb, *Sisters of the Brush: Women's Artistic Culture in Late Nineteenth-Century Paris* (New Haven and London: Yale University Press, 1994), pp. 67–104.

63. See Bea Howe, *Arbiter of Elegance* (London: Harvill 1967); Lucy Crane, *Art and the Formation of Taste: Six Lectures* (London: Macmillan and Co., 1882).

64. Christopher Newall, *Grosvenor Gallery Exhibitions: Change and Culture in the Victorian Art World* (Cambridge: Cambridge University Press, 1995), p. 23.

65. FFM, 'Ladies' Page', *ILN* (9 April 1887), p. 407.

66. Kate Flint, 'Portraits of Women: On Display', *Millais: Portraits*, eds Peter Funnell and Malcolm Warner (London: National Portrait Gallery, 1999), p. 194.

67. FFM, 'Ladies' Page', *ILN* (7 April 1888), p. 356.

68. FFM, 'Ladies' Page', *ILN* (12 April 1890), p. 476.

69. Frances Power Cobbe, 'What Shall We do with Our Maids', *Fraser's Magazine* (1862) in *'Criminals, Idiots, Women and Minors': Victorian Writing by Women on Women*, ed. S. Hamilton (Peterborough: Broadview Press, 1995), p. 97; Bessie Rayner Parkes' essay of two years earlier, 'What Can Educated Women Do II', saw Bonheur and Hosmer as inspiring, but exceptional. *English Woman's Journal* (January 1860), reprinted in *Barbara Leigh Smith Bodichon and the Langham Place Group*, ed. C. Lacey (New York and London: Routledge and Kegan Paul, 1987), pp. 163–73.

70. René Peyrol, *Rosa Bonheur; her life and work* (London: Art Journal, 1889); Elbert Hubbard, *Rosa Bonheur* (New York: George Putnam, 1897).

71. See for example 'Mlle. Rosa Bonheur', *Academy* (1872), p. 126; 'Fine Art', *Athenaeum* (23 April 1881), pp. 564–67.

72. 'Summer Lectures', *WSJ* (1 September 1883), p. 164.

73. FFM, 'The Ladies' Column', *ILN* (21 April 1894), p. 494.

74. FFM, 'Ladies' Page', *ILN* (30 May 1896), p. 698.

75. FFM, 'Ladies' Page', *ILN* (28 October 1899), p. 624; (9 March 1901), p. 356.

76. Frank Rinder, '"Henrietta Rae"– Mrs Ernest Normand', *AJ* (1901), pp. 303–307.

77. Rae's submissions were: *Eurydice sinking back to Hades, A Naiad*. FFM, 'Ladies' Page', *ILN* (2 April 1887), p. 379.

78. FFM, 'Ladies' Column', *ILN* (31 January 1891), p. 160.

79. FFM, 'Ladies' Column', *ILN* (14 April 1894), p. 462.

80. *Times* (5 May 1894), p. 16

81. See Rosemary Treble, *Great Victorian Pictures: their paths to fame* (London: Arts Council of Great Britain, 1978), p. 95. Blackburn, *Royal Academy Notes* (London: Cassell, 1894), pp. 19, 118; *MA* (1894), p. 274. See Cherry, *Painting Women*, p. 200 for *Magazine of Art*, *Times* and *Athenaeum* reviews which deployed sexual stereotypes in their criticism of *Psyche before the throne of Venus* (which was influenced by French Academic painting); Cherry, *Beyond the Frame*, p. 184.

82. FFM, 'Ladies' Page', *ILN* (11 April 1894), p. 462. Similarly, Postlethwaite emphasized the Academic and financial success of this picture; it justified Rae's status as the 'champion who is to obtain for women' membership in the RA. Hélène Postlethwaite, 'Some Noted Women-Painters', *MA* (1895), p. 17.

83. Cherry, *Painting Women*, p. 201; Cherry, *Beyond the Frame*, pp. 182–84.

84. FFM, 'Ladies' Page', *ILN* (16 February 1895), p. 214.

85. Benedict Read, *Victorian Sculpture* (London and New Haven: Yale University Press, 1982), pp. 78, 355.

86. [FFM], *WS* (7 May 1896), p. 297.

87. FFM, 'Ladies' Column', *ILN* (12 April 1890), p. 474,

88. H. H. Robson, 'Art amongst Women in the Victorian Era', *ER* (15 October 1897), p. 211.

89. H. H. Robson advised, 'Their best chance of conquering and proving themselves at least equal to the other sex is not to follow the fashion of the day or hour; but to work, inspired by the belief that the object of art is not to glorify the artist, but to elevate mankind.' 'Art in the Galleries of 1890', *ER* (15 July 1890), p. 300.

90. Beetham, p. 122.

91. FFM, 'Editor's Address', *WS* (3 October 1895), p. 216.

92. Ibid.

93. Ibid.

94. *WS* (11 February 1897), p. 1. For example, in 1897 the *Woman's Signal* covered a series of debates concerning women: suffrage – the subject of parliamentary debate – the government wishing to impose a Contagious Diseases Act in India, similar to the one Fenwick Miller had opposed two decades earlier – and a bid (unsuccessful) for degrees for women at Cambridge.

95. Two exceptions were: 'Henrietta Montalba – A Reminiscence', *AJ* (1894), pp. 215–17; Mrs. Steuart Erskine, 'The Drawings of Lady Waterford', *Studio* (1910), pp. 283–86.

96. FFM, *WS* (26 January 1899), pp. 51–52.

97. For women artists turning to suffrage action see Lisa Tickner, *The Spectacle of Women: Imagery of the Suffrage Campaign, 1907–1914* (London: Chatto, 1987), pp. 123–24.

98. FFM, *WS* (7 May 1896), p. 297.

99. Unlike Fenwick Miller, the *Athenaeum* reviewer, presumably F. G. Stephens, was highly critical of this piece with his caustic assertion that it strongly resembled the wallpaper. *Athenaeum* (6 June 1896), p. 752, in Edward Morris, *Victorian and Edwardian Paintings in the Lady Lever Art Gallery: British artists born after 1810 excluding the early Pre-Raphaelites* (London: National Museums and Galleries on Merseyside, 1994), pp. xiv, 59; Jane Sellers, *Women's Works* (Liverpool: National Museums and Galleries on Merseyside, 1988), pp. 6–7; Cherry, *Painting Women*, p. 101.

100. In fact, Lever promotion offered mixed rewards; both Frith and Millais had expressed anger that their art had been degraded by advertising. Morris, pp. xiv, 39.

101. 'Character Sketch: Adelaide Johnson The American Sculptor, A Novel Wedding', *WS* (9 April 1896), p. 1.

102. An exhibition of Bonheur's work was held at the Lefevre Gallery. 'Character Sketch: Mademoiselle Bonheur', *WS* (7 May 1896), pp. 289–90.

103. 'Women's Pictures at the Victorian Exhibition, Earls Court: Interview with Henrietta Rae', *WS* (8 July 1897), pp. 19–20.

104. Ibid., p. 19.

105. Ibid., pp. 19–20.

106. Ibid.

107. See Carol Dyhouse, *Feminism and the Family 1880–1939* (Oxford: Basil Blackwell, 1989), pp. 145–50; Lucy Bland, 'Marriage Laid Bare: Middle-Class Women and Marital Sex 1880s–1914,' *Labour and Love: Women's Experience of Home and Family*, ed. J. Lewis (Oxford: Basil Blackwell, 1986), pp. 123–46.

108. 'Women's Pictures', pp. 19–20.

109. Ernest Normand to Mr Dibden (Curator of Walker Art Gallery) (12 April, 1917), Walker Art Gallery, National Museums and Galleries on Merseyside. In the catalogue *Women's Works*, Jane Sellars wonders what Rae's reaction was to the barrage of criticism from these four men, including her husband, and how she felt about her work being covered in 'blackness', p. 16. Fenwick Miller's interview certainly lends insight into her actual reaction to the situation. Interestingly the story appeared in Rae's biography published eight years later, although by this time Leighton and Prinsep were no longer living. See Arthur Fish, *Henrietta Rae* (London: Cassell, 1905), pp. 78–79 and M. Stirling MacKinlay's 'Random Recollections of a Bohemian I – Some Studio Stories', *Strand Magazine* (29 May 1905), p. 581.

110. Ernest Normand to Mr Dibden (Curator of Walker Art Gallery) (12 April, 1917), Walker Art Gallery, National Museums and Galleries on Merseyside.

111. Dakers frames Rae's network with the observation that Normand, Herbert Schmalz, and Solomon J. Solomon steered a preference for movements of violence, often involving women. Dakers, pp. 214–21.

112. 'If Henrietta Rae were a man, she would have been an Academician before this, and if she goes on as she has done heretofore, it must be impossible to permanently overlook the claims of so great an artist for recognition from her brothers of the brush … It is clear that it is time to open whatever distinction there is in the title of RA to the modern woman artists, and it could not be better done than by the admission of Henrietta Rae.' 'Women's Pictures', pp. 19–20.

113. Bonheur was still a practising artist in the 1890s and her renowned work was frequently used for comparison with the work of both Butler and Kemp-Welch. [FFM], 'Signals from the Watchtower', WS (13 May 1897), pp. 296–97.

114. 'Royal Academy', Athenaeum (1 May 1897), pp. 581–85; (5 June 1897), pp. 752–53.

115. 'Fine Art Gossip', Athenaeum (8 May 1897), p. 624; 'Royal Academy: Fifth Notice', Athenaeum (26 June 1897), p. 848.

116. A. C. R. Carter, 'The Royal Academy, 1897', AJ (1897), p. 182.

117. 'The Chronicle of Art: May', MA (1897), p. 47; 'Chronicle of Art: June', MA (1897), p. 106; 'The Exhibition of the Royal Academy', MA (1897), p. 157.

118. FFM, 'Ladies' Page', ILN (26 February 1898), p. 310.

119. FFM, 'Ladies' Page', ILN (15 February 1899), p. 240; (3 March 1900), p. 304; (1 November 1902), p. 670.

120. Anna Lea Merritt, 'A Letter to Artists: Especially Women Artists', Lippincott's Monthly Magazine (1900), p. 463. See Gillett, Worlds of Art, p. 174.

121. For these debates see Dyhouse, No Distinction of Sex; Vicinus, pp. 121–62; Jane McDermid, 'Women and Education' in Women's History: Britain 1850–1945, ed. J. Purvis (London: University College London Press, 1995), pp. 111–12; Angela V. John and Claire Eustance, 'Shared histories–differing identities: introducing masculinities, male support and women's suffrage', The Men's Share? Masculinities, Male Support and Women's Suffrage in Britain, 1890–1920 (London: Routledge, 1997), pp. 9–10.

122. FFM, 'Art in the Woman's Section', AJ (1893), pp. xii–xvi.

123. Jeanne Madeline Weimann, The Fair Women (Chicago: Academy Chicago, 1981), pp. 280–93. In another article, Fenwick Miller muddled the specifics of the resistance to gender segregation of fine art, crediting Potter Palmer. FFM, 'Women at the World's Fair', Young Woman (August 1893), pp. 377–79.

124. Paul Greenhalgh, Ephemeral Vistas: The Expositions Universelles, Great Exhibitions and World's Fairs, 1851–1939 (Manchester: Manchester University Press, 1988), p. 182.

125. FFM, 'Art in the Woman's Section', AJ (1893), p. xiii.

126. Ibid.

127. Ibid., p. xiv.

128. Ibid.

129. Ibid.

130. Griselda Pollock, Mary Cassatt: Painter of Modern Women (London: Thames and Hudson, 1998), pp. 46–64.

131. See Judy Sund, 'Columbus and Columbia in Chicago 1893: Man of Genius Meets Generic Woman', Art Bulletin (September 1993), pp. 443–65.

132. FFM, 'Art in the Woman's Section', pp. xv–xvi.

133. Ibid., p. xvi. The reason for the absence of the sculptor stemmed from Hosmer's opposition to gendered segregation, and her Queen Isabella, commissioned by the Queen Isabella Association, had never been cast in bronze for lack of funds and it ended up outside the California Pavilion. Sund, pp. 43–47.

134. FFM, 'Art in the Woman's Section', p. xvi.

135. Florence M. Roberts-Austen, 'Notes on Preparations for Chicago Exhibition', ER (15 April 1893), pp. 131–33; 'Chicago Exhibition', ER (15 July, 1893), pp. 151–54.

136. Florence M. Roberts-Austen, 'Chicago Exhibition', *ER* (15 July 1893), p. 153.

137. FFM, 'Ladies' Page', *ILN* (5 June 1897), p. 790.

138. FFM, 'Women's Pictures at the Victorian Exhibition, Earls Court', p. 19.

139. Ibid.

140. FFM, 'Ladies' Page', *ILN* (24 January 1897), p. 126.

141. FFM, 'Women's Pictures', p. 19.

142. Henrietta Rae, 'Woman's Art Production During the Victorian Era', *Victorian Era Exhibition* (London: Earls Court, 1897), p. 33.

143. FFM, 'Women's Pictures', pp. 19–20.

144. FFM, 'Ladies' Page', *ILN* (24 January 1897), p. 126.

145. The contemporary criticism of this piece is discussed in comparison with that of Leighton's expansive 1855 Academy piece by Pamela Gerrish Nunn in her essay 'Critically Speaking', pp. 119–22. The catalogue notes to the *Pre-Raphaelite Women Artists* exhibition in 1998 state that the last recorded exhibition of her *chef d'oeuvre* was 1887 in Liverpool, but it was shown at Earls Court a decade later. Pamela Gerrish Nunn and Jan Marsh, *Pre-Raphaelite Women Artists* (Manchester City Art Galleries, 1998), p. 27.

146. Rae, 'Woman's Art Production During the Victorian Era', p. 34.

147. H. H. Robson, 'Art amongst Women in the Victorian Era', *ER* (15 October 1897), p. 210.

148. 'Passing Events', *AJ* (1897), p. vi.

149. 'Chronicle of Art: September', *MA* (1897), p. 285.

150. *FR* (July 1889), p. 139; *Some Supporters of the Women's Suffrage Movement* (London: National Society for Women's Suffrage, 1897) in Cherry, *Painting Women*, p. 93.

Chapter 5

1. Robins Pennell, *Nights*, p. 118.

2. Mrs. E. Robins Pennell, 'Cycling' in *Ladies in the Field: Sketches of Sport*, ed. Lady Grenville (London: Ward and Downey, 1894), pp. 247–65.

3. Jude Burkhauser, 'The "New Woman" in Glasgow', *Glasgow Girls: Women in Art and Design* (Edinburgh: Canongate, 1990; revised edition, 1993), pp. 43–54.

4. In 1883 Joseph Pennell had obtained a commission from the *Century* magazine for drawings of Italy and had travelled to Europe.

5. For example Leland (poet, philologist and authority on gypsies) arranged research access for Elizabeth Robins Pennell at the British Museum: 'I have received your letter, together with Mr. Leland's. It will give me extreme pleasure to be of any service to you.' N. Garrett to ERP, 26 January 1884, Library of Congress(LC), Pennell-Whistler Collection(PC), box 375.

6. John Laurence Waltman, 'The Early London Journals of Elizabeth Robins Pennell' (PhD Thesis, University of Texas, 1976), pp. 6–11.

7. Viv Gardner, 'Introduction', *The New Woman and Her Sisters: Feminism and theatre 1850–1914*, eds Viv Gardner and Susan Rutherford (London: Harvester Wheatsheaf, 1992), pp. 2–5. See also Angelique Richardson and Chris Willis (eds), *The New Woman in fiction and in fact: fin-de-siècle feminisms* (Basingstoke: Palgrave Macmillan, 2000).

8. *Punch* (10 November 1894), p. 228.

9. Sally Ledger, 'The New Woman and the crisis of Victorianism', in *Cultural Politics at the Fin de Siècle*, eds Sally Ledger and Scott McCracken (Cambridge: Cambridge University Press, 1995), p. 24. Hugh E. M. Stutfield, 'Tommyrotics', *Blackwoods* (June 1895), p. 840; Kate Flint, 'The Philistine and the New: J. A. Spender on Art and Morality' in *Papers for the Millions*, ed. J. Wiener (New York: Greenwood Press, 1988), pp. 119–220; Walkowitz, *City of Dreadful Delight*, pp. 62–66.

10. See Bland, *Banishing the Beast*, p. 144.

11. Evelyn March Phillipps, 'Women's Newspapers', *FR* (1 November 1894), p. 667.

12. C. Kegan Paul to ERP, 19 January 1884, LC, PC, box 375.

13. T. Niles to ERP, 4 July 1884, LC, PC, box 375.

14. Caroll Smith-Rosenberg, *Disorderly Conduct: Visions of Gender in Victorian America* (New York: Oxford University Press, 1985).

15. According to her publisher the book was 'well noticed' but not a financial success and her offer of another volume, on St Catherine of Siena, was rejected. T. Niles to ERP, 16 July 1885, LC, PC, box 375.

16. John H. Ingram to ERP, 17 August 1885, LC, PC, box 375. See Elizabeth Robins Pennell, *Life of Mary Wollstonecraft* (Boston: Roberts Brothers, 1884), 360 pages; *Mary Wollstonecraft Godwin* (London: W. H. Allen, 1885), 209 pages.

17. See Tickner, pp. 5–7; Bland, *Banishing the Beast*, p. 155.

18. Pennell was determined to accept the challenge and disprove her book's critics. She wrote to her husband, 'Now, if you remember, the critic in the Athenaeum when my Life of Mary came out, took me to task for not knowing what was being done on the Woman Question in France at the same period … Three days work in the British Museum will turn me into a brilliant historical scholar and my article will reduce my former critic to shame and confusion.' ERP to JP, 31 July 1890, LC, PC, box 305.

19. Elizabeth Robins Pennell, 'A Century of Women's Rights', *FR* (September 1890), pp. 408–17.

20. Mary Wollstonecraft, *A Vindication of the Rights of Woman* with an Introduction by Elizabeth Robins Pennell (London: Walter Scott, 1892), p. xxiv; see also *A Vindication of the Rights of Woman* with an Introduction by Mrs. Henry Fawcett (London: Fisher Unwin, 1891).

21. Barbara Caine, *English Feminism 1780–1980* (Oxford: Oxford University Press, 1997), p. 139.

22. Gardner, p. 11.

23. Ibsen's *A Doll's House* was first privately staged in London at the Novelty Theatre in 1889; already in the literary circle that read and reviewed Ibsen, Pennell almost certainly attended.

24. 'Ibsen in England', *Nation* (4 July 1889), pp. 7–8.

25. Like Pearson, Pennell disdained the 'shopping dolls', as he described bourgeois womanhood. Walkowitz, *City of Dreadful Delight*, pp. 135–69.

26. (18 September 1888), Waltman, p. 339.

27. She claimed to be 'the first woman' to cross the Alps on a bicycle. Elizabeth Robins Pennell, *Over the Alps on a Bicycle* (London: T. Fisher Unwin, 1898), pp. 11, 15.

28. (3 July 1889), Waltman, p. 392.

29. Joseph Pennell, *The Adventures of an Illustrator: Mostly in Following his Authors in America and Europe* (Boston: Little, Brown and Co., 1925).

30. Patricia Marks, *Bicycles, Bangs, and Bloomers: The New Woman in the Popular Press* (Lexington: University of Kentucky, 1990), p. 19.

31. Elizabeth Robins Pennell, 'Around London by Bicycle', *Harper's New Monthly Magazine* (September 1897), pp. 489–510. See de Certeau.

32. See Marks on the advantages of the new 'safety' and pneumatic tyre, as opposed to the large front wheel of the 'Ordinary' or tricycle (p. 185).

33. Pennell, 'Cycling', p. 252.

34. Ibid., p. 264.

35. Nead, *Victorian Babylon*, p. 71.

36. Waltman, pp. 6–11.

37. Whitney Chadwick and Isabelle De Courtivron (eds), *Significant Others: Creativity and Intimate Partnership* (London: Thames and Hudson, 1996).

38. Emma Chambers, *An Indolent and Blundering Art* (Aldershot: Ashgate, 1999), p. 91.

39. ERP to JP, 12 May 1888, LC, PC, box 305. The correspondence of Elizabeth Robins Pennell intimates that Joseph Pennell was a difficult and challenging personality. This is corroborated by many contemporaries. Rothenstein later wrote, 'He was so rude that when he left, Whistler was

apologetic, saying: "Never mind, … you know I always had a taste for bad company"'. William Rothenstein, *Men and Memories: Recollections of William Rothenstein 1872–1900* (London: Faber and Faber, 1931), p. 23.

40. 'Don't think me a veritable weathercock in my change of plans. But a letter received yesterday from the Editor of the Fortnightly … has made me decide to stay here till Sunday.' ERP to JP, 31 July 1890, LC, PC, box 305.

41. '[O]therwise my attentions to Edmund might seem marked.' ERP to JP, 29 September 1890, LC, PC, box 305.

42. Pennell, *Nights*, pp. 121–22.

43. Ibid., pp. 142–43.

44. The interconnectivity of the group was evident in the job market. For example, in 1893 Stevenson obtained the position of art critic of the *Pall Mall Gazette*, which was edited by H. J. C. Cust in association with Charles Whibley, a close friend of Henley. W. E. Henley, one of the more experienced associates of the group, edited successively the *Magazine of Art*, *Art Journal*, and *National Observer*, where many members of the Pennell salon published work. Ibid., p. 135.

45. Ibid., p. 118; the Hogarth Club, for example, where MacColl first met Moore, was a site where scholars, painters and writers mixed to converse and argue. See MacColl Papers, M667 in Maureen Borland, *D. S. MacColl: Painter, poet, art critic* (Harpenden: Lennard, 1995), p. 84.

46. Ibid., *Nights*, pp. 229–36 and Alfred Thorton, *The Diary of an Artist Student in the Nineties* (London: Sir Isaac Pitman and Sons Ltd, 1938) for descriptions of the Salons and their New Critics. Denys Sutton has since referred to this 'group of men who went over to "do" the Salon' which although not entirely true, since Mabel Beardsley and Elizabeth Robins Pennell were present, was an accurate description of this new clique of rebellious critics and painters primarily composed of men who frequented the same clubs back in London. No other women art critics were affiliated with the group. Denys Sutton, 'Introduction', *Velazquez* by R. A. M. Stevenson, (London: G. Bell and Sons, 1962), p. 20.

47. Pennell, *Nights*, pp. 19–20.

48. ERP to JP, n.d.[1880s], LC, PC, box 305.

49. JP to ERP, n.d., LC, PC, box 305.

50. ERP to JP, 31 May 1889, LC, PC, box 305.

51. Joseph Pennell was appointed art critic in 1888, but after a few vituperative attacks on the RA exhibition he quickly handed over the task to his wife. See *Star* correspondence in LC, PC, box 242. See also Flint, p. 334 and Waltman, p. 13. Joseph Pennell articulated his position, 'I know as an artist, that it is only in the rarest cases art criticism has any influence on a man's work and that in still rarer cases can the public for whom it is written understand it.' 'An Artist on Artists', *Star* (30 April 1888), p. 2. Elizabeth Robins Pennell, however, occupied a very different position, as a professional art critic rather than artist, yet she retained the A. U. initials.

52. Wendell O. Garrison to Elizabeth Pennell, 6 February 1888, LC, PC, box 249.

53. Wendell O. Garrison to Elizabeth Pennell, 25 November 1889, LC, PC, box 249.

54. See Larkin Pennell to ERP and JP, n.d. [Christmas] 1888; 8 January 1889, LC, PC, box 307. The article he was referring to originally appeared in the *Nation*: 'London Socialists', *Nation* (6 December 1888), pp. 449–50.

55. *Hartford Courant* (3 August 1898), LC, PC, box 249. The original article appeared in the *Nation*: 'An International Art Exhibition in London', *Nation* (2 July 1898), pp. 360–61.

56. Lucy Bland, 'Marriage Laid Bare', pp. 132–33.

57. Tickner, *Spectacle of Women*, p. 183.

58. Stokes, p. 22–23.

59. John Goodbody, 'The *Star*: its Role in the Rise of the New Journalism', in Wiener, *Papers for the Millions*, pp. 143–63.

60. Not only did Pennell draw on new journalistic approaches, her social circle included figures associated with the New Journalism like Stead and Shaw. In 1887 she attended a meeting of the Liberal Social Union at which H. W. Massingham, later editor of the *Star*, lectured on the development of New Journalism. That year Pennell also attended the meetings of the unemployed in Trafalgar Square. See also 'London Socialists', *Nation* (6 December 1888), pp. 449–50.

61. Stokes, p. 15; Beetham, p. 124.

62. She added, 'I must thank Professor Hubert Herkomer, R.A., &c, &c, for the peace offering, or the oversight by which a ticket from him reached me. I hope in either case, it will not occur again.' A. U., 'Art and Artists', *Star* (2 April 1895), p. 1.

63. Ibid.

64. A. U., 'Art and Artists', *Star* (26 April 1899), p. 1.

65. See Shelagh Wilson, '"The highest art for the lowest people": the Whitechapel and other philanthropic art galleries, 1877–1901', *Governing Cultures: Art Institutions in Victorian London*, eds Paul Barlow and Colin Trodd (Aldershot: Ashgate, 2000), pp. 172–86.

66. N. N., 'East End Missions', *Nation* (28 April 1888), p. 340.

67. Walter Besant, 'The People's Palace', *Nation* (28 June 1888), p. 526.

68. [Walter Besant], 'Notes of the Week', *PJ* (19 December 1888), p. 798. See Simon Joyce on Besant's unease with 'class', 'Castles in the Air: The People's Palace, Cultural Reformism, and the East End Working Class', *Victorian Studies* (Summer 1996), pp. 513–38.

69. Frances Borzello, *Civilising Caliban: The Misuse of Art 1878–1980* (London and New York: Routledge and Kegan Paul, 1987), pp. 98–99.

70. N. N., 'East End Missions', p. 339.

71. E. H. Currie, 'The Working of the People's Palace', *NC* (February 1890) in Deborah E. B. Weiner, 'The People's Palace: An Image for East London in the 1880s' in *Metropolis London: Histories and Representation since 1800*, eds David Feldman and Gareth Stedman Jones (London: Routledge, 1989), p. 46.

72. Pennell, 'English Faith in Art', *Century* (April 1888), p. 452. George Bernard Shaw similarly observed that middle-class attention and money was forthcoming only when East End poverty hit the headlines through either Jack the Ripper or the riots. Weiner, p. 48.

73. Pennell, 'English Faith in Art', p. 451.

74. Ibid., p. 455.

75. Borzello, p. 102.

76. Borzello, pp. 95, 103; Seth Koven, 'The Whitechapel Picture Exhibitions and the Politics of Seeing', *Histories, Discourses and Spectacles*, eds Daniel J. Sherman and Irit Rogoff (London: Routledge, 1994), p. 40.

77. Koven, p. 36.

78. Pennell, 'English Faith in Art', p. 459.

79. Artist Unknown, 'Art for Whitechapel', *Star* (31 March 1890), p. 2; Artist Unknown, 'Artist Unknown Sits Up', *Star* (8 April 1890), p. 2.

80. Stokes, p. 35.

81. Stevenson (1847–1900) studied painting in France and London from 1879 until 1885, beginning writing for the *Saturday Review* in 1888. MacColl (1859–1948) was asked by Frederick Brown to become a member of the NEAC and began writing for the *Spectator* in 1890 (15 February) and praised the NEAC for the first time that same year (5 April 1890). Moore (1852–1933) was a playwright, novelist and art critic; he reviewed the last French Impressionist exhibition (1886) and began writing for the *Speaker* in 1890. His art criticism was collected in *Modern Painting* (London: Walter Scott, 1893). See Stokes, p. 174; Borland, pp. 65, 68.

82. See Stokes, p. 34; Gruetzner Robins, 'The London Impressionists at the Goupil Gallery', p. 88; Gruetzner Robins (ed.), *Walter Sickert: The Complete Writings on Art* (Oxford: Oxford University Press, 2000).

83. As Gruetzner Robins has observed, the New Critics clique knew far more about recent developments in French art than is generally believed, but their idea of 'Impressionist Art' or 'Modern Art' as they sometimes called it did not embrace the French model. Indeed they had very particular ideas about French art and were suspicious of aspects of it. 'Fathers and Sons: Walter Sickert and Roger Fry' in Green, *Art Made Modern*, p. 47.

84. Flint, *Impressionists in England*, p. 2.

85. Only Berthe Morisot was credited with creating her own style by investing her art with femininity, yet Moore proceeded to assert that she never faltered in allegiance to the genius of her brother-in-law. Moore, *Modern Painting*, pp. 220, 226, 228–29.

86. Cherry, *Painting Women*, p. 75.

87. A. U., 'Art', *Star* (24 March 1890), p. 2.

88. A. U., 'Art And Artists', *Star* (4 June 1895), p. 1.

89. A. U., 'The Royal Academy', *Star* (13 May 1889), p. 2.

90. N.N., 'The Royal Academy', *Nation* (21 May 1891), p. 420.

91. A. U., 'The Royal Academy', *Star* (28 April 1893), p. 2.

92. R. A. M. Stevenson, 'The American Salon', *MA* (1885), p. 514.

93. A. U., 'Art and Artists', *Star* (6 May 1897), p. 1.

94. D. S. MacColl, *The Administration of the Chantrey Bequest* (London: Grant Richards, 1904), p. viii, reprinted *Saturday Review* (25 April 1903).

95. A. U., 'Art and Artists', *Star* (6 September 1904), p. 1.

96. A. U., 'Art and Artists', *Star* (27 June 1899), p. 1.

97. A. U., 'Art and Artists', *Star* (2 May 1899), p. 1. In a related issue, the decoration of St Paul's by William B. Richmond, she joined forces with another New Critic, MacColl, to call for the removal of Richmond's mosaics because they degraded a national monument. D. S. MacColl, *Saturday Review* (18 March, 1 April, 8 April, 22 April 1899); A. U., 'Art and Artists', *Star* (2 May 1899), p. 1. The New Critics were certainly guilty of logrolling. Stevenson was notoriously generous to old friends in criticism; Moore, MacColl, Stevenson and Fry reviewed one another's work and Pennell was part of this network. J. A. Spender, *The New Fiction, A Protest Against Sex-Mania and Other Papers by the Philistine* (London: Westminster Gazette, 1895), p. 26; Sutton, p. 30; Stokes, p. 45. However, this practice was not new, nor was it unusual during this period; as we have seen, F. G. Stephens advocated the work of his friends and Meynell promoted her sister's work. Evelyn March Phillipps cites an example of an artist who was offered a leading article on his work for five guineas by a weekly paper, 'The New Journalism', *New Review* (August 1895), p. 188.

98. The Editor [M. H. Spielmann], 'Royal Academy', *MA* (1899), p. 338.

99. 'Royal Academy', *Athenaeum* (29 August 1899), p. 536.

100. A. U., 'Art and Artists', *Star* (12 May 1903), p. 1.

101. M. H. Spielmann, 'At the Royal Academy Exhibition', *MA* (1901), p. 385.

102. A. U., 'Art and Artists', *Star* (6 May 1902), p. 1.

103. Harrison exemplifies this art historical methodology in his mapping of the origins of Modernism in England. During this period he identifies the associations of the 'proclamation of Modernism' with technical autonomy in art, a highly mediated interest in recent French art, and the avoidance of moral subject matter. Charles Harrison, *English Art and Modernism 1900–1939* (New Haven: Yale University Press, 1981, repr. 1994), pp. 13–18.

104. In a pseudonymous article in the *Speaker* Sickert wrongly included A.U. alongside D.S.M., G.M., and R.A.M.S. under the label 'painter-critics'. See Sickert (6 February 1897) in Gruetzner Robins, *Walter Sickert*, p. 134.

105. Anna Gruetzner, 'Great Britain and Ireland: Two Reactions to French Painting in Britain', *Post-Impressionism: Cross-Currents in European Painting* (London: Royal Academy of Arts, 1979–80), p. 180; [W. Sickert], 'The Royal Academy', *New York Herald* (16 May 1889) in Gruetzner-Robins, *Walter Sickert*, pp. 48–50.

106. A. U., 'The Royal Academy', *Star* (13 May 1889), p. 2; A. U., 'The Royal Academy', *Star* (6 May 1890), p. 2.

107. A. U., 'The Royal Academy', *Star* (28 April 1893), p. 2.

108. Gruetzner Robins, 'The London Impressionists at the Goupil Gallery', pp. 88–90; A. U., 'London Impressionists', *Star* (3 December 1889).

109. Gruetzner Robins, 'The London Impressionists at the Goupil Gallery', p. 96.

110. Scholarship has credited MacColl and Stevenson for the support of the Glasgow artists in the press, rather than Pennell. See Roger Billcliffe, *The Glasgow Boys: The Glasgow School of Painting 1875–1895* (London: John Murray, 1985), p. 294.

111. A. U., 'The Best of the three Large Shows', *Star* (7 May 1890), p. 2; N. N., 'Grosvenor Gallery', *Nation* (29 May 1890), pp. 430–31; *Saturday Review* (10 May 1890), p. 565.

112. A. U., 'The New English Art Club', *Star* (30 November 1891), p. 4.

113. D. S. M., 'Impressionism and the New English Art Club', *Spectator* (5 December 1891), p. 809.

114. Billcliffe, pp. 292–93.

115. A. U., 'The Grafton Gallery', *Star* (17 February 1893), p. 2.

116. N. N., 'The Grafton Gallery', *Nation* (2 March 1893), p. 158.

117. Billcliffe, p. 295.

118. A. U., 'The New English Art Club', *Star* (30 November 1891), p. 4.

119. N. N., 'Tendencies in English Art', *Nation* (9 January 1890), p. 30.

120. A. U., 'The New English Art Club', *Star* (30 November 1891), p. 4. As Gruetzner-Robins observes, influence and originality were later recognized as a key issue of modernist art practice. Gruetzner Robins, 'The London Impressionists at the Goupil Gallery', p. 90.

121. Elizabeth Robins Pennell, 'The Two Salons', *FR* (June 1892), p. 841.

122. Ibid., p. 845.

123. A. U., 'The Grafton Gallery', *Star* (17 February 1893), p. 2.

124. N. N., 'The Grafton Gallery', *Nation* (2 March 1893), p. 158.

125. D. S. M., 'The Inexhaustible Picture', *Spectator* (25 February 1893), p. 256; 'The New Art Criticism: A Philistine's Remonstrance', *Westminster Gazette* (9 March 1893), pp. 1–2.

126. D. S. M. 'The Grafton Gallery', *Spectator* (25 February 1893), p. 256.

127. J. A. S. [Spender], *The New Fiction*, p. v. This collection also included an essay critiquing the 'morbidity' of New Woman novels by Sarah Grand, George Egerton and Grant Allen.

128. Ibid., p. vi.

129. D. S. M. to the Philistine, in *The New Fiction*, p. 7.

130. Peter Piper, 'Summing Up', *The New Fiction*, p. 22.

131. A. U., 'Art and Artists', *Star* (13 March 1893), p. 2.

132. Ibid.

133. A. U., 'Art and Artists', *Star* (20 March 1893), p. 2.

134. A. U., 'Art and Artists', *Star* (4 April 1893), p. 2.

135. A. U., 'The Royal Academy', *Star* (28 April 1893), p. 2. Gerard Reitlinger suggests that the decline in the RA market was indicated by the cool reception of Leighton's executor sale in 1896. But the longevity of Alma-Tadema postponed the fall of the market for subject-pictures until his death in 1912. However, prices for modern French works paid by American and French buyers were considerably higher by the 1880s. Gerard Reitlinger, *The Economics of Taste: The Rise and Fall of Picture Prices: 1760–1960* (London: Barrie and Rockcliff, 1961), pp. 158–61.

136. Linda Merrill, *A Pot of Paint: Aesthetics on Trial in Whistler v. Ruskin* (Washington: Smithsonian Institution Press, 1992).

137. N. N., 'Mr. Whistler's Triumph', *Nation* (14 April 1892), pp. 280–81.

138. See also D. S. M., *Spectator* (2 April 1892) in Borland, p. 72; Richard Dorment, 'James McNeill Whistler' in *James McNeill Whistler*, eds Richard Dorment and Margaret F. Macdonald (London: Tate Gallery, 1995), pp. 13–22.

139. N. N., 'Mr. Whistler's Triumph'.

140. See Sarah Burns for a consideration of the contemporary American criticism; she documents that 'ambivalence' to Whistler's work continued to reverberate. *Inventing the modern Artist: Art and culture in Gilded Age America* (New Haven and London: Yale University Press, 1996), p. 241.

141. N. N., 'Mr. Whistler's Triumph'.

142. Richard Ormond, 'Sargent's Art' in *John Singer Sargent*, eds E. Kilmurray and R. Ormond (London: Tate Gallery, 1998), pp. 32–33; Elizabeth Prettejohn, *Interpreting Sargent* (London: Tate Gallery, 1998), pp. 66–70.

143. See Nicolai Cikovsky, Jr. with Charles Brock, 'Whistler and America' in Dorment and Macdonald, *James McNeill Whistler*, pp. 37–38.

144. A. U., 'Grafton Gallery', *Star* (23 February 1893), p. 4.

145. A. U., 'The Royal Academy', *Star* (2 May 1893), p. 2. Burns notes that Whistler consistently played down the body of positive serious criticism in order to create the appearance of the beleaguered, abused and misunderstood painter whose belligerent stance against critics was self-evidently justifiable (p. 224).

146. For an exploration of the etching revival in Britain and America see Chambers; Gladys Engel Lang and Kurt Lang, *Etched in Memory: The Building and Survival of Artistic Reputation* (Chapel Hill and London: University of North Carolina Press, 1990).

147. Katherine A. Lochnan, *The etchings of James McNeill Whistler* (New Haven and London: Yale University Press, 1984), p. 264; Whistler wasn't the only printmaker promoted by the Pennells. Joseph Pennell's article, 'A New Illustrator: Aubrey Beardsley', appeared in the inaugural issue of the *Studio* in 1893, and he was also praised in her reviews. A. U., 'Art and Artists', *Star* (2 June 1896), p. 1. Beardsley was part of the circle of New Critics that gathered in Paris for the Salon in 1893 along with the Pennells.

148. N. N., 'Two Important Exhibitions', *Nation* (2 April 1891), pp. 279–80. The debate was described in her diary (7 February 1889–24 April 1889), Waltman, pp. 453–67; W. Sickert, 'Pennell v. Herkomer', *National Observer* (28 March 1891) in Gruetzner Robins, *Walter Sickert*, pp. 83–84.

149. ERP to JP, n.d., LC, PC, box 307, undated 3.

150. *Times* (24 April 1891), p. 12; Edwards, p. 124.

151. *Sun* (16 January 1897) in Greuztner Robins, *Walter Sickert*, pp. 129–130.

152. Elizabeth Robins Pennell, 'Mr. Whistler's Lithography', *Black and White* (11 January 1896), p. 44; Elizabeth Robins Pennell, 'The Master of the Lithograph – J. MacNeill Whistler', *Scribner's Magazine* (March 1897), pp. 277–89.

153. *Speaker* (13 March 1897) in Gruetzner Robins, *Walter Sickert*, pp. 147–149.

154. See 'Art criticism – What is a Lithography? – Action for Libel – Mr. Whistler in the Box', *Daily Chronicle* (6 April 1897), p. 4 'Art Criticism – Question of Lithographs – Damages for Libel', *Daily Chronicle* (7 April 1897), p. 5 'Mr. Whistler as a Witness', *Critic* (22 May 1897), p. 361.

155. Editor, 'Pennell v. Harris and Sickert "Why drag in – Pennell?"', *Saturday Review* (10 April 1897), pp. 371–73.

156. 'An English Estimate of American Illustration', *Nation* (11 April 1888), pp. 300–302; (2 April 1891), p. 279.

157. A. U., 'The Royal Academy', *Star* (2 May 1893), p. 2.

158. Ibid.

159. A. U., 'Art and Artists', *Star* (6 September 1904), p. 1.

160. N. N., 'An International Art Exhibition in London', *Nation* (2 July 1898), pp. 420–21. Her colleagues were not all in agreement; in the *Saturday Review* MacColl cited Manet's and Whistler's work from the 1860s to demonstrate that their work had since declined, conjuring up gendered notions of art and degeneracy to explain their deterioration: 'we have the characteristic Whistlerian phantom ... a feminine reading of one picture by Velazquez ... For nearly thirty years then all that has been interesting and vital in painting has been exercised away from the male side of sculpturesque form, and the result is that the art in the hands of the followers is in a state of decadence.' D. S. M., 'The International Exhibition of Art at Knightsbridge', *Saturday Review* (21 May 1898), p. 681. This invective was clearly related to the anti-decadence trends in the press after the Wilde trial. Pennell, rather than express concern about the prevalence of femininity, decadence or Impressionism, praised the 'contemporary influences' of Monet and Degas and 'veritable triumph' of Cecilia Beaux. See Stephenson; Tara Leigh Tappert, *Cecilia Beaux and the Art of Portraiture* (Washington and London: Smithsonian Institution, 1995); Sarah Burns, '"The Earnest, Untiring Worker" and the "Magician of the Brush": Gender Politics in the Criticism of Cecilia Beaux and John Singer Sargent', *Oxford Art Journal* (Spring 1992), pp. 36–53.

161. N. N., 'An Interesting Exhibition', *Nation* (29 July 1899), pp. 492–93.

162. There was disagreement about Pennell's membership of the Executive Council. See Francis Howard to Whistler, n.d., Glasgow University Library, I24 [17 February / March 1898]; Rothenstein related in his autobiography that Whistler insisted Pennell and Ludovici were co-opted onto the Executive although neither was taken seriously as an artist. As a result Rothenstein left with Ricketts and Shannon, pp. 335–36.

163. N. N., *Nation* (24 July 1899), p. 493.

164. Whistler to Helen [Nellie] Euphrosyne Whistler, 23 July 1895, Glasgow University Library, GB 0247 MS Whistler W726.

165. Burns, p. 245.

166. Elizabeth Robins Pennell and Joseph Pennell, *The Life of James McNeill Whistler* (London: William Heinemann, 1908), 2 vols.

167. 'The Great Art Shows', *Star* (2 May 1889), p. 2.

168. See also Ormond, 'Sargent's Art', p. 31.

169. Henry James, 'John S. Sargent', *Harper's New Monthly Magazine* (October 1887), pp. 683–91.

170. N. N., 'The Edinburgh Art Congress', *Nation* (28 November 1889), p. 429.

171. N. N., 'The Royal Academy', *Nation* (21 May 1891), p. 420.

172. James, p. 683; Marc Simpson (ed.), *Uncanny Spectacle: The Public Career of the Young John Singer Sargent* (New Haven and London: Yale University Press, 1997), p. 43.

173. Ormond, 'Sargent's Art', p. 34.

174. A. U., 'Art and Artists', *Star* (13 May 1901), p. 1.

175. R. A. M. Stevenson, 'J. S. Sargent', *AJ* (March 1888), pp. 65–69; *The Art of Velasquez* (London: George Bell, 1895).

176. A. U., 'Art and Artists', *Star* (6 May 1902), p. 1.

177. D. S. M., 'The Academy', *Saturday Review* (10 May 1902), p. 595; [Roger Fry], 'Fine Arts – The Royal Academy', *Athenaeum* (10 May 1902), p. 600.

178. A. U., 'Art and Artists', *Star* (8 November 1904), p. 1.

179. P. A., 'What Modern Pictures are Worth Collecting?', *Burlington Magazine* (1904), p. 108.

180. A. U., 'Art and Artists', *Star* (8 November 1904), p. 1.

181. A. U., 'Art and Artists', *Star* (12 July 1904), p. 1; A. U., 'Art and Artists', *Star* (6 September 1904), p. 1.

182. A. J. F., 'Art and Artists: The Incorruptible', *Star* (28 March 1905), p. 1.

Chapter 6

1. Elizabeth Robins Pennell, 'The Woman's World of London', *Chataquan* (1891), p. 772.

2. AM to WM, 27 March 1912, MFP; AM to WM [c. 1911], MFP.

3. Alice Meynell, 'Votes for Duties', *Votes for Women* (26 June 1914), p. 601; Telegram, 'Votes for Women Fellowship', Hon. Sec. E. Pethick Lawrence to A. Meynell (3rd July 1914) Scrapbook, Meynell Collection, Burns Library, Boston College.

4. AM to WM [c. 1916] MFP; see also 'What a splendid demonstration was Saturday's! I was able to make most of the march after all.' AM to Mrs Brannan [1910] M 02 2A, Burns Library, Boston College.

Bibliography

Primary sources

MANUSCRIPTS

Gertrude Campbell, Emilia Dilke, and Alice Meynell, Sitter Files, Heinz Archive, National Portrait Gallery, London.
Athenaeum, Marked File, Special Collections, City University Library, London.
Dilke Papers, Additional Manuscripts, British Library, London.
Elizabeth Wollstoneholme Elmy Papers, British Library, London.
General Collections, Contemporary Medical Archives Centre, Wellcome Institute for the History of Medicine, London.
Gerritsen Collection of Women's History.
Helen Blackburn Collection, Girton College, Cambridge.
Meynell Collection, John J. Burns Library, Boston College, Boston.
Meynell Family Papers, Private Collection.
Mark Pattison Papers, Bodleian Library, Oxford.
Pennell-Whistler Collection, Special Collections, Library of Congress, Washington D.C.
Thompson Collection, John J. Burns Library, Boston College, Boston.
Whistler Papers, Glasgow University Library, Glasgow.
Women's Suffrage Collection, and Papers of Millicent Garrett Fawcett, Manchester Public Library, Manchester.
Zimmern Papers, Bodleian Library, Oxford.

JOURNALS

Academy
American Architect and Building News
Apollo
Architect
Art Journal
Atalanta
Athenaeum
Atlantic Monthly

Black and White
Blackwoods
Borough of Hackney Standard
Brighton Gazette
Brighton Herald
Burlington Magazine
Catholic World
Chataquan
Chicago Record
Contemporary Review
Cosmopolitan
Daily Chronicle
Delineator
Die Kunst Unserer Zeit
Dublin Review
Englishwoman's Review of Social and Industrial Questions
Englishwoman's Year Book
Fortnightly Review
Fraser's Magazine
Graphic
Hackney and Kingsland Gazette
Harper's New Monthly Magazine
Hearth and Home
Illustrated London News
Lady's Pictorial
Lippincott's Monthly Magazine
London Mercury
Magazine of Art
Merry England
Nation
National Observer
New Review
Nineteenth Century
North American Review
Outlook
Palace Journal
Pall Mall Gazette
Pen
Quarterly Review
Review of Reviews
Saturday Review
Shield
Sketch
Speaker
Spectator
Star
Studio
Tablet
The Album
Tomorrow

Votes for Women
Weekly Register
Windsor Magazine
Woman
Woman Journalist
Woman's Signal
Women's Penny Paper
Women's Suffrage Journal
World
Young Woman

BOOKS AND PAMPHLETS

Note: The book rests on a substantial number of occasional articles in the press; these references are given in the notes and not again here where books and pamphlets only are listed.

Barrington, E. I. *G. F. Watts: Reminiscence*. London: George Allen, 1905.
—— *The Life, Letters and Work of Frederic Leighton*. 2 vols. London: George Allen, 1906.
—— *Essays on the Purpose of Art: Past and Present Creeds of English Painters*. London: Longmans, Green, 1911.
Bateson, Margaret. *Professional Women Upon Their Professions*. London: Horace Cox, 1895.
Beale, S. Sophia. *The Louvre, A Complete and Concise Handbook to all the Collections of the Museum; being an Abridgement of the French Official Catalogues*. London: Harrison; Paris: Galignani Library, 1883.
—— *The Churches of Paris from Clovis to Charles X*. London: W.H. Allen, 1893.
—— *The Amateur's Guide to Architecture*. Edinburgh: John Grant, 1914.
Bennett, E. A. *Journalism for Women*. London and New York: John Lane, 1898.
Besant, Annie. *Marriage As It Was, As It Is, and As It Should Be: A Plea for Reform*. London: Freethought, 1882.
—— *Autobiographical Sketches*. London: Freethought, 1885.
Blackburn, Helen. *Women's Suffrage A Record*. London: William and Norgate, 1902, reprinted Kraus, 1971.
—— *Royal Academy Notes*. London: Cassell, 1894.
Bulley, A. Amy, and Margaret Whitely. *Women's Work*. London: Methuen and Co., 1894.
Burne-Jones, Georgiana. *Memorials of Edward Burne-Jones*. 2 vols. London: Macmillan, 1904.
Butler, William Francis. *Far Out: rovings retold*. London: Wm. Isbister, 1880.
Cartwright, Julia. *Sir Edward Burne-Jones, Bart*. London: The Art Journal Office, 1894.
—— *Sir Frederic Watts, R.A.* London: The Art Journal Office, 1896.
—— *Studies and Drawings by Sir Edward Burne-Jones, Bart*. London: Fine Art Society, April 1896.
—— *Beatrice d'Este, Duchess of Milan*. London: Dent, 1899.
—— *Isabella d'Este, Marchioness of Mantua*. London: John Murray, 1903.
Chetwynd, Mrs. Henry, Mrs. Rentoul Esler, and Mrs. Haweis. 'What to do with our daughters', *Lady's Realm* (November 1897). Reprinted in *Over the Teacups*, ed. Dulcie M. Ashdown. London: Cornmarket Press, 1972.
Clayton, Ellen. *English Female Artists*. London: Tinsley, 1876.

Cobbe, Frances Power. 'What Shall We do with Our Maids', *Fraser's Magazine*, 18 (1962). In *'Criminals, Idiots, Women and Minors': Victorian Writing by Women on Women*, ed. Susan Hamilton. Peterborough: Broadview Press 1995, pp. 85–107.

Collection of Portraits of Eminent British Women: As Exhibited at Chicago in 1893 – Detailed Catalogue. London: Women's Printing Society, n.d.

Collet, Clara. 'The Educated Position of Working Women', (1890). Reprinted in *Educated Working Women*. London: P. S. King and Son, 1902, pp. 23–24.

Courtney, William Leonard. *Professor Hubert Herkomer*. London: J. S. Virtue, 1892.

Crane, Lucy. *Art and the Formation of Taste: Six Lectures*. London: Macmillan and Co., 1882.

Dilke, Emilia. *Art in the Modern State*. London: Chapman and Hall, 1888.

—— *The Book of the Spiritual Life*, ed. Charles Dilke. London: John Murray, 1905.

Fairhold, Frederick William, F.S.A. *Homes, Works and Shrines of English Artists with Specimens of Their Styles*. London: Virtue, 1873.

Fawcett, Mrs Henry. Introduction. *A Vindication of the Rights of Woman*. By Mary Wollstonecraft. London: Fisher Unwin, 1891.

Fenwick Miller, Florence. 'The lessons of Life: Harriet Martineau'. A Lecture delivered before the Sunday Lecture Society, St George's Hall, Langham Place on Sunday Afternoon, 11 March, 1877. London: Sunday Lecture Society, C. W. Reynell.

—— *Simple Lessons for Home Use: Our Bodily Life*. London: Edward Stanford, 1877.

—— *Lynton Abbott's Children*. London: Tinsley, 1879.

—— *Readings in Social Economy*. London: Longmans, Green, 1883.

—— *Harriet Martineau*. London: Allen, 1884.

—— *On the Programme of the Women's Franchise League*. London: Hansard Publishing Union, 1890.

—— *In Ladies' Company: six interesting women*. London: Ward and Downey, 1892.

—— 'Work of the Franchise League – Address by Florence Fenwick Miller of England'. In *Congress of Representative Women*, ed. May Wright Sewall. Chicago and New York: Rand, McNally, 1894, pp. 420–24.

Fish, Arthur. *Henrietta Rae*. London: Cassell, 1905.

Fourth Annual Report of the Society of Women Journalists. London: Society of Women Journalists, 1897–98.

Gissing, George. *Odd Women*, London: Lawrence and Bullen, 1893.

Hamerton, Philip Gilbert. *Thoughts about Art*. London: Macmillan, 1873.

Hawthorne, S. *Notes in England and Italy*. London: Sampson Low and Co., 1871.

Hubbard, Elbert. *Rosa Bonheur*. New York: George Putnam, 1897.

Hunt, W. Holman. *Pre-Raphaelitism and the Pre-Raphaelite Movement*. London: Macmillan, 1905.

Lee, Vernon. *Renaissance Fancies and Studies*. New York: G. P. Putnam's Sons; London: Smith and Elder, 1896.

Low, Frances. *Press Work for Women*. London: L. Upcott Gill, 1904.

MacColl, D. S. *Nineteenth Century Art*. Glasgow: James Maclehose and Sons, 1902.

—— *The Administration of the Chantrey Bequest*. London: Grant Richards, 1904.

Martineau, Harriet. *Autobiography*. London: Smith, Elder, 1877.

Meynell, Alice. *The Poor Sisters of Nazareth. An illustrated record of life at Nazareth House, Hammersmith*. London: Burns and Oates, 1889.

—— and Frederic William Farrar. *William Holman Hunt: his life and work*. London: Art Journal Office, 1893.

—— *Poems*. London: Elkin Mathews and John Lane, 1893.

—— *Catalogue of Watercolour Drawings illustrating Fisher-Life by Walter Langley R.I.* London: Fine Art Society, February 1893.

—— *The Colour of Life and Other Essays on Things Seen and Heard*. London and New York: John Lane, 1896.

—— *John Ruskin*. New York: Dodd Mead and Co.; Edinburgh: Blackwood, 1900.

—— 'Introduction.' In Adolfo Venturi, *The Madonna: A Pictorial Representation of the Life and Death of the Mother of Our Lord Jesus Christ by the Painters and Sculptors of Christendom in more than 500 of their works*, ed. and trans. Alice Meynell. London: Burns and Oates, 1902.

—— *The Work of John S. Sargent R.A*. London: William Heinemann, 1903.

—— *An Exhibition of Pictures Painted in Austria-Hungary by Adrian and Marianne Stokes*. Leicester Square Galleries, London, March–April 1907.

—— 'Introduction.' In John Ruskin, *Seven Lamps of Architecture*. London: Routledge, 1910.

—— *Mary, the Mother of Jesus*. London: Philip Lee Warner, 1912.

—— *Essays*. London: Burns, Oates and Waterbourne, 1930.

—— *The Wares of Autolycus: Selected Literary Essays of Alice Meynell*, ed. P. M. Fraser. London: Oxford University Press, 1965.

Meynell, Wilfrid. *Modern School of Art*. London: Cassell, n.d.[c. 1884].

Millais, John Guile. *The Life and Letters of Sir John Everett Millais*. 2 vols. London: Longmans, 1899.

Moore, George. *Literature at Nurse*. London: Vizetelly, 1885.

—— *Modern Painting*. London: Walter Scott, 1893.

Oldcastle, John. *Journals and Journalism with a Guide for Literary Beginners*. London: Field and Tuer, 1880.

Parkes, Bessie Rayner. 'What Can Educated Women Do II'. *English Woman's Journal* (January 1960). Reprinted in *Barbara Leigh Smith Bodichon and the Langham Place Group*, ed. Candida Ann Lacey. New York and London: Routledge and Kegan Paul, 1987, pp. 163–73.

Pattison, Emilia F. S. 'Sir Frederick Leighton, P.R.A.' In *Illustrated Biographies of Modern Artists*, ed. F. G. Dumas. London: Chapman and Hall, 1882.

Pennell, Elizabeth Robins. *Life of Mary Wollstonecraft*. Boston: Roberts Brothers, 1884.

—— *Mary Wollstonecraft Godwin*. London: W. H. Allen, 1885.

—— Introduction. *A Vindication of the Rights of Woman*. By Mary Wollstonecraft. London: Walter Scott, 1892.

—— 'Cycling.' In *Ladies in the Field: Sketches of Sport*, ed. Lady Grenville. London: Ward and Downey, 1894.

—— *Over the Alps on a Bicycle*. London: T. Fisher Unwin, 1898.

—— *Nights: Rome, Venice in the Aesthetic Eighties; London, Paris in the Fighting Nineties*. Philadelphia and London: J. B. Lippincott, 1916.

Pennell, Elizabeth Robins and Joseph Pennell. *Our Sentimental Journey through France and Italy*. London: Longmans, Green and Co., 1888.

—— *The Life of James McNeill Whistler*. 2 vols. London: William Heinemann, 1908.

Pennell, Joseph. *The Adventures of an Illustrator: Mostly in Following his Authors in America and Europe*. Boston: Little, Brown and Co., 1925.

Peyrol, René. *Rosa Bonheur; her life and work*. London: Art Journal Office, 1889.

Programme, Chicago Memorial Art Palace, May 15–21 1893. The World's Congress Auxiliary of the World's Columbian Exposition of 1893: Department of Woman's Progress.

Rae, Henrietta. 'Woman's Art Production During the Victorian Era.' In *Victorian Era Exhibition*. London: Earls Court, 1897.

Rhys, Ernest. *Frederick Lord Leighton*. London: George Bell and Sons, 1895.

Rossetti, William Michael. *Fine Art, Chiefly Contemporary.* London and Cambridge: Macmillan, 1867.

—— *Dante Gabriel Rossetti as Designer and Writer.* London, 1889.

—— *Memoir of Dante Gabriel Rossetti.* 2 vols. London: Ellis and Elvey, 1895.

—— *Pre-Raphaelite Diaries and Letters.* London: Hurst and Blackett, 1900.

Rothenstein, William. *English Portraits: A Series of Lithographed Drawings.* Covent Garden: Grant Richards, 1898.

Ruskin, John. *Sesame and Lilies.* London: Smith, Elder and Co., 1865. Republished London: Dent, 1907.

Seventh Annual Report of the Society of Women Journalists. London: Society of Women Journalists, 1900–1901.

Scott, Leader. *Bartolommeo di Paolo and Mariotto Albertinelli, Andrea D'Agnolo.* London: Sampson, Marston, Searle and Rivington, 1881.

—— *Lucca Della Robbia with other Italian Sculptors of the XV and XVI Centuries.* London: Sampson Low, Marston, Searle and Rivington, 1883.

—— *The Renaissance of Art in Italy: an Illustrated Sketch.* London: Chapman and Hall, 1888.

—— *Sculpture, Renaissance and Modern.* London: Sampson Low, Marston, Searle and Rivington, 1891.

—— *Echoes of Old Florence: Her Palaces and Who Have Lived in Them.* London: Fisher Unwin, 1894.

Spender, J. A. *The New Fiction, A Protest Against Sex-Mania and Other Papers by the Philistine.* London: Westminster Gazette Office, 1895.

Spielmann, Marion Harry. *John Ruskin, 1819–1900.* New York: Cassell, 1900.

Standing, Percy Cross. *Sir Lawrence Alma-Tadema O.M. R.A.* London: Cassell, 1905.

Starke, Mariana. *Letters from Italy.* London: R. Phillips, 1800.

—— *Travels on the Continent.* London: John Murray, 1820.

Stephens, F. G. *William Holman Hunt and his Works, A memoir of the artist's life and a description of his pictures.* London: J. Nisbet and Co., 1860.

—— *Artists at Home.* London: Sampson Low, Marston, Searle and Rivington, 1884.

—— *J. C. Hooke, R.A.: His Life and Work.* London: Art Journal Office, 1888.

—— *Laurence Alma-Tadema, R.A.: A Sketch of His Life and Work.* London: Berlin Photographic Company, 1895.

—— *Sir Frederic Leighton An Illustrated Chronicle.* London: George Bell, 1895.

Stevenson, R. A. M. *The Art of Velazquez.* London: George Bell, 1895.

Waagen, Gustav F. *Works of Art and Artists in England.* London: John Murray, 1838; repr. London: Cornmarket Press, 1970.

'Women's Franchise League, Report of Meeting in support of "The Women's Disabilities Removal Bill"'. London: Hansard Publishing Union, n.d.

'Women's Franchise League, Report of Proceedings at the Inaugural Meeting, London July 25th, 1889'. London: Hansard Publishing Union.

Wood, Esther. *Dante Gabriel Rossetti and the Pre-Raphaelite Movement.* London: Sampson Low, Marston, 1894.

Zimmern, Helen. *Italy of the Italians.* London: Sir Isaac Pitman and Sons, 1906.

—— *Sir Lawrence Alma-Tadema, R.A.* London: George Bell and Sons, 1902.

Secondary sources

Adams, James Eli. *Dandies and Desert Saints: Styles of Victorian Manhood.* Ithaca and London: Cornell University Press, 1995.

Altick, Richard. *English Common Reader*. Chicago: Chicago University Press, 1957.

Asquith, Betty. *Lady Dilke, a biography*. London: Chatto and Windus, 1969.

Badeni, June. *The Slender Tree*. Padstow, Cornwall: Tabb House, 1981.

Bannerji, Himani. 'Mary Wollstonecraft, Feminism and Humanism'. In *Mary Wollstonecraft and 200 Years of Feminism*, ed. Eileen Janes Yeo. London and New York: Rivers and Oram Press, 1997, pp. 222–42.

Barringer, Tim. *The Pre-Raphaelites: Reading the Image*. London: Calmann and King, 1998.

—— ' "Not a 'modern' as the word is now understood?" Byam Shaw, imperialism and the poetics of professional society'. In *English Art 1860–1914: Modern artists and identity*, eds David Peters Corbett and Lara Perry. Manchester: Manchester University Press, 2000, pp. 64–83.

Barthes, Roland. *Image Music Text*. Trans. Stephen Heath. London: Fontana, 1977.

Beard, Mary. *The Invention of Jane Harrison*. Cambridge, Mass.: Harvard University Press, 2000.

Beetham, Margaret. *A Magazine of Her Own?* London: Routledge, 1996.

Benn, Miriam. *Predicaments of Love*. London: Pluto Press, 1992.

Betterton, Rosemary (ed.). *Looking On: Images of femininity in the visual arts and media*. London: Pandora Press, 1987.

Billcliffe, Roger. *The Glasgow Boys: The Glasgow School of Painting 1875–1895*. London: John Murray, 1985.

Bjørhovde, Gerd. *Rebellious Structures*. Oslo: Norwegian University Press, 1987.

Bland, Lucy. 'Marriage Laid Bare: Middle-Class Women and Marital Sex 1880s–1914'. In *Labour and Love: Women's Experience of Home and Family*, ed. Jane Lewis. Oxford: Basil Blackwell, 1986, pp. 123–46.

—— 'The Married Woman, the "New Woman" and the Feminist: Sexual Politics of the 1890s'. In *Equal or Different: Women's Politics 1800–1914*, ed. Jane Randell. Oxford: Basil Blackwell, 1987, pp. 141–64.

—— *Banishing the Beast: English Feminism and Sexual Morality 1885–1914*. London: Penguin, 1995.

Blunt, Wilfrid. *'England's Michelangelo': A Biography of George Frederic Watts*. London: Hamish Hamilton, 1975.

Borland, Maureen. *D. S. MacColl: painter, poet, art critic*. Harpenden: Lennard, 1995.

Borzello, Frances. *Civilising Caliban: The Misuse of Art 1878–1980*. London and New York: Routledge and Kegan Paul, 1987.

Bourdieu, Pierre. *Distinction: a social critique of the judgement of taste*. Trans. Richard Nice. London: Routledge, 1984.

Brake, Laurel. *Subjugated Knowledges*. London: Macmillan, 1994.

Brown, Lucy. *Victorian News and Newspapers*. Oxford: Clarendon Press, 1985.

Bullen, J. B. *The Pre-Raphaelite Body: Fear and Desire in Painting, Poetry, and Criticism*. Oxford: Clarendon, 1998.

Burkhauser, Jude (ed.). *Glasgow Girls: Women in Art and Design*. Edinburgh: Canongate, 1990.

Burns, Sarah. ' "The Earnest, Untiring Worker" and the "Magician of the Brush": Gender Politics in the Criticism of Cecilia Beaux and John Singer Sargent', *Oxford Art Journal* (Spring 1992), pp. 36–53.

—— *Inventing the modern Artist: Art and culture in Gilded Age America*. New Haven and London: Yale University Press, 1996.

Butler, Judith. *Gender Trouble: Feminism and the Subversion of Identity*. New York and London: Routledge, 1990.

Caine, Barbara. *English Feminism 1780–1980*. Oxford: Oxford University Press, 1997.

Certeau, Michel de. *The Practice of Everyday Life*. Trans. Steven Randall. Berkeley: University of California Press, 1984.

Chadwick, Whitney, and Isabelle De Courtivron (eds). *Significant Others: Creativity and Intimate Partnership*. London: Thames and Hudson, 1996.

Chambers, Emma. *An Indolent and Blundering Art*. Aldershot: Ashgate, 1999.

Cherry, Deborah. *Painting Women: Victorian Women Artists*. London: Routledge, 1993.

—— 'Women Artists and the Politics of Feminism.' In *Women in the Victorian Art World*, ed. Clarissa Campbell Orr. Manchester: Manchester University Press, 1995, pp. 49–69.

—— *Beyond the Frame: Feminism and Visual Culture, Britain 1850–1900*. London: Routledge, 2000.

Cherry, Deborah, and Griselda Pollock. 'Patriarchal Power and the Pre-Raphaelites', *Art History* (December 1984), pp. 480–95.

Chow, Rey. *Writing Diaspora: Tactics of Intervention in Contemporary Cultural Studies*. Bloomington and Indianapolis: Indiana University Press, 1993.

Christ, Carol T. 'The Hero as a Man of Letters.' In *Victorian Sages and Cultural Discourse*, ed. Thaïs E. Morgan. New Brunswick: Rutgers University Press, 1990, pp. 19–31.

Cikovsky Jr., Nikolai, with Charles Brock. 'Whistler and America'. In *James McNeill Whistler*, eds Richard Dorment and Margaret F. Macdonald. London: Tate Gallery, 1995, pp. 29–38.

Codell, Julie. 'The Artists' Cause at Heart: Marion Harry Spielmann and the Late Victorian Art World', *Bulletin of the John Rylands University Library of Manchester*, 71 (Spring 1989), pp. 139–63.

—— 'Artists' professional societies: production and consumption and aesthetics'. In *Towards a Modern Art World*, ed. Brian Allen. New Haven and London: Yale University Press, 1995, pp. 169–83.

—— 'The artist colonized: Holman Hunt's "bio-history", masculinity, nationalism and the English School'. In *Re-framing the Pre-Raphaelites: Historical and Theoretical Essays*, ed. Ellen Hardy. Aldershot: Scolar Press, 1996, pp. 211–29.

—— 'The Public Image of the Victorian Artist: Family Biographies', *Journal of Pre-Raphaelite Studies* (Fall 1996), pp. 5–24.

—— 'When Art Historians Use Periodicals: Methodology and Meaning', *Victorian Periodicals Review*, 34:3 (Fall 2001), pp. 284–89.

Cross, Tom. *The Shining Sands: Artists in Newlyn and St. Ives 1880–1930*. Tiverton, Devon: Westcountry Books, 1994.

Dakers, Caroline. *The Holland Park Circle: Artists and Victorian Society*. New Haven: Yale University Press, 1999.

Dellamora, Richard. *Masculine Desire: The Sexual Politics of Victorian Aestheticism*. Chapel Hill: University of North Carolina Press, 1990.

Demoor, Marysa. 'A Mode(rni)st Beginning? The women of the "Athenaeum" 1890–1910'. In *The Turn of the Century; Le tournant de siècle*, eds Christian Berg, Frank Durieux and Geert Lernout. New York: Walter de Gruyter, 1995, pp. 270–81.

—— *Their Fair Share: Women, Power and Criticism in the Athenaeum*. Aldershot: Ashgate, 2000.

Denney, Colleen. 'The Grosvenor Gallery as a Palace of Art'. In *The Grosvenor Gallery*, eds Susan P. Casteras and Colleen Denney. New Haven: Yale Center for British Art, 1996.

—— *At the Temple of Art: The Grosvenor Gallery 1877–1890*. London: Associated University Presses, 2000.

Derrida, Jacques. 'Signature, Event, Context'. In *A Derrida Reader: Between the Blinds*, ed. P. Kamuf. Hemel Hempstead: Harvester, 1991, pp. 571–98.

Dorment, Richard, and Margaret F. Macdonald (eds). *James McNeill Whistler*. London: Tate Gallery, 1995.

Dyhouse, Carol. *Girls Growing Up in Late Victorian and Edwardian England*. London, Boston and Henley: Routledge and Kegan Paul, 1981.

—— *Feminism and the Family 1880–1939*. Oxford: Basil Blackwell, 1989.

—— *No Distinction of Sex: Women in British Universities 1870–1939*. London: University College, 1995.

Edwards, Lee MacCormick. *Herkomer: A Victorian Artist*. Aldershot: Ashgate, 1999.

Eisler, Colin. 'Lady Dilke: The Six Lives of an Art Historian'. In *Women as Interpreters of the Visual Arts, 1820–1979*, eds Claire Richter Sherman with Adele M. Holcomb. Westport: Greenwood Press, 1981.

Ellegård, Alvar. 'The Readership of the Periodical Press in Mid-Victorian Britain', *Göteborgs Universitets Årsskrift*, 63 (157), pp. 17–36.

Elliott, B., and J. Wallace. *Women Artists and Writers: Modernist (Im)positionings*. London: Routledge, 1994.

Emanuel, Angela (ed.). *A Bright Remembrance: The Diaries of Julia Cartwright 1851–1924*. London: Weidenfeld and Nicolson, 1989.

Ferguson, Moira. 'Mary Wollstonecraft and the Problematic of Slavery'. In *Mary Wollstonecraft and 200 Years of Feminisms*, ed. Eileen Janes Yeo. London and New York: Rivers and Oram Press, 1997, pp. 89–103.

Fleming, G. H. *Victorian Sex Goddess*. Gloucestershire: Windrush Press, 1989.

Flint, Kate. *Impressionists in England: the Critical Reception*. London: Routledge and Kegan Paul, 1984.

—— 'The Philistine and the New: J. A. Spender on Art and Morality'. In *Papers for the Millions*, ed. Joel Wiener. New York: Greenwood Press, 1988, pp. 119–220.

—— *The Woman Reader: 1837–1914*. Oxford: Clarendon Press, 1993.

—— 'Portraits of Women: On Display'. In *Millais: Portraits*, eds Peter Funnell and Malcolm Warner. London: National Portrait Gallery, 1999, pp. 181–215.

—— *The Victorians and the Visual Imagination*. Cambridge: Cambridge University Press, 2000.

Foster, Alicia. *Gwen John*. London: Tate Gallery, 1999.

Foster, Shirley. *Across New Worlds: Nineteenth Century Women Travellers and Their Writings*. New York: Harvester Wheatsheaf, 1990.

Foucault, Michel. 'What is an author?' In *Textual Strategies: Perspectives in Poststructuralist Criticism*, ed. J. V. Harari. London: Methuen, 1980, pp. 141–60.

—— 'The Order of Discourse'. In *Untying the Text*, ed. Robert Young. Boston and London: Routledge and Kegan Paul, 1981.

Fox, Caroline, and Francis Greenacre. *Painting in Newlyn 1880–1930*. London: Barbican Art Gallery, 1985.

Fraser, Hilary. *The Victorians and Renaissance Italy*. Oxford: Blackwell, 1992.

—— 'Women and the Ends of Art History: Vision and Corporeality in Nineteenth-Century Critical Discourse', *Victorian Studies* (Winter 1998), pp. 77–100.

Frawley, Maria. *A Wider Range: Travel Writing by Women in Victorian England*. London: Associated University Presses, 1994.

—— 'Alice Meynell and the Politics of Motherhood'. In *Unmanning Modernism: Gendered Re-Readings*, eds Elizabeth Jane Harrison and Shirley Peterson. Knoxville: University of Tennessee Press, 1997, pp. 31–43.

Fredeman, W. E. *Pre-Raphaelitism: A Bibliocritical Study*. Cambridge, Mass.: Harvard University Press, 1965.

Garb, Tamar. *Sisters of the Brush: Women's Artistic Culture in Late Nineteenth-Century Paris*. New Haven and London: Yale University Press, 1994.

—— '"Unpicking the Seams of Her Disguise": Self-representation in the case of Marie Bashkirtseff'. In *Block Reader in Visual Culture*. London: Routledge, 1996, pp. 115–28.

Gardner, Viv. 'Introduction'. In *The New Woman and Her Sisters: Feminism and theatre 1850–1914*, eds Viv Gardner and Susan Rutherford. London: Harvester Wheatsheaf, 1992, pp. 1–14.

Giebelhausen, Michaela. 'Academic orthodoxy versus Pre-Raphaelite heresy: debating religious painting at the Royal Academy, 1840–50'. In *Art and the Academy in the Nineteenth Century*, eds Rafael Cardoso Denis and Colin Trodd. Manchester: Manchester University Press, 2000, pp. 164–78.

Gillett, Paula. *Worlds of Art: Painters in Victorian Society*. New Brunswick: Rutgers University Press, 1990.

—— 'Art Audiences at the Grosvenor Gallery'. In *The Grosvenor Gallery*, eds Susan P. Casteras and Colleen Denney. New Haven: Yale Center for British Art, 1996.

Goodbody, John. 'The *Star*: its Role in the Rise of the New Journalism'. In *Papers for the Millions*, ed. Joel Wiener. New York: Greenwood Press, 1988, pp. 143–63.

Gould, Stephen Jay. *The Mismeasure of Man*. New York: W. W. Norton, 1981.

Greenhalgh, Paul. *Ephemeral Vistas: The Expositions Universelles, Great Exhibitions and World's Fairs, 1851–1939*. Manchester: Manchester University Press, 1988.

Greiman, Liela Rumbaugh. 'William Ernest Henley and the *Magazine of Art*', *Victorian Periodicals Review* (Summer 1983), pp. 53–64.

Grieve, Alastair. 'The Pre-Raphaelite Brotherhood and the Anglican High Church', *Burlington Magazine* (May 1969), pp. 294–95.

Gruetzner, Anna. 'Great Britain and Ireland: Two Reactions to French Painting in Britain'. *Post-Impressionism: Cross-Currents in European Painting*. London: Royal Academy of Arts, 1979–80, pp. 178–81.

Gruetzner Robins, Anna. 'Degas and Sickert: notes on their friendship', *Burlington Magazine* (March 1988), pp. 225–29.

—— 'The London Impressionists at the Goupil Gallery; Modernist Strategies and Modern Life'. In *Impressionism in Britain*, ed. Kenneth MacConkey. New Haven: Yale University Press, 1995.

—— 'Fathers and Sons, Walter Sickert and Roger Fry'. In *Art Made Modern: Roger Fry's Vision of Art*, ed. Christopher Green. London: Courtauld Institute of Art, 1999, pp. 45–56.

—— (ed.). *Walter Sickert: The Complete Writings on Art*. Oxford: Oxford University Press, 2000.

Harrison, Charles. *English Art and Modernism 1900–1939*. New Haven: Yale University Press, 1981, repr. 1994.

Harrison, Jane E. *Reminiscences of a Student Life*. London: Leonard and Virginia Woolf, 1925.

Hichberger, J. W. M. *Images of the Army: The Military in British Art 1815–1914*. Manchester: Manchester University Press, 1988.

Higonnet, Anne. 'Imaging Gender'. In *Art Criticism and its Institutions in Nineteenth-century France*, ed. Michael R. Orwicz. Manchester: Manchester University Press, 1994, pp. 146–61.

Hind, C. Lewis. *Naphtali*. London: John Lane, 1926.

Holcombe, Lee. *Victorian ladies at work; middle-class working women in England and Wales, 1850–1914.* Newton Abbot: David and Charles, 1973.

Hollis, Patricia. *Ladies Elect: Women in English Local Government 1865–1914.* Oxford: Clarendon, 1987.

Holton, Sandra Stanley. 'From Anti-Slavery to Suffrage: The Bright Circle, Elizabeth Cady Stanton and the British Women's Movement'. In *Suffrage and Beyond: International Feminist Perspectives*, eds Caroline Daly and Melanie Nolan. New York: New York University Press, 1994, pp. 213–33.

—— *Suffrage Days: Stories from the Women's Suffrage Movement.* London and New York: Routledge, 1996.

—— 'Now you see it, now you don't: the Women's Franchise League and its place in contending narratives of the women's suffrage movement'. In *The Women's Suffrage Movement*, eds Maroula Joannou and June Purvis. Manchester: Manchester University Press, 1998, pp. 15–36.

Howe, Bea. *Arbiter of Elegance.* London: Harvill, 1967.

Hughes, Linda K. 'Rosamund Marriott Watson'. In *Dictionary of Literary Biography: Late Nineteenth- and Early Twentieth-Century British Women Poets.* Volume 240, ed. W. B. Thesing. Detroit: Gale, 2001, pp. 308–20.

Hutchison, S. *The History of the Royal Academy, 1768–1968.* London: Chapman and Hall, 1968.

Israel, Kali A. K. 'Writing Inside the Kaleidoscope: Re-Representing the Victorian Women Public Figures', *Gender and History* (Spring 1990), pp. 40-48.

—— 'Drawing from Life: Art, Work and Feminism in the Life of Emilia Dilke'. PhD thesis, Rutgers University, 1992.

—— *Names and Stories: Emilia Dilke and Victorian Culture.* New York and Oxford: Oxford University Press, 1999.

John, Angela V., and Claire Eustance. *The Men's Share? Masculinities, Male Support and Women's Suffrage in Britain, 1890–1920.* London: Routledge, 1997.

Johnston, Judith. *Anna Jameson: Victorian Woman of Letters.* Aldershot: Scolar, 1997.

Jones, Aled. *Powers of the Press: Newspapers, Power and the Public in Nineteenth Century England.* Aldershot: Scolar Press, 1996.

Joyce, Simon. 'Castles in the Air: The People's Palace, Cultural Reformism, and the East End Working Class', *Victorian Studies* (Summer 1996), pp. 513–38.

Kent, Christopher. 'Periodical Critics of Drama, Music, and Art, 1830–1914: A Preliminary List', *Victorian Periodicals Review*, 7 (Spring/Summer 1980), pp. 31–55.

Kestner, Joseph A. *Masculinities in Victorian Painting.* Aldershot: Scolar Press, 1995.

Koven, Seth. 'The Whitechapel Picture Exhibitions and the Politics of Seeing'. In *Histories, Discourses and Spectacles*, eds Daniel J. Sherman and Irit Rogoff. London: Routledge, 1994, pp. 22–48.

Kranidis, Rita. *Subversive Discourse.* London: Macmillan, 1995.

Lang, Gladys Engel, and Kurt Lang. *Etched in Memory: The Building and Survival of Artistic Reputation.* Chapel Hill and London: University of North Carolina Press, 1990.

Ledger, Sally. 'The New Woman and the crisis of Victorianism'. In *Cultural Politics at the Fin de Siècle*, eds Sally Ledger and Scott McCracken. Cambridge: Cambridge University Press, 1995, pp. 27–44.

Leeuw, Ronald de. *Hague School: Dutch Masters of the Nineteenth Century.* Paris: Grand Palais; London: Royal Academy; Hague: Gemeentemus, 1983.

Levine, Phillippa. *Feminist Lives in Victorian England.* Oxford: Basil Blackwell, 1990.

Lewis, Jane. *Women in England 1870–1950: Sexual Divisions and Social Change*. London: Harvester Wheatsheaf, 1984.

Lochnan, Katherine A. *The etchings of James McNeill Whistler*. New Haven and London: Yale University Press, 1984.

Lomax, James, and Richard Ormond. *John Singer Sargent and the Edwardian Age*. Leeds Art Gallery, National Portrait Gallery and Detroit Institute of Arts, 1979.

Lowndes, Marie Belloc. *The Merry Wives of Westminster*. London: Macmillan, 1946.

Maas, Jeremy. *Gambart: Prince of the Victorian Art World*. London: Barrie and Jenkins, 1975.

—— *Holman Hunt and the Light of the World*. London and Berkeley: Scolar, 1984.

—— *The Victorian Art World in Photographs*. London: Barrie and Jenkins, 1984.

MacLeod, Dianne Sachko. 'F. G. Stephens, Pre-Raphaelite critic and art historian', *Burlington Magazine* (June 1986), pp. 398–406.

—— *Art and the Victorian Middle Class: Money and the Making of Cultural Identity*. Cambridge: Cambridge University Press, 1996.

Maltz, Diana. ' "Engaging Delicate Brains": From Working-Class Enculturation to Upper-Class Lesbian Liberation in Vernon Lee and Kit Anstruther-Thomson's Psychological Aesthetics'. In *Women and British Aestheticism*, eds Talia Schaffer and Kathy Alexis Psomiades. Charlottesville: University Press of Virginia, 1999.

Mansfield, Elizabeth. 'Victorian Identity and the Historical Imaginary: Emilia Dilke's *The Renaissance of Art in France*', *CLIO: A Journal of Literature, History and the Philosophy of History*, 26:2 (1997), pp. 167–88.

Marcus, Laura. 'Brothers in their anecdotage: Holman Hunt's Pre-Raphaelitism and the Pre-Raphaelite Brotherhood'. In *Pre-Raphaelites re-viewed*, ed. Marcia Pointon. Manchester and New York: Manchester University Press, 1989, pp. 1–21.

Marks, Patricia. *Bicycles, Bangs, and Bloomers: The New Woman in the Popular Press*. Lexington: University of Kentucky, 1990.

McDermid, Jane. 'Women and Education'. In *Women's History: Britain 1850–1945*, ed. June Purvis. London: University College London Press, 1995, pp. 107–30.

Merrill, Linda. *A Pot of Paint: Aesthetics on Trial in Whistler v. Ruskin*. Washington: Smithsonian Institution Press, 1992.

Meynell, Sir Francis. *Catalogue of the Alice Meynell Centenary Exhibition*. London: National Book League, 1947.

Meynell, Viola. *Alice Meynell: A Memoir*. London: Jonathan Cape, 1929.

—— *Francis Thompson and Wilfrid Meynell*. London: Hollis and Carter, 1952.

Millet, Kate. 'The Debate over Women: Ruskin versus Mill'. *Victorian Studies* (September 1970), pp. 63–82.

Morgan, Thaïs E. (ed.). *Victorian Sages and Cultural Discourse*. New Brunswick: Rutgers University Press, 1990.

Morris, Edward. *Victorian and Edwardian Paintings in the Lady Lever Art Gallery: British artists born after 1810 excluding the early Pre-Raphaelites*. London: National Museums and Galleries on Merseyside, 1994.

Nead, Lynda. *Victorian Babylon: People, Streets and Images in Nineteenth-Century London*. New Haven and London: Yale University Press, 2000.

Newall, Christopher. *Grosvenor Gallery Exhibitions: Change and Culture in the Victorian Art World*. Cambridge: Cambridge University Press, 1995.

Newton, Stella Mary. *Health, Art and Reason: Dress Reformers and the Nineteenth Century*. London: John Murray, 1974.

Nord, Deborah Epstein. *Walking the Victorian Streets: Women, Representation and the City*. Ithaca and London: Cornell University Press, 1995.

Nunn, Pamela Gerrish. *Victorian Women Artists*. London: Women's Press, 1987.

—— *Problem Pictures: Women and Men in Victorian Painting*. Aldershot: Scolar, 1995.

—— 'Critically Speaking'. In *Women in the Victorian Art World*, ed. Clarissa Campbell Orr. Manchester: Manchester University Press, 1995, pp. 107–24.

—— and Jan Marsh. *Pre-Raphaelite Women Artists*. Manchester: Manchester City Art Galleries, 1998.

Onslow, Barbara. *Women of the Press in Nineteenth-Century Britain*. Basingstoke: Macmillan, 2000.

Ormond, Richard. 'Sargent's Art'. In *John Singer Sargent*, ed. Elaine Kilmurray and Richard Ormond. London: Tate Gallery, 1998.

Parker, Rozsika, and Griselda Pollock. *Old Mistresses, Women, Art and Ideology*. New York: Pantheon, 1981.

Pembleton, John. *The Mediterranean Passion: Victorians and Edwardians in the South*. Oxford: Clarendon Press, 1987.

Perkins, Harold. *The Rise of Professional Society: England Since 1880*. London and New York: Routledge, 1990.

Pickvance, Ronald. ' "L'Absinthe" in England', *Apollo* (May 1963), pp. 395–98.

Pointon, Marcia. 'The artist as ethnographer: Holman Hunt and the Holy Land'. In *Pre-Raphaelites re-viewed*, ed. Marcia Pointon. Manchester and New York: Manchester University Press, 1989.

Pollock, Griselda. 'Artists, Mythologies and Media Genius, Madness and Art History', *Screen* 21:3 (1980), pp. 57–96.

—— *Vision and Difference*. London: Routledge, 1988.

—— *Mary Cassatt: Painter of Modern Women*. London: Thames and Hudson, 1998.

Prettejohn, Elizabeth. 'Aesthetic Value and the Professionalization of Victorian Art Criticism 1837–78', *Journal of Victorian Culture* (Spring 1997), pp. 71–94.

—— *Interpreting Sargent*. London: Tate Gallery, 1998.

—— 'Out of the Nineteenth Century: Roger Fry's Early Art Criticism 1900–1906'. In *Art Made Modern: Roger Fry's Vision of Art*, ed. Christopher Green. London: Courtauld Institute of Art, 1999, pp. 31–44.

—— 'The modernism of Frederic Leighton'. In *English Art 1860–1914: Modern Artists and Identity*, eds David Peters Corbett and Lara Perry. Manchester: Manchester University Press, 2000, pp. 31–48.

The Pre-Raphaelite Critic: Contemporary Criticism of the Pre-Raphaelites from 1846 to 1900, ed. Thomas J. Tobin (March 2000) <http://www.engl.duq.edu/servus/ PR_Critic/>.

Prochaska, F. K. *Women and Philanthropy in Nineteenth-Century England*. Oxford: Clarendon Press, 1980.

Purvis, June. *A History of Women's Education in England*. Milton Keynes: Open University Press, 1991.

Pykett, Lyn. 'Reading the Periodical Press: Text and Context'. In *Investigating Victorian Journalism*, eds Laurel Brake, Aled Jones and Lionel Madden. London: Macmillan, 1990, pp. 3–19.

Rappaport, Erika Diane. *Shopping for Pleasure: Women in the Making of London's West End*. Princeton and Oxford: Princeton University Press, 2000.

Read, Benedict. *Victorian Sculpture*. London and New Haven: Yale University Press, 1982.

Reitlinger, Gerard. *The Economics of Taste: The Rise and Fall of Picture Prices: 1760–1960*. London: Barrie and Rockcliff, 1961.

Richardson, Angelique, and Chris Willis (eds). *The New Woman in fiction and in fact: fin-de-siècle feminisms*. Basingstoke: Palgrave Macmillan, 2000.

Roberts, Shirley. *Sophia Jex-Blake: A Woman Pioneer in Nineteenth Century Medical Reform*. London and New York: Routledge, 1993.

Robinson, Jane. *Wayward Women: A Guide to Women Travellers*. Oxford: Oxford University Press, 1990.

Rogers, Frederick. *Labour, Life and Literature* (1913), ed. David Rubinstein. Brighton: Harvester Press, 1973.

Rothenstein, William. *Men and Memories: Recollections of William Rothenstein 1872–1900*. London: Faber and Faber, 1931.

Rubinstein, David. *Before the Suffragettes: Women's Emancipation in the 1890s*. Brighton: Harvester Press, 1986.

Salmon, Richard. 'Signs of Intimacy: The Literary Celebrity in the "Age of Interviewing"', *Victorian Literature and Culture* (1997), pp. 159–77.

Sanders, Valerie. *The Private Lives of Victorian Women*. London: Harvester Wheatsheaf, 1989.

Schaffer, Talia. *The Forgotten Female Aesthetes: Literary Culture in Late-Victorian England*. Charlottesville: University Press of Virginia, 2000.

Sedgwick, Eve Kosofsky. *Between Men: English Literature and Male Homosocial Desire*. New York: Columbia University Press, 1985.

Seeley, Tracy. 'Alice Meynell, Essayist: Taking Life "Greatly to Heart"', *Women's Studies*, 27 (1998), pp. 105–30.

Sellers, Jane. *Women's Works*. Liverpool: National Museums and Galleries on Merseyside, 1988.

Shattock, Joanne, and Michael Wolff (eds). *The Victorian Periodical Press: Samplings and Soundings*. Leicester: Leicester University Press, 1982.

Sherman, Claire Richter, with Adele M. Holcomb (eds). *Women as Interpreters of the Visual Arts, 1820–1979*. Westport: Greenwood Press, 1981.

Shiman, Lilian Lewis. *Women and Leadership in Nineteenth-Century England*. London: Macmillan, 1992.

Showalter, Elaine. *A Literature of Their Own*. London: Virago, 1982, pp. 58–60.

Simpson, Marc (ed.). *Uncanny Spectacle: The Public Career of the Young John Singer Sargent*. New Haven and London: Yale University Press, 1997.

Sims, George R. *My Life: Sixty Years' Recollections of Bohemian London*. London: Eveleigh Nash, 1917.

Smith, Alison. *The Victorian Nude: Sexuality, Morality and Art*. Manchester: Manchester University Press, 1996.

—— 'Nature Transformed: Leighton, the Nude and the Model'. In *Frederic Leighton: Antiquity, Renaissance, Modernity*, eds Tim Barringer and Elizabeth Prettejohn. New Haven and London: Yale University Press, 1999, pp. 19–48.

—— 'The "British Matron" and the body beautiful: the nude debate of 1885'. In *After the Pre-Raphaelites*, ed. Elizabeth Prettejohn. Manchester: Manchester University Press, 1999, pp. 217–39.

Smith, Anthony. 'The long road to objectivity and back again: the kinds of truth we get in journalism'. In *Newspaper History: from the 17th Century to the present day*, eds G. Boyce, J. Curran, and P. Wingate. London: Constable, 1978, pp. 153–71.

Smith, Sidonie. *A Poetics of Women's Autobiography: Marginality and the Fictions of Self-Representation*. Bloomington and Indianapolis: Indiana University Press, 1987.

Smith-Rosenberg, Caroll. *Disorderly Conduct: Visions of Gender in Victorian America*. New York: Oxford University Press, 1985.

Spalding, Frances. *Roger Fry – Art and Life*. London: Granada; Toronto: Paul Elek, 1980.

Spivak, Gayatri Chakravorty. 'Three Women's Texts and a Critique of Imperialism'. In *The Feminist Reader: Essays in Gender and the Politics of Literary Criticism*, eds Catherine Belsey and Jane Moore. London: Macmillan, 1997, pp. 148–63.

Springhill, John. '"Up Guards and at them!"': British Imperialism and Popular Art 1880–1914'. In *Imperialism and Popular Culture*, ed. John MacKenzie. Manchester: Manchester University Press, 1986, pp. 49–72.

Stephenson, Andrew. 'Refashioning modern masculinity: Whistler, aestheticism and national identity'. In *English Art 1860–1914: Modern Artists and Identity*, eds David Peters Corbett and Lara Perry. Manchester: Manchester University Press, 2000, pp. 133–49.

Stokes, John. *In the Nineties*. New York: Harvester Wheatsheaf, 1989.

Sund, Judy. 'Columbus and Columbia in Chicago 1893: Man of Genius Meets Generic Woman', *Art Bulletin* (September 1993), pp. 443–65.

Sutton, Denys. Introduction. *Velazquez*. By R. A. M. Stevenson. London: G. Bell and Sons, 1962.

Tagg, John. *The Burden of Representation: Essays on Photographies and Histories*. London: Macmillan Education, 1988.

Tappert, Tara Leigh. *Cecilia Beaux and the Art of Portraiture*. Washington and London: Smithsonian Institution, 1995.

Thompson, Nicola Diane. *Reviewing Sex*. London: Macmillan, 1996.

Thorton, Alfred. *The Diary of an Artist Student in the Nineties*. London: Sir Isaac Pitman and Sons Ltd, 1938.

Thwaite, Anne. *Edmund Gosse: A Literary Landscape*. Oxford: Oxford University Press, 1985.

Tickner, Lisa. *The Spectacle of Women: Imagery of the Suffrage Campaign, 1907–1914*. London: Chatto, 1987.

Treble, Rosemary. *Great Victorian Pictures: their paths to fame*. London: Arts Council of Great Britain, 1978.

Tuchman, Gayle, and Nina Fortin. *Edging Women Out: Victorian Novelists, Publishers, and Social Change*. New Haven: Yale University Press, 1989.

Tuell, Anne Kimball. *Mrs. Meynell and Her Literary Generation*. New York: E. P. Dutton, 1925.

Usherwood, Paul, and Jenny Spencer-Smith. *Lady Butler, Battle Artist: 1846–1933*. London: National Army Museum, 1987.

—— 'Officer material: Representations of leadership in late nineteenth-century British battle painting'. In *Popular imperialism and the military*, ed. John MacKenzie. Manchester: Manchester University Press, 1992, pp. 325–54.

Vadillo, Ana I. Parejo. 'New Woman Poets and the Culture of the *Salon* at the *fin-de-siècle*', *Women: a cultural review*, 10:1 (Spring 1999), pp. 22–34.

Van Arsdel, Rosemary T. 'Mrs. Florence Fenwick Miller and *The Woman's Signal*, 1895–1899', *Victorian Periodicals Review*, 15:3 (1982), pp. 107–18.

—— 'Women's Periodicals and the New Journalism: The Personal Interview'. In *Papers for the Millions*, ed. Joel Wiener. New York: Greenwood Press, 1988, pp. 253–55.

—— 'Victorian Periodicals Yield Their Secrets: Florence Fenwick Miller's Three Campaigns for the London School Board', *Bulletin: History of Education Society* (1986), pp. 26–42.

—— *Florence Fenwick Miller: Victorian feminist, journalist and educator*. Aldershot: Ashgate, 2001.

Vicinus, Martha. *Independent Women 1850–1920: Work and Community for Single Women.* London: Virago, 1985.

Vogt, Elizabeth. 'Honours of Morality: the Career, Reputation and Achievement of Alice Meynell as a Journalistic Essayist'. PhD thesis, University of Kansas, 1990.

Walker, Lynne. 'Vistas of pleasure: Women consumers of urban space in the West End of London 1850–1900'. In *Women in the Victorian Art World,* ed. Clarissa Campbell Orr. Manchester: Manchester University Press, 1995, pp. 70–85.

Walkley, Giles. *Artists' Houses in London 1764–1914.* Aldershot: Scolar Press, 1994.

Walkowitz, Judith R. *Prostitution and Victorian Society: Women, class and the state.* Cambridge: Cambridge University Press, 1980.

—— *City of Dreadful Delight: narratives of sexual danger in late-Victorian London.* London: Virago, 1992.

Waltman, John Laurence. 'The Early London Journals of Elizabeth Robins Pennell'. PhD thesis, University of Texas, 1976.

Watts, M. S. *George Frederick Watts: The Annals of an Artist's Life.* 2 vols. London: Macmillan, 1912.

Weedon, Chris. *Feminist Practice and Post-Structuralist Theory.* Oxford: Basil Blackwell, 1987.

Weimann, Jeanne Madeline. *The Fair Women.* Chicago: Academy Chicago, 1981.

Weiner, Deborah E. B. 'The People's Palace: An Image for East London in the 1880s'. In *Metropolis London: Histories and Representation since 1800,* eds David Feldman and Gareth Stedman Jones. London: Routledge, 1989, pp. 40–55.

Whybrow, Marion. *St. Ives 1883–1993: Portrait of an Art Colony.* Woodbridge, Suffolk: Antique Collectors' Club, 1994.

Wiener, Joel H. 'Edmund Yates: The Gossip as Editor'. In *Innovators and Preachers: The Role of the Editor in Victorian England,* ed. Joel H. Wiener. London: Greenwood Press, 1985, pp. 259–74.

Wilson, Shelagh. '"The highest art for the lowest people": the Whitechapel and other philanthropic art galleries, 1877–1901'. In *Governing Cultures: Art Institutions in Victorian London,* eds Paul Barlow and Colin Trodd. Aldershot: Ashgate, 2000, pp. 172–86.

Yeldham, Charlotte. *Women Artists in Nineteenth-Century France and England.* New York: Garland, 1984.

Yeo, Eileen Janes. 'Protestant feminists and Catholic saints in Victorian Britain'. In *Radical Femininity: Women's Self Representation in the Public Sphere,* ed. Eileen Janes Yeo. Manchester: Manchester University Press, 1998, pp. 127–48.

Index

Note: page references in *italics* indicate illustrations.

Academy 19, 130
Advanced Woman 122, 131
Album 77
Allingham, Helen 93, 110, 113–14
Alma-Tadema, Laura 60, *61*
Alma-Tadema, Lawrence 29, 43, 91
American 116
Appleton, Charles 19, 26
Architect 46
Armstrong Forbes, Elizabeth 75, *76*
Art Journal 57, 59, 97, 106, 113, 150, 156
 Butler and 57, 58
 Fenwick Miller in 108
 Meynell in 46, 49, 51, 67, 72, 73, 80
 on Newlyn School 72, *73*
 RA, Press Days 1, 9, *10*, 17
Art Weekly 130
Athenaeum 2, 18, 19, 21, 23, 57, 106, 150
Atlantic Monthly 116

Barnett, Samuel and Henrietta 127, 129
Barrington, Emilie 40, 42
Bashkirtseff, Marie 22
Bateson, Margaret 13, 14, 15, 18
Baxter, Lucy 22, 43
Beerbohm, Max 51
Beetham, Margaret 15
Belloc Lowndes, Marie 18
Benham Hay, Jane 112
Bennett, E. A. 15–16
Bernhardt, Sarah 62

Besant, Annie 83, 88, 89
Besant, Walter 26, 28, 127–8
Betterton, Rosemary 3
Billington, Mary Frances 17
Blackburn, Helen 30–1
Blackwood, William 69
Blackwoods 53
Bland, Lucy 65, 126
Blast 160–1, *161*
Boldini, Giovanni 36, *38*
Bonheur, Rosa 58, 89, 95–6, *96*, 103
Borzello, Frances 128
Bulley, Agnes Amy 18, 28
Burlington Magazine 3, 133, 151, 159
Burne-Jones, Edward 29, 30, 128–9, *130*
Burns, Sarah 147
Butler, Elizabeth 12, 34, 46, 48, 49, 93,
 113–14
 Floreat Etona 56–7
 and Meynell 53–8
 reviews of 106–7
 Roll Call 55, 58, 93
 Rorke's Drift 54, *55*
 To the Front 54, 58, 110
Butler, Judith 23
Butler, William 55

Campbell, Gertrude 12, 23, 27, 33, 36–7, *38*
Carter, A. C. R. 106
Cartwright, Julia 12, 14, 19, 22, 26, 29–30
 and clubs 31, 32

and Society of Women Journalists 27
Cass, Elizabeth 16
Cassatt, Mary 108–10, *109*
Catholic Suffrage Society 79, 80
Century 116, 128–9
Certeau, Michel de 6, 90
Chadwick, Whitney 122–3
Chantrey Bequest 97, 106, 132–3
Cherry, Deborah 90, 98
Chetwynd, Mrs Henry 13
Chow, Rey 6, 90, 114
Cobbe, Frances Power 14, 95
Codell, Julie 7–8, 69
Collett, Clara 13–14
Columbian Exposition, Chicago 30, 58,
 108–11
Connoisseur 18, 159
Contemporary Review 24, 67, 68
Cook, E. T. 15
Critic 125
Cruttwell, Maud 29, 31
Currie, E. H. 128

Daily Chronicle 19, 52–3, 77, 78, 125
Daily Mail 15
Daily News 17
Daily Sketch 78
Dakers, Caroline 105–6
de Courtivron, Isabelle 122–3
De Mattos, Katherine 12, 43
Degas, Edgar 70–2, 137, 138, *140*
Demoor, Marysa 19
Demorest's American Monthly 57
Dilke, Charles 12, 21, 37, 40
Dilke, Emilia 11, 12, 14, 19, 21, 43
 and nudity in art 66
 and politics 30, *31*, 84
 portraits of 37–40, *39*, *41*
Dixon, Ella Hepworth 12, 19, 22–3

Elmy, Elizabeth Wolstoneholme 84
Englishwoman's Review 93, 99, 110, 112
Englishwoman's Year Book 23
Evening Post 125

Farrar, W. 67
Fenwick Miller, Florence 8–9, 19, 21–2, 24,
 158
 on great women artists 89–106
 in *Illustrated London News* 66, 83, 86,

90–100, *92*, 114
 and London School Board 14, 22, 82–3,
 85
 medical training 12, 13, 14
 and politics 81–2, 83–5
 portraits of 30–1, *32*
 on RA and membership of women 91–4
 reviews of women's work 106–13
 self-representation 87–9
 Woman's Signal, editorship of 100–6
Fine Art Society 55, 146
Flint, Kate 94
Forbes, Stanhope 72, 74, *75*, 134
Fortnightly Review 2, 30, 43, 69, 119,
 125,137
French Impressionism 70–2, 74, 130–1,
 134, 137–8
Fry, Roger 3, 26, 151

Garb, Tamar 22, 94
Garrison, Wendell O. 125
Gibbons, Mr 16
Gillett, Paula 107
Glasgow Boys 134, 135–6
Gosse, Edmund 23, 40–2, 116
Goupil Gallery 134, 135, 142
Grafton Gallery 71, 135–7, 138, 144
Graphic 30, *31*
Greenhalgh, Paul 108
Greiman, Liela Rumbaugh 72
Grosvenor Gallery 49, 63, 94, 135
Gruetzner Robins, Anna 135
Grundy, Sydney 116
Guthrie, James *139*

Hamerton, Philip Gilbert 24–5
Harmsworth, Alfred 15
Harper's New Monthly Magazine 125, 148
Harris, Frank 146
Harrison, Jane 31–2, *33*
Hartford Courant 126
Haweis, Mary Elizabeth 101
Hayden, Sophia 108
Hearth and Home 16, 18
Henley, W. E. 51, 72
Herkomer, Hubert 40, *41*, 62–3, 144
Hichberger, J. W. M. 56
Hogarth, Janet E. 18
Holcomb, Adele 4
Horsley, J. C. 65, 98

Hosmer, Harriet 98, 103, 108, 110
Hubbard, Elbert 95–6
Hunt, Holman 67–9, *68*
Hunt, Violet 33

Ibsen, Henrik Johan 119
Illustrated London News 2, 15, 37, 111, 122
 Fenwick Miller in 66, 83, 86, 90–100, *92*, 114
Impressionism 70–2, 74, 130–1, 134, 135, 137–8
Ingram, John H. 118–19
Institute of Journalists 14, 27
International Society of Painters, Sculptors and Gravers 126, 147
Israel, Kali 37

Jameson, Anna 46, 49
Jex-Blake, Sophia 82
Johnson, Adelaide 103, *104*, 108
Jopling, Louise 78, 86, 89, 93, 94–5, 99, 113
 Blue and White 101, *102*

Kegan Paul 77, 118, 119
Kemp-Welch, Lucy 93, 106, *107*, 132
Koven, Seth 129

Lady's Pictorial 14, 16, 20, 118
Lady's Realm 13
Lane, John 51
Langley, Walter *73*, 75
Ledger, Sally 118
Lee, Vernon 12–13, 22, 29, 31
Leighton, Frederic 40, 43, 63, *64*, 85–6, 98, 105
Leland, Charles Godfrey 116, 129
Lever, William 101
Little's Living Age 125
Loft, L. G. 39
London Dialectical Society 82, 83
London Impressionists 71, 131, 134, 135
Low, Frances 14, 15, 16, 18

MacColl, D. S. 25, 26, 139, 151
 on Degas 138
 on Glasgow Boys 135
 and NEAC 134
 in *Saturday Review* 132–3
 in *Spectator* 130
Macleod, Diane Sachko 70

Magazine of Art 17, 59, 106, 113, 130, 132, 133, 151
 Meynell in 46, 47, 49, *50*, 51, 62, 70, 74, 76
Mariott-Watson, Rosamund, *see* Thomson, Graham
Martineau, Harriet 14, 83, 88, 89
Men and Women's Club 120
Meredith, George 51
Merrit, Anna Lea 97, 98, 107, 110
Merry England 9, 46, 47, 49, 51, 72
Meynell, Alice 8–9, 16, 22, 31, *50*, 78, 160
 assessment of 157–8
 biography reviews 59–70
 and Butler, support for 53–8
 career 12, 19, 45–53
 on Degas 70–2
 on Hunt 67–9
 Newlyn School, support for 72–6
 on nudity in art 65–6
 and politics 77–9
 portraits of 9, *10*, 34, *35*, *36*
 on Pre-Raphaelitism 67–9
 on Ruskin 69–70
 and Society of Women Journalists 27, 33
 Wares of Autolycus 48, 76, 77
Meynell, Elizabeth, *see* Butler, Elizabeth
Meynell, Viola 51, 80
Meynell, Wilfrid 14, 18, 19, 34, 47, 51–3, 63, 72
Modern School of Art 63
Monet, Claude 70, 137
Montalba, Clara 93, 110
Moore, George 130, 131, 140
Morten, Honnor 28

Nation 69, 125
 on Grafton Gallery 135–7
 Pennell and 115, 119, 127, 137, 138, 142, 144, 147, 148
National Observer (formerly *Scots Observer*) 51, 144
Nead, Lynda 122
New Criticism and New Critics 20, 25, 71, 115, 124, 130–41, 150–2
New English Art Club (NEAC) 130, 134, 142, 148
 and Degas 71, 72
 and Newlyn School 74, 76
 Pennell on 135–7
New Gallery 76

New Journalism 20, 21, 23, 24, 59, 62
 Pennell and 126–9
New Woman(hood) 20, 115, 116–26,
 117
New York Herald 130, 134
New York Observer 125
Newlyn School 72–6, 131, 134, 135
Nights 124
Niles, T. 118
Nineteenth Century 24, 30
Nolan, James J. 16
Nord, Deborah Epstein 13, 16–17
Normand, Ernest 97, 105
North American Review 125
nudes 63–7, 97–8, 99
Nunn, Pamela Gerrish 4–5, 60

Oldcastle, Alice, *see* Meynell, Alice
Oldcastle, John, *see* Meynell, Alice;
 Meynell, Wilfrid
Outing 120, 125

Paget, Violet, *see* Lee, Vernon
Palace Journal 26, 128
Palgrave, F. T. 23
Pall Mall Gazette 2, 25, 43, 63, 125
 Meynell in 48–9, 52, 75
 Wares of Autolycus 33, 48, 76, 77
Patmore, Coventry 34, 51
Pattison, E. F. S., *see* Dilke, Emilia
Pattison, Mark 12, 19, 25, 26
Pearson, Karl 119–20
Pen 46, 47, 69
Pennell, Elizabeth Robins 8–9, 66–7, 69,
 155, 158
 bicycling 120–2, *121*
 on black and white art 146–7, 152
 in *Fortnightly Review* 119, 137
 in *Nation* 115, 119, 127, 137, 138, 142, 144,
 147, 148
 on NEAC 135–7
 and New Criticism 130–41
 and New Journalism 126–9
 on People's Palace 127–8
 portraits of 34–6, *37*
 RA, criticism of 131–4, 141, 146, 148
 and Sargent 148–51
 in *Star* 115, 125, 129, 130, 131–2, 137, 138,
 140–1, 146, 151
 Thursday salon 33, 123–4

 on Whistler 141–5, 147
 on Wollstonecraft 116, 118–19
Pennell, Joseph 116, 120–2, 123, 124–5,
 144, 146, 147
Pennell, Larkin 125
Penny Illustrated 125
Perkins, Harold 21
Peyrol, René 95
'Philistine', *see* Spender, J. A.
Phillipps, Evelyn March 18, 20, 24, 27, 118
Pollock, Griselda 74, 110
Pre-Raphaelitism 67–9
Press 116
Press Day at the Royal Academy 1, 9, 10
Prettejohn, Elizabeth 2–3, 25–6
Prinsep, Val 105
Punch 116, *117*, 156, 157

Quarterly Review 19
Queen Isabella Association 108

Rae, Henrietta 86, 96–8, 103–6, 113–14
 Columbian Exposition 110, 112
 nudes 96–8, *97*, *99*, 99
 and RA, Membership of 89, 93,
 105–6
 Victorian Era Exhibition, curator of
 Woman's Work section 58, 111–12
Rational Dress 110, 120
Review of Reviews 15
Richmond, William Blake 105
Roberts, Helene E. 29
Roberts-Austen, Florence M. 110–11
Roberts Brothers, Boston 118
Robson, H. H. 99, 112
Rogers, Frederick 82–3
Romane, George 13
Rossetti, W. M. 23, 40, 67
Rothenstein, William 33, 34, *36*
Royal Academy (RA) 7, 63, 67
 and membership of women 77, 91–4
 Pennell's criticism of 131–4, 141, 146, 148
 Press Days 1, 9, *10*, 17, 27
Royal Academy Pictures 98
Royal Scottish Academy 135
Royal Society of Painters in Watercolours
 75
Ruskin, John 69–70, 71, 78–9, 141–2

St. Nicholas 125

Sanders, Valerie 88–9
Sargent, John Singer 34, *35*, 93, 131–2, *149*
 Pennell and 148–51
Saturday Review 132–3
Schreiner, Olive 16
Scots Observer, see *National Observer*
Scott, Leader, *see* Baxter, Lucy
Scottish Art Review 135
Scribner's 116, 146
sculpture 40, 98–9, 103, 108, 110
Sesame Club 31–2, 33
Seymour Haden, Francis 144
Shafts 118
Shaw, George Bernard 120
Sherman, Claire Richter 4
Shiman, Lilian Lewis 87
Shorter, Clement 52
Sickert, Bernhardt 135
Sickert, Walter 71, 130, 134, 135, *136*, 146
Simpson, Marc 148
Sketch 28, 52
Smith, Alison 65
Society of Authors 26, 120
Society of Women Artists (formerly
 Society of Lady Artists) 107, 131
Society of Women Journalists 26, 27, 33
Spectator 77, 130
Spender, J. A. 20, 25, 130, 138–9
Spielman, M. H. 27, 133–4, 151
 women critics, attitude to 1, 9, 17–18
Standard 130
Standing, Percy Cross 43
Star 9, 69, 126, 134
 Pennell in 115, 125, 129, 130, 131–2, 137,
 138, 140–1, 146, 151
Stead, W. T. 14, 15, 18, 20, 52, 126
 women critics, attitude to 16, 17
Steer, Philip Wilson 135
Stephens, Frederic George 23, 43, 57, 67,
 106, 133
Stephenson, Andrew 26
Stevenson, R. A. M. 25, 130, 132, 135,
 150
Stokes, Adrian 34, 75–6, 134
Stokes, John 130
Stokes, Marianne 49, *50*, 74, 75–6, 93
Strong, Francis, *see* Dilke, Emilia
Studio 130
Sun 146
Swynnerton, Annie 110, 111

Tablet 46, 49, 63, 65–6, 72
Tagg, John 62
Thomas, L. Basil 27
Thompson, Christiana 12, 46
Thomson, George 135
Thomson, Graham 33
Thornycroft, Hamo 23, 59
Thornycroft, Mary 40, *42*, 98
Tickner Lisa 126
Time and Tide 80
Times 2, 63–5, 66, 98, 144
Tomasson, Catherine 82
Trevelyan, Pauline 37, *39*

Union des Femmes Peintres et Sculpteurs
 94

Van Ardsel, Rosemary T. 87
Velasquez, Diego Rodriguez de Silva y
 150
Vicinus, Martha 16, 31
Victoria, queen of England 30, 54, 58,
 93
Victorian Era Exhibition 58, 93, 103,
 111–13
Vorticists 160

Walker, Lynne 17
Walkley, Giles 60–2
Watts, G. F. 29–30, 40
Wedmore, Frederick 130
Weekly Register 46–7, *51*, *57*, 72
Westminster Gazette 15, 138, 139, 141
Whirlwind 130
Whistler, James MacNeill 34, 36, 131–2,
 137, *145*, 146
 Nocturne series 141–2, *143*
 Pennell on 141–5, 147
Whitely, Margaret 18, 28
Whitney, Anne 103, 108, 110
Wollstonecraft, Mary 77, 116, 118–19
Woman 15, 77, 78, 125
Woman Journalist 16, 26
Woman's Signal 20, 83, 86, 87, 111, 118
 Fenwick Miller, editorship of 100–6, 114
Woman's World 20
Women Writers Suffrage League 160
Women's Franchise League 84, 114
Women's Penny Paper 82
Women's Suffrage Journal 84

Women's Work 18
Women's Writers' Club 28
World 12, 52
Wynman, Margaret, *see* Dixon, Ella
 Hepworth

Yates, Edmund 52
Yeo, Eileen Janes 49
Young Woman 18, 20, 118

Zimmern, Helen 12, 40–2, 43, 59